The Handbook of Art Therapy

This new edition of *The Handbook of Art Therapy* is thoroughly revised and updated and includes new sections on neurobiological research, and a current review of literature and contemporary practice. It provides a comprehensive introduction to the field of art therapy in a variety of different settings.

Caroline Case and Tessa Dalley draw on their experience of teaching and practising art therapy, concentrating on what art psychotherapists actually do, where they practice, and how and why art therapy is effective. First-hand accounts of the experience of art therapy from both therapists and clients are used throughout, enriching the discussion of subjects including:

- The art therapy room
- Art and psychoanalysis
- Art therapy and creativity
- Working with groups in art therapy
- Art therapy with individual patients

This straightforward and highly practical handbook will be invaluable not only as an introduction to the profession but also as a reference for students of art psychotherapy both during and after their training.

Caroline Case is an experienced art therapist and child and adolescent psychotherapist working in a CAMHS team, in private practice and as a clinical supervisor. She has published widely on her work with children, but also works with adults. Her most recent publication is *Imagining Animals: Art, Psychotherapy and Primitive States of Mind*.

Tessa Dalley is an experienced art therapist who works in private practice and as a clinical supervisor. She is also a child and adolescent psychotherapist working in an in-patient adolescent unit and in the Parent-Infant Project at the Anna Freud Centre, London. She has published a number of books and articles and is currently editor of the *International Journal of Art Therapy: Inscape*.

The Handbook of Art Therapy

Second edition

Caroline Case and Tessa Dalley

Routledge
Taylor & Francis Group

LONDON AND NEW YORK

First edition published 1992 by Routledge
27 Church Road, Hove, East Sussex BN3 2FA

Reprinted 1993, 1995, 1997, 1999, 2000, 2002 and 2004

This edition published 2006 by Routledge
27 Church Road, Hove, East Sussex BN3 2FA

Simultaneously published in the USA and Canada
by Routledge
270 Madison Ave, New York, NY 10016

*Routledge is an imprint of the Taylor & Francis Group, an informa
business*

© 2006 Caroline Case and Tessa Dalley

Typeset in Times by
RefineCatch Limited, Bungay, Suffolk
Printed and bound in Great Britain by
TJ International Ltd, Padstow, Cornwall
Paperback cover design by Lou Page

This publication has been produced with paper manufactured to
strict environmental standards and with pulp derived from
sustainable forests.

British Library Cataloguing in Publication Data
A catalogue record for this book is available from the British Library

Library of Congress Cataloging in Publication Data
Case, Caroline, 1948–
 The handbook of art therapy / Caroline Case and Tessa Dalley.
 p. cm.
 Rev. ed. of: Handbook of art therapy / Caroline Case and Tessa
Dalley. London ; New York : Tavistock / Routledge, 1992.
 Includes bibliographical references and index.
 ISBN13: 978–1–58391–791–6 (hbk.)
 ISBN10: 1–58391–791–8 (hbk.)
 ISBN13: 978–1–58391–792–3 (pbk.)
 ISBN10: 1–58391–792–6 (pbk.)4
 1. Art therapy–Handbooks, manuals, etc. 2. Art therapy–Great
Britain–Handbooks, manuals, etc. 3. Arts–Therapeutic use–
Handbooks, manuals, etc. I. Dalley, Tessa. II. Title.
 RC489.A7C38 2006
 616.89'1656–dc22 2006004558

ISBN13: 978–1–58391–791–6 (hbk)
ISBN13: 978–1–58391–792–3 (pbk)

ISBN10: 1–58391–791–8 (hbk)
ISBN10: 1–58391–792–6 (pbk)

Contents

List of illustrations vi
Foreword viii

1 Introduction 1

2 The art therapy room 17

3 The therapy in art therapy 69

4 Theoretical developments and influences on current art
 therapy practice 89

5 Art and psychoanalysis 113

6 The image in art therapy 137

7 Development of psychoanalytic understanding 160

8 The art therapist 185

9 Art therapy with individual clients 213

10 Working with groups in art therapy 230

 Bibliography 272
 Glossary 277
 The British Association of Art Therapists 290
 Name index 297
 Subject index 301

Illustrations

PLATES

1 First castle, second castle, third castle
2 (a)–(i) Red, black and yellow sequence
3 Mother
4 Elephant princess
5 Bill 'n' Bob
6 Abstract pattern
7 (a)–(h) Windmills
8 Rosie: Forest
 Rosie: Me
 Rosie: Therapist
 Rosie: Rabbit

FIGURES

2.1 The art therapy room, St Mary's School for Children
 with Special Needs, Bexhill-on-Sea 19
2.2 The art therapy room, Leytonstone House, London 24–5
2.3 The art therapy room, St Thomas's Hospital, London 30
2.4 The art therapy room, Bloomfield Clinic, London 43
2.5 The art therapy room, Hill End Hospital, St Albans 46
4.1 The dialogue between image and patient; patient and
 therapist (after Michael Edwards) 91
4.2 Three-way relating – the dynamic field
 (after Joy Schaverien) 91
6.1 Stencil 142
6.2 Finger paints 144
6.3 Death's head mask 145
6.4 Nuns 150
6.5 Divorce 152
6.6 (a)–(f) Isolation, degradation, despair . . . 155–7
8.1 A tree, a nest, and three birds 197

8.2 Group therapy interaction chronogram 200
8.3 Mapping the progress of group members 201
8.4 Recording the work of three children and the therapist 202
10.1 (a)–(f) Six group pictures: (a) Abdul, (b) Colin, (c) Graham,
 (d) Susie, (e) Jane, (f) Georgina 242–3
10.2 (a)–(h) 'Draw yourself as a tree' 260–1
10.3 Imran's clay soldier 263

Foreword

This book is entitled *The Handbook of Art Therapy* to give a clear account of the theory and practice of art therapy. It is not designed to instruct a person to be an art therapist, and anyone reading this book will be advised against thinking that it is a 'manual' for practice. The purpose of the book, however, is to give clear guidelines and a detailed understanding of how art therapy is practised and the theory on which this practice is based. Hopefully, this will be useful for people interested in all aspects of art and therapy and perhaps encourage some people to embark on training courses essential for becoming an art therapist.

Throughout the book, both client and therapist will be referred to generally as 'she' except where a specific example is being described. This is because the majority of art therapists are women, and most clients who are in therapy are also women. Also, we have in general chosen to use the word 'client' to describe the person in treatment with the 'therapist' but this can be interchangeable with 'patient', 'resident', 'member' and does not imply any difference in the approach, although it might reflect some difference in the treatment setting. For readers outside the UK, the National Health Service will be referred to throughout as the NHS.

We would like to acknowledge our clients, who have so extensively informed our experience, and also the help of our colleagues, who have made several contributions throughout the book. By working with us and giving generously of their time in describing their particular experience, we feel that this has enabled the text to become 'alive' and relate to real circumstances, and has considerably enhanced the quality of the book. In particular, we are grateful to Anna Goldsmith, Clare Morgan and Caroline Gilder for their invaluable contribution and help in updating Chapter 2. Also, our thanks go to our long-suffering families whose help and support are actually immeasurable.

Chapter 1

Introduction

Definition

Art therapy, or art psychotherapy as it is sometimes called, involves the use of different art media through which a client can express and work through the issues, problems and concerns that have brought her into therapy. In the therapeutic relationship, the art therapist and client are engaged in working together to understand the meaning of the art work produced. For many clients, it is easier to use a non-verbal form of communication and, by relating to the art therapist, make sense of their own experience through the art object which provides a focus for discussion, analysis and reflection. As the art work is usually concrete, there is a memory of the therapeutic process in the making of the object and in the interaction between therapist and client. Transference develops within the therapeutic relationship and also between therapist, client and the art work, giving a valuable 'third dimension' or three-way communication (Schaverien 2000).

The art therapist

Art therapy in the United Kingdom is a state registered profession with the Health Professions Council (HPC). Art therapy practitioners are bound by law to be registered with the HPC. The British Association of Art Therapists (BAAT) is the professional organisation for art therapists in the UK and has its own code of ethics of professional practice. The BAAT works to promote art therapy and has 20 regional groups, a European and international membership and maintains a comprehensive directory of qualified art therapists. The professional journal of the BAAT, *The International Journal of Art Therapy: Inscape* is published biannually. *Newsbriefing* is also published biannually and provides information and communication for the profession as a whole.

We hope to introduce the reader to the clinical practice of a qualified professional who meets the required standards for registration as outlined by the BAAT and the HPC. The history of the profession is well documented

(Waller 1991). The first art therapy post was established in the NHS in 1946 which marked tentative beginnings of a discrete profession in the 1950s. It was not until 1981 that the profession was officially recognised by the Council for Professions Supplementary to Medicine (CPSM) which led to state registration in 1999.

Art therapists work in a variety of residential and community-based settings within the NHS, in social services, education, the prison service and for independent agencies such as palliative care and voluntary organisations. Approaches and orientations of art therapists vary widely, particularly in relation to the client group with whom they are working. Some art therapists are more concerned with the internal world of the client in understanding emotional experiences and unconscious processes, while others focus more on the art process and product of the session. As the practice of art therapy is evolving, informed by psychoanalytic concepts, there is an ongoing debate whether to call the profession 'art psychotherapy' (Dudley 2004). This debate, along with many others, underpins the development of art therapy as a profession and will be discussed in this book (Waller and Gilroy 1992; Edwards 2004).

The handbook

This handbook is designed to introduce the reader to theoretical and clinical aspects of art therapy. This introductory chapter gives a broad outline of the work of an art therapist and describes different work settings which is followed by a chapter describing the context of the work – the art therapy room. The 'therapy' in art therapy is explained in Chapter 3 using detailed case material, covering issues such as assessment, therapeutic contracts and building a therapeutic alliance. Once the therapeutic relationship is underway, the nature of transference, counter-transference and the relationship of the art object between the client and the therapist is explored. Theoretical developments and the influences on current art therapy practice are the subject of Chapter 4 whereas Chapter 5 introduces the work of Freud, Anna Freud, Klein, Winnicott, Milner and Jung. All these writers have been highly influential in informing our practice. Chapter 6 gives an in-depth explanation of the role of the image and art process, and is followed in Chapter 7 by some theoretical considerations of creativity, aesthetics and symbolism. The last three chapters focus on the work of the art therapist, her practice, background and training. Working with individual clients and groups is described, and detail is provided on the various stages of assessment, ongoing work and termination. A general glossary of terms is provided on page 277. Details of the BAAT art therapy training courses and other general information is provided on page 290.

Historical aspects

Over the years, writers have explored the complex relationship between art and psychoanalysis and how the practice of art therapy has evolved to incorporate both (Gosso 2004; Mann 2006). Edwards (1989) traces the evolution of differing models of art therapy by describing attitudes towards art, madness and psychoanalysis back to their origins in the eighteenth and nineteenth centuries. He demonstrates how ideas from other areas of enquiry, such as the use of art in rituals, religious customs and anthropology, form a 'more elaborate and enduring context' for art therapy that was in existence well in advance of its establishment as a discrete profession.

Art history and the history of psychiatry have given rise to certain models of art therapy practice. Edwards postulates that the codified, diagnostic attitude towards imagery is rooted in eighteenth-century neoclassicism, and in the 'rational' belief that a person's state of mind could be read from a picture. The depiction of feeling in art was formalised and enabled the painter and the audience to remain uninvolved. By contrast, the nineteenth-century romantics embraced a positive conception of the imagination and valued the artistic representation of inner experience. This attitude related to a belief in the natural healing capabilities of art.

It is true to say that in the development of the profession in the early years of pioneer work in art therapy, most art therapists emphasised the process of art and its inherent healing properties as central to art therapy practice. Influenced by such innovators as Herbert Read (1942) and Adrian Hill (1941), the two strands of art therapy developed in parallel – one in an educational setting, developing out of enlightened art teaching; the other from medical roots where art was used to help soldiers traumatised by their experiences of war (Waller 1984). Such statements as 'art should be the basis of education' (Read 1942: 1) and the consideration of expression, imagination and spontaneity in art greatly influenced the direction of art teaching at that time. This had the effect of highlighting the central nature of art in terms of its possibilities for emotional communication and the inherent potential for therapeutic work.

The influence of early psychoanalytic writing, such as that of Jung, gave support to the idea that art was an important means of communication, both unconscious and conscious. Jung's work will be considered in more depth in later chapters, but during his own self-analysis, he drew his own dreams and fantasies and encouraged his patients to do likewise: 'What a doctor then does is less a question of treatment than that of developing the creative possibilities latent in the patient himself' (Jung 1983: 41).

Jung's technique of active imagination – encouraging the kind of fantasy that came into his patients' minds when they were neither asleep nor awake at a particular time when judgement was suspended but consciousness not lost – closely parallels that of the creative process and the inspiration of artists and

inventors. The mobilisation of the psyche through an image or a chain of images and their related associations was observed to promote change as the gap between conscious and unconscious, inner and outer, private and public experience is bridged (Maclagan 2005; Schaverien 2005). This has led us to look further into psychoanalytic theory and how the art process can be understood in a therapeutic setting, drawing from the ideas of Freud, Klein or Jung or later writers such as Donald Winnicott and Marion Milner (Nowell Hall 1987; Weir 1987; Mann 2006).

Clinical practice

Art therapists work with clients either individually or in groups. Following an initial assessment, the treatment can be brief – up to 20 sessions – or long term, lasting over many years (Hershkowitz 1989; Case 2005). Wherever the art therapist is working, a therapeutic contract between patient and therapist provides the framework, such as time (the beginning and the end) of the session, the consistent space where the work takes place and some under-standing about duration of treatment (such as whether there is a time limit to the work). By placing boundaries around the sessions in terms of time and place, a sense of safety, confidentiality and trust is created, allowing the therapeutic relationship to develop (Schaverien 1989). The maintenance of these boundaries makes room for the image to emerge in a contained setting and enables the expression of deep feelings and experiences.

The presence of the art object made within the session makes art therapy distinct from other verbal psychotherapies. The image is of great significance in the symbolic representation of inner experience. The emphasis on the unconscious communication, the feelings, anxieties and concerns that surface through the art work are worked through in the relationship between thera-pist and client. Consideration of transference and counter-transference issues is an integral part of the process (see Chapter 3). The art therapist receives regular clinical supervision by a more senior practitioner to process material that is held in the image and the developing transference phenomena within the session (Killick 2000). Safe keeping of the image by the art therapist for the duration of the treatment is therefore part of the boundaries and containment of the art therapy process.

Different client groups and work settings

Art therapy offers the possibility of working with many different client groups. The orientation of the art therapist will vary accordingly. It is in the nature of image-making that most people are capable of making marks and therefore can use art therapy is some way. Where a therapeutic contract has been established between therapist and patient, following an initial assessment period, most art therapy sessions involve a combination of image-making,

talking and reflection on the issues that have surfaced (Dudley 2004b). The art therapist will be mindful of the extent that image-making is used in a session. For example, a client who fills the whole session time by painting without leaving space for reflection or where there are long stretches of time of 'not doing' are important communications in themselves. These can be understood to be equivalent to a client in verbal psychoanalytic therapy who might talk non-stop or engage in long periods of silence and will be open for thinking and interpretation. For those clients who are without language or, for developmental reasons, cannot use art materials, activities using water, sand, play and body movement become the means for non-verbal communication and expression (Rabiger 1998).

Distribution of workplaces

In 1990, a survey carried out by the BAAT reflected the distribution of employment for the 64.4 per cent of the membership who replied to the questionnaire: NHS 54 per cent, social services 15 per cent, education 7 per cent, non-statutory services 7 per cent, adult/higher education 5 per cent, Home Office 2.5 per cent, self-employed 2.5 per cent. Six per cent of therapists had more than one employer, two-thirds who replied were in full-time employment and the other third worked part-time.

In 2004, there were 1257 registered members of the BAAT plus 220 trainees and 48 associate members. Of these, 57 per cent worked in the NHS, 25 per cent in education, 17 per cent in social services, 11 per cent in the voluntary sector, 3 per cent in prisons and 18 per cent in private practice. A number of art therapists also work in GP practices (Turnbull and O'May 2002; Wilson 2002). The biggest change over the 14 years has been the growth of work in education, voluntary sectors, in particular palliative care, and in private practice. The diversity of these areas of work is reflected in the number of special interest groups that have developed in affiliation with the BAAT. These include special interest groups working with issues of ethnicity, race and culture and from feminist perspectives (Schaverien 1995; Hogan 1997; Campbell 1999).

The majority of art therapists work within the public sector of health, social services and education. The work will depend on the nature of the treatment setting. In an adult mental health unit, for example, the art therapy department tends to be autonomous but the art therapist works in liaison with colleagues within the multi-disciplinary team. In an inpatient setting, art therapists are clinically responsible to the consultant psychiatrist and have a responsibility to attend ward rounds, case conferences and contribute to the patients' care plan. On discharge, the patient may continue to attend art therapy as an outpatient (Killick 1987; C. Wood 1990; Dalley *et al.* 1993).

Art therapists who are based in social services (Aldridge 1998), in mainstream and special schools (Arguile 1990; Dalley 1990; Reddick forthcoming;

Welsby forthcoming) and other treatment centres such as day centres and assessment centres (Case 1990) work in the same way within the multi-disciplinary team in which art therapy may be one of many treatment interventions. Increasingly, art therapists are working in forensic settings, in medium- and high-security prisons, such as Holloway, and in secure psychiatric units such as Rampton and Kneesworth Hospitals (Laing 1984; Rothwell 2005).

As the work settings vary, the orientation of the art therapist will depend on the needs and difficulties of the particular client group and therapists will adapt their practice accordingly.

Children

Engaging in the process of art provides the possibility of a more spontaneous, non-verbal means of communication through which children can express many of the difficulties with which they are struggling (Mathews 1989, 1999; Burkitt and Newell 2005). The art therapist working with children has an understanding of child development and the importance of working with the internal world of the child, attachment issues and early infantile experience. For example, the art therapist working in a child and adolescent mental health service (CAMHS), as a member of the multi-disciplinary team, sees children who have a wide variety of emotional and behavioural difficulties, either individually or in a group (Case and Dalley 1993, forthcoming; Dalley 1993; Buckland and Murphy 2001; Dalley forthcoming a and b; Dalley forthcoming; Case forthcoming). The art therapist works alongside colleagues in core work assessments in the initial stages with children and their families. Work in art therapy with children with particular developmental needs and diagnostic categories such as those aged under 5 (Meyerowitz-Katz 2003; Hall forthcoming), children who have impulsive behaviour or attention deficit hyperactivity disorder (ADHD) (Murphy 2004), children who are looked after in the care system and with attachment disorders (Knight 1989; Boronska 2000, forthcoming; O'Brien 2004, forthcoming) and those suffering from family breakdown, bereavement and loss has been well documented (Donnelly 1989; Greenaway 1989; Deco 1990; Kuczaj 1998). Using art, sand and water play can be particularly helpful in the assessment and treatment of children for whom words are very frightening – for example, disclosure work of past or present sexual abuse (Thomas 1998; Douglass 2001; Murphy 2001; Muir forthcoming).

Children who have ritualistic or phobic responses to situations, or obsessive compulsive disorders, can be helped to use art to explore their feelings in a safe, non-threatening environment (Lillitos 1990; Vasarhelyi 1990). Trauma and sudden loss for a child can be particularly problematic when trying to make sense of confusion and chaos around them. Art therapists work in trauma clinics such as the Medical Foundation for Victims of Torture

(Kalmanowitz and Lloyd 2005). The use of drawing to help children suffering from trauma and loss in the aftermath of disasters such as the attack on the World Trade Centre, New York on September 11 2002 (Wise 2005), and the victims of natural disasters such as the tsunami that devastated South-East Asia in December 2004 is well known from newspaper reporting. Some art therapists are employed in areas where war, conflict and political violence is a daily experience (Kalamanowitz and Lloyd 2005; Solomon 2005).

Education

An important area of work for art therapists working with children is in the field of education. Traditionally, art therapists have worked in special schools or residential establishments for children with emotional and behavioural difficulties, which operate on therapeutic lines (Robinson 1984). Since the 1981 Education Act and the integration of children with special needs, the notion of inclusion has prompted greater need for therapists to be located within mainstream school settings. The introduction of the National Curriculum and regular testing of children has created extra pressure for teachers and children alike. There is a growing recognition that working therapeutically in schools with children who have special educational needs or challenging behaviour helps problems associated with low self-esteem, poor academic performance and unruly behaviour. The statement of special educational needs can include specialist therapeutic provision for these children (Dalley *et al.* 1987; Nicol 1987; Welsby forthcoming).

Children with moderate or severe learning disabilities use the process of art therapy differently in conveying their experience through use of drawing, sand, water and play. The art therapist attends to the detail of the communications of the child who may not be able to use language (Rabiger 1990; Dubowski and James 1998; Rees 1998; Damarell and Paisley forthcoming). Children on the autistic spectrum have particular social and emotional communication disorders. They tend to be experienced by other people as withdrawn, ritualistic and internally preoccupied. Change creates anxiety for the autistic child and therefore therapeutic intervention is complex. Art therapists work with children who are autistic or who have Asperger's syndrome in special schools, autistic units or assessment centres (Plowman 1988; Fox 1998; Stack 1998; Evans and Dubowski 2001; Patterson forthcoming; Tipple forthcoming). Some autistic children show exceptional drawing ability. There are well-known examples, such as Nadia (Selfe 1977), who have shown technical skill in drawing well beyond their chronological age. The reasons for this remain unknown and are explored by McGregor (1990). This phenomenon is of particular interest to art therapists who will occasionally come across it in their practice (Hermelin 2001; Meyerowitz-Katz forthcoming). (For further reading on autism and Asberger's syndrome see Tustin 1981; Rhode and Klauber 2004; Fitzgerald 2005.)

Adolescents

Adolescents face particular difficulties in their developmental path from childhood to adulthood. The nature of this transient phase can be characterised by emotional confusion, unhappiness, vulnerability and distress in the search for individuation and separation. These feelings are often expressed by acting out through alcohol and substance misuse, violent mood swings, cutting and other self-harming behaviours including eating disorders (Levens 1995; Maclagan 1998; Milia 2000; Dalley forthcoming, a). The intensity of feeling is often difficult to contain and in a treatment setting requires strong boundaries and specialist understanding of the complexity of the problems. Art therapists work within the multi-disciplinary teams of inpatient adolescent units and also in outreach community treatment teams. As part of such teams, the art therapist engages the adolescent in therapeutic work in the home. This is particularly beneficial when the disturbed adolescent is resistant to treatment or help. Youth offending teams and social service youth teams also use art therapists to structure therapeutic services for these troubled young people (Bissonet 1998; Welsby 1998; Brown and Latimer 2001).

Adults

Art therapists work with adult patients in different treatment settings such as acute psychiatric inpatient and outpatient units (Killick 1987; Killick and Schaverien 1997), centres for patients who have a learning disability (Rees 1998), in prisons and with young offenders (Leibmann 1994; Tamminen 1998), in specialist clinics such as drug and alcoholic units (Luzzatto 1989; Waller and Mahoney 1998) and in hospices and palliative care (M. Wood 1990; Pratt and Wood 1998; Hardy 2001).

With the closure of the Victorian psychiatric hospitals or asylums, patients are now living in the community, attending outpatient day centres for their ongoing support and care (Henzell 1997; Wood 1997). Art therapists will work either individually or in groups according to clinical need (Liebmann 1986; McNeilly 1989, 2000; Waller 1993; Skaiffe and Huet 1998). The images produced in art therapy express inner turmoil and conflict and some illustrate quite graphically the account of emotional experience. Case studies documented in detail show this process clearly (Dalley 1980; Dalley 1981; Dalley *et al.* 1993). Severe mood swings, from depression to elation, often prompt different use of materials which provides the means to communicate these volatile states of mind (Wadeson 1971).

Working in the community

Patients who have been living in hospital for a number of years may have become institutionalised. This in itself creates problems of socialisation and

difficulties of being able to cope in the community. Art therapists work with such clients in outpatient settings focusing on developing independence, making and maintaining social contacts and facing the demands of the real world. Patients might spend many hours working at paintings or other types of art activity such as pottery as a safe way to express their sense of isolation and loneliness, which in turn helps to build self-esteem and interpersonal relationships with others. Open art therapy groups provide a forum for patients in the long process of rehabilitation. Using art materials to experiment with different media and learn new skills such as printing, woodcarving, picture framing etc. is particularly helpful when working towards employment opportunities (Molloy 1997; Morter 1997; Skailes 1997).

Working in prisons

Art therapists working in the prison service, with young offenders or in medium- or high-security psychiatric institutions are working with clients within a total institution. The work is complex as some clients are potentially violent and dangerous. There is a question about how a therapeutic process which involves personal growth and development of insight can be of help to a prisoner or patient confined in a locked environment. Art therapy enables a space for reflection and thinking and provides a release of pent up frustration through safe expression of violent and angry feelings. The therapeutic relationship and the use of imagery over time helps to build a stronger sense of self and some understanding as to the nature of the crime that has been committed (Cronin 1990; Leibmann 1994). The special unit at Barlinnie was a notable example of how prisoners, serving life sentences for murder, channelled their creativity to produce some extraordinary art work (Laing and Carrell 1982; Laing 1984).

Palliative care and old age

Working in the area of palliative care and with people who are ageing is another important area for art therapists (Pratt and Wood 1998; Waller 2002). Old people often feel lonely and isolated and therapeutic work helps acceptance of old age and infirmity by focusing on the past, recollecting significant events that happened a long time ago. For those who are terminally ill, art therapy enables an experience of working towards acceptance of death. For younger patients and children, who have life-threatening illnesses such as cancer or AIDS, using art helps to express uncertainties, fears and anxieties about the future (Miller 1984; Case 1987; Hardy 2001).

Research and evidence-based practice

A growing body of research activity is developing within the profession. (Gilroy 2004, 2006). This is in line with the need for evidence-based practice and the government requirement to participate in clinical audit activity. The main research activity is concentrated in the areas of outcome studies, clinical observation and feedback from service users (Pounsett *et al.* 2006). The role of the case study in art therapy research is explored by Edwards (1999).

References

Aldridge, F. (1998) Chocolate or shit? Aesthetics and cultural poverty in art therapy with children, *Inscape*, 3(1): 2–9.

Arguile, R. (1990) 'I show you': children in art therapy, in C. Case and T. Dalley (eds) *Working with Children in Art Therapy*. London: Tavistock/Routledge.

BAAT (British Association of Art Therapists) (1990) *Survey of Conditions of Employment*. London: BAAT.

Bissonet, J. (1998) Group work with adolescent boys in a social services setting, in D. Sandle (ed.) *Development and Diversity: New Applications of Art Therapy*. London: Free Association Books.

Boronska, T. (2000) Art therapy with two sibling groups using an attachment framework, *Inscape*, 5(1): 2–10.

Boronska, T. (forthcoming) The Sibling Bond: Art therapy groups with siblings in care, in C. Case and T. Dalley (eds) *Art Therapy with Children: Through Development*. London: Routledge.

Brown, A. and Latimer, M. (2001) Between images and thoughts: an art psychotherapy group for sexually abused adolescent girls, in J. Murphy (ed.) *Lost for Words: Art Therapy with Young Survivors of Sexual Abuse*. London: Routledge.

Buckland, R. and Murphy, J. (2001) Jumping over it: group therapy with young girls, in J. Murphy (ed.) *Lost for Words: Art Therapy with Young Survivors of Sexual Abuse*. London: Routledge.

Burkitt, E. and Newell, T. (2005) Effects of human figure type on children's use of colour to depict sadness and happiness, *International Journal of Art Therapy: Inscape*, 10(1): 15–23.

Campbell, J. (ed.) (1999) *Art Therapy, Race and Culture*. London: Jessica Kingsley.

Case, C. (1987) A search for meaning: loss and transition in art therapy with children, in T. Dalley *et al.*, *Images of Art Therapy*. London: Tavistock.

Case, C. (1990) Reflections and shadows: an exploration of the world of the rejected girl, in C. Case and T. Dalley (eds) *Working with Children in Art Therapy*. London: Tavistock/Routledge.

Case, C. (2005) *Imagining Animals: Art, Psychotherapy and Primitive States of Mind*. London: Routledge.

Case, C. and Dalley, T. (eds) (1993) *Working with Children in Art Therapy*. London: Routledge.

Case, C. and Dalley, T. (eds) (forthcoming) *Art Therapy with Children: Through Development*. London: Routledge.

Charlton, S. (1984) Art therapy with long-stay residents of psychiatric hospitals, in T. Dalley (ed.) *Art as Therapy*. London: Tavistock.

Cronin, P. (1990) A house of mess, unpublished thesis, London, Goldsmiths College.

Dalley, T. (1980) Art therapy in psychiatric treatment: an illustrated case study, *Art Psychotherapy*, 6(4): 257–65.

Dalley, T. (1981) Assessing the therapeutic effects of art: an illustrated case study, *Art Psychotherapy*, 7(1): 11–17.

Dalley, T. (ed.) (1984) *Art as Therapy: An Introduction to the Use of Art as a Therapeutic Technique*. London: Tavistock.

Dalley, T. (1990) Images and integration: art therapy in a multi-cultural school, in C. Case and T. Dalley (eds) *Working with Children in Art Therapy*. London: Tavistock/Routledge.

Dalley, T. (1993) Art psychotherapy groups for children, in K. Dwivedi (ed.) *Groupwork for Children and Adolescents*. London: Jessica Kingsley.

Dalley, T. (forthcoming, a) The use of clay as a medium for working through loss and separation in the case of two latency boys, in C. Case and T. Dalley (eds) *Art Therapy with Children: Through Development*. London: Routledge.

Dalley, T. (forthcoming, b) Multi-family groups with young people who are anorexic, in C. Case and T. Dalley (eds) *Art Therapy with Children: Through Development*. London: Routledge.

Dalley, T. *et al.* (1987) *Images of Art Therapy*. London: Tavistock.

Dalley, T., Rifkind, G. and Terry, K. (1993) *Three Voices of Art Therapy: Image, Client, Therapist*. London: Routledge.

Damarell, B. and Paisley, D. (forthcoming) Art psychotherapy and the life transitions of children with learning disabilites, in C. Case and T. Dalley (eds) *Art Therapy with Children: Through Development*. London: Routledge.

Deco, S. (1990) A family centre: a structural family therapy approach, in C. Case and T. Dalley (eds) *Working with Children in Art Therapy*. London: Tavistock/Routledge.

Donnelly, M. (1989) Some aspects of art therapy and family therapy, in A. Gilroy and T. Dalley (eds) *Pictures at an Exhibition*. London: Tavistock/Routledge.

Douglass, L. (2001) Nobody hears: how assessment using art as well as play therapy can help children disclose past and present sexual abuse, in J. Murphy (ed.) *Lost for Words: Art Therapy with Young Survivors of Sexual Abuse*. London: Routledge.

Dubowski, J. and James, J. (1998) Arts therapies with children with learning disabilities, in D. Sandle (ed.) *Development and Diversity: New Applications in Art Therapy*. London: Free Association Books.

Dudley, J. (2004a) Politics and pragmatism, *AT newsbriefing*, December: 4–5.

Dudley, J. (2004b) Art psychotherapist and use of psychiatric diagnosis: assessment of art psychotherapy, *Inscape*, 9(1): 14–25.

Edwards, M. (1989) Art, therapy and romanticism, in A. Gilroy and T. Dalley (eds) *Pictures at an Exhibition*. London: Tavistock/Routledge.

Edwards, D. (1999) The role of the case study in art therapy research, *Inscape*, 4(1): 2–9.

Edwards, D. (2004) *Handbook of Art Therapy*. London: Sage.

Evans, K. and Dubowski, J. (2001) *Beyond Words: Art Therapy with Children on the Autistic Spectrum*. London: Jessica Kingsley.

Fitzgerald, M. (2005) *The Genesis of Artistic Creativity: Asperger's Syndrome and the Arts*. London: Jessica Kingsley.

Fox, L. (1998) Lost in space: the relevance of art therapy with clients who have autism or autistic features, in M. Rees (ed.) *Drawing on Difference: Art Therapy with People who have Learning Difficulties*. London: Routledge.

Gilroy, A. (1989) On occasionally being able to paint, *Inscape*, spring: 2–9.

Gilroy, A. (2004) On occasionally being able to paint revisited, *Inscape*, 9(2): 69–78.

Gilroy, A. (2006) *Art Therapy Research and Evidence Based Practice*. London: Routledge.

Gilroy, A. and Dalley, T. (eds) (1989) *Pictures at an Exhibition*. London: Tavistock/Routledge.

Gosso, S. (ed.) (2004) *Psychoanalysis and Art: Kleinian Perspectives*. London: Karnac.

Greenaway, M. (1989) Art therapy in search of a lost twin, in A. Gilroy and T. Dalley (eds) *Pictures at an Exhibition*. London: Tavistock/Routledge.

Hall, P. (forthcoming) Beginning at the beginning, in C. Case and T. Dalley (eds) *Art Therapy with Children: Through Development*. London: Routledge.

Hardy, D. (2001) Creating through loss: an examination of how art therapists sustain their practice in palliative care, *Inscape*, 6(1): 23–3.

Hermelin, B. (2001) *Bright Splinters of the Mind: A Personal Story of Research with Autistic Savants*. London: Jessica Kingsley.

Hershkowitz, A. (1989) Art therapy in acute psychiatry: brief work, in D. Sandle (ed.) *Development and Diversity: New Applications in Art Therapy*. London: Free Association Books.

Henzell, J. (1997) Art madness and anti-psychiatry: a memoir, in K. Killick and J. Schaverien (eds) *Art Psychotherapy and Psychosis*. London: Routledge.

Hill, A. (1941) *Art versus Illness*. London: Allen & Unwin.

Hogan, S. (1997) *Feminist Approaches to Art Therapy*. London: Routledge.

Jung, C.G. (1983) *The Psychology of the Transference* (*Collected Works*, Vol. 16). London: Ark.

Kalmanowitz, D. and Lloyd, B. (eds) (2005) *Art Therapy and Political Violence: With Art, Without Illusion*. London: Brunner-Routledge.

Killick, K. (1987) Art therapy and schizophrenia: a new approach, unpublished MA thesis, Hertfordshire College of Art and Design.

Killick, K. (2000) The art room as container in analytic art psychotherapy with patients in psychotic states, in A. Gilroy and G. McNeilly (eds) *The Changing Shape of Art Therapy: New Developments in Theory and Practice*. London: Jessica Kingsley.

Killick, K. and Schaverien, J. (eds) (1997) *Art, Psychotherapy and Psychosis*. London: Routledge.

Knight, S. (1989) Art therapy and the importance of skin when working with attachment difficulties, in D. Sandle (ed.) *Development and Diversity: New Applications in Art Therapy*. London: Free Association Books.

Kuczaj, E. (1998) Learning to say goodbye: loss and bereavement in learning difficulties and the role of art therapy, in M. Rees (ed.) *Drawing on Difference: Art Therapy with People who have Learning Difficulties*. London: Routledge.

Laing, J. (1984) Art therapy in prisons, in T. Dalley (ed.) *Art as Therapy*. London: Tavistock.

Laing, J. and Carrell, C. (1982) *The Special Unit, Barlinnie Prison: Its Evolution through its Art*. Glasgow: Third Eye Centre.

Levens, M. (1995) *Eating Disorders and the Magical Control: Treatment through Art Therapy*. London: Routledge.

Liebmann, M. (1986) *Art Therapy for Groups: A Handbook of Themes, Games and Exercises*. London: Croom Helm.

Liebmann, M. (ed.) (1990) *Art Therapy in Practice*. London: Jessica Kingsley.

Liebmann, M. (ed.) (1994) *Art Therapy with Offenders*. London: Jessica Kingsley.

Liebmann, M. (2002) Working with elderly Asian clients, *Inscape*, 7(2): 72–80.

Lillitos, A. (1990) Control, uncontrol, order and chaos: working with children with intestinal motility problems, in C. Case and T. Dalley (eds) *Working with Children in Art Therapy*. London: Tavistock/Routledge.

Luzzatto, P. (1989) Drinking problems and short-term art therapy: working with images of withdrawal and clinging, in A. Gilroy and T. Dalley (eds) *Pictures at an Exhibition*. London: Tavistock/Routledge.

Maclagan, D. (1998) Anorexia: the struggle with incarnation and the negative sublime, in D. Sandle (ed.) *Development and Diversity: New Applications in Art Therapy*. London: Free Association Books.

Maclagan, D. (2001) *Psychological Aesthetics: Painting, Feeling and Making Sense*. London: Jessica Kingsley.

Maclagan, D. (2005) Re-imagining art therapy, *International Journal of Art Therapy*, 10(1): 23–31.

Mann, D. (2006) Art therapy: re-imagining a psychoanalytic perspective – a reply to David Maclagan, *International Journal of Art Therapy: Inscape*, 10(2): 33–40.

Matthews, J. (1989) How young children give meaning to drawing, in A. Gilroy and T. Dalley (eds) *Pictures at an Exhibition*. London: Routledge.

Matthews, J. (1999) *The Art of Childhood and Adolescence: The Construction of Meaning*. London: Falmer Press.

McGregor, I. (1990) Unusual drawing development in children: what does it reveal about children's art?, in C. Case and T. Dalley (eds) *Working with Children in Art Therapy*. London: Tavistock/Routledge.

McNeilly, G. (1989) Group analytic art groups, in A. Gilroy and T. Dalley (eds) *Pictures at an Exhibition*. London: Routledge.

McNeilly, G. (2000) Failure in group analytic art therapy, in A. Gilroy and G. McNeilly (eds) *The Changing Shape of Art Therapy: New Developments in Theory and Practice*. London: Jessica Kingsley.

Meyerowitz-Katz, J. (2003) Art materials and processes – a place of meeting: art psychotherapy with a four year old boy, *Inscape*, 8(2): 60–9.

Meyerowitz-Katz, J. (forthcoming) Conversations with Sally: art psychotherapy with a sixteen year old girl, in C. Case and T. Dalley (eds) *Art Therapy with Children: Through Development*. London: Routledge.

Milia, D. (2000) *Self Mutilation and Art Therapy: Violent Creation*. London: Jessica Kingsley.

Miller, B. (1984) Art therapy with the elderly and the terminally ill, in T. Dalley (ed.) *Art as Therapy*. London: Tavistock.

Molloy, T. (1997) Art psychotherapy and psychiatric rehabilitation, in K. Killick and J. Schaverien (eds) *Art, Psychotherapy and Psychosis*. London: Routledge.

Morter, S. (1997) Where words fail: a meeting place, in K. Killick and J. Schaverien (eds) *Art, Psychotherapy and Psychosis*. London: Routledge.

Muir, S. (forthcoming) Gender disorder in the treatment of a young person in care, in C. Case and T. Dalley (eds) *Art Therapy with Children: Through Development*. London: Routledge.

Murphy, J. (ed.) (2001) *Lost for Words: Art Therapy with Young Survivors of Sexual Abuse*. London: Routledge.

Murphy, J. (2004) An art therapy group for impulsive children, *Inscape*, 9(2): 59–68.

Nicol, A.R. (1987) Psychotherapy and the school: an update, *Journal of Child Psychology and Psychiatry*, 28(5): 657–65.

Nowell Hall, P. (1987) Art therapy: a way of healing the split, in T. Dalley *et al. Images of Art Therapy*. London: Tavistock.

O'Brien, F. (2004) The making of mess in art therapy: attachment, trauma and the brain, *Inscape*, 9(1): 2–13.

O'Brien, F. (forthcoming) The attempt to attach: simultaneous working by an art psychotherapist with a child rejected by his mother, and the grandmother who cared for him, in C. Case and T. Dalley (eds) *Art Therapy with Children: Through Development*. London: Routledge.

Patterson, Z. (forthcoming) The development of thought: working with ASD children within education, in C. Case and T. Dalley (eds) *Art Therapy with Children: Through Development*. London: Routledge.

Plowman, K. (1988) A case study of P: an autistic young man, unpublished thesis, Hertfordshire College of Art and Design.

Pounsett, H. *et al.* (2006) Examination of the changes that take place during an art therapy intervention, *International Journal of Art Therapy: Inscape*, 11(2), forthcoming December 2006.

Pratt, M. and Wood, M. (eds) (1998) *Art Therapy in Palliative Care: The Creative Response*. London: Routledge.

Rabiger, S. (1990) Art therapy as a container, in C. Case and T. Dalley (eds) *Working with Children in Art Therapy*. London: Tavistock/Routledge.

Rabiger, S. (1998) Is art therapy? Some issues arising in working with children with severe learning difficulties, in M. Rees (ed.) *Drawing on Difference: Art Therapy with People who have Learning Difficulties*. London: Routledge.

Read, H. (1942) *Education through Art*. London: Faber & Faber.

Reddick, D. (forthcoming) Art based narratives: working with the whole class in a primary school, in C. Case and T. Dalley (eds) *Art Therapy with Children: Through Development*. London: Routledge.

Rees, M. (ed.) (1998) *Drawing on Difference: Art Therapy with People who have Learning Difficulties*. London: Routledge.

Rhode, M. and Klauber, T. (eds) (2004). *The Many faces of Asperger's Syndrome*. London: Tavistock.

Robinson, M. (1984) A Jungian approach to art therapy based in a residential setting, in T. Dalley (ed.) *Art as Therapy*. London: Tavistock.

Rothwell, K. (2005) Mind the gap: art therapy with a violent offender patient, unpublished MA thesis, Goldsmiths College, London.

Schaverien, J. (1989) The picture within the frame, in A. Gilroy and T. Dalley (eds) *Pictures at an Exhibition*. London: Tavistock/Routledge.

Schaverien, J. (1995) *Desire and the Female Therapist: Engendered Gazes in Psychotherapy and Art Therapy*. London: Routledge.

Schaverien, J. (2000) The triangular relationship and the aesthetic counter transference in analytical art therapy, in A. Gilroy and G. McNeilly (eds) *The Changing Shape of Art Therapy: New Developments in Theory and Practice*. London: Jessica Kingsley.

Schaverien, J. (2005) Art and active imagination: reflections on transference of the image, *International Journal of Art Therapy*, 10(2): 39–52.

Selfe, L. (1977) *Nadia, a Case of Extraordinary Drawing Ability in an Autistic Child*. London: Academic Press.

Skaiffe, S. and Huet, V. (1998) *Art Psychotherapy Groups: Between Pictures and Words*. London: Routledge.

Skailes, C. (1997) The forgotten people, in K. Killick and J. Schaverien (eds) *Art, Psychotherapy and Psychosis*. London: Routledge.

Solomon, G. (2005) Development of art therapy in South Africa: dominant narratives and marginalized stories, *International Journal of Art Therapy: Inscape*, 10(1): 3–15.

Stack, M. (1998) Humpty Dumpty's shell: working with autistic defence mechanisms in art therapy, in M. Rees (ed.) *Drawing on Difference: Art Therapy with People who have Learning Difficulties*. London: Routledge.

Tamminen, K. (1998) Exploring the landscape within: art therapy in a forensic unit, in D. Sandle (ed.) *Development and Diversity: New Applications in Art Therapy*. London: Free Association Books.

Taylor, S. (1998) There is light at the end of the tunnel: ways to 'good clinical effectiveness research', in M. Rees (ed.) *Drawing on Difference: Art Therapy with People who have Learning Difficulties*. London: Routledge.

Thomas, L. (1998) From re-presentations to representations of sexual abuse, in D. Sandle (ed.) *Development and Diversity: New Applications in Art Therapy*. London: Free Association Books.

Tipple, R. (2003) The interpretation of children's art work in a paediatric disability setting, *Inscape*, 8(2): 48–59.

Tipple, R. (forthcoming) Paracosms and paranoia – brief art therapy with youngsters who have Aspergers syndrome, in C. Case and T. Dalley (eds) *Art Therapy with Children: Through Development*. London: Routledge.

Turnbull, J. and O'May, F. (2002) GP and clients' views of art therapy in an Edinburgh practice, *Inscape*, 7(1): 26–9.

Tustin, F. (1981) *Autistic States in Children*. London: Routledge & Kegan Paul.

Vasarhelyi, V. (1990) The cat, the fish, the man and the bird: or how to be a nothing: illness behaviour in children; the case study of a 10 year old girl, in C. Case and T. Dalley (eds) *Working with Children in Art Therapy*. London: Tavistock/Routledge.

Wadeson, H. (1971) Characteristics of art expression in depression, *Journal of Nervous and Mental Disease*, 153(3): 197–204.

Waller, D. (1984) A consideration of the similarities and differences between art teaching and art therapy, in T. Dalley (ed.) *Art as Therapy*. London: Tavistock.

Waller, D. (1991) *Becoming a Profession: History of Art Therapy*. London: Routledge.

Waller, D. and Gilroy, A. (1992) *Art Therapy: A Handbook*. Buckingham: Open University Press.

Waller, D. (1993) *Group Interactive Art Therapy*. London: Routledge.

Waller, D. (2002) *Arts Therapies and Progressive Illness: Nameless Dread*. London: Brunner-Routledge.

Waller, D. and Mahoney, J. (eds) (1998) *Treatment of Addication: Current Issues for Arts Therapists*. London: Routledge.

Weir, F. (1987) The role of symbolic expression in its relation to art therapy: a Kleinian approach, in T. Dalley *et al.*, *Images of Art Therapy*. London: Tavistock.

Welsby, C. (1998) A part of the whole: art therapy in a comprehensive school, *Inscape*, 3(1): 37–40.

Welsby, C. (forthcoming) Seen and unseen: school based art therapy with adolescent girls, in C. Case and T. Dalley (eds) *Art Therapy with Children: Through Development*. London: Routledge.

Wilson, C. (2002) A time-limited model of art therapy in general practice, *Inscape*, 7(1): 16–26.

Wise, S. (2005) A time for healing: art therapy for children, post September 11 New York, in D. Kalmanowitz and B. Lloyd (eds) *Art Therapy and Political Violence: With Art. Without Illusion*. London: Brunner-Routledge.

Wood, C. (1990) The beginnings and endings of art therapy relationships, *Inscape*, autumn: 7–13.

Wood, C. (1997) The history of art therapy and psychosis 1938–1995, in K. Killick and J. Schaverien (eds) *Art, Psychotherapy and Psychosis*. London: Routledge.

Wood, M. (1990) Art therapy in one session: working with people with AIDS, *Inscape*, autumn: 27–33.

Chapter 2

The art therapy room

The creative arena or 'potential space'

The art therapy room or department is the space in which the relationship between therapist and client develops. The notion of the art therapy room, art therapist and client immediately introduces a concept of a triangular relationship, with art forming a vital third component. However, the way the space, or 'creative arena' is set up and organised is important to enable this relationship to develop.

In this chapter we are going to illustrate this by placing the reader in various different settings where art therapy takes place. By using the descriptions from practising art therapists, it is clear how and why their rooms and working spaces have developed in a particular way. Here are three vignettes of clients using the art therapy room in an adolescent unit in a psychiatric hospital.

Nusrat is upset. She can't face anybody. She doesn't want to be in this stupid place. I offer her my area, a desk built into a corner, shielded by side walls and a low ceiling. It is densely packed with ephemera and memorabilia; mostly images of faces. Around the edge are pinned 52 different playing card Jokers. She begins to draw 'the shadow of my father'.

Sarah brings a bundle of magazines, her own felt tips, her own sketch pad. She covers the desk with pages from the magazines, being careful not to touch the table with her hands. She places the sketch pad on the covered surface and begins to draw. She bends at the waist, thighs well clear of the table and holds the pen at its top, between thumb and forefinger. When she finishes she picks up the magazine pages using her hands like a crane's mechanical grab and drops the sheets into a wastebin. She leaves by opening the door with her foot. For weeks only her shoes touched the room.

Nigel comes back to see us every six months or so. He comes into the room and looks up at the ceiling where his fibreglass face (cast from life) looks back

down on him. He was admitted to the unit after a suicide attempt following the death of his friend, who fell through a factory roof where they were both trespassing. Nigel left us to take up a YTS in Roofing.

(Letter to the authors from Patrick Goodall (1990)
Hollymoor Adolescent Unit, Birmingham)

Each person entering an art therapy room uses it individually and forms a unique relationship with the therapist. Although the same space will be experienced differently by each client, it will have the same role in each relationship, being not only a practical space containing client, therapist and art materials but also a symbolic space.

All therapy needs to be contained within a framework of boundaries. It takes place at a particular time each week, and for the same length of time each session. The client, who may have experienced a great lack of constancy of relationships, finds that this space in the week is kept for her regularly; it is her space and her session. The therapist is a constant person for the client in that space. The art therapy room offers as near as is possible the same choice of possibilities from the same range of materials and workspaces in the room.

Entering the room, one enters a particular framework of safety, through the boundaries that are protecting this space for the client's use. Within this framework, there is the potential to explore preoccupations, worries, problems and disturbances through using the art materials and the relationship with the art therapist:

> Whatever happens here is split off from everyday existence and is observed, rather than acted upon. This is crucial because, without this space set apart, there is the inclination to behave and respond spontaneously, as we do in our social relationships. Here the frame provides a setting where the therapist can maintain a certain objectivity, a therapeutic distance. This allows the client to make a split which enables her both to regress and also to function as an observer of her own behaviours.
>
> (Schaverien 1989: 149)

Later, we shall see how the picture or art object made provides a further framework for the client containing representations of experience and symbolising aspects of inner life. For the moment let us look at this description of the 'creative arena' in St Mary's School for children with various special needs. Roger Arguile is the art therapist, and also practises as an artist (Arguile 1990):

Nearly all of my work is one-to-one therapy. The main art therapy room is

approximately 20 × 20 feet. It is divided in half by a six-foot high partition with a gap at one end enabling easy access between the two halves (see Figure 2.1).

One half is my studio space. I paint and write. In addition to ongoing art work I have a desk, record player and books in the studio. Children are not banned from this area but generally use the accepted art therapy space in the other half of the room.

I like my own space being, to an extent, part of the art therapy room so that the child can see a distinction between my personal space and the more anonymous art therapy space. Also, I like the feeling of the room better because I paint in it. I think it is important for children to see art work in progress. I do not work on my own work while children are in therapy, but should they go into the studio area, they can see ongoing painting. I like there to be a sense of life. It should be a space for creative living. Many children have not experienced the vitality of the potential space; the creative play space; the area where outer and inner realities and needs meet. They sometimes discover such an area for themselves in therapy and it becomes a whole and

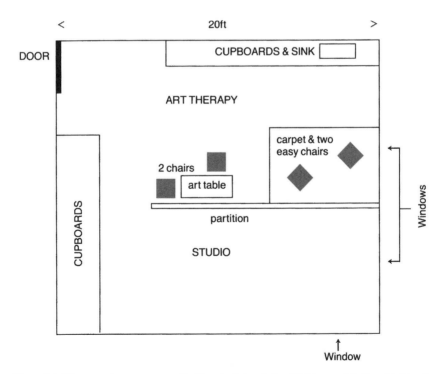

Figure 2.1 The art therapy room, St Mary's School for Children with Special Needs, Bexhill-on-Sea.

nourishing exercise being in the safety of that experience for their set time each week. They know they won't be interrupted by visitors, other staff or their peers.

The room is relatively clean for an art room. This is so that if children make a mess, it is seen as their mess, their chaos, and isn't blurred or lost in other people's chaos as may be their normal experience. Children learn the art of bringing order from chaos. For many, their experience of mess and disorder has always been negative because of deprivation. The lack of emotional holding has meant they live wrapped in chaos. In therapy the space is clear for them to put down their own chaos and creatively find their own order from it, and so readjust to their newly-resolved situation. The layout of the room assists in this process.

I have basic materials – pencils, crayon, charcoal, paint, glue, card, plasticine, paper. I also have available music, video and drama if sessions develop that way. Drama often springs naturally from the drawings. The drama is improvised performance, based in the here and now. I don't suggest drama as such, it unfolds three-dimensional art from two-dimensional art.

The central division of the room, the small carpeted sitting area and the larger open floor area all change into things such as a treasure island, a bedroom, a shop, space, a cave, the stage, the sea, a street etc.

So the whole room is a creative arena set in the fine art context, in which children can battle through their own personal trauma and in the process discover a creative spark that sometimes ignites. Through the process of art-making they can cultivate a greater confidence and self-reliance to deal with events at school, home, and personal life. They do the work – at their pace. It is most worthy.

(Letter to the authors from Roger Arguile (1990)
St Mary's School, Bexhill-on-Sea)

Setting up a department

Issues such as light, warmth, space to move around, access to materials, wash basins and water in the room, places to sit and work must all be thought through to maximise the function of the room for its intended purpose. The possible variations are enormous and will reflect the way the art therapist works and how the environmental conditions will affect the therapeutic alliance.

Many art therapists run their own department. The administrative responsibility for budgets, ordering of materials etc. is the responsibility of the senior art therapist. The management of budget and administration is onerous but necessary in setting up and running a separate art therapy

department. Materials and equipment essential for the work in art therapy include paints, palettes, paint brushes, water pots, crayons, pencils, clay, a variety of paper and so on. Consideration should be given to the particular properties of the materials such as free-flowing paint that washes out of clothes, a range of crayons including some that can be easily picked up, overalls, clay that is self-hardening in the absence of a kiln. Many art therapists stress the need for good-quality art materials with a variety of availability, otherwise the art-making is seen to be devalued (Schaverien 1992). These issues become second nature to the art therapist already familiar with the various properties of art materials.

Where particular client groups are involved, special adaptation to the department might be needed. Aids for easy access in and out of the department for the less mobile will include wheelchair ramps, handrails and so on. One art therapist working with visually impaired people designed her department so that everything would guide the client to where she wanted to be. Handrails all round the walls, tables with lips to enable her to feel the edges and to prevent things falling on the floor out of reach, coded paint brushes and pallettes to indicate different colours and so on (Broadbent 1989). Children in particular will need protection from access to sharp instruments and dangerous liquids.

A well-organised and thoughtfully laid-out room forms the basis of the atmosphere of the department. There is a striking variety in the way that art therapists set up their departments. The following example shows an 'ideal' working space in that it has been purposefully designed for the art therapist working with people with learning disabilities.

The large room, which is suitable for group work, has been furnished with four large formica-topped (white) tables which can be taken down and folded up and placed against the wall. There are eight small chairs and an easy chair (low armchair), a plan chest with six drawers and a small upright piano in the room. Usually there are only three tables in use as four does not leave enough space for movement about the room. Some individual work is conducted in this room.

The large room is ideal for small closed art therapy groups. It will hold six people comfortably. In the groups, clients usually choose to sit round the three tables and there is a tendency to choose the same chair each week. When someone is absent there is often an empty chair by the table to remind the group. All the clients have good access to the materials on the sink surfaces and in the cupboard. The higher shelves are usually used for storage of work. Art work from previous sessions is stored in the plan chest and clients have immediate access to this. Pictures can be taken down and pinned up during the session. The adjacent speech therapy room is sometimes used as a waiting area by clients who arrive early for the group.

The one-way screen enables the session to be viewed from the office. Microphones enable the session to be recorded. The screen can be used by other professionals and students to observe assessment sessions and the art therapist at work. It has provided security when working alone with a challenging client. Some transcripts have been made of sessions. When using the screen and microphones, the art therapist asks the client for permission. The small room is quiet and allows two people to work together round a table. There is wall space which can be used for display of work and there are shelves which hold paper. There is a sink and cupboards and therefore everything that is needed for art work can be made readily accessible. Some clients like the intimate atmosphere that exists in this room.

Administration has increased considerably and so an office is very important to have a quiet space where notes can be written, reports compiled, returns completed. Lockable filing cabinets for confidential information, bookshelves and storage shelves are useful and can all be locked when treatment is in process. The use of an answerphone means that messages can be received when working with clients. This was once thought of as a luxury but, without a secretary, it is a necessity.

(Letter to the authors from Robin Tipple (1990) Harperbury Hospital, Herts)

(The art therapy department at Harperbury Hospital is now closed. Robin Tipple now works in a paediatric assessment setting in the hospital grounds (Tipple 2003).)

With hospital closures, clients are being moved out into the community. This means that many studio-style art therapy departments have had to close (Wood 2000). Many art therapists have found their departments set up in 'temporary' spaces for two to five years. This description of 'H' block at Leytonstone House is a good example of the creative use of a temporary placing of a department. The art therapist is Sue Hammans.

The present art therapy department at Leytonstone House is temporary and is situated in a vacated house/ward. This description of 'H' block was the building used for the department for around three years. Figure 2.2 shows the layout, and how art therapy used the whole ground floor, therefore being accessible to wheelchair users. The client group included a full range of people with learning difficulties. This included adults with superimposed mental illness, sensory and physical disabilities and those with difficult behaviour, all of whom were long-stay residents. The climate of the institution was that of transition and impermanence. 'H' block was known to be a building due for demolition when it was taken over by the art therapy

department, so there was a freedom 'to do what we liked with it'. This was particularly useful for establishing the large psychodynamic art therapy group setting, as the environment could grow like a living organism, reflecting the group processes and relationships as they developed in time and space.

In the space chosen, we decided to allow a volunteer to fulfil a dream, creating a 'picture wall' prior to moving in. The last bits were carried out after we moved to enable our clients to see how it had been made, and as a subtle way to encourage clients to use the walls themselves without actually directing them (which was exactly what happened). Spontaneously, so much began to happen to the walls, pictures were added, replacing or hiding others, some removed and spaces left, some were doodled and written on and some were used as communication aids.

The clients gradually considered that they too could really influence and change their own environment. There was little scope for walls to be personalised in other areas of life, not even wallpaper choices, so the walls in the art therapy room were very important. Here are several more detailed examples of how some clients used them.

Andrew painted a complete corner of the room, creating what he called his 'office' and organised and obtained a desk as his work surface. The walls would change from day to day, as he repainted them influenced by his moods; new items were added too, swivel chair, old telephone, waste bin etc.

Barney began overlapping large strips of cardboard, paintings and collage work into a previous client's painted wall. This did not cause conflict as there was a degree of respect and appreciation of creativity between the two men.

Clare occupied a row of three school-type desks adjacent to the picture wall. She was fond of collages and created her own picture wall on a small scale, using her unique sandwiches of pictures and coloured/textured papers loosely stuck together to form a type of relief, sometimes several inches thick.

Doreen worked in the central communal areas of the room but was attracted to Clare's wall and frequently added to it. Brief negotiation would take place between the two of them to achieve this. Doreen would also scatter herself all over the room through her drawings, paintings and collages, sometimes heavily pasted, other times loose and vulnerable.

Ellen was physically disabled and needed a wheelchair, so her choice of workspace was limited to a number of areas which allowed easy access, and the opportunity for her to be viewed as a person and not an obstacle in the room. Some changes from her original position became preferable through practice, mainly because she developed a new style in her art work which was very messy and resulted in paint splattering everywhere. After acknowledging

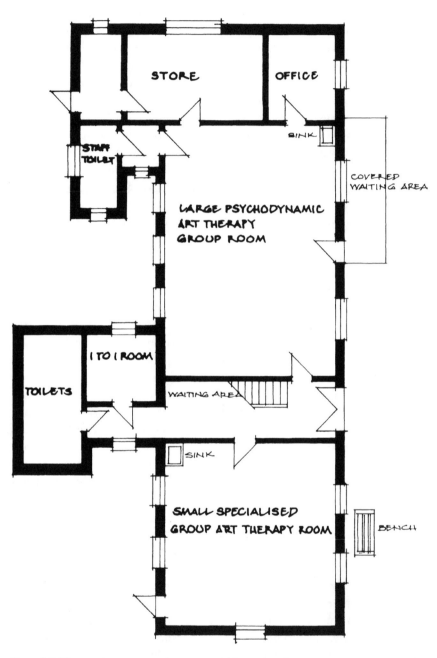

Figure 2.2 The art therapy room, Leytonstone House, London.

long term work storage

storage

kettle filing

disused kitchen

filing

materials supply

sink

toilets

coffee table

lockers & drawers

covered waiting area

blackboard

wheelchair user

communal table

Art Therapy Room 1

radio

Art Therapy Room 3

toilets

waiting area

sink

trolley

materials

lockers

potters wheel

cupd.

Art Therapy Room 2

dolls house

bench

storage

paper supply pot

screen

work table

her physical difficulties and her pleasure at causing powerful effects, her tables were turned round, allowing a highly personalised area to be formed. The paint crept from the tables up the walls onto the floor and generally all about her.

Parts of the walls became battlegrounds through the art work, strong characters dominating prime viewing areas, private works in corners, sociable people displaying anywhere and everywhere, vulnerable characters displaying near doors or well-used areas where they could be easily damaged and knocked down. People with wheelchairs tended to display at their eye level and sometimes ladders would be used and therapists directed to reach desired spots. In fact, most work would never reach the walls but would be stored in safe places, usually in folders. Even the floor staged many noteworthy events; it held the invisible boundaries of personal territories, reflected the 'accidental' effects, the results of conflicts and careless actions. Each item of furniture also held a story of its own about how it came to be in any one place and looking the way it did.

Within the art therapy room, space was allocated for 16 fixed working areas (not necessarily to be all used at once, but to enable a space to be left untouched for a couple of days if a person only attended twice weekly, for example), an area for serving teas, a relaxing area for breaks away from clients' work tables if desired, an area for individual lockers (for their art materials or personal possessions), a sink and washing-up area, places to soak brushes, etc., a supplies table, shelves for papers, a lockable cupboard for equipment requiring supervised use, the trimmer, sewing machine, foot rest, easels, blackboard, coat hooks, safe smoking area, waste bins and storage boxes, buckets and bowls. This was the result of learning from the experience of our previous working space.

In fact an area designed to accommodate approximately 50 different personalities within any one week needed to utilise space with a degree of planning and negotiation, to be workable. However cramped the space sometimes felt, therapists needed to influence seating and objects which prevented clear access in case of emergencies. Images earmarked important signs, as most of our clients were unable to read. For example, a photograph of a fireman in action was stuck above the fire extinguisher.

Another of the art therapy rooms was used for individual art therapy sessions and consisted of one table, two chairs, a hand basin and art materials. All of the art therapy rooms were self-contained as far as materials were concerned but sometimes additional things would be taken into the rooms too. The small group room was used for a long time by two men whom it was felt needed the opportunity to work with minimum supervision. Out of all the

space in 'H' block it was this room which perhaps underwent the most changes due to more varied uses, and the two men who dominated this room for much of the time took many risks to transform the room's appearance from the ceiling to the floor. Both were frequently occupied with 'whole wall paintings' either jointly or individually. Even the windows were painted at times.

This was also the room where most of the clay was kept, although it was taken into the other rooms; the main bulk and potter's wheel were occupying a clay area within the room. This room also housed an eight-foot table, a piano (kept well tuned), a display screen, plenty of open shelving, a doll's house and folder storage. This small group room was used for specialised closed art therapy groups and everything would be cleared away after a session to enable other groups to take place as well. Student/in-service training/visitors would have talks in this space, providing it did not clash with the therapy programmes, as it was felt important for people to get a 'feel' for the art therapy environment.

Some areas of the department were seldom or never ventured into by some residents and if client movement had been charted, some residents had a very limited area into which they were prepared to move, whereas others would have been everywhere. This would have made an interesting study in itself.

(Letter to the authors from Sue Hammans (1990)
Leytonstone House, London E11)

Some art therapy departments are interesting to visit as they are visually stimulating, bright and are hives of creativity and concentrated activity. The department at Leytonstone House is unique in the sense of its atmosphere and the feelings of containment and safety. The work and the relationship that the staff have built up with the residents over the years is displayed by the feeling generated in the room in which they are working.

Sharing space

There are many different styles of rooms and ways to organise the working space. Some art therapists are not able to have their own room and so have to organise the space accordingly. Multi-purpose use of rooms can occur, particularly when room space is limited. The art therapist keeps the room clean and tidy as colleagues tend to find any mess incompatible with their own work. Sometimes, a messy and chaotic art therapy room can be an indication of some process going on that the therapist is leaving around and 'not clearing up'. One example of this was when a visiting student, using an office, found it extremely difficult, in the beginning, to leave the room in a satisfactory state for other users. After several complaints by cleaning and other

staff, she managed to organise sufficient time to clear up the space. At the end of the day, however, she found dirty footprints on the carpet leading to the door. She came to understand that this might be some indication of material spilling out from the sessions as she was working with a particularly problematic child.

These are important issues to think about if the art therapist is working in a space not specifically designed as an art room. Where therapists are working on wards, for example, this problem may be exacerbated. An example of this is working as an art therapist on a paediatric ward in a general hospital where using art materials appeared incompatible with standards of hygiene and cleanliness. By confining the activity to one area, it was possible to enable the children to work with the materials freely, without too much concern as they could use them in a contained way. Leaving practical considerations aside for a moment, sometimes the anxiety about mess resides in the possibility of what might emerge and the potential for spilling out or non-containment of feelings and emotions in art therapy. This can be projected onto the materials as a need to keep them under control and contained.

Many art therapists work part-time, working sessionally either in different institutions or in different parts of the same institution. In many settings, there is an acute shortage of space and a well-equipped studio permanently set up for the sole use of the art therapy department may not be possible. Camilla Connell worked for 12 hours a week with cancer patients at the Royal Marsden Hospital:

My facilities are extremely limited. I have a small walk-in three-cornered cupboard for storage and the use of a close carpeted 'group therapy room' one afternoon a week. It has a table plus a folding table and some chairs, most of which are low and upholstered. No water, no use of walls, but at least I can shut the door and have some control over who comes in. Here I conduct a small group comprising patients from the rehabilitation ward and anyone sufficiently well and ambulant from the rest of the hospital. I offer Redimix-type paint in lidded transparent plastic pots, safely anchored in wooden racks, to avoid spillage. Also crayons of several types, charcoal, felt-tips, coloured tissue paper, glue, clay etc. I have had a lot of drawing boards made in softboard by the works department for use with larger paper and also offer A4 pads of cartridge paper.

The larger part of my work is on the wards, mostly at the bedside, sometimes with a small group at a table in the centre of the ward. For this I carry a canvas bag stuffed with all the aforementioned, plus masking tape, scissors, glue, pads, the A4 notebook, my own notebook and under my other arm a drawing board or two with several pieces of paper taped to each. Jamjars, paper towelling and plates for mixing paint I find on the wards as required.

I have considered a trolley but decided the bag was simpler. It is quite easy to fix up board and paints for patients in bed and with limited physical capacity. I offer the pots of paint in shallow cardboard trays in this situation, as they can't fall over. There are 12 in a box and with the lids off they are an inviting range of colours and the paint keeps well and there is no wastage or clearing up afterwards. I keep it fairly thick and viscous so it doesn't run off the paper and can be applied thickly and vigorously, or thinned with water. I think attention to these details enhances the appeal and use of the colours.

(Letter to the authors from Camilla Connell (1990)
Royal Marsden Hospital, London)

Each art therapy room will be formed by the forces within it and outside it. These will be as various as the personalities of art therapists, their theoretical orientation of practice, the effect of the client group as users of the service and the attitude of the institution to art therapy. The outer environment in which the institution is set will also directly and indirectly impinge upon and influence the sessions as clients make use of the content of the rooms and whatever is offered by the external environment. Aleathea Lillitos (1990) was working part-time at St Thomas's Hospital, London, where the acute shortage of space meant that most rooms had multi-purpose functions. This is her description of a corner room mainly used for art therapy, but also by other professionals:

Although the room is nondescript, entering it from the ward is sometimes literally breathtaking because the large windows that run along two sides of it offer a panoramic view across the River Thames in both directions and to the Houses of Parliament and Big Ben opposite (see Figure 2.3). This view of the outside world has evoked memories, feelings and fantasies in a great many clients and has often played a vital part in their art therapy sessions.

As other professionals occasionally use the room, materials have to be put away at the end of the day and the floor and walls kept clean of paint. There is a cupboard in which the materials are kept and some shelves above it on which the clients' work is stored. The furniture is basic and, unfortunately, there is no sink in the room. Apart from most of the usual materials used in art therapy (bottled paints, clay, plasticine, sand, crayons, and empty boxes and oddments for collage) I also provide some simple toys. If a client continually expresses the need for something that I have not provided (or brings his or her own materials) this can, if appropriate, be interpreted and worked on in the sessions. Children have used the room and the furniture in a wide variety of ways; some have accepted the room as it is and have sat week after week in the same place, whereas others have wanted to rearrange the furniture to build a house,

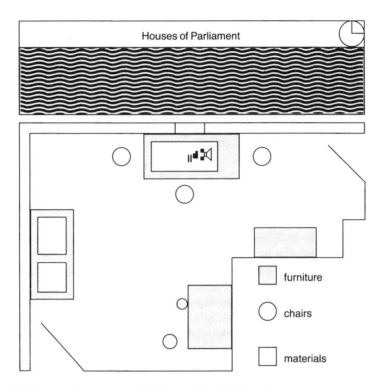

Figure 2.3 The art therapy room, St Thomas's Hospital, London.

a boat, a camp or, like one little girl, to make 'an office like the one that Mummy works in'. The locked cupboard also invites projections: a 7-year-old boy who had difficulty in accepting younger siblings expressed curiosity about what was inside it and made cardboard and clay models of it. Painstakingly, over several weeks, he constructed a model whose doors and drawers could be opened. Inside his cupboard he put 'lots of babies' bottles' imagining that this is what the one in the room contained. It became clear that the cupboard symbolised both his mother's body and mine as the 'mummy' therapist who had other sibling clients. With the aid of his model of the cupboard we were able to work through his fantasies about the inside of his mother's body, his envious feelings about her ability to have babies and his jealousy towards the babies that she had had subsequent to him.

Although some seem to be oblivious to it, the view from the windows can and has played a large part in many of the children's art therapy sessions. The Houses of Parliament and Big Ben are potent images in our society and are ripe for projection. Water, boats and bridges have symbolic meanings as well. The River Thames that flows past the window can literally be a calm,

pleasant strip of water where pleasure boats sail, or symbolically a deep, dark river with dangerous currents that can drag you under, or full of sharks and crocodiles that may bite.

Looking out of a window may seem to be an escape from the difficulties of therapy, but the external landscape can lead a child back into the fantasies he or she may be wishing to escape from. Much to my exasperation, because I thought she was wasting time, a girl of 5 who was concerned about the disappearance of her stepfather constantly gazed out of the window (looking for him). Then, in one session, she pointed to a small tug pulling a huge container and said, 'Isn't that little boat clever, it's pulling that big boat.' I realised that she had, as it were, pointed out to me how small she herself was to be looking after her mother. Subsequently, we were able to go on to talk about how she felt responsible for the disappearance of her stepfather and the fact that she took on the burden of looking after her mother now that he had gone. Rather than being an escape, the time she spent gazing out of the window was reflective and important.

There is no clock in the art therapy room and I do not need to wear a watch since Big Ben can both be seen and heard and marks the passing of each quarter hour by chiming. This in itself can produce tension in clients who may either be wishing that the time would pass, or be anxious that it is doing so. Symbolically, Big Ben is phallic and seems to stand for authority; it also represents the superego. I remember an 8-year-old boy who was extremely competitive with his mother (and me in the transference). He had been alone with his mother since birth, but she had recently remarried. Towards the end of the session time, when I warned him that it was nearly over, he would get extremely angry with me, question the time and tell me that he would not go. Yet, when Big Ben struck he became compliant, prepared to leave and accepted 'his' authority. Obviously he felt that he could not argue with Daddy Big Ben's chimes but sometimes, in wordless rage, stuck his tongue out at 'him'. This behaviour mimicked his attitude towards his stepfather with whom he felt angry, but dared not verbally challenge.

According to Circlot's *A Dictionary of Symbols* (Circlot 1971), a room is a symbol of individuality – of private thoughts – and the windows symbolise the possibility of understanding and of passing through to the external and beyond. Although I have been lucky to work in a room with such a view because it has stimulated the children's fantasies, I believe that what the child or adult has to speak of in art therapy will find its way to consciousness whatever the surroundings are like. A blank wall, like a pristine sheet of paper, can render a projection of an internal image and will not remain blank for long.

(Letter to the authors from Aleathea Lillitos (1990)
St Thomas's Hospital, London)

Working peripatetically

The hospital closures programme and the moving of patients back into the community has led to changing accommodation for art therapy departments within hospitals but also to the widening of an art therapy service to community centres. Sometimes art therapists are based at such a centre with a purpose-built art therapy room, but sometimes staff will only use this as a base, travelling to visit clients in day centres or their homes. The difficulty of obtaining funding in other sectors of care has also meant that one art therapist will often be working across a borough in a different school or centre or across a region.

Pauline McGee works for Aberlour Child Care Trust, a Scottish voluntary organisation funded by local authorities, urban aid, bequests etc. The voluntary agency brings aid to client groups with enormous needs which are less catered for by the statutory services. It was an innovative move in deciding to appoint an art therapist in this part of the UK where art therapy is less established. The work stretches across Scotland covering family centres, intermediate treatment projects, two dependency units for women, residential homes for young people and children with learning difficulties, and also similar homes for emotionally disturbed children and adolescents, and, lastly, a drop-in centre and counselling service for young people. Pauline is the sole art therapist and works in several different projects over a normal week. In this situation the art therapist has to adapt her working method to each client group and staff team as she moves about the country during the week. She also has to fit in to the often cramped space available. These practical difficulties add enormously to the normal pressures of working as a therapist:

The question of space and rooms to use is often a big issue in all of the projects as many are based in the middle of housing schemes where the need for services is greater. I'll start with a Monday and the dependency units for women. The first is in a council tenement building in Edinburgh. The flats, apart from the bottom floor, are where the women live with their children. The front door of the building is always locked and the women have to say when they are going out and when they expect to be back. This sounds a bit like a prison but I have since realised the need for this as the estate is a big drug-using community and temptations for the women are literally on the doorstep. The locked door serves to protect the philosophy of the house in being completely drug and alcohol free. Women have been asked to leave the house when found to be bringing in drugs or being under the influence of alcohol.

The bottom two flats have many uses. One bedroom is for the overnight worker to sleep in. One room, originally a living room in the tenement, is fairly cramped with chairs and a large table. This room, which opens onto a little

kitchen area, serves as a meeting room for staff, a meeting room for residents and staff and on a Monday morning as the art therapy room. The big table takes up virtually all the floor space and everyone works at the table. There are many limitations as everyone has to do fairly small clay pieces or struggle round the table with boards for painting and drawing. One woman who needed to move on to bigger paintings had difficulty in negotiating more space round the table and this required the cooperation of the other women.

While the group is on, staff stay out of this area and younger children are minded by a playworker in the flat across the landing. The sink in the kitchen area is not ideal as dishes have to be washed in there after staff lunch. It feels difficult to leave a mess there as it is not very nice for staff to cook lunch in an area covered in clay or paint. As the staff get little enough time to themselves, this space should always be clean and tidy.

Once everyone has started working at the big table people cannot move around and so they stay in the same place until the end of the group. The end of the session is tricky as paintings and clay work have to be moved around as we tidy up. There is nowhere to store work but the women always seem happy to take things back to their flats. One woman is really proud to have all her paintings hanging on her living room wall. She was one who never felt she could get involved in painting, never mind be proud of her efforts.

Pauline works in a similar but slightly larger room in the sister project in Glasgow in the afternoon. On Tuesday morning she runs a group for parents in a family centre in Aberdeen. Here she uses a meeting room, clearing it of chairs before she begins, as well as covering the carpeted floor and protecting the walls:

Tuesday afternoon I work in a semi-detached house. The house is for independent living for three boys with learning difficulties. Colin has recently been thrown out of his workplace for his angry outbursts (this is his fourth placement). The house has three bedrooms, living room, kitchen etc. The first two sessions I had with him were working in his bedroom. This did not feel at all comfortable and again carpets etc. had to be protected from paint and clay. Eventually I got him to help me clear out the garage and we now work there. It is very cold but has advantages of wall space and a stone floor. We can also walk through to the kitchen for water and Colin certainly makes good use of the space.

Wednesday I work in two residential homes for adolescents. Space and privacy are a problem in both houses. In the first house I have to use an 'office'. This also has a bed which overnight staff use. There is a sink in the room and a tiny bit of floor space which is not carpeted. I now use the wall

which, again, I have to cover with plastic sheets. The other house has even less room and the girl and I work in her bedroom.

Thursday and Friday I'm back at Falkirk in a family centre. Having been part of the team for two and a half years I feel I am given a lot of privacy for art therapy work to take place. As a team we change the rooms around to suit various uses and to accommodate the specialist work which does go on. The family centre is four council houses with small rooms. The room I use for art therapy is in the house where we hold adult groups and I have adapted the room as best I can. It houses a kiln in one corner, cupboards for materials and shelves for day work. Children love to use the room as it is cut off from the rest of the house and somehow feels 'special'. The parents' art group and sewing group use the room in the afternoons so it does have a creative feel about it. I usually work on the floor with the children; there is a sink and toilet next door to the room and there are shelves for storage space. Another room, which was a kitchen, stores bags of clay and a sand tray. This part of the house offers most privacy and space for one-to-one sessions and although not ideal certainly feels like a bit of sanity in comparison with my first days of the week.

> *(Letter to the authors from Pauline McGee (1990)*
> *Aberlour Child Care Trust, Stirling, Scotland)*

It can be seen from these descriptions that the 'set apart' space need not be 'ideal' but needs to be 'good enough' to provide an outer framework to the 'inner space' that is created between therapist and client. Some degree of difficulty in the environment can give a sense of solidarity and aid group identity, as is seen in the first example of the working week above. There is, though, a fine line between this and the dissolving of the boundaries that makes work possible. Poor conditions and poor materials can add to the lack of sense of value, lack of identity and worth already experienced by clients.

Helen Thomas works in a London borough:

I am part of a team specialising in working with children with emotional and behavioural difficulties. I am the only art therapist on the team and receive referrals from other support and psychological services. As I cover a large borough, I visit and work with my clients in their schools or units.

Schools often look spacious with masses of room, but usually every part is designated to work going on within the school and is booked for other peripatetic and remedial teachers. It is extremely difficult to find a quiet room where I can work undisturbed for an hour.

Only one room given to me has a sink and water, which means I have to take

in a water container, plus art materials. The accommodation varies in each school and the following describes three examples of the different spaces used.

1. Prefabricated building used as a dining hall separate from the school – situated on the edge of a large playing field. The child I worked with used all of the space. The room was filled with tables and chairs, the main kitchen was locked. My client would begin to paint – sometimes sitting with me or at the far end of the room. He appeared to like the uniformity of the rows of furniture as he had a deep anxiety about mess and getting paint on his hands. Often he would fantasise and act out situations, pacing around the room, trying to make sense of his own relationships within his family and peer group. When he made secondary transfer, we had to use a small medical room in the new school, and his behaviour changed completely which resulted in his exclusion from school. I now work with him in a disused canteen attached to my office.

2. Two basements, both used as pottery workshops/store rooms – one very cold, poor lighting and no water. In one of these rooms I work with a girl who is an elective mute – she presents herself to be shy and timid and I was rather concerned that going down into the bowels of the school with a stranger might alarm her (possibly more about my own anxiety and discomfort). However, she skips and laughs and appears to feel quite safe in the room.

3. An attic – my client always says how much he likes being up in this room. He calls it 'Our special place'. As it is an attic it is used to store everything not used in the school. The child often dresses up in the stage costumes and acts out harrowing scenes from a 'family' where he plays all the parts.

(Letter to the authors from Helen Thomas (1990)
E.B.D. Team, Barnet Social Services)

As Helen Thomas describes, art therapists working in education tend to work peripatetically without a secure base. Clare Morgan, who works as a freelance art therapist taking referrals from education across Hertfordshire describes the adaptation necessary to provide the therapeutic framework:

A primary aim for therapists is to provide a setting for therapy which is consistent and as unchanging as possible from one session to the next. The room is the background against which and within which communication between the two people takes place. When this room is unchanging in every respect we know that what happens in the therapy is the result of something else – it is not a reaction to change within the physical setting. Many therapists are able to provide a consistent setting but often I am not. Also I am unable to provide a room which is free from the presence of others who use it at different times.

Working in educational settings I travel from one school to another and have encountered many different rooms which became the therapy room for the weekly session.

The variety of rooms has ranged from smart rooms used for meetings and visitors to cluttered and untidy art rooms, from a science laboratory to a textiles room – almost any sort and size of room that you could find in a school environment. I occasionally work in a student's home and have worked in a caravan parked on the front drive of a student's house.

Some of these rooms have fallen far short of what one might think of as the ideal or even the minimum requirements for art therapy, but therapy has still taken place. In reality, space is at a premium in many schools and it can be difficult to find a regular space for the art therapist, especially when the therapist has only one possible session time to offer in the week. In a very small village school, I worked in a small lobby/storage room which led to the staff room. Fortunately the session could take place just after lunch when staff did not need access.

Finding a room with a sink, especially in secondary schools, can be particularly difficult. It is, of course, possible to refuse what is an obviously unsuitable room but if there is no other room available my personal preference is to say yes, accept the limitations and begin the therapy. Sometimes a more suitable room does later become available.

In schools, the internal arrangement of the room frequently does not remain constant from one week to the next. Furniture can come and go or be rearranged, a fleet of laptops suddenly appear on the desktops and so on depending on the daily use of the room. Consistency can be offered in the arrangement of the art materials on the table and the positioning of the table and chairs. It isn't always possible to rearrange the rest of the room.

Occasionally the room itself becomes unavailable and a temporary room is provided. I have arrived to find that Ofsted inspectors have taken over 'my room' for three days and in the anxiety generated by the inspection the art therapy requirements have taken second place. On another occasion a temporary room had to be found while a wasps' nest was removed. A permanent change of room may occur at the start of another academic year in September as a previously unused classroom becomes required again.

Sudden changes of room in particular are unsettling for the student as well as myself. Both of us have to adjust. Changes are undesirable but sometimes unavoidable. They have to be acknowledged and worked through in the session.

An important consideration when thinking about the suitability of a room is whether the contents pose a risk when working with someone who is known

to be aggressive and potentially violent. Art rooms can contain sharp or potentially dangerous items such as cutting wires for clay, as do technology rooms with their range of tools. Visibility may have to be taken into consideration. I have worked in a dining room where staff could keep a passing eye on the therapy because the child had previously accused a visiting adult of hitting him.

Both the student and myself will have some reaction to the room we work in. For children in a junior or primary school the room may already be familiar. There may be positive or negative associations. Sometimes a child will say something about the room as they enter for the first session. Six-year-old Sally told me at once that this had been her classroom when she was in Reception. For her the room had positive associations. I may ask whether a child has been in the room before and in what context. Comments about the room may also be unconscious references to the therapist. Therapy in a kitchen may evoke associations to mother and home. I am sometimes asked whether we can make biscuits or cakes. There is both a concrete and symbolic reference to nourishment being expressed in this request as well as sometimes a wish to have an experience that may have been missed.

I also have reactions to the room. Some rooms are attractive and offer the right amount of light, space and amenities. However, this can sometimes be offset by their proximity to disturbance nearby from the photocopier, children watching a video close to the door or people passing the window on their way to the reception area. These external impingements, which are usually everyday occurrences in a school, can be disturbing to a greater or lesser extent depending on what is happening inside the therapy room. Finding a room in a school completely free from disturbance can be difficult.

Some rooms raise anxieties. Very smart, newly-furnished and carpeted rooms are a case in point. Although obvious steps can be taken to protect the carpet and furnishings, mess can quickly be created, get out of hand and be distributed to unexpected places.

If the room is very small I wonder how art activities and play will be possible. I have found that children often have their own creative solutions to a room which seems inadequate in some way. They, after all, do not come with a preconceived idea of what the room should offer.

When 8-year-old John wanted to play football in a tiny room he solved the problem by making a tiny football out of rolled up paper and sellotape. Then he could kick it forcefully wherever he wanted within the very limited space available and there was no risk to the furniture, room or me. He also did not seem to think that hide and seek was impossible. Both of us could pretend that he couldn't be seen underneath the table. A very small room such as this has practical implications. Messy activities which require a lot of space are not

possible. John sometimes used the floor as a worksurface because the table was small. A small room can, however, provide physical containment that aids a sense of security and intimacy, particularly when working with young children.

Working in rooms that are used by other people and which contain all sorts of things that are not part of the art therapy materials raises a fundamental question for me. What is included in the art therapy space, what can be used as part of the therapy? Can I allow a child to use the objects that are in the room by chance or which may be introduced quite unexpectedly during the course of the therapy? What happens if something that becomes significant for the child is removed from the room? Aside from safety and damage aspects a continual assessment has to be made about how the space and contents in a room that is not a designated art therapy room can be used.

There are certainly rooms that are so full of things of one sort or another that I wonder whether the child will be distracted or perhaps confused when faced with art materials and an array of books, games, equipment and so on. An example of this was work with 10-year-old Billy. Billy had been referred because of his obvious anger, frustration and unhappiness. He was often mean to other children and they were afraid of him. At home he would show his frustration if he didn't get his own way.

The only room available was the nursery which was ideally placed on the other side of the playground. We would be uninterrupted and there would be no distractions from other people nearby. The room itself though was filled with the presence of the nursery children whose many artistic endeavours hung from the ceiling. Every wall and surface was covered with images, games or toys. The room was a treasurehouse of colour and redolent with activity but how would Billy react to this particular room? The art materials looked lost on the table in such a busy-looking space so obviously dedicated to very young children.

Billy did make images but during the first session he began to explore the nursery. He opened some drawers and found something that he had 'had at home when little'. It was a board with holes that you push coloured pegs into to make a picture. Billy used the pegs to write his own name and we were able to begin to think about his experiences of being little.

Billy's mother had told me that she was called into nursery school because he was 'possessive and taking toys'. Now he could revisit a nursery and have a different experience. The nursery environment was now one over which he had total control and in which he need not feel any sense of inadequacy since he could easily master all the activities there. Only some of the nursery activities were chosen and these were usually repeated from one session to another so that a pattern gradually emerged and Billy could continue to work

through particular concerns. For example, he used the adult dolls in the dolls' house to enable him to think about sex and adult relationships. He would often sit on the floor like a much younger child and play with enjoyment. The defensive front so evident in school could disappear. The nursery setting provided an opportunity for Billy to express some of his concerns in a very direct way. It facilitated therapy by placing him in an environment which had once been the site of earlier difficulties.

When working with potentially aggressive and violent students I make a clear statement in my initial explanation of the boundaries about respecting the whole space and the contents. This sets a limit on what is acceptable behaviour but also reflects my anxiety when working in a room where testing boundaries could easily result in damage to other people's work and belongings. Stating this boundary is necessary and in practice attacks on the room or its contents are unusual. In other non-violent cases looking after the room can be talked about if the risk of damage seems imminent during the course of the therapy.

Children often want to use the whole room and its contents for play. It is informative to observe if and when this happens and to wonder about the possible meaning. I have found that children tend to move away from the table when they have made a connection to me and feel secure enough to do so. It can happen quite quickly or perhaps after many sessions if the child is insecure. I think it is an important moment. It may mirror the developmental stage in infancy when the baby is able to move away from mother and play a little further away but still in her presence. Sometimes a move away may, however, reflect a need to create a little distance from the therapist, perhaps to lessen the intensity of the transference. Perhaps the child's curiosity about or familiarity with the room encourages them to explore the space. If the move is made, the art therapy space expands and the possibilities for play, expression and communication increase.

Each student will use the room in a different way. I make decisions about what they can use or play with at any one time based on my sense of the child, my knowledge of their general behaviour and their current state of mind. I try to understand what is being communicated in whatever way that might be.

Some activities are always out of bounds. For example, if there is a computer in a room I tend not to allow it to be used because this affects the interaction between myself and the client. However, I have discovered that I can make a different decision under special circumstances. I worked very briefly with a child whose parent had died. One day she asked if she could write her grandparents a letter using the computer. The letter was an important part of the bereavement process as it expressed her fear that she might

lose the grandparents too. I did not refuse this request because using the computer was a tool for producing the letter, a familiar way of writing for her.

As my work continues to develop I may change my mind about using computers. They are a part of everyday life and perhaps I am missing an opportunity to understand their potential usefulness in therapy.

Although adolescents do walk round the room, sometimes explore items and use them in some way, they usually confine themselves to the table and the art materials, though they may communicate through the personal possessions they have with them such as the contents of their pockets and rucksack.

Children may have a greater need to find a different way of expressing something other than through the art materials, particularly a need to play. I always provide some small toys. A school room can provide a much richer variety of things that can be used or played with than I can offer. I have found that anything in a room may evoke associations.

Ten-year-old Harry had communication difficulties. He sometimes stood in his classroom and growled and used objects to convey words. Harry was often silently angry, his body conveying his feelings. He came to therapy on sufferance, said very little and skilfully produced drawings which showed a defended world. People were always hidden in armoured tanks or were unreachable and invisible inside buildings. Harry's drawings were very detailed and showed close observation of what was drawn. He didn't like talking about his drawings and didn't like talking to me. The intimacy of therapy was extremely threatening for Harry and I thought that using the art materials was a defence against relating because using them kept him busy. The sessions felt very uncomfortable and intense for both of us. Harry often looked up at the clock conveying in this small gesture his longing for the session to end.

To relieve the immense pressure after several sessions Harry would sometimes get up from the table and walk round the room. We were in a large classroom not used on a daily basis. Harry would point to things and ask what they were or what was inside them. Being away from the table seemed to offer some relief as he could focus on objects. He noticed and focused on things in the room that I wasn't aware of: holes in the worktop, uncapped pipes sticking up from the floor, the central heating control panel and then one day the infrared sensor high up in the corner of the ceiling. He told me that it detects body heat. He went on to talk about a very small sensor that he had in his home, how it was situated in the spare room and the cable ran along to his bedroom, how it wasn't working just at present. He talked on and on, the link to home leading to further associations. Exploration of the room and its objects

provided a safe means of communication with me that was not otherwise available and we were able to explore the meaning of this together.

When thinking about the variety of rooms I have worked in I was struck by the way each room evoked strong memories of the client I had worked with in it. The room had become imbued with the client and the way they had used that particular room. It was difficult to think of the room simply as a room. On further thought I realised too that the school itself was also connected in my mind to the client. Process notes must be written in the therapy room or my car. Entering another school is to enter the world of the next child and the previous session has been mentally filed away.

The internal contents of a room may change unexpectedly but a further change occurs when something is brought into the room by the child. An adolescent often brings a bag. During the first session one client got out a magazine from his bag and proceeded to read it as if I wasn't there. The magazine was a specialist one and I took this to be a communication about what was of interest to him. I started to talk to him and it soon emerged that this was more than an interest, it was a passion and occupied all his spare time, took him away from his family and affected his education because he neglected his homework and sometimes truanted from school in order to engage with the activity. Getting out the magazine provided an immediate link to a most important aspect of his life and also enabled us to establish an initial connection as he talked enthusiastically.

Children sometimes bring a special object from home to therapy but they may also want to bring in something from the school. Eight-year-old Martin was referred to art therapy because staff were very concerned about his state of mind. He showed extremes of emotion and could be very depressed and in floods of tears. When very young he had witnessed violence in the home and was an anxious and frightened boy unable to concentrate on learning. In the playground he hid his fears by behaving aggressively. He presented as a much younger child and developmentally had fallen behind. Martin was frightened by unexpected noises in school such as the sudden appearance of carpenters working near to our room. He evoked a maternal counter-transference as he did in members of staff. Although we were in a very small and containing medical room which contained a number of toys he remained at the table with me using the art materials or the range of small toys the school had provided. One day he told me he had noticed a large box and asked if he could bring it into the therapy room.

We went to the hall together and after emptying it the caretaker brought the box to our room. On its side Martin could easily lie down in it and when upended if he stood in it he couldn't be seen. This box was immensely

important and became a central feature of the therapy. It was a containing, warm dark place in which Martin could feel safe. It was the womb in which he could hide and admit that he did not feel the world was a safe place. He spent one session sealing it up so that no light got in when it was upside down. Later on he cut out a door and some windows. Sometimes it had to be mended as it became more fragile with use. Martin could lie down in it and pretend to sleep, he could take toys into it and play, he could be born from it. His attachment was such that when the therapy was unfortunately coming to a premature end he spent several sessions laboriously cutting it up with scissors so that he could take it home in pieces, demonstrating his need both to attack it but also to save it.

If the box had not been available Martin would have processed his thoughts and feelings in a different way, but I think that its three dimensional large form enabled him to communicate and process his need to feel safe using his whole body and that at an unconscious level he recognised this.

I cannot offer a room that remains constant from one session to another nor can I control what is in the room, but I think that the extra things that are so often found in school rooms can be a useful addition to those on the art therapy table and many children in particular take advantage of the somewhat unorthodox therapy room. A student who explores the room may or may not want to use or play with something or to use the space in some way. If they do select something there will be conscious and unconscious factors affecting that choice. I cannot know what may result from that choice, what associations are evoked and how the therapy may develop as a result, but I am willing to allow them that freedom and see where that leads us.

(Letter to the authors from Clare Morgan (2005),
art therapist working in Hertfordshire)

In contrast to this working situation, the following description gives a clear account of how a permanent space can be designed to fulfil its maximum therapeutic potential. Vera Vasarhelyi (1990) works with children at Bloomfield Clinic:

Setting up the therapeutic space seems to me one of the most important prerequisites of a safe and fruitful therapeutic relationship. My room in the Department of Adolescent and Child Psychiatry was designed after careful consideration (see Figure 2.4). My purpose was to express some of my therapeutic aims in the environment and therefore provide a space which was not only continuously available but also congruous with the content of therapy.

Although the room itself is just one of a number of identical rooms, the colours are very different. The floor is dark blue Pirelli rubber, designed to

Figure 2.4 The art therapy room, Bloomfield Clinic, London.

withstand heat, acid etc., and therefore strong enough to take destructive 'attacks' without being destroyed. The other major feature in the room is the red, L-shaped working surface, resting on storage shelves. It fulfils the role of a container as well as making available an empty space to welcome the appearance of images.

A large selection of white and coloured paper is available on the surface of the bench, together with paint, crayons, pencils and felt-tip pens as well as brushes, pots, and water jugs. The full selection of art materials – including clay – is visibly displayed on wall racks and in metal baskets, with the aim of facilitating free choice.

Finally there are three red folding chairs for the children to arrange in whatever combination they might wish. I work with both out- and inpatients, but the feedback from both groups of children is the same: the 'red and blue art therapy room' means a 'different' space, which they are eager to use freely and appropriately to formulate and express their inner world.

(Letter to the authors from Vera Vasarhelyi (1990)
Bloomfield Clinic, Guys Hospital, London)

The final example of the art therapeutic space is a detailed account of how the working environment closely matched the client group and how careful consideration was given to their needs and how these could be most

appropriately met. The following description of a well-established department gives a real sense of the separate space essential for the establishment of a relationship and good therapeutic alliance. This historic account documents the essence of the traditional art therapy department and offers a unique description of how these art therapy departments were set up. There is a sense of the 'asylum within the asylum'. When we came to write the second edition we decided to keep Anna Goldsmith's original description but asked her to describe what happened with the hospital closures and move out into the community in the mid-1990s.

The hospital

Hill End Hospital was an old Victorian red-brick asylum, set in green belt land that rings outer London. The hospital catered for adult psychiatric patients from the North West Hertfordshire catchment area.

Art therapy had been established in the hospital for many years and developed to specialise in work with psychotic and borderline psychotic patients. The geographical location, the layout of the hospital and of the rooms of the department within it made it a highly valuable space to accommodate our particular approach to this patient group. Equally, it was flexible enough to meet the needs of other patients able to negotiate boundaries and relationships at a more ordinary symbolic level.

The department

The department itself was at the back of the hospital, a 'spur' off a long corridor to one side of the administration block. It was a more or less self-contained set of eight rooms which many years ago were part of a larger ward area. These rooms functioned as a large main studio space with at one end a kitchen and to the side an office and two small therapy rooms, each with a door adjoining the main department. To complete the number there were two locked store cupboards for patients' work just beyond the kitchen, and across the corridor was the toilet area, shared with another department nearby.

Despite the old ward status there was little clinical about the department though its style was certainly recognisable as institutional. The fittings were solid, the proportions generous and the rooms throughout were light and airy. The department as a whole was pleasant to the eye and had a certain neutral solidity that could accommodate much of what took place within it.

The main studio was spacious and quiet with room to walk around as well as to sit in. The therapy rooms (and office) were small, creating an atmosphere of privacy and the safety of self-containment. The rooms were usually warm,

and sometimes too warm so that even in winter the windows needed to be opened to let fresh air circulate. Net curtains and fluted glass gave some privacy to those inside from people walking by outside.

Entrances and exits
The main entrance and exit was by the outside garden doors, as they were called. These were double wooden doors which opened onto a grassed area where wooden benches lined the outside wall and sat irregularly placed under the many huge lime and chestnut trees. Patients from the department used this outside space to leave and enter the main room, to walk around outside, to sit alone or to soak up the sun. Very occasionally to draw. There was little disturbance from other hospital activities and empty wards and an abandoned occupational therapy department stood around us.

Another door from the main room led to the kitchen on one side and the toilets on the other. A large room, infrequently used, led off from them. This room, unless being used by another department, was locked, as was the outer door beyond the kitchen leading to the main hospital corridors. This area constituted a series of spaces, all of which could be 'used' differently from their intended function by patients – e.g. to be alone, to hide, to create distance, to look in mirrors, to talk to oneself and so on.

Rooms and tables
The large room had within it approximately 21 tables, many of them old wooden, oval or rectangular, each with a chair. The staff table was near the office and was side-on to the room. The centre of the room was marked by a table with several large pot plants. The tables each had qualities inherent to their size, location relative to each other and the spaces between, to social areas of congregation and to the staff table. Consequently, some table spaces were more 'open', some further from traffic, some in more containing corners (or claustrophobic depending on your view). These qualities and possible perceptions were taken into account when allocating space to new patients (see Figure 2.5).

The walls had ample space for patients to put up images after selecting and perhaps negotiating for the desired place. The mantelpieces and shelves, too, were laden with unfired clay and other made objects.

The office, which was located between the two therapy rooms, had within it all the paraphernalia required of an office but remained too small for the needs of four members of staff. It was sometimes the only available space for detaching oneself from the main room to work on reports and administration or to speak privately on the phone and, equally important, to confer in private

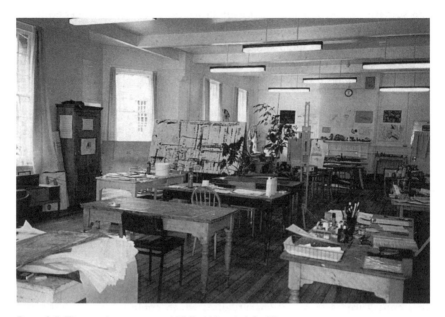

Figure 2.5 The art therapy room, Hill End Hospital, St Albans.

on some aspect of room management or therapeutic strategy that needed immediate attention. It was possible to have visual contact with the main room via the netted glazed door and also to be more available and in touch by having the door open while working.

The two individual therapy rooms were where patients brought their work and in which in-depth therapy was most usefully carried out. Each room had two easy chairs and a coffee table between them for placing work. On the walls and shelves there were various objects and images which the patients had requested and negotiated should remain. The rooms were more or less soundproofed and the glazed, but netted, doors gave a veiled visual access both to the therapist into the events in the main department should she be the only staff member available, as well as providing a visual link for patients remaining in the main room.

The space as 'studio'

For patients whose level of functioning was sufficiently integrated, i.e. who were clinically best described as neurotic rather than psychotic, this department was most readily understood as a studio-type space. Here, referred patients were expected to be present during their programme times. After the initial introduction to the department, its facilities, the materials and sometimes the discussion as to how they may best use this time for them-

selves, they were then left free to find their own preferred level of relating to what was available within the limits or 'rules' of the department.

They were free to sit at their designated table space and make images or read from the selection of books provided, make tea when they wished, sit in the easy chairs in the 'social space' and so on. There was room to walk around and to move in and out of the main room, to have a variety of levels of engagement in personal exploration in different spatial contexts. Work that was produced was kept safely and doubly private by being kept in a personal folder, also kept in the main room on shelves for that purpose. Each folder was laid out on the patient's table in readiness for the session. After assessment, therapy was embodied in the form of a verbal contract which defined times, duration and focus of therapy where this was possible and desirable. There was then an overall expectation that patients be present at the agreed times both for sessions in the main room and for individual therapy, and that we were kept informed by them of changes that could affect the contract. The relationship between the department, therapist and patient was one of the 'whole person'. Bearing in mind the tremendous differences between people's ability to take personal responsibility for themselves (perhaps the meat of therapy in this context), negotiations and explorations of relationships, boundaries, time, spaces and meanings were possible at a level that was symbolic and was between people who experienced their 'selfhood' as more or less separate and boundaried.

Concepts of 'private space for personal material' of 'sharing inner experiences with another person' and of 'exploring the meaning of imagery' were all relatively understandable and negotiable although the content could be fraught with difficulty. The avoidance and disruption to those processes that were made manifest in their relations to the contract (e.g. not keeping to session and therapy times) and in relation to the content of therapy (e.g. in the transference material) all took place in the context of a developing 'whole person' relationship. Here, feelings, thoughts, actions were experienceable and attributable as such, though distorted to varying degrees.

Consequently, the rooms existed as spaces in which what was inside a person could be put outside in an atmosphere of containment and safety, the level of which was dependent on that person's own self-experience, the differing function and significance of the rooms and relations with the therapist as well as on our ability to maintain the experienceable structures (e.g. timing, confidentiality, care of work).

To work in the department was understood as constituting a spatially defined area, a level of privacy, a behaviourally 'loose' connection with staff and an internally experienced world that may or may not be laid bare

externally, in images or forms. Moving into an individual session room involved a shift in that definition to allow for an increase in the level of privacy as well as an intensification of the relationship experienced and a context in which an intention to explore the work more deeply could be 'framed'.

Space and body spaces – the psychotic experience
However, for a person who was struggling with psychotic anxieties, loss of self-structure and of the 'ordinary' notions and experiences of 'inner' world and 'outer' reality, the concepts outlined above, necessary for therapeutic engagement, were rendered useless. There was not a sufficiently and viably integrated 'self' with whom to 'do business' in the ordinary therapeutic manner, and attempts to activate this were usually met with an increase in and an intensification of psychotic fragmentation. For example, the psychotic person might experience a compression of meaning with the 'signified' so that an expectation to 'express yourself' might as well be a request to 'have your guts ripped out', not as a metaphor but as a description of the experiential level involved in this kind of relationship contact.

However, what was possible, and was part of the way in which this department worked, was to defer the expectation in the therapist of a 'whole person' relationship and to concentrate instead on building 'concrete' areas of negotiation between therapist and client. In this way the 'currency' of this exchange was made up of the 'concrete' realities within the environment.

The whole department and everything in it then became available in a different way from that described earlier. The concept of 'personal space' was viable here as a concretised location, as literal space that could be available for manipulation at an experiential level and may have to be defined by 'concrete' boundaries. The spaces and real objects or substances that existed could be focused on as felt extensions and repositories of body experiences in a relatively safe context. When 'control' of them was not 'challenged' (including by therapists who wanted to attribute a symbolic meaning or relational connectedness to them) they could become parts of the 'self'. It became important in a different way, then, that the space and the objects within it were the property, not just the territory, of the client.

The programme for this kind of functioning state was designed so that the table was kept entirely for that person's use and the work and other objects put on or near the table were left totally undisturbed. The table and its environs (including any images) may be experienced as an extension of the psychotic person's self-structures. To interfere with, or to make unsafe, that safe area of experiencing was to risk gross intrusion into fragile 'self'-defining structures, to impose expectations and therefore to bring demands

of a 'whole person' relationship order. To support it could enable the psychotic person to relax some of the defensive strategies and experiment with others that later may be more viable in the world of relationships and symbolic structures.

Despite the psychotic person's avoidance or inability to relate at an ordinary level, it was inevitable that some contact was made over issues of table space, folders, materials, opening and closing times, tea-making and so on. It was here that boundary-setting, 'rules' of the department and other structure-creating communications were entered into and where the therapist could participate in building a relationship with the client in the form of negotiating to accommodate their wishes within the boundaried structures of the department.

A further level of negotiating took place in relation to how to deal with imagery. These negotiations or exchanges could also be concretised and could be approached at the same level by the therapist. An example could be the perceived 'power' or 'evil' of imagery that was created. Where it should be kept so that it did not harm others may have been a crucial consideration. A department with many different kinds of rooms or spatial contexts, with cupboards, shelves, drawers, corners and alcoves and with a table space that was sacrosanct and kept safe for the client, provided numerous possible solutions to this consideration, which could be negotiated, again concretely, with the therapist.

The studio-type space where entering and exiting could be done autonomously allowed psychotic people to come when they 'felt ready' and leave when they had 'had enough', their relationship with the spaces being controlled by whatever aspects of themselves they were presently driven by. The proximity of the individual rooms to the larger space allowed a similar disengagement without that person having to leave the whole departmental space entirely. In this way any engagement that the psychotic person was able to make, even if it was only with the inanimate room space itself, was nevertheless an engagement and therefore a basis for negotiations that could be capitalised on by the therapist.

To have to arrive at a pre-set time, to knock at a door to gain entry for engagement in an intensive relationship and to have to be able to 'contain' the contents at a symbolic level, having perceived that therapy is finished until next time, is an expectation placed upon one to function at a highly integrated level with another.

In a system of this kind – where patients had to exert a reasonable degree of responsibility to adhere to specific days and times, where the layout of rooms meant that the person is either in or out, engaged or not, where table space was fought for and 'unstable' and where all the work with the therapist required a

relationship at a highly symbolic level perhaps in a small closed room – there was little room for manoeuvre of the negotiations-type described earlier.

There was indeed less ambiguity, and perhaps the opportunity for patients to 'test' or 'push the boundaries' was reduced and rendered more explicit in a space that was therapeutically 'clear cut'. In the less 'clear-cut' but nonetheless boundaried structure of the department at Hill End Hospital, we could focus on the increased opportunities afforded us to mediate between concrete and symbolic structures. Through the recognition of the value of working with the 'concrete' level of functioning we aimed to utilise the actual spatial locations and their experiential components as part of the basic 'work' and not only as the 'frame' or context of the work. In this way the department itself 'participated' in our techniques by enabling us to reduce the otherwise implicit demand, that 'clear-cut' therapeutic spaces made for high-level functioning of a more integrated 'self' that could be immediately achieved by these clients.

Acknowledgement
The specialised work of the department and the development of its facilities in work with psychotic and borderline psychotic patients was pioneered by my predecessor Ms Kathy Killick. Her work is described in her later publications (Killick 1987, 2000; Killick and Schaverien 1997).

<div style="text-align: right">

(Letter to the authors from Anna Goldsmith (1990)
Hill End Hospital, St Albans)

</div>

Hospital closures and the move into the community

Hill End Hospital is now closed. The art therapy department is now located within a new community setting. The following descriptions document the changes 15 years after the hospital closure. The first is provided by Anna Goldsmith who has worked as head art therapist for many years and has overseen so many of the changes.

The period around 1993–4 was perhaps one of the most dramatic in my experience of working in a large psychiatric hospital in the NHS, when the ground beneath everyone's relationships to each other, including clients, shifted, never to be aligned in the same way again.

Since then events of a seismic impact have been the order of the day with change, in the form of politically-driven strategies, following on the heels of change. I have almost forgotten now what divided one political party's agenda from the other. The reality was that we were all, staff and clients alike, unceremoniously turned out of the institutions that we learned not so much to love, as to live and work in, and remain exasperated with, in equal measure.

I realise that back then we enjoyed a high level of certainty that the building and the rooms we had would remain, that staff organisation stayed the same, that we would keep our jobs. This 'no change' allowed us the privileged necessity to really focus on our work and to act with a semblance of internalised coherence, within ourselves as individuals, as a clinical team and within our context of referrals and management. Very little else would demand our time and attention. This contextual stability set up the conditions for each of us to prepare ourselves for our part in attempting to follow the thread that made up each individual client's labyrinthine knot of uncertainties, fragility, stubbornness and convoluted desire that are a consequence of the human condition.

What occurs to me in reflecting on this is that there is a whole generation, if not two, of art therapists, clients and people generally who know nothing of the old-style psychiatric institutions except by hearsay. For most, this familiarity will not be missed and my consideration of them may sound more like a curious, personal foible.

However, what is true is that much of what evolved to become part of current theory, practice and knowledge about how art therapy can work, especially with extreme states of mind, derived from the clinicians and patients who worked together in these buildings. These environments existed and shaped us for many years. These places were many things good and bad, home and hell, 'hospitable' and prison depending on who you were and what was available to you.

Their closure was brought about quite suddenly in the history of psychiatry, by a wind of change from 'outside', in the wider political world. The NHS decided to close institutions, people were decanted, the land was sold and care in the community began. From where I stood, this change, fired by the economics of funding the NHS, required a systematic process of demonising hospitals and all things associated, to carry public opinion. There were very many things wrong with institutions and their part in the dehumanising of people with mental health problems (or without, in some cases) is often cited. However, the speed and the way their closure was carried out is another chapter in the story, yet to be written, of how ideas that are presented as humanitarian, when hitched to a political/economic agenda and people's employment, gain a momentum, making it possible to perpetrate other dehumanising processes in their turn.

Like other similar institutions, Hill End nonetheless had undergone previous changes. In the early 1970s, I worked in a different hospital at the tail end of an era that still had hospital cricket teams (patients and staff) competing across hospitals, and summer fêtes, where local worthies judged

watercolours and sponge cakes and older patients carried memories of more civil incarcerations.

In the Victorian and Edwardian eras tea parties, cricket matches and musical events characterised the social calendar of institutional life, a microcosm of the pleasantries of life outside. That most prolific of artist inmates Louis Wain (1860–1939) (who by chance had resided in an institution not far away) depicted these earlier, 'civilised' times in the form of gentlemen and lady cats playing tennis and holding conversations among the bandstands and pavilions, dotted among the shrubbery and sweeping lawns. The old institutions all had orchards and farms, laundries and theatres, and Hill End once boasted its own railway stop for Sunday visitors.

Patients were usually assigned to one of the various working areas of the asylum, divided on a gender and class basis no doubt. Women in the laundry and men on the farms, for example, would not have been contested.

The two world wars changed all that, and twentieth-century ideas affected the notion of what it was to be a madman or woman and how they should spend their time. These older structures were still very strong however, and farms and laundries, like cricket teams, persisted into the 1970s. In that decade, industrial therapy, as simple assembly work was called, was already in full swing as ideas about personal value being equal to labour value influenced the policy-makers. This was enabled by earlier advances in medication and the continued need to organise the population in institutions, and it became briefly the zeal of the time.

Laws had been passed before then that prevented institutions from retaining patients within their walls as unpaid labour, lest the need to keep the hospitals' domestic economy ticking over should dictate the fate of inmates. The institution as a 'would-be factory' attempted to update the notion of social purpose from that of 'everyone in their place' (a weird stately home with the patients 'below stairs'), to 'worker' and 'shop floor' with the accompaniment of concepts of lateness, (minimal) wages and docking pay, but strictly non-union of course. This attempt to inculcate the 'order' of the assembly line really only worked in a limited way for patients who could stick to it and therefore earn more cigarette money and keep in with the powers that be. Many could not and obeyed a different set of more personal rules of logic known only to themselves. However, even the maddest was usually allowed to sit somewhere and enjoy the tea break – the needs of madness always awkwardly subverting those of any new ordering of relationships and meaning.

Occupational therapy had a huge impact on patients' lives. It is hard to imagine what the quality of day-to-day living would have been for most

incarcerated people without the multitude of craft and social activities that generated manual skills, pride and 'intermediate objects' that provided social glue and eased the search for peace of mind, purpose and distraction from one's pain.

In Hill End in the early 1980s, art therapy was quietly thriving along with a number of similar set-ups in institutions around the country. It was relatively easy to obtain work in hospitals and art therapy was a new and different ingredient to add. Around us all, however, were the relics of another age, bandstands and orchards, like so much fading scenery of a long-forgotten play. The institutionalised patients on back wards were a captive and willing audience to the new play of art therapy, most having lived with the gradual change in hospitals since they were young men and women and who by now had lost any active desire to leave nor had anywhere else to go.

Initially, these long-stay patients along with very distressed and psychotic patients admitted to the acute wards, were seen on the ward or referred to the department. Later, we were able to develop our service to include outpatients.

Within the art therapy department there was without doubt a sense of ordered time, of belonging, of relationships and of ownership of what we were doing together, including the spaces and the objects within them. This epitomised a quality of mindfulness that seemed possible, was vital and seemed to belong to the place and the pace of our working lives.

This attentiveness allowed us to interact and engage with some of the most bizarre and exotic flowerings to which human beings can commit themselves. It enabled us to witness the psychotic universe but also to allow the psychotic universe to enter the space and in so doing, and by our communally-held strategies of negotiating the interface, to become humanised.

By this I don't mean *normalised*. I mean that whatever was offered by the patient, sometimes the mere act of just arriving at the door, was brought into the frame and was taken as concrete communication but not responded to as such. So what it decidedly did not mean was that we should act as if an embodied 'person' stood at the door. 'Ordinariness', the business of a 'being' and relating person was what this 'not-a-person' had long since diverged from. There is no metaphorical 'journey' and we are talking of an entirely different proposition, such as 'how to find a link with an exploding star or a collapsing universe'. This is a place of extreme crisis of being, where the world and the body (there is no dividing line), has to be pushed into 'thought', then to be subjected to the wakeful and glaring light of awareness, like stones being restlessly turned.

The work had evolved within the institution and the particularity of its

interconnecting spaces and functions, and we could work at the extremes of what constituted engagement and therapy.

The change of government strategy that meant the closure of big institutions and the decamping of services to various teams, collections of leased premises and brand-new buildings, removed this work at a stroke. That is not to say we did not attempt to put old wine into new bottles. Indeed we did, but perhaps we had not seen the whole picture, the reality of what new spaces would permit and the power relations that flowed from new ideas.

The new space was different in every way, being in the town centre, hard on the high street with a view of shops and buses, cars and people going about their normal business. The building is a quaint eighteenth-century purpose-built office that used to house some of the local government council functions. The interior, particularly in the 'attic', is of uneven wooden floors finished with deep skirting-boards and small casement and sash windows. They look out onto tiled roofs, a council flower garden and the busy high street, giving a sedate and middle-class purposefulness, Dickensian in flavour, especially when it snows.

The move was modified somewhat by the utilitarian necessity of having to divide rooms up quickly and cheaply and fit in modern office furniture. This was compounded by having to fit the old-style studio furniture into the new accommodation. For instance, the wedging in of oversized office desks, their journey up the two floors of the spiralling staircase having been Herculean, and they have long since given up their capacity to keep all their draws closed at once.

The acute unit was now ten minutes walk away through the busy town instead of being at the end of a covered and quiet corridor. The day hospital was being shut down, without any time to 'grieve'. It too was surplus to requirements and was seen as one of the last representations of the medicalisation of people's problems. Long-stay patients (renamed 'residents' and later 'users') were seen to have merely a 'housing' problem and hospitals, being expensive and occupying prime land, were no longer to be the solution.

All the battles with psychiatric models of illness and cure and the accommodation of each other's professional differences within the institution had not prepared me to feel suddenly so particularly allied with the psychiatrists against what felt like a new 'regime'. This was change with a politico-economic agenda, with a doctrine of 'houses for all' and a new language that paid lip-service to deconstructing the meaning and position of 'patients'. One of the absurdities which we had to, open-mouthed in disbelief, accept, was that a new day centre (in an outside locality) open to clients we

had worked with in the hospital retracted its request for us to run a group, as therapy was now seen as too 'medical' a model.

The departmental structures and functions were also changed by new spaces. The hospital office had been a room off the main studio into which we could step to speak in private yet keep an eye and ear, through the glass door, on the studio. It was now the next floor up, through three doors and in an area out of bounds and unseen by patients. The separation of the office from the actual engagement with patients meant you could no longer be in two places at once and office work was no longer a sideline. It was of course a harbinger of what was later to come, because office work is now a major part of what we all do and the office is just an office, not an extension of a therapy space.

However, what was even more crucial and a preview of the changes to come, was the collection of other 'concrete' differences, that is, being on the high street, on the first floor and all people needing discrete appointments. This was a new stage setting, manageable for outpatients whose ego structures were sufficiently viable. For those without this capacity the concreteness of the institutional setting itself was utilised as a containing, alternative self-structure. These changes were the worst for ex-patients who were schizophrenic and those experiencing psychosis. Many of the long-stay patients at Hill End were 'rehoused' in their own flats, some local and others in Hemel Hempstead, a thirty-minute journey by bus. For these people to return to us to continue their therapy required of them to wake up in the morning, with an unambivalent state about coming that would survive getting up, dressing, catching a bus and having the bus fare. Then, enduring the journey, arriving in town, and waiting in the office, if they were early, until fetched. Next, there was the experience of staying in a room with a person for a defined therapy session and with a time limit, to be followed by leaving and all the above in reverse, back to the flat. I cannot stress sufficiently what demand this places on a person in the sway of psychosis where there is no 'thing' to attach to and no safety in relinquishing any protective strategies or symptoms.

These voluntary actions demand a good enough organising self/ego to see them through. It has to withstand the ebb and flow of thoughts and the constructions of threatening meaning that may be initiated by the slightest look a stranger on the bus gives, a chance word overhead, the sense of a body that burns and moves in response to who knows what. To want to go to therapy means to carry a sense of desire and anticipation that can modify the fear and anxiety that relating brings. It means being able to recognise the desire as one's own and to feel it as 'good' as well as to trust another. These are not the givens of psychosis.

There were several people who could not manage the transition from old to new. One was Andrew, a tall young man who at Hill End appeared one day at the garden doors that faced onto the large studio room, standing on tip-toes and wearing camouflage trousers. He turned and left, to return again the next day. After a few days of this he made fleeting eye contact before he left. Eventually and bit by bit, contact was made sufficiently to offer him a table to use when he was there. Later he could agree a time to meet in the side room with his work, but in the knowledge that he could bring it to a close whenever he wanted. Within a few weeks he was working for several days a week at his complex imagery and meeting with his therapist, whose job it was to see how he could talk to her and about what. He talked about his thoughts, how he made sense of the world, revealing more of his self-structure while at the same time developing a negotiated close communication with another, the therapist, who in turn resisted the desire to breach his defenses and look for who was behind them – i.e. the person inside. In this way the focus of work consisted of helping him to negotiate more sustainable ways of 'being', in relationship to others.

His attempts to make the transfer to the new setting required clarity and constancy of identity and that his voice express agency to say who he was at the intercom. For a week or two it sort of worked out but then disintegrated. He couldn't 'land' at the right time and place even though we, being also new to this, looked out for him, eager to ease the transfer. However, this 'gathering' of himself left him without resources for therapy itself and he was unsettled and soon stopped coming. He was never at ease in the new small studio, which was about a sixth of the size. Going out of the studio door, instead of leading to a neutral corridor or garden space allowing him distance as in the hospital, brought him into the space of others and therefore into mutual impingement. Weeks later we heard that he had set fire to his room, had been admitted to the acute unit and then placed on a locked, low secure ward.

Presumably he fell prey to his anxieties and developed more intense symptoms. The outcome was that by being readmitted he created some relational certainties – patient and nurses – and a containment via the setting to hold everything together. He could also be 'mad' there and know it was in the frame of reference of others, more so than outside in public. The setting acted in place of a self-structure when this was no longer sustaining for the level of anxiety and fragmentation. Over the next ten years or so, this young man settled, took self-discharge, left the country, returned, was admitted several times over and finally engaged more usefully (for him) in a low secure unit over a long period of time (without always having to be discharged when the symptoms subsided). This enabled a slow process of development of relation-

ships and skills within a containing structure and a subsequent move to a small staffed house, though he never wanted to return to art therapy.

The need for secure units has increased since hospitals closed and our local one contained patients we used to see within the unlocked, looser hospital setting.

Another person who uncomfortably straddled this transitional time was Peter. I had first met him in the hospital when, arriving one morning to open up, I found him asleep in a bundle of quilts and coats in the inner doorway leading to the studio. He was a frightening character, a young man who shouted and swore with a vengeance that kept you at a distance and precipitated the need to do something about him. We couldn't let him stay as he wasn't a patient but he chose to come to the hospital for food and shelter – forcing patients and staff he visited to give him leftovers, biscuits and tea and stealing anything else he needed. I'm sure staff felt sorry for him as he was young and very crazy but somehow likeable as he could switch quickly in mood.

A *laissez-faire* attitude existed around him; after all, there were plenty of deserted annexes at the ends of corridors that he could tuck away into and he was plainly very mad.

His appearance in our area inevitably caused a stir as he invaded the adjoining art therapy kitchen area and aroused conflict with our patients who didn't take to an interloper stealing tea. Eventually, after incidents involving the police being called and even a newspaper article wrongly attributing the infectious danger of HIV to him, the hospital admitted Peter and we were able to follow up with a referral to us as our harassment by him had developed into some sort of relationship. At least if he could legitimately attend he could eat and drink and we wouldn't have to confront him about it. This invitation was responded to with some amazement and interest by him, and I think he felt relieved by this – he could relax his aggressive alertness to anything (and that meant everything) that threatened his basic psychic survival.

I cannot imagine any of the new developments and mental health locations allowing for Peter's entry into therapy in this way, as he would most certainly be locked up. His diagnosis on receiving paperwork about him, was 'aggressive sociopath' which sounded arcane then, and would now be, I expect, 'antisocial personality disorder'. It was necessary to persevere over months with him and what was most helpful was the largeness of the studio room. Peter could have a table a long way from the staff and sit, near the hatch and door to the kitchen, the toilets, to two exits and have his back to the rest of the patients and staff in the room when at his table. Closeness, through physical distance and eye contact were obviated and he could move about spaces or

not at all and avoid interaction with others. He did find a way to take up a personal space, eventually trying out easy chairs which were near to staff and from where he could fling comments at us and make eye contact. These interactions bore a particular flavour as his jokiness became apparent along with his frequent incorporation of phrases and titles of 1970s pop songs into his exchanges. This became much more the language he could use in relationships, particularly with myself as his therapist.

In time he and I managed to develop a process where communication and linking became viable, where a self-narrative could emerge and be tolerated and where I, as an 'other', could be allowed to be more present for him. The transition to the community was extremely difficult and intensified, once more, his fears and anxieties at a primitive level.

He travelled from the closing hospital to our new studio which was too small and where everyone else was now too close for comfort. To get to us he now had to pass through the town: pubs, girls, people working, having lives and seeing *him*. Desire, envy, loss and shame crowded in and enraged him each time. His presence in the studio was unbearable to him and to others and he often left spitting insults, primitive projections, as he went. He used our individual time less and less as his self-structure was not adequate to cope with these violent storms without activating his much-needed primitive defences.

When I was about to take some annual leave I was concerned how Peter would manage. Being able to link to others and the 'room' was now less viable as it was no longer so neutral, but was more alive and generated threat and impingement for him. I believed that my absence would be felt by him as a primitive persecutory experience, not available for thinking, and might push him to greater fragmentation and severe behaviours. I felt he needed something else with which to link, that was concrete and durable for the time involved, so that he could mark the time and move toward the future – my actual return. My solution was to buy him his own colouring book, sheets of stickers and felt-tips, some of which were large and somewhat flashy, all assembled in a tough cardboard box. I was nervous that the nature of these objects would also bring into play hitherto unthinkable aspects of relating/transference such as mother and child, and that this would force him to spit this out as a terrifying reminder of his vulnerability and connectedness to an 'other'. However, he fell on the art materials with an appetite and a delight.

While I was away, I imagined him roughly colouring the shapes that appeared on each newly-turned page, the black outlines of each fragment guiding the rush of colour, holding themselves in one piece whether he completed the picture or not. Then the rhythm as each sticker was peeled and slapped onto

the paper surface – it didn't matter where, they were each a 'whole' as well as parts of a whole.

When I returned, the connection was still maintained as was apparent when Peter showed me what he had done in my absence, which was what I had imagined as well as him having used the surface of his box to hold the marks and images he'd made. It represented his survival on two counts, that of survival in achieving a relationship with me and others (in the studio) and survival, through compensation/transitional object, of the loss of me as an 'other'. A move too between part object relating and whole object relating.

Overall however, his time here was not sustainable in the long-term for the reasons outlined. He was disastrously, nearly rehoused with his girlfriend in a flat, the increased proximity of intense relating driving him mad. Eventually, after much lobbying about his needs as opposed to what he 'demanded', he was relocated to a group home where he settled in the more contained and managed setting, a little way out of the city centre.

In our last few meetings he made some interesting comments: that being in art therapy had made him 'sane like crazy', which I took to mean that to connect and be 'in touch' drove him mad; and that on seeing some alchoholics on a bench outside the window, if it hadn't been for art therapy, he would have joined them long ago. These moving statements recognised entirely his predicament and that of many others like him.

(Letter from Anna Goldsmith to the authors (2005). Anna is an art psychotherapist who has worked in the NHS for 30 years. She also has a small private practice and is a member of the Guild of Psychotherapists)

The following description is written by Caroline Gilder, who has worked in the NHS adult mental health services since 1994, providing group and individual art therapy for clients with a range of mental health difficulties. She currently works with Anna Goldsmith in the art therapy department for Hertfordshire Partnership NHS Trust.

Establishing a secure base in a community setting

The presence of an art therapist in a multi-disciplinary team (MDT) within a community mental health centre (CMHC) setting is an increasingly common occurrence. Often, the art therapist is part-time and may be working in other settings; she may be attached to a wider therapy team, or a district-wide service, or she may be working single-handed in a loose grouping of 'therapies'. In writing this piece I reflect on my personal experiences of working as a 'visiting' therapist, that is to say, being attached to a district-wide team where therapists work predominantly from one community base, but also offer sessions in other community facilities. I use the word 'visiting' as a way

of differentiating between the attachment and containment of working from the base where the team is located and where the service has its studio and secretary and offices etc., to the experience of working alone in a different location where the art therapy input is a once-weekly group and there is very limited integration with other professionals and services.

As I began thinking about this, an image came to my mind of concentric circles around an empty space. The concentric circles seemed to stand for the experience of working within a room, within a building, within a service, and within a location, and also for the layers of symbolic containment necessary for the provision of therapeutic work. The empty space in the centre of the circles then seemed to be related to both a lack of attachment and a need to acquire a thinking space. Attachment theory conceptualises this in terms of the infant/caregiver dyad, in that the caregiver, usually the mother, needs to be a reliable provider of adequate and well-attuned attention, in all its forms, to provide the infant's developing psyche with the containment it needs. Unreliable or inadequate provision leads to insecure attachment and this hampers the capacity to develop reflective thinking, and the ability to contain and process emotions and feelings. For the therapist in an insecure position, reflective thinking about clinical work can be difficult to generate and sustain, and feeling 'in' or feeling 'out' of a team or a context can be mirrored in the experiences with the client, often referred to as 'parallel process'.

The following describes some aspects of the struggle to make art therapy feel like an integral, useful and permanent part of the service provided within the CMHC as well as a helpful treatment intervention for the clients.

Background

The CMHC is a multi-disciplinary, multi-purpose setting, and in common with many NHS CMHC's, the building houses psychiatrists, social workers, nurses, psychologists, psychotherapists, day service workers, drug clinics, outpatient clinics and a drop-in facility.

The art psychotherapy service covers two localities and several service area groups: adult community mental health, older-age mental health and acute inpatient services. We are housed in a central location with offices, studio space and individual treatment rooms where the majority of the clinical work is carried out. However, to offer as wide an opportunity for provision as possible requires therapists to work in satellite settings, away from 'home' as it were, in ward, day hospital or CMHC facilities.

The art psychotherapy treatment input within the CMHC has developed since 1995; in the early years it began as one group session a week. The

relationship between the CMHC setting and the clinical work undertaken has developed, regressed and progressed over time and had a role in the type of treatments offered. The dominant theme of these relationships seems to have been 'being in' or 'being 'out' in both therapeutic and professional encounters, mirroring the process of secure or insecure attachment.

For an inexperienced, part-time therapist, undertaking the brief to develop group work away from the departmental 'home' was an anxiety-provoking experience. I had some experiential and theoretical awareness of the existence of the 'dynamics' in teams working in stressful occupations, and was cautious about how to approach developing the work. I had a number of referrals for clients within the locality who had all been assessed as requiring a group therapy intervention, with a further recommendation that this be art therapy. I began my work trying to find a place within the building and the team for an art psychotherapy group.

The setting, an outer circle
The setting has had an unusual beginning. The CMHC building was originally designed and built to be an inpatient unit, but was destined not to open as such. A use for the building was sought and eventually the community mental health team took up residence. The legacy of the building was apparent. Consulting rooms were made from bedrooms and storage rooms were originally bathrooms. The building's origins as an inpatient acute facility has led to some of the difficulties in establishing good working environments for the practitioners based within it. There has been a sense of dissatisfaction with the space and staff worked hard to make the environment fit their purposes.

There has never been enough space for everyone to fit and much elbow-jostling and rearranging and reallocating of rooms has gone on. It is impossible not to connect this to the much greater 'circle' around the community services of the NHS and governmental initiatives. As trends in mental health care ebb and flow, different services come into fashion and it can suddenly be imperative for the Trust to create a new service team which then has to be found a home. This tends to engender a great deal of feeling in the wider team because the new service can seem, in fantasy, to be the one that will be the saviour, provide the cure or the hope for the stressed-out team. Resources are redirected in, and staff often recruited from existing services, leaving them depleted and with colleagues carrying extra burdens of work. There is rarely any room for reflection or thinking about the changes.

The grass roots experience for mental health professionals and workers can be that new initiatives follow old, nothing stays around long enough to be fully evaluated and more office space has to be found for the next innovation. It was

in this environment that I began developing the art therapy service. I was aware the struggle for space was paramount. There was intense demand on multi-purpose rooms and resentment of services who rigorously protected 'their' space. I felt sensitive to being another demand on the space, this time a newcomer with a 'special' insistence on a guaranteed weekly booking with no interruptions or diversions. As a basic premise for offering safe and containing therapy work we expect to be able to offer the minimum of a room, a therapist and the art materials, but in this new situation this seemed difficult to establish. Selecting a potential space was relatively straightforward – the need for a washable floor, sink, storage space and room size pointed to the kitchen – but establishing a sense of ownership over the space was more problematic.

Early days: establishing a place for art therapy
One of the first dilemmas I encountered was what type of relationship to have to the existing day services, which at that time were running a weekly programme of groups and activities within the kitchen. We both needed the only available activity space. As a department, we thought about whether to be 'in', which would mean becoming part of the day service programme and accepting clients into art psychotherapy, or to be 'out' and operate alongside it, and if so how to accept and communicate with the team regarding referrals and assessments.

After thinking through the options with the head art therapist, we decided that the art therapy service would be 'out'. We took this decision to retain autonomy and clinical control over who would attend the group, and for how long. Referrals would be made to the department, discussed by the team, assessment carried out by the therapist and feedback made to the referring clinician, as is the case with all outpatient referrals. The alternative had been that referrals were made as part of a day service programme and discharge from the day service would equate with discharge from the group, which could be problematic if further work needed to be done in art therapy.

The decision not to be in the day services was a difficult one. Ambivalent feelings about this decision were sometimes acted out in poor communications. The following examples illustrate how this ambivalence and the unprocessed feelings led to a lack of reflective thinking, affecting both the work in the group and the links with the setting.

Finding an approach to fit the client group
The reason for referrals to the group was for clients who were unable to tolerate the emotional intensity of verbal psychotherapy and required a mediated therapy to help them engage in introspection and manage the

anxious business of beginning a therapy group. They were all felt to be in need of a group where personal difficulties could be held and worked with, although they had a variety of diagnoses. All were new to therapy and highly anxious about the prospect of others seeing their distress. They were not used to introspection or linking their early experiences with their current lives.

I had organised the room on a model I was familiar with, providing five separate work tables around the perimeter and a circle of chairs around a coffee table in the centre. This emulated the arrangement of the studio in my 'home' base, and was an attempt at feeling more at home in the new surroundings with new group members. I would sit in the circle at the beginning of the group with the group members, and then they would move to their tables to make images and return to the circle for discussion in the second half of the session.

In the first weeks of the group I experienced a profound inertia and difficulty in thinking about the material; images, words and actions. The depressed, anxious and uncommunicative group, who just wanted me to tell them what to do, sat listlessly around and made unconvincing attempts at communication. In retrospect I can see that applying the model I was familiar with in order to feel more at home was initially counterproductive, because of the different nature of the environment and the function and purpose of the group and group members. It had been a short cut to the familiar in the unfamiliar surroundings but had bypassed real thinking.

I had an honest discussion in group supervision which allowed more thinking space to open up. I realised how theoretical notions had crowded my head, replacing real thinking. My supervision provided the necessary containment along with a concrete suggestion: 'You have to show them how to do it'. Released from my anxiety in the following session I acted on intuition and decided to act in (and out) on behalf of the group. I pushed all the tables together, suggested to the members we sit together and used the materials myself with a focus on what we hoped the group could be. The effect was powerful and exciting and the group began to function as a space for communication and thinking together. It seemed as if providing a very concrete model in myself of how it might be possible to use the art materials had allowed a similar function to take place in the group.

After some months I began to withdraw from image-making and offering themes, which I did occasionally, and the group gradually took on a more self-directing stance. I rethought the position of in or out in relation to being the therapist and decided I needed to be a bit more out in order to act as a more efficient group therapist for this older and wiser group. From that point I was

more comfortable with observing, feeling and thinking about the images and the group's interactions as they took place, opening up more possibility for thinking and reflecting for the group.

The group room

When a service is poorly housed there is a danger of 'infighting' for proper space within which to provide therapy interventions. For the art therapist the group room needed to be a dedicated therapy space, and to others a multi-purpose room which sometimes had an art therapy group in it. The difficulties over space could be illustrated by the stationery cupboard which was inside the group room. Sometimes someone would 'pop in' in the middle of a session and say they were just going to get some envelopes, did I mind? I minded a great deal but found it hard to assert my role and introduce conflict into the relationship. We routinely ascribe difficulties like this to envy, part of what we evoke, a fantasy of a special relationship, intimate and time-limited, and this jerks the unconscious in others into retaliatory acts of sabotage such as intrusions or scheduling of appointments in the middle of the therapy group. We often understand such intrusions as unconscious attacks on the work resulting from whatever dynamic processes are at play in the particular setting. I found it awkward to challenge this and thus protect the integrity of my group. I gradually got better at this and found ways of managing situations, otherwise I think the work would have collapsed within a few months. I made a sign for the door, which read 'Art Therapy Session in Progress: Please do not Disturb' and was generally left undisturbed. The continued pressure on rooms meant that the space was lost after a year.

Present day: art therapy established

It feels proper to leap forward several years at this point and say something about how things are today, and how the situation of acceptance, on both sides, may have come about.

For a couple of years after the group ended I offered individual sessions on the same afternoon as the group had been, in a dingy room with taramasalata-pink walls, couch roll dispenser and nasty health service stickers telling you to mind where you put your syringe. A colleague then began offering sessions on a different afternoon, and it was good to share experiences.

In the wider circle of service management, developments were taking place with the psychology service, and the friendly terms we had been on developed into a new format, the Psychological Therapies Forum (PTF). This is ongoing today and is a venue for discussing referrals to psychology or for psychological treatments to ascertain an appropriate treatment intervention.

We also attend multi-disciplinary team referral and assessment meetings again as part of the PTF.

Perhaps the most important concrete change has been establishing the ownership, or perhaps identity, of the room we offer therapy in. An unmissable opportunity arose last summer when a major reorganisation of rooms and services was underway in the building. We heard that the room was to be for art therapy's sole use. While the building was in upheaval, we removed the couch roll holder, chucked out the filing cabinets, painted the walls, put up pictures and put down rugs. We bought plants for the window sills and purloined matching armchairs. We were pleased with the result and have watched carefully over the intervening months to see if this has had any effect. Interestingly, and with no prompting from us, the room has begun to be referred to as the art therapy room. It has taken some years to become established, during which it has been important to make links with other likeminded disciplines to gain a sense of belonging to a team and also to establish a secure base in the concrete nature of a dedicated art therapy room.

Summary

The art therapy rooms and working spaces that we have looked at in this chapter vary enormously but all of them provide a 'set apart' space or a 'creative arena' for interactions to take place with materials and therapist:

It seemed so important that the room was a safe container for the work that took place within it. The patients came, making their own inner journeys and deciding what they wanted to do with their work. They could take it away, more often they put it away, or hid it somewhere, knowing it could be found, sometimes just leaving it – but knowing that it was safe, until they came back, maybe the next session, or it could be a year or two later that someone would come and view their object or picture and then perhaps take it away. It has meant that over the years many images have gathered within the room, and for some that might appear a little chaotic. Yet I have found the room to be a very special place to work.

(Letter to the authors from Claire Skailes (1990)
Coney Hill Hospital, Gloucester)

Other long-established departments such as in Gogarburn Hospital once 'bulged with the accretions of almost 20 years of creative work'. They used to offer a protected space for long-term clients: 'One man has requisitioned a corner of the main room, where he keeps his collection of fossils, books and other personal objects in preference to keeping them in his ward' *(letter*

to the authors from Simon Willoughby Booth (1990), Gogarburn Hospital, Edinburgh).

In contrast, many part-time art therapists and those working peripatetically, as we have seen, adapt to an extraordinary variety of spaces offered to them which do not have the same sense of permanence. Within the space of the art therapy room, art materials offer the opportunity for the client to seek out further intimate private space. In the process of painting, it is not uncommon for a client to work silently on her own, away from the public gaze of the other members of the group and/or the therapist and re-emerge when she feels she has finished. This is a qualitatively different experience from sitting in silence, as making images sets up a deep internal dialogue, the product of which has now been externalised and made public in the form of an image or object. It is like putting one's intimate thoughts or even dreams on paper and it is too risky to allow those to be seen during the process.

The art therapist respects this fact and the importance of the privacy and space that she allows for the client for this dialogue to emerge. One boy persistently sat with his back to the therapist in the corner of the room and for weeks did not want anyone to see what he was doing. The therapist sat at the other corner in the usual place, and soon realising that she was not going to intrude on his space he began to turn around, check if the therapist was still there, and return to his work. As time went on in this way, he began to let the therapist see what he had done, began to turn towards the therapist while he was working, but hide it quickly if he felt an intrusion imminent. He developed into a child that was more able to share his space and thoughts and even became spontaneous about his work in the interaction with the therapist. Intrusion by the therapist would have interfered with his developing ability to trust and gain some understanding that what he did was acceptable. It can now be appreciated that the consistency of the therapist, as well as the room and the space in which this happens, is of paramount importance.

Display of art work

Given that the consistency of the space in the art therapy room enables the feeling of safe keeping of the objects made, some consideration should be given to where the art work is kept and whether it should be displayed, or even open to view by other clients using the room. We have had descriptions of the way the spaces can accommodate different ways of working with these issues and can see that images hung on the wall affect the therapeutic process in terms of how the images are related to by therapist and client. Ideally, there should be as few images on the wall as possible, particularly the most recent work of clients still in therapy. When the room is being used as a studio where ongoing work remains hanging, it is often advisable to cover art works up or

turn them to the wall. For example, several groups might be meeting in a room where images are placed from other ongoing work and the group dynamics can be strongly affected by the powerful imagery that surrounds it. Any working environment is visually affected, but where the images are very strong, this is more extreme.

In schools or educational establishments, putting pictures on the wall is taken more for granted, but it is helpful if the art therapy room is an exception. Display of art work invites comment, comparison and judgement which is not part of the images made in art therapy. If a child asks to hang her picture on the wall, this can be seen as some indication of what is happening in the therapy and her relationship to the therapist and the space in which they meet. As she is given the sense that she has control over what she does and chooses to do in the room, then asking for the picture to go on the wall is part of the material to be worked with. Similarly, when wet paintings are placed to dry or clay models put by to harden, this sets up difficulties for other clients. Touching or commenting on the work should be kept to a minimum, but this is difficult if it is included in the therapeutic space which children and adults have to share and often serves as a crude reminder of that fact. These are all considerations to be thought about when setting up the room, its ongoing use and function of the space. This will be considered in more depth in the chapter concerning the image (Chapter 6) but, firstly, we shall turn to examine the reasons for this set-apart space and consistency of experience and why they are important for the therapeutic process of art therapy.

References

Arguile, R. (1990) 'I show you': children in art therapy, in C. Case and T. Dalley (eds) *Working with Children in Art Therapy*. London: Tavistock/Routledge.

Broadbent, S. (1989) Certain considerations using art therapy with blind adults, unpublished thesis, Hertfordshire College of Art and Design.

Circlot, J. (1971) *A Dictionary of Symbols*. London: Routledge & Kegan Paul.

Killick, K. (1987) Art therapy and schizophrenia: a new approach, unpublished thesis, University of Hertfordshire.

Killick, K. (2000) The art room as container in analytical art psychotherapy with patients in psychotic states, in A. Gilroy and G. McNeilly (eds) *The Changing Shape of Art Therapy*. London: Jessica Kingsley.

Killick, K. and Schaverien, J. (1997) *Art, Psychotherapy and Psychosis*. London: Routledge.

Lillitos, A. (1990) Control, uncontrol, order and chaos: working with children with intestinal motility problems, in C. Case and T. Dalley (eds) *Working with Children in Art Therapy*. London: Tavistock/Routledge.

Schaverien, J. (1989) The picture within the frame, in A. Gilroy and T. Dalley (eds) *Pictures at an Exhibition*. London: Tavistock/Routledge.

Schaverien, J. (1992) *The Revealing Image: Analytical Art Psychotherapy in Theory and Practice*. London: Routledge.

Skailes, C. (1990) The revolving door: the day hospital and beyond, in M. Leibmann (ed.) *Art Therapy in Practice*. London: Jessica Kingsley.

Tipple, R. (2003) The interpretation of children's art work in a paediatric setting, *Inscape*, 8(2): 48–59.

Vasarhelyi, V. (1990) The cat, the fish, the man and the bird: or how to be a nothing: illness behaviour in children, the case study of a 10 year old girl, in C. Case and T. Dalley (eds) *Working with Children in Art Therapy*. London: Tavistock/Routledge.

Wood, C. (2000) The significance of studios, *Inscape*, 5(2): 40–53.

Videos

Art Therapy (1985) Tavistock Publications (shows Sue Hammans working with clients in an art therapy department, Leytonstone House).

Art Therapy – Children with Special Needs (1987) Tavistock Publications (shows Roger Arguile working with children in the art therapy department at St Mary's School).

The therapy in art therapy

Having considered the 'space' of the art therapy room, this chapter will look at the process of therapy that takes place within that space. The essence of art therapy lies in creating something. This process of creativity and its product, the art form, are of central importance within the therapeutic encounter. The art process facilitates the emergence of inner experience and feelings expressed both consciously and unconsciously through the art materials. The art product may be in a chaotic raw form, but is the starting point for reflection and understanding between therapist and client.

Making marks and forms of art are activities common to all human beings. Since ancient times, humans have drawn, carved and scratched as forms of individual expression and communication. The impact of these primitive marks is important in the understanding of how art is used as a means of communication. Roger Cardinal refers to 'that rudimentary yet expressive mark incised by a human hand upon a surface' as the 'primitive scratch'. 'To investigate some of the ways in which minimal traces seemingly mute, indigent, even paltry – can achieve eloquence may be good groundwork for the construction of a model of the Primitive and, indeed, of our reception of human signals at large' (1989: 113). By comparing graffiti, prehistoric Camunian rock incisions as 'picture making at its most basic' and also drawings by Miro and Michaux he argues that it is the first-hand experience of seeing and absorbing pictures which creates their impact and meaning – the mark has its own significance as well as that of the time, place and original reason for its creation.

Mark-making and creating art objects provides the basis for using images in therapy. The significance of the mark and the place in which it is made, the therapy room, and how it is received, the therapist response, sets up the essential parameters of the art therapeutic process. The various components of this will be considered here in some detail. One of the most important aspects of images is that they hold meaning at different levels, reflecting the culture within which they were made and in which they are viewed. In a therapy relationship, the artist/client brings her own meaning to the image from her own 'culture' into the 'culture' of the therapy room where it is

viewed with subsequent impact and resonance in both client and therapist. The importance of remaining open to these many levels of communication in a picture, and being aware of them, is central to the practice of art therapy:

> Pictures, even when apparently finished, evoke movement and relation-ship but cannot be read. Maps can be read; on maps the figures and marks do not necessarily signify something outside themselves. Even a two-dimensional image is three-dimensional in the sense that it is full of multiple potential meanings which reverberate and echo against one another. No picture can be fully explained in words; if it could there would be no need to make it.
>
> (Schaverien 1989: 153)

Art work produced in therapy embodies subtleties, ambiguities and multi-dimensions of expression which can be hard to articulate verbally. To some extent this can be explained by the origins and complexity of creativity and what happens to the artist/client when she begins to paint and draw. Tchaikovsky wrote in a letter from Florence in 1878:

> Generally the germ of a future composition suddenly comes and unexpectedly. If the soil is ready – that is to say, if the disposition of work is there – it takes root with extraordinary force and rapidly shoots up through the earth, puts forth branches, leaves and finally, blossoms. I cannot define the creative process in any other way than by this simile. The great difficulty is that the germ must appear at a favourable moment, the rest follows of itself.
>
> (Newmarch 1906: 274)

Here we can understand creativity in its unpredictability, potential chaos, novelty, newness and indeed experimentation: 'Creativity is the ability to bring something new into existence for that person' (Storr 1972: 11). Another way of looking at this stresses the influence of the environment in which this inner process may occur: 'My definition, then, of the creative process is that it is the emergence in action of the individual on the one hand, and the materials, events, people or circumstances of his life on the other' (Rogers 1970: 139).

The creative experience will be discussed in more detail in a later chapter, but one aspect of creating something or the process of image-making involves tapping some inner reality of the person and therefore some expres-sion of unconscious processes. For our purposes in understanding how art and creative processes can be used therapeutically, it is useful to draw com-parisons between art processes and dreams, particularly in relation to the expression of the unconscious (Schaverien 2005). There is an obvious differ-ence which lies in the fact that art activity is a conscious process which gives

concrete form to feelings, which are often unconscious. The dream equivalent of this would be an attempt to make sense of a vivid dream on waking, but there is no tangible form, such as painting, that can act as a record of this experience and thereby facilitate the process. Describing a dream is a different experience to that of dreaming it – similarly, describing an image is a different experience from making it, but reflecting on a completed image can evoke the same feelings and associations even though these are formulated in a more rational way when they are put into words. When the events of the dream or image are verbally articulated, some outer sense is made of inner, often uncontrolled sensations and experience: 'The artist himself is cast in the role of the spectator faced with the chaos of newly created art' (Ehrenzweig 1967: 80).

The process of making sense of an image is helped by the fact that the concrete form outlasts the actual experience of making it. A picture does not evaporate like a dream, even though the effect of the dream might stay with the dreamer for quite a long time during the waking hours. One often has the experience of being wakened in the middle of a dream and just wanting to go back to sleep to continue it. Painting an image can be interrupted in the same way but it can be returned to, although some state might have been altered by the interference. Indeed it can happen that images have a particular association for the artist/client while they are being made, but this can change over time and the image can take on a new significance with increased insight and understanding. Images last over time in a different way to the momentary experience of dreaming. It is for this reason that 'it may be that the analysis of art continues where the analysis of the dream left off' (Ehrenzweig 1967: 4).

The presence of the art form creates the complexity and essentially the uniqueness of art therapy. The intensity of this relationship is fundamental to the art therapy process. Art therapists who use a psychoanalytic approach encourage the process of pictorial expression of inner experience, and in this sense art is recognised as a process of spontaneous imagery released from the unconscious. This is similar to the processes of free association developed by Freud as the fundamental rule of psychoanalysis. In free association the client says anything and everything that comes to mind, however trivial or unpleasant. This gives access to unconscious chains of associations, to the unconscious determinants of communication. In interpreting a dream, although symbolism may be important, access to its meanings is through the client's free associations. A dream involves the gathering together or 'pooling' of unconscious events in the client's mind and the associations to it are externalised in words. Painting provides another way to externalise these feelings and events but as parts of dreams might be committed to memory, the concrete nature of images means that they take on a life of their own. Paintings or images from clients in art therapy can be understood and approached in the same way in terms of the client's associations – images that are produced

may be one-off sketches, doodles or accidental marks and can be destroyed or significantly changed. They might be accomplished completed paintings that have been worked on over a number of weeks. It is not always a finished considered piece of work that the art therapist and the client will be reflecting on at the end of a session.

This clarifies the position that making art in a therapy session has a different purpose from that of, for example, painting for public exhibition where the painting is likely to be viewed aesthetically. Both the art product and process are important. The art process in a therapeutic situation will be affected by many considerations which include the setting, the client and most prominently the therapist. Schaverien (1989: 152) emphasises this point in terms of showing the finished art product:

> The artist who has finished her picture has now to consider where to show it. She may choose not to show it, keeping it private. It exists then as her private framed experience which perhaps feels too precious or powerful to risk showing. It may be a dialogue with herself, or something of which she is ashamed, or maybe she anticipates others' rejection of it. Quite possibly her motivations are unclear; it just feels wrong to show it. The client in therapy may well go through similar feelings in deciding whether to show her picture to the therapist. This transition from private to public is a common feature of all art. It is a step from the process of image-making to acceptance of the picture as a product.

The process of image-making and how the final product is received within the bounds of a therapeutic situation forms the basis of the art therapeutic process. It is here that the orientation of the therapist is important in terms of how she receives and works with the images produced. In Chapter 2 we discussed some of the many different approaches that inform the practice of art therapists. The art therapist provides a setting in which healing can occur and connections with previously repressed, split off and lost aspects of the self can be re-established. Events, associations and feelings from the past can emerge through the imagery while the art therapist as artist allows an understanding of this process. The ability of the therapist to provide a setting where this might occur depends on her capacity to understand this. This capacity, in turn, depends on her personal knowledge of how it feels to create images in the same way as her patients, with consideration of boundaries and the understanding of transference relationships.

Boundaries

Before entering into treatment, a contract is made between therapist and client which helps to establish the therapeutic alliance. Social interaction is maintained by codes of behaviour that are learnt or acquired and are based

on patterns of expectations which are somehow informal and usually unverbalised. The therapeutic encounter, however, is different in that some rules are agreed to in a contract worked out between art therapist and patient. This involves the time of the session, where it will take place and how long over time this arrangement will continue. If payment of fees is involved, this makes an additional commitment in that the client agrees to pay for the sessions whether she comes or not.

These conditions establish the frame inside which therapeutic work begins. The frame acts as a container. If this feels unsafe and is experienced by the client as moveable or negotiable, then she will be affected by this rather than using the boundaries of the session as a framework on which she can depend and trust, and begin to express inner difficulties and vulnerabilities. The session becomes a safe space in which feelings and thoughts are allowed to emerge.

The art therapist has the outer frame of the session and the inner frame of the art work with which to work:

> The therapeutic frame includes the time, space, place and the limits of therapy. Part of this frame, responsible for it but also a part of the picture within, is the therapist. In any psychotherapeutic encounter, the setting and the person of the therapist are the main constants. In art therapy, in addition to these, and central within the frame, are the pictures made by the client. At times when boundaries of the outer frame are unclear, such as very often in a psychiatric hospital, the picture, the inner frame of therapy, remains the stable factor.
>
> (Schaverien 1989: 148)

As we described in Chapter 2, some art therapists work in situations where it is not possible to have a regular time and space to the sessions – in open groups in large institutions, for example. They will be working within different parameters than the art therapist who can maintain boundaries in terms of regular time and therapeutic space, and may be working with a transference model. Both, however, will be looking at the images produced as a focus of the session.

Time boundaries

The maintenance of time boundaries means that the sessions start and finish on the agreed time which sets the frame around the psychic container. Both therapist and client will know when the session will start and finish and so part of the work might focus on how this time is used. For example, if the time is changed by either client or therapist, if the client is late or indeed arrives very early, this is worked with in the session itself. The therapist holds this in mind as a communication and makes use of it in terms of

understanding the material of the session as a whole. Although consciously there might be a very good 'reason' for lateness, the underlying reasons can be explored. Similarly, if the therapist has particular feelings about seeing a client, she may find herself unwittingly late or unreasonably early and well prepared. It is helpful if the feelings of the therapist towards the client – that is, the counter-transference – are thought about and understood. Why is this happening? Why does the client make her feel this way?

At the end of the session, there might be the temptation to finish early as 'nothing seems to be happening'. This may cut off material before it has been allowed to surface. The therapist sits and waits to stay with the feelings and the impact of the end of the session and separation that follows. This may be an area of difficulty for the client and if responded to in this way by the therapist's anxiety, denies the client understanding. Equally, if the session is allowed to overrun because something terribly important came up at the last minute, why is this accomodated one week and not the next? This makes the client feel unsafe and certainly unsure, and does not permit her to reflect on why she chose to bring up this important material just as the session was ending.

There are many examples of the way that patients use the time of the session which give important communication of both conscious and unconscious processes. The client who is constantly turning up for the last ten minutes, or who leaves early without being able to stay with the difficult feelings that have arisen, could be said to be resisting looking at these issues. The therapist reminds her of the boundaries of time to understand the impact of her behaviour that she is bringing to the therapeutic situation. 'Acting out' or breaking of therapeutic boundaries is one of the most overt ways in which the client expresses her difficulties. This is made obvious by the behaviour, although the underlying causes may be denied. The therapist uses these as important indicators of psychic processes.

Setting the scene or therapeutic space

Both place and time create the 'therapeutic space'. This is a term used in different ways according to the orientation of the therapist. Moreno used it to describe the 'stage' upon which psychodrama is enacted whereas others use it to describe intrapsychic space – that is, the realm within the personality in which there is room for manoeuvre and growth. Cox uses the term metaphorically to describe an invisible boundary to the 'space' within which the therapist and patient meet, and where the phenomena of transference and counter-transference are 'housed' (1978: 42). He goes on to say that the therapeutic space refers to that space within and between those who share in a formal psychotherapeutic alliance. In other words, it includes both the intrapsychic space of patient and therapist and the interpersonal space between them: 'It is the shared air they breathe'.

In concrete ways, the interpersonal space can be clarified. The room to

which the patient is introduced remains as constant as possible. Many different types of working space have already been described, and there are usually some general guidelines. For example, the art therapist might say that the materials are there for the patient to use as she wishes, that they must stay in the room and any images or objects that are made will also remain in the room until the therapy has finished. Usually art therapists offer the client the opportunity of a personal folder, or shelf for the safe storage of their art objects made in therapy, which emphasises safe-keeping. Usually, clients will be curious about who else uses the room, and this brings up strong feelings. Consideration must be given to how much the work of other patients using the space is in evidence. The patient may choose to destroy her own work. This can be understood as an important communication about her own self-esteem and how much she values herself and what she has made, feeling that perhaps she is 'rubbish'. The art activity may become extremely messy, with water, sand and paint spilling and running everywhere; this provides an opportunity for the therapist to enable the client to gain some understanding and experience of containment of these 'spilling out feelings'. As with the physical place of the therapy room, the way the materials are used can be helpful in understanding the mental processes and inner experience of the client (Sagar 1990). Uncontained mess and chaotic use of materials can be understood by art therapists as an expression of uncontained and messy feelings (O'Brien 2003). Other examples – such as a child choosing to use the whole bag of clay, defacement of the tables by an angry adolescent, drinking the paint water by a man with dementia, mixing all the materials together by a severely psychotic patient – these are times when it is helpful for the therapist to stay within the limits of what she considers appropriate or tolerable. Otherwise this activity will be experienced as being out of control and the anxiety will be intense and overwhelming. Setting limits enables the anxiety to be contained.

There are other considerations with regard to physical contact, such as how much touching is tolerated or the degree of physical violence. If these boundaries have not been clearly established, the therapist has to work from the position of trying to correct the behaviour rather than being able to use it as material in the session and interpret if appropriate. An example of this was shown through some therapeutic group work with children in a primary school. The therapist was clear about two conditions: no fighting and no swearing. This was the agreement made between therapist and children but frequently the children would be physically or verbally abusive to each other in their interaction. When this occurred, it was possible to explore the meaning of this behaviour and help the children understand their aggression. One day, when sweets were brought into the group, although they were also not allowed in school, this challenged the relationship between therapist and children and the boundaries of the group. It was helpful to think about the group in terms of the dynamics of the wider institution.

The therapy space provides a microcosm of society at large. The children had an experience of how the therapist, the school and the outside world fitted together. When these more 'concrete' things are established within the therapeutic space, it frees the path for the illusory quality of that space. Both therapist and client have a feeling about the therapeutic space based on the fantasy and experience of it. It is a concrete and existential fact for both therapist and client. In a paper entitled 'The role of illusion in the analytic space and process', Khan (1974) writes:

> Clinically the unique achievement of Freud is that he invented and established a therapeutic space and distance for the patient and analyst. In this space and distance the relating becomes feasible only through the capacity to sustain illusion and to work with it . . . It is my contention here that Freud created a space, time and process which potentialise that area of Illusion where symbolic discourse can actualise.
>
> (Khan 1974: 251)

The clinical experience of the therapeutic space has a much firmer reality than is conveyed by the word 'illusion'. Khan suggests that the relational process through which the illusion operates is the transference. The transference might be an illusion, but without genuineness, which endorses reality, a transference relationship may not develop. The setting in which therapy takes place is 'secure' in the sense that there are physical walls and a door which is closed which serve as reminders to both art therapist and client that therapeutic space has physical limits. The physicality of the walls, doors and windows provides the possibilities of going in or out through the physical boundaries of the space. In this sense the therapeutic space is an exact opposite of an illusion and the confinement to a space of a room intensifies rather than diminishes the feeling of safety. There is the symbolic illusion of therapeutic space and the mixture between symbolic and literal intensifies transference phenomena and therefore facilitates the therapeutic process.

Winnicott (1945: 133) describes this in terms of the feeding of an infant: 'I think of the process as if two lives came from opposite directions, liable to come near each other. If they overlap there is a moment of illusion – a bit of experience which the infant can take as either his hallucination or a thing belonging to external reality'. This early nurturing situation frequently parallels the experience of therapeutic space or potential space – that which happens between mother and baby – also therapist and client.

In art therapy there is also the space created by the image-making process – the inner frame within the outer physicality of the session. The materials that are used to make objects or images – the paper, clay and the objects used for the activity – also enhance the feeling of space. The activity of painting sets up a relationship between client and the paper, which can be exclusive of the

therapist, but the therapist, attentive to the process at all times, holds the safety of the scene like the mother ever attentive to her infant.

Wood (1984: 68) describes how painting in the presence of the therapist alters the intention and the dynamic balance. Dyad becomes triad, and this may be described as a triangulation around the potential space:

> Painting ceases to be part of the general flow of playing and becomes the focus of therapy. As the precipitate of the interaction between inner and outer worlds, the painting becomes a third world, unchanged by attitude, time or distortions of memory, yet different aspects of meaning and relating can be discovered on different occasions. As the centre of triplex structure, the painting can survive a degree of impact from denials and distortions, and hold together fragmented elements from the other worlds, while continuing to make a statement about the contents as a whole ... The presence of the therapist produces a complementary triangulation in the mirroring process. The child is caught in response to self or to experience as reflected in the painting, and in response to the therapist's receptivity, whether or not interpretation is made.

The therapeutic process

The art therapist maintains the safe space for the client and the 'therapeutic process' becomes established. This refers to the sequence of integrating energies released in a client as a result of her interaction with the therapist (Cox 1978). It is a process in which the client is enabled to do for herself what she cannot do on her own. The therapist does not do it for her, but she cannot do it without the therapist. The task of the art therapist is to facilitate a re-engagement with the past. This facilitating process implies that the art therapist is receptive so that the client feels she can disclose anything. The art therapist tolerates these disclosures and is prepared for them to be understood in terms of the present – the here and now of the situation – and in terms of the client's past, particularly in terms of the client's early experiences as an infant. As the focus of the session is narrowed onto the object of the image and onto the person of the therapist, early infantile experiences will be experienced in the exploration of original relationships. This is how the transference relationship becomes established.

Transference

Transference occurs when the patient transfers strong, infantile feelings that originate from childhood experiences or early relationships onto the therapist. Freud referred to transference as something that happens in the therapeutic exchange – a reliving and repossessing of stages of development that had been experienced at earlier times in psychosexual development.

In his 'Fragment of an Analysis of a Case of Hysteria', Freud (1905: 116) defines the transference situation in the following way:

> What are transferences? They are new editions or facsimiles of the tendencies and phantasies which are aroused and made conscious during the progress of the analysis, but they have this peculiarity which is characteristic for their species, that they replace some earlier person by the person of the physician. To put it another way: a whole series of psychological experiences are revived, not as belonging to the past, but applying to the physician at the present moment.

So the phenomenon of transference occurs in the present situation between therapist and patient but involves aspects of the patient's life in terms of the relationships that occurred in the past. The therapeutic use of transference is to interpret these earlier stages or experiences, to integrate them and to understand them so that they become part of the conscious ego-controlled content of psychic life:

> The characteristic of psychoanalytic technique is this use of transference and the transference neurosis. Transference is not just a matter of rapport or of relationships. It concerns the way in which a highly subjective phenomenon repeatedly turns up in an analysis. Psychoanalysis very much consists in the arranging of conditions for the development of these phenomena at the right moment. The interpretation relates the specific phenomenon to a bit of the patient's psychic reality and this in some cases means at the same time relating it to a bit of the patient's past living.
>
> (Winnicott 1958: 158)

Melanie Klein's ideas on transference differed somewhat from those of Freud. Particularly in the case of Dora, Freud came to understand that transference was linked to early traumas in the client's history and how the trauma is re-lived, re-experienced, re-enacted as real life in the transference to the therapist. Klein's emphasis is not, as in Freud's work, on the reconstruction of a past relationship which is transferred onto the therapist, but rather on the development within the setting of the relationship which displays all the mechanisms which characterise the client's way of dealing with life in the world outside.

One important reason for this revision of transference is that Klein was working with young children, when it is assumed the traumatising events are actually taking place and thus the re-enactments of the children were from their immediate present. Their play was a series of enactments of all kinds of happenings and relationships. The vigour of this re-enactment made Klein convinced that children were enacting their fantasy life and this was the

children's own way of relating their own worst fears and anxieties. The relationships enacted in the sessions were the expressions of the children's efforts to encompass the traumatic way they experienced their daily lives.

In the practice of Kleinian analysis, the transference is therefore understood as an expression of unconscious fantasy, in the here and now of the session. The transference is moulded upon the infantile mechanisms with which the client managed their early experiences: 'The patient is bound to deal with his conflicts and anxieties re-experienced towards the analyst by the same methods he used in the past. That is to say, he turns away from the analyst as he attempted to turn away from his primal objects' (Klein 1952: 55).

Klein (1955: 16) emphasised that one of the most important points in her play technique was the analysis of the transference:

> As we know in the transference on the analyst the patient repeats earlier emotions and conflicts. It is my experience that we are able to help the patient fundamentally by taking his phantasies and anxieties back in our transference interpretation to where they originated – namely in infancy and in relation to first objects. For by re-experiencing early emotions and phantasies and understanding them in relation to his primal objects, he can, as it were, revise these relations at their root and thus effectively diminish them.

In her paper 'The origins of transference' (1952: 49), Klein describes clearly the manifestations of transference:

> It is characteristic of psychoanalytic procedure that, as it begins to open up roads into the patient's unconscious, his past (in its conscious and unconscious aspects) is gradually being revived. Thereby his urge to transfer his early experiences, object relations and emotions is reinforced and they come to focus on the psychoanalyst; this implies that the patient deals with the conflicts and anxieties which have been reactivated, by making use of the same mechanisms and defences in earlier situations.

She states that it follows that the deeper we are able to penetrate into the unconscious and the further back we can take the analysis, the greater will be our understanding of the transference. She continues (p. 50):

> The analysis of very young children has taught me that there is no instinctual urge, no anxiety situation, no mental process which does not involve objects, external or internal; in other words, object relations are at the centre of emotional life. Furthermore, love and hatred, phantasies, anxieties and defences are also operative from the beginning and are *ab initio* indivisibly linked with object relations. This insight showed me many phenomena in a new light.

As art therapists, this informs our understanding of how transference operates within art therapy and the effect of the introduction of the art object within the relationship (Weir 1987). The process of making the image will set up three lines of communication: between therapist and client, client and painting, therapist and painting. The image often becomes the focus through which the transference relationship is explored. It holds the significance of feeling in that it acts as a receptacle for the fantasies, anxieties and other unconscious processes that are now emerging into consciousness for the client in therapy – it contains aspects of the transference relationship but a separate response also takes place in terms of the painting in its own right. Schaverien (1987: 80) makes the distinction between two sorts of image:

> There are times when the pictures merely exhibit the transference. These pictures enhance and widen the scope of psychotherapy but are distinct from the pictures which embody feeling. When the picture embodies feeling, and movement starts to occur in relation to the image created, it is then that change is possible through the medium of the picture itself. This is similar to the transference relationship to the therapist but here the focus is the picture.

Counter-transference

We are concerned with the presence of an image within the therapy relationship – for both patient and therapist. In art therapy, both transference and counter-transference develop through the response to the image itself. Counter-transference is the therapist's response and the feelings that are aroused by the interaction with the client and the image in a therapeutic situation. The meaning and importance of this has changed over the years. Discarding the old idea of the need of the therapist to be a blank screen, which was perceived to be a defence (Ferenczi 1919; Fenichel 1941), there is now increased emphasis on the emotional interaction between therapist and client (Heimann 1960; Joseph 1989).

'The aim of the analyst's own analysis is not to turn him into a mechanical brain which can produce interpretations on the basis of a purely intellectual procedure, but to enable him to sustain his feelings as opposed to discharging them like the patient' (Heimann 1960: 82). Heimann's main thesis was that by 'comparing the feelings roused in himself with the content of the patient's associations and the qualities of his mood and behaviour, the analyst has the means for checking whether he has understood or failed to understand his patient' (Heimann 1960: 83). The therapist's feelings or counter-transference can be understood as a useful indicator of the patient's emotional experience rather than the intrusion of the therapist's own neurosis and neurotic transference into the psychoanalytic work.

Bion (1959) later formulated clearer pictures of the analyst as a container

for the patient's intolerable experiences. Through the analytic process of putting these experiences into thought and words, they are processed, modified and contained. Bion developed the idea of the analyst as a maternal container and so it became possible to formulate in intrapsychic terms the interpersonal situation of the analytic setting. By being able to discern something of what is wrong, the important ego function involved in mothering, she can act in such a way as to relieve something of the distress. The mother's capacity of understanding the distress is communicated by her response to her infant. The child then takes back her experience of distress but in a form that has been modified by the mother's function of understanding the distress expressed and responding appropriately. The infant has the experience of being understood in the interaction between these two intrapsychic worlds. Meaning has been generated. Through the mother's actions the child can now understand what a certain sensation means; for example, hunger. Accumulating these experiences begins to amount to an acquisition of an internal object that has the capacity to understand the child's experiences. This, as Segal (1975: 135) puts it, 'is a beginning of mental stability' and she described this mother–child interaction as a model for the therapeutic endeavour.

This 'model' of maternal containment gives a clear account of how the counter-transference is an important instrument for understanding the therapeutic process. Problems may arise if the therapist's feelings result in evasion of her own feelings which may hinder the process and progress of therapy. However, the mind of the therapist, with both fallibilities and capacities, contributes to the 'total situation' (Joseph 1989). Clients are sometimes very sensitive to the therapist's feelings. The client's perception and experience of the capacity of the therapist to modify anxiety is important. She may project her feelings into particular aspects of the therapist – into the therapist's wish to be mother, the wish to be all-knowing or to deny unpleasant knowledge, or into her defences against it. Above all she projects into the therapist's internal objects (Brenman Pick 1985: 161).

The importance of projective identification in this process is clearly described by Christopher Bollas (1987: 5):

It is my view, and one shared by many British psychoanalysts, that the analysand compels the analyst to experience the patient's inner object world. He often does this by means of projective identification: by inspiring in the analyst a feeling, thought or self state that hitherto has only remained within himself. In doing this the analysand might also represent an internal object which is fundamentally based on a part of the mother's or father's personality, in such a way that in addition to being compelled to experience one of the analysand's inner objects, the analyst might also be an object of one feature of the mother's mothering, and in such a moment the analyst would briefly occupy a position previously held by the analysand.

The concept of projective identification is complex and creates much debate within psychoanalytic circles and also within the understanding of counter-transference in art therapy. For example, David Mann (1989) contends that the counter-transference response to the image is in fact a process of projective identification. These ideas have been developed further in the literature (Gosso 2004).

Interpretation

Interpretation involves bringing unconscious processes (that is, what is in the client's mind at a preconscious level), into consciousness. By putting this into words, understanding of something previously not understood or thought about can take place. When latent feelings become manifest through an interpretation, meaning is generated. The thought or the word comes from either the artist/client in an attempt to make sense of the significance of her art work, or from the therapist who might see some important aspects emerging either in the picture or within the relationship. This can be either clarification of the transference process between therapist and client or some feelings, on a symbolic level, emerging through the image itself. One of the advantages of using images in therapy is that they are concrete and open to visual interpretation more obviously than verbal process. The disadvantage is that images made in therapy are more vulnerable to misinterpretation. Direct interpretation might prevent or deny the client the satisfaction of discovering and finding out for herself. Images are statements that have different layers of meaning, which gradually unfold over time. As the image is unique to the client, it is only she who can ultimately come to understand its full significance. Premature interpretation can easily interfere with this delicate process. The art therapist waits, receptive to the communication of the client through the imagery until the client is ready to begin to understand and let the meaning unfold.

The therapist's role is to remain open to the imagery and all its potential meaning for the client and to contain the anxiety and feelings that are generated in the making of the image and in the efforts to understand it. A clear meaning may not emerge – much of the imagery produced in art therapy is a raw expression of unconscious material which only surfaces to consciousness after many weeks, when links can be made and understood. The importance of being patient, waiting and thinking, and staying with the uncertainty or 'not knowing' what an image 'means' or 'says' is central to the art therapeutic process. Making things concrete can be harmful and pre-empt real understanding. How often one hears in a gallery: Well it's very nice – but what is it? The viewer is moved by the image but cannot stay with the uncertainty or lack of clarity because there is a need to *understand* it. The strength of feeling or emotional impact of the image can be modified or even relieved if its content or form is identified or 'named' in a similar way to Bion's idea of generating 'meaning'.

The counter-transference response of the therapist to the image is therefore very important. The following clinical vignette of work with a 10-year-old boy serves to illustrate many of the points made.

Peter was referred to art therapy as his behaviour was becoming increasingly unmanageable at school. This had occurred since his twin brother had been in therapy following a depressive episode. It was felt that art therapy would provide Peter with a space for himself to work out some of his own difficulties away from his brother and the home environment. He had attended weekly for 15 months. The work was in the termination phase. This session took place after the summer break, in the knowledge that an end date for the sessions had been agreed. At this stage, Peter usually chose to work in clay which he modelled one week and left to dry ready for painting the next week. This was understood by the therapist as a way of holding onto thinking between sessions, making links from one week to the next. Peter had carefully made two 'heads' which he had put by the window to dry, and when he came the following week he rushed in and went straight towards them to see if they were still there. He picked them up and a piece broke off in his hands. 'Oh dear,' he said, 'need to get some glue.' He spent some time with the glue, sticking on the mouth and hat. He was distracted by the rim of the glue pot and became absorbed picking off the glue around the edge of the pot. He suddenly said, 'Why am I doing this?' and put it down. He began to paint each head very carefully, but having stuck on the head realised that this was stupid as he wanted to paint it and so took it off again. As the heads were carefully painted, the therapist was struck by the feeling that these were some kind of epitaph or heads of tombstones. As they were closely fixed together on the same base they could have represented the therapist and him, he and his brother, stuck together in their unconscious relationship or, alternatively, two aspects of himself which he was struggling to understand. The heads seemed to represent Peter's conflict about separation and fears of falling apart.

The therapist remained silent with her thoughts and as he completed the process, he stuck on the heads and painted the base black. His fingers were covered in glue. As he propped the heads up with a pencil against the table, he became anxious about his sticky fingers and went to the basin to wash off the glue. He spent a long time there, going 'Yuk, what a mess,' etc., leaving the therapist 'abandoned' with the full impact of the image.

When he had finished, he spoke about the heads as a kind of underground people – 'Bill tells Bob what to do all the time – he is a sort of servant for Bill – rather peculiar really.'

Th: I was thinking about the sunglasses? It looks as though they can't see
 or speak.

Peter: Well that's their sort of uniform. Underground – sort of criminals
 I think – don't really know what they feel or think.

Th: Are they like anyone you know?

Peter: I don't think so – Bill tells Bob what to do – neither of them is
 like me.

He looked embarrassed, got up, wrote the names on a piece of paper, cut them out and stuck them onto the plinth with Blu-Tack. It was time to go and so he put them carefully back by the window. The next few sessions he worked on a house for Bill and Bob which had black windows – the house of a secret society which you could not see into or out of.

The completed image (see Plate 5) suggests conflicts about fusion and separation, aspects of double identity and twinship, feelings which were kept underground which Peter cannot see or speak about. But, importantly, while the image was being made the therapist felt that Peter was struggling with these feelings about endings, burial, going underground. As the sessions were ending, he now had to face the integration of himself and leaving the therapist. Unlike the experience of his mothering, he had been the only child in his relationship with the therapist and it was hard for him to leave. He had experienced a space, separate from his brother, and these were threads on which the therapist was able to comment at appropriate moments. The image contained many layers of meaning in working through the ending of his therapy.

The transference and counter-transference response to the image is complex in the art therapy process. Both therapist and client will feel a whole range of emotions and responses to the images produced, indicating the multiplicity of meanings that are being conveyed. Feelings, attitudes, even fantasies which occur to the therapist in the therapeutic relationship and through the image, are evoked. By accepting and acknowledging this, the client's relation to the unconscious as held in the imagery is deepened. Kuhns (1983: 92) puts forward some definitions of transference in terms of the art object by referring to ways in which the artist reacts to, makes use of, reinterprets and restructures aesthetically the tradition within which the work is carried out. From this he defines counter-transference as the relationship between the audience and the work, which involves the viewer's response to the peculiarities of the object in terms of their associations and interpretations. A deeper understanding of those objects becomes clear through the transference relationship between therapist and client. What is of interest to art therapists is Kuhns's idea of 'cultural' transference which he says occurs as objects become more fully integrated into the conscious awareness of individuals through psychoanalytic interpretations:

The process is one of 'mirroring', reverberating and reflecting back and forth through several layers of consciousness; the consciousness of the object, of the artist, who creates the presentation of the self through the object or in the object, and of the beholder, who responds to all the layers with an accumulation of conscious and unconscious associations which include deeply private nodal points in the unique experience to which there are correspondences, but not identities, in others.

(Kuhns 1983: 21)

Art therapy involves working towards some understanding of this, the process of communication between therapist, patient and image – the 'triangular relationship' (Case 2005). Following the ideas of Bion, Winnicott and the later psychoanalysts, the idea of mother–infant relationships moves us closer towards understanding the complexity of the process of interpretation or making unconscious processes conscious. For Winnicott, the mother–child relationship in which communication was relatively non-verbal changed the role of interpretation in psychoanalytic treatment. Language, in Winnicott's theory, was merely an extension of the child's capacity for communication and separateness, but is not in itself considered formative of her identity. He based his work on the sociability from the very beginning that predates language. The infant does not speak but survives because she communicates with a receptive object (Winnicott 1965a: 117).

There is a language of maternal care that is not made only of words. For Winnicott, verbal interpretations were a form of mothering. The therapeutic setting is a medium for personal growth, not exclusively the provision of a convincing translation of the unconscious. The therapist, like the mother, facilitates by providing opportunity for communication and its recognition. Just as a feed can be seen as an interpretation of the infant's cry by the mother, so the therapist's verbal interpretations can be like a feed for the client in language.

By extending this analogy, Winnicott (1965b: 59–60) also warns against the dangers of early interpretations:

It is very important except when the patient is regressed to earliest infancy that the analyst shall not know the answer except insofar as the patient gives the clues. Magical interpretations pre-empt the patient's separateness, he is robbed of a mind of his own. The mother does not give the infant a feed, the infant gives the mother the opportunity to feed him. The clues provided by the patient facilitate the analyst's capacity to interpret. It is not so much a question of giving the baby satisfaction as of letting the baby find and come to terms with the object.

Winnicott (1965c: 189) implies that language, in the form of an accurate interpretation for which the client is not ready, can reach her innermost being, evoke her most primitive defences and acquire an unexpected potency:

Here there is danger if the analyst interprets instead of waiting for the patient to creatively discover. If we wait we become objectively perceived in the patient's own time, but if we fail to behave in a way that is facilitating the patient's analytic process (which is equivalent to the infant's and child's maturational process) we suddenly become not-me for the patient and then we know too much, and we are dangerous because we are too nearly in communication with the central still and silent spot of the patient's ego-organisation.

In this context language can become potent and terrifying. The over-interpretive art therapist becomes a tyrannical mother and language is integral to her power. The unacceptable interpretation, like maternal impingement, cannot be made use of by the client as it is not taken in as a thought but resisted, ejected or split off. A good interpretation is something the client can entertain in her mind and hold onto.

This can be seen from the example given that an early interpretation of Peter's heads would have prevented him from working with their meaning for him over several weeks and coming to understand their significance for him. He experienced his mother as intrusive, which was worked through in the transference. Following her counter-transference response, the therapist waited, thinking about how, when and whether to verbalise her feelings and understanding of Bill and Bob which enabled the many meanings to emerge into consciousness for both the therapist and Peter. Timing of interpretations is most important. In his relationship with the therapist, Peter was able to work through aspects of his early infantile experience, sharing his twin with his mother who remained emotionally unavailable. This affected his self-esteem and the complex relationship with his brother. The image represented, symbolically, all these expressions of feeling in one object and contains the emotional significance in the product but also in the process of making it (such as sticking together his fingers with the glue – getting stuck down). The image can literally 'speak' for itself.

References

Bion, W. (1959) Attacks on linking, *International Journal of Psychoanalysis*, XL: 308–15; republished (1962) in *Second Thoughts*. London: Heinemann.

Bollas, C. (1987) *The Shadow of the Object: Psychoanalysis of the Unthought Known*. London: Free Association Books.

Brenman Pick, I. (1985) Working through in the counter transference, *International Journal of Psychoanalysis*, LXVI: 157–66.

Cardinal, R. (1989) The primitive scratch, in A. Gilroy and T. Dalley (eds) *Pictures at an Exhibition*. London: Tavistock/Routledge.

Case, C. (2005) *Imagining Animals: Art, Psychotherapy and Primitive States of Mind*. London: Routledge.

Cox, M. (1978) *Structuring the Therapeutic Process: Compromise with Chaos*. Oxford: Pergamon.

Ehrenzweig, A. (1967) *The Hidden Order of Art*. London: Paladin.

Fenichel, O. (1941) *Problems of Psychoanalytic Technique*. New York: Psychoanalytic Quarterly.

Ferenczi, S. (1919) Theory and technique of psychoanalysis, in *Further Contributions to Psycho-Analysis*. London: The Hogarth Press.

Freud, S. (1905) Fragment of an Analysis of a Case of Hysteria, in *Standard Edition, Vol. VII*. London: The Hogarth Press.

Gosso, S. (ed.) (2004) *Psychoanalysis and Art: Kleinian Perspectives*. London: Karnac.

Heimann, P. (1960) Counter transference, *International Journal of Psychoanalysis*, XXXI: 81–4.

Joseph, B. (1989) Transference: the total situation, in M. Feldman and E. Bott Spillius (eds) *Psychic Equilibrium and Psychic Change: Selected Papers of Betty Joseph*. London: Routledge.

Khan, M. (1974) The role of illusion in the analytic space and process, in *The Privacy of the Self*. London: The Hogarth Press.

Klein, M. (1952) The origins of transference, in *Works of Melanie Klein, Vol. III*, pp. 48–56. London: The Hogarth Press.

Klein, M. (1955) The psychoanalytic play technique, in M. Klein, R.E. Money-Kyrle and P. Heimann (eds) *New Directions in Psychoanalysis* (1977). London: Maresfield Reprints.

Kuhns, F. (1983) *Psychoanalytic Theory in Art*. New York: IUP.

Mann, D. (1989) The talisman or projective identification? *Inscape*, autumn.

Newmarch, R. (1906) *Life and Letters of Peter Illich Tchaikovsky*. London: John Lane.

O'Brien, F. (2003) Bella and the white water rapids, *Inscape*, 8(1): 29–41.

Rogers, C.R. (1970) Towards a theory of creativity, in P.E. Vernon (ed.) *Creativity*. Harmondsworth: Penguin.

Sagar, C. (1990) Working with cases of child sexual abuse, in C. Case and T. Dalley (eds) *Working with Children in Art Therapy*. London: Tavistock/Routledge.

Schaverien, J. (1987) The scapegoat and the talisman: transference in art therapy, in T. Dalley *et al.*, *Images of Art Therapy*. London: Tavistock.

Schaverien, J. (1989) The picture within the frame, in A. Gilroy and T. Dalley (eds) *Pictures at an Exhibition*. London: Tavistock/Routledge.

Schaverien, J. (2005) Art and active imagination: reflections on transference and the image, *International Journal of Art Therapy: Inscape*, 10(2): 39–52.

Segal, H. (1975) A psychoanalytic approach to the treatment of schizophrenia, in M.H. Lader (ed.) *Studies of Schizophrenia*. Ashford: Headley Bros.

Storr, A. (1972) *The Dynamics of Creation*. Harmondsworth: Penguin.

Weir, F. (1987) The role of symbolic expression in its relation to art therapy: a Kleinian approach, in T. Dalley *et al.*, *Images of Art Therapy*. London: Tavistock.

Winnicott, D.W. (1945) Primitive emotional development, *International Journal of Psychoanalysis*, XXVI: 137–43.

Winnicott, D.W. (1958) Transitional objects and transitional phenomena, in *Through Paediatrics to Psychoanalysis*. London: Tavistock.

Winnicott, D.W. (1965a) Child analysis in the latency period, in *The Maturational Processes and the Facilitating Environment*. London: The Hogarth Press.

Winnicott, D.W. (1965b) Ego integration in child development, in *The Maturational Processes and the Facilitating Environment*. London: The Hogarth Press.

Winnicott, D.W. (1965c) Communicating and not communicating, leading to a study of certain opposites, in *The Maturational Processes and the Facilitating Environment*. London: The Hogarth Press.

Wood, M. (1984) The child and art therapy: a psychodynamic viewpoint, in T. Dalley (ed.) *Art as Therapy*. London: Tavistock.

Theoretical developments and influences on current art therapy practice

Image and meaning are identical: and as the former takes shape, so the latter becomes clear. Actually the pattern needs no interpretation: it betrays its own meaning.

(Jung 1960: 204)

Contemporary theoretical approaches to art therapy in Britain

This chapter covers an introduction to the latest developments in art therapy theory since the publication of the first *Handbook of Art Therapy* in 1992. In this first part of the chapter we will be focussing on theoretical developments and different approaches to art therapy, giving references for further reading. In the second part, we consider significant advancements in understanding human development and research into neurobiology.

The most recent introductory texts on the theory and practice of art therapy, for example, Rubin (1998), Malchiodi (2002) and Edwards (2004), cover many of the new developments in thinking. The first two are from the USA and later in the chapter we will consider other literature from there. However, in this section we wanted to highlight some of the other recent writing in particular areas of clinical practice and adaptation of practice in new clinical settings.

In Chapter 1 we looked at the wide range of client groups and settings within which art therapists work. Working with different client groups may necessitate an adaptation in technique to take into account clinical need or the particular circumstances of the setting. An example of this would be the restriction on tools and equipment that might be imposed in a prison setting or an art therapist working with terminally ill patients who takes a portable collection of materials to a patient's bedside and may draw for the client who is too weak to do so for themselves (Gold in Schaverien 1994; Hardy 2001). In the Highlands and islands of Scotland, for example, a sparse population meant that an art therapist visited the Shetlands for the duration of a week per month, flying out from Aberdeen. Each patient then had to manage a gap

in treatment which naturally impacted on the work. In these situations, the art therapist has to be fairly adaptable in her practice.

Before the closure of large psychiatric hospitals which had established art studios as well as rooms for individual work, it used to be possible for some adult patients to have their own area of studio or table for their sole use (Killick and Schaverien 1997; Killick 2000). Killick (1993, 1995) developed a specific approach for psychotic patients using the materials and table on which the patient worked as a first kind of safe relationship; a precedent for that with the therapist. With the changes in the NHS and the hospital closures, art therapists are now based much more in the community. This will frequently impose limits on the type of materials that can be used and it can be difficult to keep the boundaries of the setting when working in a patient's home. There has also been a marked increase in the number of art therapists in educational settings. Art therapists used to work in special schools but have moved more into mainstream work and are now employed as part of a wider school counselling service (Gersch and Goncalves 2006).

New theoretical perspectives

Different approaches to art therapy take into account the dynamics of the interactions in therapy, that is, whether the art work takes a more central role or if there is more expectation towards verbalisation of experience and of the relationship. Some writers have arranged their thoughts diagrammatically which can be useful. Firstly, Edwards (1987) considers the dialogue between the image and patient which he sees as taking place 'somewhat independently' of the relationship to the therapist (see Figure 4.1). This three-way relationship in art therapy between art work, client and therapist has sometimes been considered as a triangular one (Wood 1984, 1990; Case 2000; Schaverien 2000; Skaife 2000).

In *The Three Voices in Art Therapy*, Dalley *et al.* (1993) describe, in detail, the process of a therapeutic relationship between an art therapist and adult patient in an outpatient setting. The third voice is the voice of the patient who gives his own account of the process and an insight into his own art-making.

Waller and Gilroy (1992) discuss art-making as a reflection of the transference. Schaverien (1987, 1992, 1995) has explored this in two different ways. Firstly, she has been interested in the role of the image as a scapegoat for unbearable feelings that the patient does not want to own. In thinking about this she used the triangular relationship (see Figure 4.2) but also posited several different relationships within the dynamic:

1 the real relationship with the therapist
2 the therapeutic alliance
3 the transference (to the therapist)
4 the scapegoat transference (to the picture)

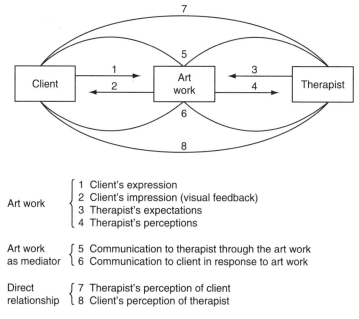

Art work		1 Client's expression
		2 Client's impression (visual feedback)
		3 Therapist's expectations
		4 Therapist's perceptions

| Art work as mediator | | 5 Communication to therapist through the art work |
| | | 6 Communication to client in response to art work |

| Direct relationship | | 7 Therapist's perception of client |
| | | 8 Client's perception of therapist |

Figure 4.1 The dialogue between image and patient; patient and therapist.

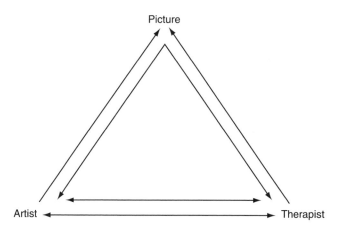

Figure 4.2 Three-way relating – the dynamic field.

Looking at the process of therapy, change or insight might happen through the transference to the therapist or the scapegoat transference to the image. Developing this pattern further, Schaverien (1994) proposed three different categories of art therapy. This was partly stimulated by the current debates over a possible name change for the profession from art therapy to art psychotherapy. Firstly, she suggested art therapy involves the real relationship, the therapeutic alliance and the scapegoat transference, but not transference phenomena between therapist and client. The client's relationship to the picture could remain largely unconscious. Secondly, in art psychotherapy she sees the picture as being more a 'backdrop' for the client–therapist relationship which is central. In this kind of art therapy the real relationship, the therapeutic alliance and the transference are worked with, but not the scapegoat transference. The client's relationship to the picture becomes conscious. Lastly, in analytical art psychotherapy she suggests that all relationships between client picture and therapist are equal and of the same significance. The client's relationship to the picture becomes conscious and assimilated both verbally and non-verbally. Skaife (1995) gives a critical response to this paper, suggesting that it is at the point of tension between the non-verbal and the verbal that the work of therapy can be done. This debate continues in the profession. Case (2000) explores the possible differences to adult work involved when working with disturbed children and how this might be construed in other shapes than a triangle.

Studio-based art therapy

Historically, studio art therapy was one of the main ways of working within large hospitals for those with learning disability or psychiatric illness. This approach was described in Chapters 1 and 2. For a perspective on this traditional approach, Adamson (1990) who worked at Netherne has had a large influence; Bach (1990), who also worked there, went on to write about work with ill children; Lyddiatt (1971) similarly pioneered this approach with many different client groups. Edwards (1999) has written about the work at Withymead in a therapeutic community where he worked with Champernowne. This history can be found in Stevens (1986), Waller (1991), Hogan (2001) and Edwards (1999). For more recent thoughts about a studio-based approach see Luzzatto (1997), Wood (2000) and Hyland Moon (2004). Recently, there has been a revival and a renewed interest in this approach, going back to the origins of art therapy (Henzell 2006).

Jungian approaches to art therapy

The ideas of Jung continue to be particularly important to British art therapists, most notably Edwards, Schaverien and Killick. He was very influential in the early days of art therapy in the work of Lyddiatt (1971), Baynes (1940),

Hillman (1975, 1978, 1979) and Naumberg (1950), a pioneer of art therapy from the USA. Jung drew, painted and made representations of his inner experiences at times of personal distress (Jung 1963; Edwards 1987, 1999). His patients were encouraged to make visual representations of dreams in order to enter into a relationship with the image. He called this technique 'active imagination' (Jung 1964, 1997).

In this way an image was seen to reveal its meaning. Jung believed that images had a collective origin and understood them to be made up of personal and collective (or archetypal) elements. Hillman (1975) discusses personification as allowing the imagination to inform us and bring a way of accessing emotions. Feelings can be personified and addressed as 'out there' in the picture allowing the client to gradually form a relationship with an aspect of the self.

Several writers have made further contributions to this approach. Schaverien (1992) developed the idea of the 'diagrammatic image' and the 'embodied image' and has written extensively about art and active imagination (2005). McNiff (1992) explored the 'dialogue with the image' and Lanham (1998) writes about archetypal images in art therapy and the need to keep the images alive with the activity of our imagination, using examples from his own painting.

The British independent tradition

Developments in psychoanalytic thinking continue to inform the practice of art therapy, how art therapists understand the art process, personality development and the evolving nature of the relationship with the client as well as different states of mind. For example, Winnicott's ideas (1971) about the development of a potential space between mother and child within which play can happen and the child can experience a sense of 'me and not me' as the basis for art and culture are now well established. Children start with a piece of blanket or teddy or other transitional phenomena; through their play they make use of it to explore what is internal and what is external reality, gradually establishing what is self and what is other, although the process began as 'me and not me'. Art therapists will be aiming to recreate or create for the first time this kind of space within which a child or adult in therapy can 'play'. Art mediums act as pliable matter through which object relations can be explored (O'Brien 2003; Case 2005a).

Art therapists working with children and those working with severely disturbed psychotic adult clients have been equally influenced by the work of Bion and Klein. Klein's concept of projective identification is an attempt to understand the complex non-verbal communication between mother and baby when a baby is in distress. Her work in this area of human experience gives a helpful theoretical framework to support the therapist. Art therapists work with both child and adult patients who project their emotional upset in

a similar way to an infant with their carer. Disturbed clients may project their distress with the hope that it may be understood and returned by the therapist in a more palatable form. Through non-verbal communication the therapist may take on some aspects of this communication and find themselves identified with it, which can be a very disturbing experience. The art therapist working with these processes provides containment before it reaches a stage of being expressed in the art work, and becomes understood. This enables the relationship between art therapist and client to be explored. Writers on psychosis and disturbed children have drawn extensively on these ideas (e.g. Killick 1995; Wood 1997; Thomas 1998; Reddick 1999; Case 2005a).

Bion's concept of 'containment' has been similarly useful with client groups where primitive states of mind predominate, and fear and terror are experienced. These patients may not have had a carer who could safely process their early infantile fears. Killick (1993, 1995, 2000) has explained how there is not a sufficient ego to 'do business' with the therapist and a presence of an object which can contain these fears has to be established in the client's mind before the therapist can be used. Both Killick and Greenwood (1995) and Greenwood (2000) discuss how the art room is crucial as a containing environment that can survive 'intrusive attacks' in mediating the experience of a containing object. The art room, the patient's table and art work act as a concrete container in the first instance until a relationship with the therapist can begin to be risked. Dalley (2000) and Case (2005a) discuss Bion's concept in terms of the containing image.

Developmental art therapy

Art therapists working in the field of learning impairment and autism have traditionally drawn from theory of psychological models of child development as well as being influenced by psychodynamic models (Rees 1998). Work with patients who have developmental delay, or a more global delay, has highlighted the importance of understanding normal child development in art (Matthews 1984, 1989). Many of these clients will be at a pre-symbolic stage and not yet able to use art materials for the making of images through which feelings can be expressed and insight gained. These clients may need to explore the qualities of their material so that the process of working and play, always an important element, becomes the central focus of interactions (Dubowski 1984, 1990).

Piaget and Inhelder (1969) named some of the characteristics of early child behaviour. Piaget described the sensori-motor stage from birth to 2 years during which the infant explores through their body, a trial and error process encompassing motor, emotional and cognitive growth. Object permanence is achieved along with differentiation of self and other. He describes a pre-operational stage (ages 2 to 7) during which the child is egocentric,

progressing towards the capacity to represent their subjective reality and towards symbolisation.

Lowenfeld and Brittain (1987) and Kellogg (1970) delineated stages of drawing which were used by the art therapists developing this approach. In brief, this starts with the exploration of materials, random scribbles, named early shapes, pre-schematic representations of person and cephalod, to the development of schemas; moving on to the representation of images from life and fantasy. Some clients draw at a developmental stage which is earlier than their chronological age, which may give information about their emotional development. This background is helpful for all art therapists.

Fox (1998) writes about work with adult autistic patients and the reclamation of symbolic function. Dubowski (1990) has been instrumental in the furtherance of a developmental model of art therapy with children with learning difficulties, as well as children with encapsulated autism. Dubowski highlights the importance of development in other modes (e.g. drawing), when language is not available.

'Emerging affective art therapy' (Evans and Rutten-Saris 1998) is a model of art therapy which uses concepts, developed by Stern, of exploring vitality affects and their categorical affects in reconstructing infant-based pre-verbal communication, and the developmental aspects of schemata in the art work. This approach has been informed by Stern (1995) whose ideas will be discussed later in the chapter, and Trevarthen and Neisser (1993). The aim is for pre-verbal communication to become a shared dialogue when spoken language and other shared symbols and signs are not available to the client.

Evans and Dubowski (2001) have constructed a similar model of intervention: 'interactive art therapy', based on observation of the therapist's and child's experience, using an assessment video as a base for future work. Dubowski discusses how the ability to communicate with pictures develops through a series of stages which parallel language development and lead to the development of a sense of self (1984, 1990). They aim to develop inter-subjectivity between child and therapist as they understand this to be a fundamental part of pre-symbolic functioning. They suggest that this model of art therapy provides 'a communication scaffolding' which can result in the further use of verbal language.

Aesthetic-based approaches to art therapy

It might seem rather strange to separate an approach which focuses on the qualities of the image. However, some writers have defined an approach in juxtaposition to those which use psychodynamic theory. Maclagan (1994: 51), for instance, suggests that the 'aesthetic and the psychological are pruned away for the sake of analytic respectability', missing the need for a psycho-analytic understanding of states of mind which together with the making of images can give a greater insight. These approaches not only return back to

the basics of early traditions in art therapy, but also illuminate developing new theory.

Simon (1992, 2002) writes about changes in style of painting, both within a session and through a treatment, and the implicit psychological significance. She elaborated a 'circle of styles' in the aesthetic sense which is also a cycle of psychological states. There is an acknowledged debt to Jung in her work through the adaptation of his model of the four basic psychological functions, that is, thinking, feeling, sensation, and intuition. She discusses a client's 'habitual attitude' to the world and the way it is expressed through style rather than content, though this is an artificial divide.

Robbins (2000) and Maclagan (2001) have paid attention to the dynamic relation between aesthetic features of images and psychological states. Robbins coined the term 'psychoaesthetics' in thinking about the aesthetic features of a client's art work and the qualities of the therapeutic relationship. Maclagan has been interested in exploring 'between the aesthetic and the psychological', feeling that there are irreplaceable clues given to a feel of a picture. He finds that these may be ambiguous and hard to put into words as they may be to do with pre-verbal or pre-symbolic feelings, and suggests that a 'scatter of readings' of a picture is needed in response to it. Both Maclagan (2005), and McNiff (2004) have been influenced by Hillman (1983) in seeing the image with a 'life of its own', arguing that they need to be allowed to illuminate consciousness. Maclagan usefully draws our attention to reinvest in looking at the 'material facture of a painting' and its corresponding psychological lining. McNiff (2000) has been helpful in positing the arts as primary modes of enquiry.

Other writers have combined a style that draws from aesthetics and psychodynamic ideas or analytical psychology. Schaverien, in her exploration of the 'triangular relationship', has identified 'the life in the picture' (1991) and the 'life of the picture' (1994). These are to do with the transference embodied in the art work and the counter-transference to the picture as an object. She has made a distinction between two types of picture: 'the diagrammatic' and the 'embodied', which she understands as reflecting the transference that is made to the art work during its creation (1987, 1992, 2000). In the former, the communication may be conscious and formed of a wish to tell the therapist about something, more like a map or aid. In the latter, the embodied image 'conveys a feeling state for which no other mode of expression can be substituted' (2000: 59). She suggests that in the embodied image an unconscious element of the psyche may be revealed and felt, so that it is transforming, playing a significant part in the healing process.

Case (1994) has explored the importance of the therapist's own art work outside the session as a 'reflective counter-transference', enabling one to 'see' a client who is not painting more clearly. She has explored some of the aesthetic qualities of the transference/counter-transference relationship which are made visible in the image in a series of papers (1995, 1996, 1998). The first

of these looked at the aesthetic qualities encapsulated in a client's silence which creates an image in the therapist's mind. She went on to look at the location of children's experiences within the therapeutic setting as 'aesthetic moments in the transference', in relation both to an art work on the wall and the children's images.

American literature

Some recent literature from the USA has already been mentioned. A new edition of Judith Rubin's (2001) book gives a useful introduction to some approaches that differ from those in the UK. An important part of training is the development of an approach that 'fits' the student, one that they feel comfortable with and that will support them in their work, while they gain experience and are then able to modify how they work to each client group and setting. Some therapists will have an eclectic approach which draws from several sources.

Advances in understanding human development

> In order to use the mutual experience one must have in one's bones a theory of the emotional development of the child and the relationship of the child to the environmental factors.
>
> (Winnicott 1971: 3)

There have been significant new developments in our theoretical understanding and ways of thinking about human development. Here we intend to give an overview of these new ideas and how they have impacted on art therapy practice.

Firstly, we look at the work of developmental psychologists, particularly Daniel Stern and his colleagues, in thinking about infant development, intersubjectivity, and the notion of attunement. Secondly, we consider advances in thinking about attachment theory, particularly disorganised/disoriented attachment behaviour which can be seen in the behaviour of many 'looked-after children'. These children are among the most vulnerable in terms of developing mental health problems as adults. Thirdly, we examine the growing awareness of the importance of neurobiology in understanding the impact of trauma on the development of the brain. This includes the effect on children of living with a depressed main carer, usually the mother, which impacts on their mental health in adulthood. In retrospective studies, a high correlation has been demonstrated between disrupted early attachments, associated with early trauma and abuse, and both adult borderline personality disorder (Fonagy *et al.* 1997; Lyons-Ruth and Jacobvitz 1999) and dissociative, or multiple personality, disorders (Liotti 1999 quoted in Balbernie 2001).

Intersubjectivity

Stern's seminal book *The Interpersonal World of the Infant* (1985) has had a huge influence on the therapy world in general by giving credence to the vital presence of the therapist as an instrument in the client's therapy. It takes the model of mother and infant and the way that the mother empathically attunes to the infant giving non-verbal resonance to the infant's feeling/body states. This interaction between baby and caregiver involves self-regulation and sensitivity to the state of the other which has become known as 'attunement'. If this breaks down, it is possible for misalignment to be repaired (Fonagy and Target 1998).

Stern writes about pre-verbal communication and development of the infant's sense of self in the first 18 months of life, followed by the emergence of the verbal self. He challenges the previous view of developmental stages, suggesting instead a progression through increasingly complex modes of relatedness that continues to develop through the life of the individual. He does however chart formative phases when a particular sense of self comes into existence (Stern 1985). These phases are from birth to 2 months for the sense of an emergent self, from 2 to 6 months for a sense of a core self, from 7 to 15 months for a sense of an intersubjective self and from 18 to 30 months for the verbal sense of self.

Of particular interest to art therapists is Stern's understanding of the impact of language on other modalities of expression. He suggests that, although language has a positive benefit of enabling the sharing of personal experience, infants become estranged from direct contact with their own personal experience: 'Language forces a space between interpersonal experience as lived and as represented' (1985: 182). Evans and Rutten-Saris (1998) and Evans and Dubowski (2001) have used Stern's work to develop thinking about an art therapy approach with children on the autistic spectrum. These children have severe communication disorders. Stern had posited that each child has their own 'vitality affect' (i.e. a way of moving or doing that characterises their behaviour). This could be 'attuned to' by the art therapist responding in a bodily way in a parallel rhythm as a means of non-verbal communication to replicate the earliest kind of interaction between mother and baby. In their work, Evans, Rutten-Saris and Dubowski suggest that movements change to drawing and painting leading to naming of feelings (Stern's 'categorical affects'), and eventually the capacity to symbolise. It is a way of working which starts at the beginning of development to fill in what may have been missed.

Attachment theory

Attachment theory emphasises the importance of intimate emotional bonds for survival; the utilisation of working models of self and other in relationship

with each other; and the powerful influence on the child of the way they are treated by their primary care figures: 'Within the attachment framework the concept of a working model of an attachment figure is in many respects equivalent to, and replaces, the traditional psychoanalytical concept of internal object' (Bowlby 1988: 120).

Each child has the potential to form a strong, healthy attachment with a primary caregiver: 'Human helplessness and dependency are greatly prolonged compared with other species, making the attachment relationship, a matter of essential protection, the defining factor for human survival' (Balbernie 2001: 239). This bond is an enduring emotional relationship with a specific person. It brings comfort and safety. The loss of this relationship causes extreme distress. The attachment relationship with the mother or primary caregiver is a model for other important attachments in the family with father and siblings, although each will be different; and for future social relationships throughout life. If the child has an attentive, loving and attuned caregiver it is a marker for healthy relationships with others. If the child has a poor attachment, then emotional and behavioural problems usually follow (Fonagy *et al.* 1997).

Bowlby (1988) gives an excellent explication of the development and use of attachment theory. It is a way of explaining and understanding the externally observable fact that people need to have intimate relations. Bowlby uses the analogy of a homeostatically organised physiological system. That is to say, infants, children, adolescents or older people maintain their relationship to their attachment figure(s) between certain limits of distance or accessibility in a way that is analogous to the physiological system that regulates body temperature. Bowlby postulates the existence of an internal psychological organisation which includes representational models of the self and of attachment figure(s). These original ideas were based on observations of how young children respond when left in strange situations with strange people, and the effects such experiences have on the child's relationship with the returning parent (Ainsworth and Wittig 1969: Ainsworth *et al.* 1971).

A diversity of different attachment research has developed from this original test situation. Although attachment theory developed out of object relations theory, it also uses concepts from evolution theory, ethology, control theory and cognitive psychology. The two roles that make up attachment behaviour are care-seeking and care-taking and are regarded as a principal feature of effective personality functioning and mental health. The third basic component is exploring the environment, including play and various activities. When an individual of any age is feeling secure, they are likely to explore away from their attachment figure. When alarmed, anxious, tired or unwell, they feel an urge towards proximity. There is a typical pattern of behaviour between child and adult/parent known as 'exploration from a secure base' (Ainsworth 1967).

Over the first year of life a growing number of component responses to

what will become attachment behaviour develop. The goal of proximity or accessibility to a discriminated mother figure enables development into an organised system which requires that the child should have developed the cognitive capacity to keep their mother in mind when she is not present. This capacity develops during the second and sixth months of life. From nine months onwards most infants will cry and protest if left with a strange person. They develop a representation of mother, which becomes available to them for the purposes of comparison during her absence and for recognition after her return. Each infant develops working models for each relationship, in interaction with others, and can be understood in behaviour patterns first described by Ainsworth *et al.* (1971). A brief description of these patterns is given here and they are more fully discussed by Bowlby (1988).

Secure attachment

The individual is confident that their parent/parental figure will be available, responsive and helpful should they encounter adverse or frightening situations; with this assurance they feel bold in exploring the world. Parents, especially mother in the early years, are readily available, sensitive to child's signals, lovingly responsive when they seek protection and/or comfort.

Anxious resistant attachment

The individual is uncertain whether their parents will be available, responsive or helpful when called upon. Because of this uncertainty they are always prone to separation anxiety, tend to be clinging and are anxious about exploring the world. This pattern, in which conflict is evident, is promoted by a parent being available and helpful on some occasions but not on others, and by separations and threats of abandonment used as a means of control.

Anxious avoidant attachment

The individual has no confidence that, when they seek care, they will be responded to helpfully but, on the contrary, expect to be rebuffed. They try to become emotionally self-sufficient, living without the love and support of others and may later be diagnosed as narcissistic or as having a 'false self' (Winnicott 1960). This pattern, in which conflict is more hidden, is the result of the child's mother constantly rebuffing them when they approach her for comfort or protection.

Disoriented or disorganised attachment

This pattern developed by Main and Weston (1981), Crittenden (1985), Main and Solomon (1986), Radke-Yarrow *et al.* (1985) and Main and Hesse (1990)

has received a lot of interest from those working with traumatised or neg-lected children where there are generational patterns of neglect, abuse, depression or intense bereavement. These children can appear dazed, frozen, immobile, stopping/starting in movement and fall-prone. They may change their facial expression and avert their head to the caregiver and exhibit con-tradictory behaviour patterns. This is normally found in conjunction with one of the other major attachment categories, usually anxious resistant; attached but lacking in coping skills. Findings indicate that the parents or carers are themselves frightened, frightening or abusive, or unavailable due to bereave-ment. They may have suffered trauma in their own attachments.

There are interesting links with neurobiological research into traumatised children. Infants whose attachment is disoriented or disorganised tend to grow up to be very controlling or punitive in their own relating. Perry (2002) suggests that attachment difficulties could be framed in terms of develop-mental neglect, in the sense of mistimed, abnormal or absent caregiving interactions. Taylor *et al.* (1997) suggest that affect dysregulation resulting from early forming attachment pathologies is a fundamental mechanism in all psychiatric disorders.

As research and theory of attachment patterns has developed, prospective studies have shown that each pattern of attachment, once developed, tends to persist. One reason for this is that the way a parent treats a child (for better or worse) tends to continue unchanged. Each pattern tends to be self-perpetuating, eliciting more of the same behaviour (e.g., a secure child is a happier and more rewarding child and elicits loving care whereas an anxious, ambivalent child tends to be whiney and clinging, eliciting clinging and pushing away in return) (Bowlby 1988).

Cycles of unfavourable responses can develop. Evidence shows that in a young child the pattern is defined by the relationship with the parent. If a parent changes behaviour, so will the relationship pattern change; as a child grows older the pattern becomes the property of the child so that they tend to impose it or some derivative of it on new relationships. This is particularly poignant for adoptive parents trying to offer a child a new life only to be rejected by the child's response in an old attachment pattern. A securely attached child updates their working model as their parents treat them differ-ently as they mature, but the anxiously attached child has less flexibility due to anxiety and the accompanying defences. The child's working model becomes more habitual, generalised and largely unconscious, persisting in an unamended and unchanged state even with individuals treating them in ways unlike their parents when they were young.

The importance of narrative

'A thing which has not been understood inevitably reappears; like an unlaid ghost, it cannot rest until the mystery has been resolved and the spell broken'

(Freud 1909). The importance of patterns of attachment and how these impact on the parent that the child will become is clearly illustrated in a seminal paper called 'Ghosts in the nursery: a psychoanalytic approach' (Fraiberg *et al.* 1975). This paper explores how ghosts from a mother's past – her own experience of being mothered and fathered – influence the mother she will become. In particularly damaged circumstances it shows how 'it is the parent who cannot remember his childhood feelings of pain and anxiety who will need to inflict his pain upon his child' (p. 280).

Further research studies explore the vulnerability of new parents who are either vividly put in touch with childhood experiences on becoming a parent or who become distant, out of contact or potentially abusive to their new baby because they either cannot remember traumatic material, which is then enacted, or they remember factually but are not in touch with their own pain and terror (Fraiberg *et al.* 1975; Fonagy *et al.* 1992; Tracey *et al.* 1996). A parent who can remember a childhood narrative, but without the accompanying emotions, will be likely to become 'identified with the aggressor'. They will have an internal alliance against the new baby who will then become severely at risk. They are severely affected in the way they can relate to their baby because of defences against pain.

These two later papers stress the research findings that a parent who is able to formulate and discuss a coherent narrative of the past and hence become in touch with pain will be able to stop the past repeating itself. Remembrances of suffering can become a form of protection to the new baby. The papers also illustrate how one good experience amidst many neglectful, violent and emotionally impoverished ones can be internalised or become a working model and can be drawn on very positively.

Developments in neurobiological research

'Research suggests that emotion operates as a central organising process within the brain. In this way, an individual's ability to organise emotions – a product in part of earlier attachment relationships – directly shapes the ability of the mind to integrate experience and to adapt to future stressors' (Seigal, 1999: 4 in Balbernie 2001). An infant's brain is shaped by emotional interactions with the mature brain of the caregiver (Seigal 1999), so that 'for the developing infant the mother essentially is the environment' (Schore 1994: 78). The quality of the baby's emotional relationship with the mother/ caregiver is crucial. Pally (2000) gives a very useful overview of these processes, particularly 'emotional processing'. Perry (2002: 87) describes the core principles of neurodevelopment in the following way. Firstly, genetic and environmental influences; secondly the brain develops in a sequential and hierarchical fashion in that different areas develop, organise and become fully functional at different times during childhood. The brain organises itself 'from least (brainstem) to most complex (limbic, cortical areas)'. Thirdly,

neurodevelopment is activity-dependent. The early use of the brain within the co-created environment between mother and child and the wider circle about them will foster the growth of use-dependent pathways (Perry *et al.* 1995). Fourthly, the infant's brain has 'windows of opportunity/windows of vulnerability' (p. 276) in development as experiences actually shape the way it can organise itself. Perry, referencing Spitz, gives an example of 'touch' which is essential to an infant who may literally die without it (Spitz 1945, 1946), whereas an adolescent could not be touched for weeks without significant adverse effects.

When a child is bought up in a loving and attentive environment, reflections and understandings of its emotional life will be mirrored by the mother. In this way the orbital cortex, which is the location of reflective thought, will develop in the child: 'The orbitofrontal cortex is known to play an essential role in the processing of interpersonal signals necessary for the initiation of social interactions between individuals' (Schore 2001a: 36). The orbitofrontal cortex mediates empathic and emotional relatedness or attuned communication. It contributes to generating self-awareness, personal identity, episodic memory and the ability to imagine oneself in the future or to remember oneself in the past (Balbernie 2001). In the right hemisphere, functions develop which control emotion, and appraise incoming stimuli and interpersonal communications.

Children who are bought up in a neglectful environment or who experience repeated traumatic stress are particularly vulnerable due to the 'malorganisation of the neural systems mediating socio-emotional functioning' (Perry *et al.* 1995: 276). Perry (2002) provides further evidence of the damage to a baby's developing brain when they are exposed to neglect. The IQ of children raised in orphanages, where there had been an institutional environment without individual attention, cognitive stimulation or emotional affection was measured. At age 16 these children had a mean IQ of 60. Children were then adopted more regularly so that it was possible to measure the IQ of children adopted between the ages of 0–2 and 2–6 when they became 16. The findings showed that the earlier the children were adopted out of the neglectful environment, the higher the IQ score, i.e. at age 0–2 a mean IQ of 100, at age 2–6 a mean IQ of 80 at age 16 years (Dennis 1973).

Neglect causes actual damage to the developing brain as the neural pathways atrophy due to lack of the required stimulus at the right time. Actual trauma initiates primitive flight/fight or freezing responses, immobility, dissociation or fainting due to the overactivation of important neural systems during sensitive periods of development which leads to hyperarousal (which initially may bring help): 'Traumatised children use a variety of dissociative techniques' (Perry *et al.* 1995: 281). These patterns of response overtake the more elaborate reflective processes, where thought takes precedence over action. In this way, child abuse and neglect can shape the way that the brain is programmed in these crucial early years (Glaser 2000; Schore 2001b), which

can have negative long-term effects (Nelson and Bosquet 2000). The adaptability of the mind, which aids our survival, means that it will adapt to the conditions it finds itself in. These responses continue as neural pathways develop, even when the child is no longer in the neglectful situation.

For these reasons, neglected children have many developmental problems caused by abnormalities in the brain. The sooner these children are removed from the neglectful environment the more possibility there is for some recovery of function and brain size. Mothers and carers support the child's development of symbolic capacities and acquisition of language. A healthy mother and infant develop a model of mutual regulation which, if successful, allows the creation of dyadic states of consciousness allowing error and repair. This is adversely affected by maternal depression, which is a form of unintended neglect (Zeanah *et al.* 1997). It is thought that babies exposed to short-term depression may recover but prolonged depression is damaging to the left frontal region of the cortex associated with outwardly directed emotions (Nelson and Bosquet 2000). Maternal depression affects mother–infant communication which plays a crucial role in protecting the child against mental or emotional disorders: 'this position of communication is based on the specific adaptive relevance of communication in human evolution' (Papousek and Papousek 1997: 38).

The experience of an infant between the ages of 6 and 18 months of age whose mother is depressed can lead to persisting emotional and cognitive difficulties (Murray 1997; Sinclair and Murray 1998; Balbernie 2001). Tronick and Weinberg (1997: 73) posit the effect of maternal depression on a child's social and emotional functioning and development: 'the human brain is inherently dyadic and is created through interactive exchanges'. Infants become aware of the mother's depression and become hyper-vigilant of her emotional state in order to protect themselves, causing them to become emotionally restricted. In the dyadic mother–infant system, during maternal depression, the infant is deprived of the experience of expanding their states of consciousness in collaboration with the mother. Instead they may take on elements of the mother's depressed state – sadness, hostility, withdrawnness and disengagement – in order to form a larger dyadic system. In the service of growth the infant incorporates the mother's depressed states of consciousness.

Implications for art therapy

All these research findings highlight the need for early intervention programmes: 'It is easier to help a still fluid set of relationships, or constellation of neurons, to change than one that has become established' (Balbernie 2001: 249). It is possible for neural pathways to connect where previously there have been none and it is possible for reflective thinking processes to develop within a therapeutic relationship, but it is a slow and uphill task. Schore has

emphasised that human learning takes place throughout the life cycle; although a complete cure may be unrealistic, it is possible to repair some damage and improve the quality of the relationship and therefore the future life of the child and their children. Schore maintains that 'The patient-therapist relationship acts as a growth promoting environment that supports the experience-dependent maturation of the right brain, especially those areas that have connections with the subcortical limbic structures that mediate emotional arousal' (1994: 473).

Art therapists are likely to be working with children and adults who have experienced adverse circumstances in their childhood. These will include the 'looked-after' child population. Amini *et al.* (1996) suggest that psychotherapy may act as an attachment relationship which is able to modify emotions through the restructuring of implicit memory which stores non-verbal experience in an unprocessed form. The art therapy room can offer an engaging, sensual environment that together with an empathic attuned therapist offers multi-modal possibilities of work. Emotional states may be expressed through tactile experience using clay, or seen externally in an image, without the immediate use of words. The images have the capacity to work back in the sense of feedback to the maker as they can be kept, stored and retrieved as one works towards verbal expression: 'The ultimate endpoint of experiencing catastrophic states of relational-induced trauma in early life is a progressive impairment of the ability to adjust, take defensive action, or act on one's own behalf, and, most importantly, a blocking of the capacity to register affect and pain' (Schore 2001b: 232).

Art materials, used safely, can act as a catalyst for play. In playing, one can surprise oneself as an image emerges. In this way there is the powerful possibility of forms taking shape from the experience of the client which give non-verbal access to painful material, starting points for interaction with the therapist. Schore has shown how a successful therapeutic relationship 'optimises the growth of "two mind's in the making", that is, increases in complexity in both the patient's and the therapist's continually developing unconscious right minds' (2001c: 320).

Fonagy and Target (1998) suggest that there has been a shift in emphasis in psychoanalytic practice from a focus on the retrieval of forgotten experience to the creation of a meaningful narrative being considered as mutative. This echoes a move towards the interactional and interpersonal aspects of the work, working towards the development of a reflective function (Fonagy and Target 1997). Reflective functioning is an important outcome of a secure attachment, which allows the perception of another's state. Schore suggests that in therapy:

> non-verbal transference-countertransference interactions that take place
> at pre-conscious-unconscious levels represent right hemisphere to right
> hemisphere communications of fast-acting, automatic, regulated and

dysregulated emotional states between patient and therapist. Transference events clearly occur during moments of emotional arousal, and recent neurobiological studies indicate that 'attention is altered during emotional arousal such that there is a heightened sensitivity to cues related to the current emotional state'.

(Lane *et al.* 1999: 986)

Resonance between the unconscious of both therapist and patient then becomes of prime importance as they attune empathically. This suggests that the client must have a vivid affective experience of the therapist (Amini *et al.* 1996 in Schore 2001c).

Recent art therapy papers have highlighted the importance of the early years, attachment research and neurobiological theory. Boronska (2000) uses an attachment framework in her art therapy groups with looked-after children who are being prepared for long-term placements. The aim of the groups is to support the children's capacity for more enriching relationships. These children, with traumatic histories, also demonstrate the gender difference in their presentation. In evolutional terms it has been shown that a male child's chance of survival when under attack is increased by moving along a continuum of vigilance (crying), resistance, defiance and aggression. A female child's chance of survival is increased by moving along a continuum of avoidance (crying), compliance, dissociation and fainting. This is simplified as there are variations to do with the age of the child, but traumatised children differ by gender in their overt symptoms despite coming from the same background. Boys show externalised symptoms of attention deficit hyperactivity disorder, conduct disorder and oppositional-defiant disorder while girls show internalised symptoms of compliance, dissociation, depression and anxiety. In childhood the ratio of boys/girls presenting to mental health services is 3:1 whereas in adulthood women/men present 2:1 (Perry *et al.* 1995).

O'Brien (2004) explores the hypothesis that artwork created during art therapy may activate neurological structures of the brain, enabling non-verbal early experience to become known. Like Boronska, she works individually with neglected and abused children. In her paper on the 'Making of mess in art therapy' she explores the meaning of the mess that these children make. She draws on both neurological and attachment theory, suggesting that mess may be a result of damaged neural pathways resulting from early relational abuse with dissociation used to repress the memory of abuse or neglect. Case (2005b) explores the formation of memory after trauma, through art work, in therapy with an adopted child. Knight (1998) outlines the importance of skin when working with attachment difficulties and how separation and identity are themes that are often at the core of therapeutic work with children and their families. She concludes: 'As art making can facilitate the expression of pre-verbal and unconscious processes, art therapy has an essential role in considering how to approach attachment problems. The sensual and tactile

nature of the art materials, combined with the emotional support of the therapist, encourage reparation to occur by uniting mind and body in physical acts of creativity throughout the therapeutic process' (p. 159).

Teasdale's (1995, 1997) research on attachment disorder in prison popula- tions suggests that art therapy can be utilised to facilitate an attachment to the picture, by the maker, acting as a forerunner of attachment to people.

References

Adamson, E. (1990) *Art as Healing*. Coventure: London.

Ainsworth, M.D.S. (1967) *Infancy in Uganda: Infant Care and the Growth of Attach- ment*. Baltimore, MD: John Hopkins University Press.

Ainsworth, M.D.S. and Wittig, B. (1969) Attachment and exploratory behaviour in one-year-olds in a stranger situation, in B.M. Foss (ed.) *Detirminants of Infant Behaviour*. New York: Wiley.

Ainsworth, M.D.S., Bell, S.M. and Stayton, D.J. (1971) Individual differences in strange situation behaviour of one-year-olds, in H.R. Schaffer (ed.) *The Origins of Human Social Relations*. London: Academic Press.

Amini, F., Lewis, T. and Lannon, R. (1996) Affect, attachment, memory: contributions toward psychobiologic integration, *Psychiatry*, 59: 213–39.

Bach, S. (1990) *Life Paints its own Span: On the Significance of Spontaneous Pictures by Severely Ill Children*. Switzerland: Daimon Verlag.

Balbernie, R. (2001) Circuits and circumstances: the neurobiological consequences of early relationship experiences and how they shape later behaviour, *Journal of Child Psychotherapy*, 27(3): 237–55.

Baynes, H.G. (1940) *The Mythology of the Soul*. London: Routledge & Kegan Paul.

Boronska, T. (2000) Art therapy with two sibling groups using an attachment frame- work, *Inscape*, 5(1): 2–10.

Bowlby, J. (1988) *A Secure Base: Clinical Applications of Attachment Theory*. London: Tavistock/Routledge.

Case, C. (1994) Art therapy in analysis: advance/retreat in the belly of the spider, *Inscape*, 1: 3–10.

Case, C. (1995) Silence in progress: on being, dumb, empty, or silent in therapy, *Inscape*, 1: 21–6.

Case, C. (1996) On the aesthetic moment in the transference, *Inscape*, 1(2): 39–45.

Case, C. (1998) Brief encounters: thinking about images in assessment, *Inscape*, 3(1): 26–33.

Case, C. (2000) Our lady of the queen: journeys around the maternal object, in A. Gilroy and G. McNeilly (eds) *The Changing Shape of Art Therapy: New Develop- ments in Theory and Practice*. London: Jessica Kingsley.

Case, C. (2005a) *Imagining Animals: Art, Psychotherapy and Primitive States of Mind*. London: Routledge.

Case, C. (2005b) The mermaid: moving towards reality after trauma, *Journal of Child Psychotherapy*, 31(3): 1–17.

Crittenden, P. (1985) Maltreated infants: vulnerability and resilience, *Journal of Child Psychology and Psychiatry*, 26: 85–96.

Dalley, T. (2000) Back to the future: thinking about theoretical developments in art

therapy, in A. Gilroy and G. McNeilly (eds) *The Changing Shape of Art Therapy*. London: Jessica Kingsley.

Dalley, T., Rifkind, G. and Terry, K. (1993) *Three Voices of Art Therapy*. London: Routledge.

Dennis, W. (1973) *Children of the Crèche*. New York: Appelton-Century-Croft.

Dubowski, J. (1984) Alternative models for describing the development of children's graphic work: some implications for art therapy, in T. Dalley (ed.) *Art as Therapy: An Introduction to the use of Art as a Therapeutic Technique*, London: Routledge.

Dubowski, J. (1990) Art versus language (separate development during childhood), in C. Case and T. Dalley (eds) *Working with Children in Art Therapy*. London: Tavistock/Routledge.

Edwards, D. (2004) *Art Therapy*. London: Sage.

Edwards, M. (1987) Jungian analytic art therapy, in J. Rubin (ed.) *Approaches to Art Therapy*. London: Brunner-Routledge.

Edwards, M. (1999) Learning from images, in R. Goldstein (ed.) *Images, Meanings and Connections: Essays in Memory of Susan Bach*. Daimon Press

Evans, K. and Dubowski, D. (2001) *Art Therapy with Children on the Autistic Spectrum: Beyond Words*. London: Jessica Kingsley.

Evans, K. and Rutten-Saris, M. (1998) Shaping vitality affects, enriching communication: art therapy for children with autism, in D. Sandle (ed.) *Development and Diversity: New Applications in Art Therapy*. London: Free Association Books.

Fonagy, P. and Target, M. (1997) Attachment and reflective function: their role in self-organisation, *Development and Psychopathology*, 9: 679–700.

Fonagy, P. and Target, M. (1998) An interpersonal view of the infant, in A. Hurry (ed.) *Psychoanalysis and Developmental Theory*. London: Karnac Books.

Fonagy, P., Steele, M., Moran, G., Steele, H. and Higgett, A. (1992) Measuring the ghost in the nursery: an empirical study of the relation between parents' mental representations of childhood experiences and their infants' security of attachment, *Journal of American Psychoanalytical Society*, 41(4): 957–89.

Fonagy, P., Target, M., Steele, M., Steele, H., Leigh, T., Levinson, A. and Kennedy, R. (1997) Morality, disruptive behaviour, borderline personality disorder, crime, and their relationship to security of attachment, in L. Atkinson and K.J. Zucker (eds) *Attachment and Psychopathology*. New York: Guilford Press.

Fox, L. (1998) Lost in space: the relevance of art therapy with clients who have autism or autistic features, in M. Rees (ed.) *Drawing on Difference: Art Therapy with People who have Learning Difficulties*. London: Routledge.

Fraiberg, S., Adelson, E. and Shapiro, V. (1975) Ghosts in the nursery: a psychoanalytical approach to the problem of impaired infant-mother relationships, *Journal of American Academy of Child Psychiatry*, 14: 387–422.

Freud, S. (1909) *Pelican Freud Library Vol. 8: Case Histories 1, Little Hans*. Harmondsworth: Penguin.

Gersch, I. and Goncalves, S.J. (2006) Creative arts therapies and educational psychology: let's get together, *International Journal of Art Therapy: Inscape*, 10(2): 22–31.

Glaser, D. (2000) Child abuse and neglect and the brain: a review, *Journal of Child Psychology and Psychiatry*, 41(1): 97–116.

Greenwood, H. (2000) Captivity and terror in the therapeutic relationship, *Inscape*, 5: 53–61.

Hardy, D. (2001) Creating through loss: an examination of how art therapists sustain their practice in palliative care, *Inscape*, 6(1): 23–21.

Henzell, J. (2006) Unimaginable imagining, *International Journal of Art Therapy: Inscape*, 11(1): 13–21.

Hillman, J. (1975) *Re-visioning Psychology*. New York: Harper.

Hillman, J. (1978) *Further Notes on Images*. Dallas, TX: Spring.

Hillman, J. (1979) *The Dream and the Underworld*. New York: Harper.

Hillman (1983) *Healing Fiction*. New York: Station Hill.

Hogan, S. (2001) *Healing Arts: The History of Art Therapy*. London: Jessica Kingsley.

Hyland Moon, C. (2004) *Studio Art Therapy: Cultivating the Artist Identity in the Art Therapist*. London: Jessica Kingsley.

Jung, C. (1960) *The Transcendent Function*. Princeton, NJ: Bollingen.

Jung, C. (1963) *Memories, Dreams and Reflections*. London: Collins.

Jung, C. (1964) *Man and his Symbols*. London: Aldus.

Jung, C. (1997) *Jung on Active Imagination*. London: Routledge.

Kellog, R. (1970) *Analysing Children's Art*. Palo Alto, CA: National Press.

Killick, K. (1993) Working with psychotic processes in art therapy, *Psychoanalytical Psychotherapy*, 7(1): 25–38.

Killick, K. (1995) Working with psychotic processes in art therapy, in J. Ellwood (ed.) *Psychosis: Understanding and Treatment*. London: Jessica Kingsley.

Killick, K. (2000) The art room as container in analytical art psychotherapy with patients in psychotic states, in A. Gilroy and G. McNeilly (eds) *The Changing Shape of Art Therapy*. London: Jessica Kingsley.

Killick, K. and Greenwood, H. (1995) Research in art therapy with people who have psychotic illnesses, in A. Gilroy and C. Lee (eds) *Art and Music: Therapy and Research*. London: Routledge.

Killick, K. and Schaverien, J. (1997) *Art, Psychotherapy and Psychosis*. London: Routledge.

Knight, S. (1998) Art therapy and the importance of skin when working with attachment difficulties, in D. Sandle (ed.) *Development and Diversity: New Applications in Art Therapy*. London: Free Association Books.

Lane, R.D., Chua, P. and Dolan, R.J. (1999) Common effects of emotional valence, arousal and attention on neural activation during visual processing of pictures, *Neuropsychologia*, 37: 989–97.

Lanham, R. (1998) The life and soul of the image, *Inscape*, 3(2): 48–55.

Liotti, G. (1999) Disorganisation of attachment as a model for understanding dissociative psychopathology, in J. Solomon and C. George (eds) *Attachment Disorganisation*. New York: Guilford Press.

Lowenfeld, V. and Brittain, W.L. (1987) *Creative and Mental Growth*, 8th edn. New York: Macmillan.

Luzatto, P. (1997) Short-term art therapy on the acute psychiatric ward: the open session as a psychodynamic development of the studio-based approach, *Inscape*, 2(1): 2–10.

Lyddiatt, E.M. (1971) *Spontaneous Painting and Modelling*. London: Constable.

Lyons-Ruth, K. and Jacobvitz, D. (1999) Attachment disorganisation: unresolved loss, relational violence and lapses in behavioural and attentional strategies, in C. Cassidy and P.R. Shaver (eds) *Handbook of Attachment*. New York: Guilford Press.

Maclagan, D. (1994) Between the aesthetic and the psychological, *Inscape*, 2: 49–51.

Maclagan, D. (2001) *Psychological Aesthetics: Painting, Feeling and Making Sense*. London: Jessica Kingsley.

Maclagan, D. (2005) Re-imagining art therapy, *International Journal of Art Therapy: Inscape*, 10(1): 23–30.

Main, M. (1990) Procedure for identifying infants as disorganised/disoriented during the Ainsworth strange situation, in M. Greenberg, D. Cicchetti and M. Cummings (eds) *Attachment in the Preschool Years*. Chicago: University of Chicago Press.

Main, M. and Hesse, E. (1990) Parents unresolved traumatic experiences are related to infant disorganised attachment status: is frightened and/or frightening parental behaviour the linking mechanism?, in M. Greenberg, D. Cicchetti and M. Cummings (eds) *Attachment in the Preschool Years*. Chicago: University of Chicago Press.

Main, M. and Solomon, J. (1986) Discovery of a new, insecure/disorganised/disoriented attachment pattern, in T.B. Brazelton and M. Yogman (eds) *Affective Development in Infancy*. Norwood, NJ: Ablex.

Main, M. and Weston, D. (1981) Quality of attachment to mother and to father: related to conflict behaviour and the readiness for establishing new relationships, *Child Development*, 52: 932–40.

Malchiodi, C. (ed.) (2002) *The Handbook of Art Therapy*. New York: Guilford Press.

Matthews, J. (1984) Children's drawings: are young children really scribbling?, *Early Child Development and Care*, 18: 1–39.

Matthews, J. (1989) How young children give meaning to drawing, in T. Dalley and A. Gilroy (eds) *Pictures at an Exhibition*. London: Tavistock/Routledge.

McNiff, S. (1992) *Art as Medicine*. Boston, MA: Shambhalla.

McNiff, S. (2000) *Art-Based Research*. London: Jessica Kingsley.

McNiff, S. (2004) *Art Heals: How Creativity Heals the Soul*. Boston, MA: Shambhalla.

Murray, L. (1997) Post-partum depression and child development, *Psychological Medicine*, 27: 253–60.

Naumberg, M. (1950) *An Introduction to Art Therapy*. New York: Teachers College Press.

Nelson, C.A. and Bosquet, M. (2000) Neurobiology of fetal and infant development: implications for infant mental health, in C.H. Zeanah (ed.) *Handbook of Infant Mental Health*, 2nd edn. New York: Guilford Press.

O'Brien, F. (2003) Bella and the white water rapids, *Inscape*, 8(1): 29–41.

O'Brien, F. (2004) The making of mess in art therapy: attachment, trauma and the brain, *Inscape*, 9(1): 2–13.

Pally, R. (2000) *The Mind-Brain Relationship*. London: Karnac.

Papousek, H. and Papousek, M. (1997) Fragile aspects of early social integration, in L. Murray and P. Cooper (eds) *Postpartum Depression and Child Development*. New York: Guilford Press.

Perry, B. (1997) Incubated in terror: neurodevelopmental factors in the 'cycle of violence', in J.D. Osofsky (ed.) *Children in a Violent Society*. New York: Guilford Press.

Perry, B. (2002) Childhood experience and the expression of genetic potential: what childhood neglect tells us about nature and nurture, *Brain and Mind*, 3: 79–100.

Perry, B., Pollard, A., Blakeley, T., Baker, W. and Vigilante, D. (1995) Childhood trauma, the neurobiology of adaptation, and 'use-dependent' development of the brain: how 'states' become 'traits', *Infant Mental Health Journal*, 16(4): 271–91.

Piaget, J. and Inhelder, B. (1969) *The Psychology of the Child*. London: Routledge & Kegan Paul.

Radke-Yarrow, M. *et al.* (1985) Patterns of attachment in two- and three-year olds in normal families and families with parental depression, *Child Development*, 56: 884–93.

Reddick, D. (1999) Baby-bear monster, *Inscape*, 4(1): 20–8.

Rees, M. (1998) *Drawing on Difference: Art Therapy with People who have Learning Difficulties*. London: Routledge.

Robbins, A. (2000) *The Artist as Therapist*. London: Jessica Kingsley.

Rubin, J. (1998) *Art Therapy: An Introduction*. New York: Brunner-Mazel.

Rubin, J. (2001) *Approaches to Art Therapy*, 2nd edn. New York: Brunner-Mazel.

Schaverien, J. (1987) The scapegoat and the talisman: transference in art therapy, in T. Dalley *et al.*, *Images of Art Therapy: New Developments in Theory and Practice*. London: Routledge.

Schaverien, J. (1992) *The Revealing Image: Analytical Art Psychotherapy in Theory and Practice*. London: Routledge.

Schaverien, J. (1994) Analytical art psychotherapy: further reflections on theory and practice, *Inscape*, 2: 41–9.

Schaverien, J. (1995) *Desire and the Female Therapist: Engenered Gazes in Psycho-therapy and Art Therapy*. London: Routledge.

Schaverien, J. (2000) The triangular relationship and the aesthetic countertransference in analytical art psychotherapy, in A. Gilroy and G. McNeilly (eds) *The Changing Shape of Art Therapy: New Developments in Theory and Practice*. London: Jessica Kingsley.

Schaverien, J. (2005) Art and active imagination: reflections on transference and the image, *International Journal of Art Therapy: Inscape*, 10(2): 39–52.

Schore, A.N. (1994) *Affect Regulation and the Origin of the Self: The Neurobiology of Emotional Development*. Hillsdale, NJ: Erlbaum.

Schore, A.N. (2001a) Effects of a secure attachment relationship on right brain development, affect regulation and infant mental health, *Infant Mental Health Journal*, 22(1–2): 7–66.

Schore, A.N. (2001b) The effects of early relational trauma on right brain develop-ment, affect regulation, and infant mental health, *Infant Mental Health Journal*, 22(1–2): 201–69.

Schore, A.N. (2001c) Minds in the making: attachment, the self-organising brain, and developmentally-oriented psychotherapy, *British Journal of Psychotherapy*, 17(3): 299–328.

Seigal, D.J. (1999) *The Developing Mind: Towards a Neurobiology of Interpersonal Experience*. New York: Guilford Press.

Simon, R. (1992) *The Symbolism of Style*. London: Routledge.

Simon, R. (2002) *Self Healing through Visual and Verbal Art Therapy*. London: Routledge.

Sinclair, D. and Murray, L. (1998) The effects of post-natal depression on children's adjustment to school, *British Journal of Psychiatry*, 172: 58–63.

Skaife, S. (1995) The dialectics of art therapy, *Inscape*, 1: 2–7.

Skaife, S. (2000) Keeping the balance: further thoughts on the dialectics of art therapy, in A. Gilroy and G. McNeilly (eds) *The Changing Shape of Art Therapy: New Developments in Theory and Practice*. London: Jessica Kingsley.

Spitz, R.A. (1945) Hospitalism: an inquiry into the genesis of psychiatric conditions in early childhood, *Psychoanalytic Study of the Child*, 1: 53–74.

Spitz, R.A. (1946) Hospitalism: a follow-up report on investigation described in volume 1, 1945, *Psychoanalytic Study of the Child*, 2: 113–17.

Stevens, A. (1986) *The Withymead Centre: A Jungian Community for the Healing Arts*. London: Coventure.

Stern, D.N. (1985) *The Interpersonal World of the Infant: A View from Psychoanalysis and Developmental Psychology*. New York: Basic Books.

Taylor, G.J., Bagby, R.M. and Parker, J.D.A. (1997) *Disorders of Affect Regulation: Alexithymia in Medical and Psychiatric Illness*. Cambridge: Cambridge University Press.

Teasdale, C. (1995) Reforming zeal or fatal attraction: why should art therapists work with violent offenders. *Inscape*, winter: 2–9.

Teasdale, C. (1997) Art therapy as a forensic investigation. *Inscape*, N2: 32–40.

Thomas, L. (1998) From re-presentations to representations of sexual abuse, in D. Sandle (ed.) *Development and Diversity: New Applications in Art Therapy*. London: Free Association Books.

Tracey, N., Blake, P., Warren, B., Enfield, S. and Shein, P. (1996) Will I be to my son as my father was to me? Narrative of a father with a premature baby, *Journal of Child Psychotherapy*, 22(2): 43–64.

Trevarthen, C. and Neisser, U. (1993) *The Perceived Self: Ecological and Interpersonal Sources of Self-knowledge*. Cambridge: Cambridge University Press.

Tronick, E. and Weinberg, M.K. (1997) Depressed mothers and infants: failure to form dyadic states of consciousness, in L. Murray and P. Cooper (eds) *Postpartum Depression and Child Development*. New York: Guilford Press.

Waller, D. (1991) *Becoming a Profession: A History of Art Therapists 1940–82*. London: Routledge.

Waller, D. and Gilroy, A. (eds) (1992) *Art Therapy: A Handbook*, Buckingham: Open University Press.

Winnicott, D.W. (1960) Ego distortion in terms of true and false self, in D.W. Winnicott (1965) *The Maturational Process and the Facilitating Environment*. London: Hogarth Press.

Winnicott, D.W. (1971) *Playing and Reality*. Harmondsworth: Penguin.

Wood, C. (1990) The triangular relationship: the beginnings and endings of art therapy relationships, *Inscape*, winter: 7–13.

Wood, C. (1997) The history of art therapy and psychosis (1938–1995), in K. Killick and J. Schaverien (eds) *Art, Psychotherapy and Psychosis*. London: Routledge.

Wood, C. (2000) The significance of studios, *Inscape*, 5(2): 40–53.

Wood, M. (1984) The child and art therapy: a psychodynamic viewpoint, in T. Dalley (ed.) *Art as Therapy: An Introduction to the Use of Art Therapy as a Therapeutic Technique*. London: Routledge.

Zeanah, C.H., Boris, N.W. and Larrien, J.A. (1997) Infant development and developmental risk: a review of the past ten years, *American Academy of Child and Adolescent Psychiatry*, 36(2): 165–78.

Art and psychoanalysis

When art activity is understood in terms of spontaneous expression giving access to unconscious material, the links with psychoanalytic practice become clearer. The following sections offer an exploration and introduction to some of the literature and background of ideas on art and psychoanalysis that have influenced and formed present thinking about art and therapy. The chapter is intended to be more of an introduction for prospective art therapists to encourage them to make their own forays into the subject, rather than a critical review, but inevitably the authors' bias will be apparent at times. Emphasis is placed on those writers who have made significant contributions to the debate, tracing the re-evaluation of primary process thinking and its implications. Links are made from Freud's view of art as symptomatology – 'Every psychoanalytic treatment is an attempt at liberating repressed love which has found a meagre outlet in the compromise of a symptom' (Freud 1907: 113) – to the influence of later writers, such as Adrian Stokes (1972), who give full value to notions of destructive and reparative forces in art and the interplay of primary and secondary processes.

For the person getting lost in new terminology and concepts, it may be helpful to consider that the basis of the discussion is about the nature and interplay of 'desire' in a painting. It is a study of feelings and the mental processes which accompany and formulate those feelings and particularly of the intense loves and hates of the infant and their repetition and interplay in later life.

Freud and the classical analytical view of art

The visitor to the Freud museum in Hampstead will be delighted and surprised by Freud's study and consulting room which contains evidence of his interest in ancient and near Eastern *objets d'art*. These antiquities are placed around his desk and shelves and divert interest from the couch.[1] Gombrich

1 The Freud Museum, 20 Maresfield Gardens, London NW3 SSX.

(1966) comments on how 'The mysterious dream-like aura of these images, of course, retained its fascination for the explorer of dreams'. The pleasure that Freud gained from these tiny statues, and evidence in his letters of his enjoyment of visiting galleries, is at variance with his well-known uncompromising hostility to modern art movements and his famous comments on the artist.

Freud wrote a number of books and papers on art and artists in which his understanding is based on his working model of the mind. One of Freud's earliest and most fundamental ideas was the assumption of a primitive psychic apparatus which had the function of regulating states of tension by discharging instinctual impulses. There were two modes of discharge, primary and secondary. Primary processes are characteristic of unconscious thinking and occur earlier in each individual than secondary processes which are characteristic of conscious thinking. Primary process is governed by the pleasure principle and reduces the discomfort of instinctual tensions by hallucinating wish-fulfilment. Secondary process thinking is governed by the reality principle and reduces the discomfort of instinctual tension by adaptive behaviour. Freud believed that, as an individual matures, progression could only be made by the repression of this earlier infantile way of dealing with instinctual demands. Primary process is therefore seen as inherently maladaptive, something to grow out of. Dreaming is most characteristic of the primary process where images may be subject to condensation and displacement, i.e. they can become confused and can replace and symbolise one another, ignoring categories of space and time. Thought is most characteristic of secondary processes, using words and the laws of grammar and formal logic.

Freud saw the human ego as being slowly educated by the reality principle and external necessity to renounce a variety of objects and aims of the pleasure principle. One of the processes by which instinctual energies are discharged in non-instinctual forms of behaviour is that of sublimation. This process is described by Anna Freud (1979: 52) as 'the displacement of the instinctual aim in conformity with higher social values'. As the ego has to give up these primitive sexual and aggressive instincts, they are given further existence in the form of phantasies, by compensation. Freud compares the creation of the 'mental realm of phantasy' to a 'nature reserve', rather poetically it seems, yet 'everything, including what is useless and even what is noxious, can grow and proliferate there as it pleases' (Freud 1916: 372).

This rather harsh view of a human jungle of the unconscious echoes the social mores of his time where to be a 'creature of reason' was vastly superior to being an 'animal of pleasure'. It is in his discussion of 'symptom formation' that Freud's famous sayings on artists reach their zenith:

> For there is a path that leads back from phantasy to reality – the path, that is, of art. An artist is once more in rudiments an introvert, not far

removed from neurosis. He is oppressed by excessively powerful instinct-
ual needs. He desires to win honour, power, wealth, fame and the love of
women, but he lacks the means of achieving these satisfactions.

(Freud 1916: 375)

Freud thought that neurotic symptoms arise out of a conflict between the
pleasure and reality principles. The need to satisfy the libido is filled by
a compromise between the two forces that are reconciled in the form of a
symptom. Of artists Freud thought: 'Their constitution probably includes a
strong capacity for sublimation and a certain degree of laxity in the repres-
sions which are decisive for a conflict'. Whereas other people only have a
limited satisfaction from phantasies, the artist 'understands how to work over
his day dreams in such a way as to make them lose what is too personal about
them and repels strangers and to make it possible for others to share in the
enjoyment of them' (Freud 1916: 376).

In Freud's view, the artist gains pleasure from this representation of
unconscious phantasy gaining relief of his repressed instincts. To summarise,
Freud formulated the classical analytical view of works of art being the
product of sublimation, substitutes for primitive sexual and aggressive
instincts. As other people view the pictures they desire consolation and allevi-
ation from their own sources of pleasure in their unconscious which have
become inaccessible to them: 'He earns their gratitude and admiration and he
has thus achieved through his phantasy what originally he had achieved only
in his phantasy – honour, power and the love of women' (Freud 1916: 376–7).
Put into these terms Freud is seeing the artistic process as a regression to an
early infantile state of consciousness, a turning away from reality to fantasy,
dominated by the primary process. Therefore the artist 'turns away from
reality and transfers all his interest and his libido too, to the wishful construc-
tions of his life of phantasy, whence the path might lead to neurosis' (1916:
376).

'Clearly to Freud there was no artistic value in the primary process as such'
(Gombrich 1966). In 'An Autobiographical Study', Freud (1925) writes of a
temptation to make a general analysis of poetic and artistic creation, but this
was never fulfilled. In fact, Freud later developed his mapping of the inner
world to a less rigid system, the ego, the id and the superego replacing the two
mental processes, primary (unconscious) and secondary (conscious). The
ego, which replaced the 'conscious', becomes 'that part of the id which has
been modified by the direct influence of the external world' (Freud 1923: 25).
In this new configuration, what is unconscious is not necessarily repressed
and the ego is not necessarily conscious. Later writers, such as Rycroft (1985)
and Wollheim (1970), reject the idea that the primary processes are archaic and
maladaptive and have regretted that Freud did not reconsider the constructive
role and value of unconscious processes.

Freud was unable to embrace artistic activity as anything except the

product of sublimation, and neither distinguished between good and bad art, nor, more importantly, between a work of art and a neurotic symptom. His comments about art have to be gleaned from the main issues of his writings but the most central description of his views can be found in his three studies of artists and their work. The first two are the studies of Leonardo da Vinci (Freud 1910) and the *Moses* of Michelangelo (Freud 1914). Wollheim suggests that the main distinction between these two different studies is in terms of expression. In Leonardo, Freud explores what the artist does in his works and, in Michelangelo he studies what is expressed by the subject of the work. The whole Leonardo paper originates from the analysis of a childhood memory or possible phantasy, and what is known of Leonardo's infancy. It is both speculative and a very clear vehicle for exploring Freud's current thinking about the genesis of one particular type of homosexuality and the first full emergence of the concept of narcissism. Freud gives a detailed construction of Leonardo's life from his earliest years and relates it to later known characteristics of his personality. For instance, it is known that Leonardo did not finish his paintings and worked very slowly. Freud writes that through Leonardo's identification with his father (who had abandoned him and his mother in his early years), he too 'left' his paintings by not finishing them. He thinks that this 'rebellion' against his father established his scientific researcher attitude and quotes from Leonardo: 'He who appeals to authority when there is a difference of opinion works with his memory rather than with his reason' (Freud 1910: 122).

This keenness as a researcher and his lack of sexual interest are connected, in Freud's view, as passions transformed into a thirst for knowledge. His libido was not repressed but sublimated from the beginning into curiosity and attached to the powerful instinct to research. The first wish to research is seen as the infant's original sexual researches; curiosity about parental intercourse: 'We should be most glad to give an account of the way in which artistic activity derives from the primal instincts of the mind if it were not just here that our capacities fail us. We must be content to emphasise the fact – which it is hardly any longer possible to doubt – that what an artist creates provides at the same time an outlet for his sexual desire' (Freud 1910: 226). Freud defends himself against possible accusations of having written a 'psychoanalytical novel' by the 'attraction of this great and mysterious man' (Freud 1910: 228). The Leonardo paper starts a tradition of 'analytic biography' on great artists and writers. Like his clinical case studies it attempts to exhibit the dependence of the adult capacities and proclivities on infantile sexuality. Leonardo's paintings become another item of Leonardo's symptomatology. Freud explores the *Mona Lisa* and the *Madonna and Child with St Anne* and uses 'evidence' from the pictures to confirm the link he has postulated between Leonardo's later painting and a certain 'infantile complex'. Gombrich suggests that Freud approaches these two paintings as if they were the phantasies of a patient: 'He always took it for granted that what

we must seek in the work of art is the maximum psychological content in the figures themselves' (1966: 33).

This paper on Leonardo is the clearest exposition of Freud's views on the nature and workings of the mind of the creative artist. The problem with the 'analytic biography' tradition is that it does not account for Leonardo's extraordinary gifts and achievements or explain the origin of the creative impulse. However, when a work of art had a powerful effect on him, Freud needed to try to explain what caused that effect: 'Whenever I cannot do this, as for instance with music, I am almost incapable of obtaining any pleasure. Some ritualistic, or perhaps analytic, turn of mind in me rebels against being moved by a thing without knowing why I am thus affected and what it is that affects me' (Freud 1914: 253). He asks almost in some exasperation why the artist's situation could not be communicated and comprehended in words 'like any other fact of mental life'. He therefore has to know the meaning of the work and he has to be able to 'interpret' it. An example of this was Freud's fascination for the *Moses* of Michelangelo, visiting it every day for three weeks, studying it, measuring it and even drawing it: 'I have often observed that the subject matter of works of art has a stronger attraction for me than their formal and technical qualities' (Freud 1914: 253).

Interestingly, Freud describes *Moses* as 'inscrutable' and also comments on his 'inward fire' and 'outward calm of his bearing'. His conservative approach to art was, in the nineteenth-century tradition, judging a painting on its 'spiritual content' but, influenced by Giovanni Morelli, the founder of scientific connoisseurship, Freud drew up a 'scientific method', a schedule of forms. Freud felt that this was closely related to the technique of psychoanalysis: 'It too is accustomed to derive secret and concealed things from despised or unnoticed features, from the rubbish dump, as it were, of our observations' (1914: 265).

The whole paper on *Moses* sets out to explore whether it is a 'character study' or 'a particular moment in his life'. Freud's argument that the *Moses* is a study of a particular moment in his life is based on small touches that would normally 'slip past the barriers of attention' (Wollheim 1970). It rests on the positioning of the right hand on his beard and the angle of tablets and he infers that the 'moment' of the statue is not the inception of a violent action but the remains of a movement that has already taken place. Freud concludes: 'so that the giant frame with its tremendous physical power becomes only a concrete expression of the highest mental achievement that is possible in a man, that of struggling successfully against an inward passion for the sake of a cause to which he has devoted himself' (1914: 277).

Peter Fuller (1980), in *Art and Psychoanalysis*, explores *Moses* and also more briefly the Leonardo work to discuss Freud himself. He suggests that the two very different approaches to the papers represent two sides of Freud's investigations. The Leonardo, the intuitive, imaginative, and the Michelangelo, an empirical study of observation and measurement. It is

possible that Freud perhaps tried to control his emotional response to the *Moses* by scientifically trying to unlock its secret. (Fuller also posits that the *Moses* paper reflects the position and schisms in the psychoanalytical movement at the time. With the split over Adler and Jung, Freud was having to hold the movement together.)

These two very different papers do offer insight into Freud's view on art and artists, into the rationalist approach over emotions of the western intellectual tradition and also insight into the workings of Freud's mind. The third study of an artist and his work is that of the author Jensen and his novel *Gradiva*. This study of creative writing has been included because it is in such stark contrast to Freud's writings on the visual arts. Of the writer, Freud (1907: 68) says: 'The description of the human mind is indeed the domain which is most his own; he has from time immemorial been the precursor of science, and so too of scientific psychology' (in his knowledge of pathological mental states and the frontier between these and normal life that we cross several times a day).

In 'Delusions and Dreams in Jensen's *Gradiva*', Freud (1907) interprets the dreams of the character Norbert Hanold, the hero of the story. The story is an enjoyable romance and Freud's analysis with accompanying theoretical material from *The Interpretation of Dreams* is meticulously detailed. It is the story of a young man who has repressed his erotic instincts and put all his life's energies into archaeology. Hanold is attracted to a relief of a young girl stepping along revealing her sandalled feet. He enters into a search for her, travelling to Pompeii, unaware that his infatuation with the girl on the relief is actually a repressed affection for a childhood playmate, Zoe. His love and thought for Zoe appear disguised in his dreams, and it is these fictional dreams that Freud analyses. In the story, Hanold flees to Pompeii only to find what he has flown from, the real Zoe. She gradually cures him of his delusions and reveals herself to him in a manner similar to psychotherapy, making conscious what has been repressed, and awakening his feelings to love.

Throughout this paper Freud praises creative writers for their insight, 'but creative writers are valuable allies and their evidence is to be prized highly, for they are apt to know a whole host of things between heaven and earth of which our philosophy has not yet let us dream' (1907: 34).

It is perhaps both frustrating and disappointing that Freud's admiration for the creative writer and appreciation of his ability to work with his unconscious should not have been extended to include a study of all the arts which would have been such a valuable contribution. For instance, he compares the workings of Jensen's mind and Freud's own approach to studying the mind:

> Our procedure consists in the conscious observation of abnormal mental processes in other people so as to be able to elicit and announce their laws. The author no doubt proceeds differently. He directs his attention

to the unconscious in his own mind, he listens to its possible develop-
ments and lends them artistic expression instead of suppressing them by
conscious criticism ... But we need not state these laws, nor even be
clearly aware of them; as a result of the tolerance of his intelligence, they
are incorporated within his creations.

<div align="right">(Freud 1907: 115)</div>

Both in his paper on Leonardo and in 'An Autobiographical Study' Freud
admits the limits of his knowledge about artistic gift, work and function.
Saying that although psychoanalysts study the artist's life, experiences and
works and construct his mental constitution and instinctual impulses at
work, 'It can do nothing towards elucidating the nature of the artistic gift,
nor can it explain the means by which the artist works – artistic technique'
(1925: 65), and 'Since artistic talent and capacity are intimately connected
with sublimation we must admit that the nature of the artistic function is also
inaccessible to us along psychoanalytic lines' (1910: 228). He follows this with
the suggestion that the answer might lie in 'biological research' and this path
has been followed by later writers (Fuller, and close observers of early human
relationships such as Winnicott and Milner).

Melanie Klein

Melanie Klein was a pioneer of child analysis, discovering that all child's play
had symbolic significance. This led to the development of her play technique
in which the main task is to understand and to interpret the child's
phantasies, feelings, anxieties and experiences expressed by play, or, if play
activities are inhibited, the causes of the inhibition.

Her work developed particularly from the Freudian concept of life and
death instincts (Freud 1920). She was to lay great stress on the ambivalence
between love and hate and emphasised the child's powerful innate 'instincts'
more than the environment. Later, object-relations theorists were to give the
actual external environment greater importance, which was to include the
mother and the care for her newborn baby as a first environment (Winnicott
1988).

The terminology of object relations can be confusing. The reader might
reasonably think that it refers to 'things' rather than people, however, 'In
psychological writings, objects are nearly always persons, parts of persons, or
symbols of one or the other' (Rycroft 1977: 100).

Objects can be external, where the subject recognises the object as being
outside themselves, or internal. An internal object has acquired the signifi-
cance of an external object but is a phantom (Rycroft 1977) – an image
occurring in phantasy which is reacted to as real. They are images, derived
from external reality through introjection and conceived to be located in
internal reality. Kleinian theory is an object theory, not an instinct theory,

because it attaches central importance to resolution of ambivalence towards the mother and breast. It does, however, attach little importance to the infant's experience of actual mothering which later object-relations theorists were to do (Fairbairn 1939; Winnicott 1988). Kleinian analysis therefore follows Freud in having a dual instinct theory but prefigures later object-relations theory in attaching great importance to the first year of life.

The difficulty for the infant is how to cope with the overbearing instinctual drive in relation to the mother and the breast. Love and desire for it when it satisfies; hate and destructiveness for it as it frustrates. Envy at weaning that the 'giving' breast does not belong to it, is not under its control and fear at the loss of it. The infant has phantasies about mother and the breast. Phantasies are seen to be the mental representation, the psychic representative of instinct. Phantasies colour the infant's experience of real objects and the impact of reality constantly modifies phantasy life. Phantasy life expresses itself in symbolic ways: 'All art is symbolic by its very nature and it is a symbolic expression of the artist's phantasy life' (Segal 1975: 800).

In Kleinian terms the ego is innate, not formed by the reality principle as we saw earlier in Freud. The growth of the ego is a product of a continual process of projection and introjection. Through these mechanisms a whole world of internal objects is formed with their own phantasised relationships: 'It is this internal world, with its complex relationships, that is the raw material on which the artist draws for creating a new world in his art' (Segal 1975: 800).

Klein emphasises two worlds, an inner and outer reality, whereas Freud uses the terms unconscious and conscious. Freud outlines libidinal phases – oral, anal, genital – through which the infant develops. Klein describes two positions between which the infant oscillates in the first year of life. The first of these is the paranoid-schizoid position where the infant deals with their ambivalence towards the breast by splitting it into two separate part objects. The infant also splits the ego and projects the destructive feelings onto the bad object (breast) by which it then feels persecuted. It is a defence against realising that the 'good' breast is not as idealised as the child would like it to be in their phantasy. The second is the depressive position. The infant learns to accept ambivalence, that good and bad are aspects of the same whole object – the mother – who has an independent life of her own. In the depressive position the infant experiences total desolation and feels that their destructive hateful feelings have destroyed the good breast. They feel loss and guilt. This leads to a desire, a wish to restore and recreate, the lost loved object both outside and within the ego: 'These reparative impulses lead to growth' (Segal 1975: 800). The infant stresses their importance in human functioning. Reparative impulses contribute to good relationships, sublimation to work 'and are a fundamental drive in all artistic creativity'.

In her discussion of art and the inner world, Segal refers to Melanie Klein's work on the rebuilding of the inner world in mourning. Every time we

experience loss we are taken back to the depressive position and our original loss is relived. In mourning, we have to build our inner world as well as our external world of relationships. She feels that the artist is working through again the infantile depressive position every time a new piece of work is embarked on: 'The artist's aim is always, even if he is not quite aware of it himself, to create a new reality. It is this capacity to create and impose on us the conviction of a new reality that is, to me, the essence of art' (Segal 1975: 800).

Klein (1948) discusses the experience and work of the painter Ruth Kjar, written about by Karin Michaelis. Kjar suffered depression in the midst of happiness, feeling 'an empty space which she could never fill'. In a house full of pictures, space was suddenly created as an artist removed one of his pictures which he had only lent the family. 'This left an empty space on the wall, which in some inexplicable way seemed to coincide with the empty space within her' (Klein 1948: 232). She decided to paint in the space until a new picture could be obtained as the effect of the empty space was so devastating to her. This started her career as an artist and she went on to paint as part of her life: 'She was on fire, devoured by ardour within. She must prove to herself that the divine sensation, the unspeakable sense of happiness she had felt (while painting) could be repeated' (1948: 233).

All Kjar's work was either of women or female relatives. Klein makes a connection between the 'empty space' and the profound anxiety experienced by girls, the equivalent of castration anxiety. In the early stages of the Oedipus conflict the little girl wishes to steal the imagined contents of her mother's body for herself and destroy the mother. This is followed by anxiety and fear of retaliation, that her own body will be destroyed and mutilated. Klein concludes: 'It is obvious that the desire to make reparation, to make good the injury psychologically done to the mother and also to restore herself was at the bottom of the compelling urge to paint these portraits of her relatives' (1948: 235).

Artists are therefore able to recreate their own inner worlds and to give them life in the external world. This latter quality is important because it mirrors the original recognition that a mother has an independent life of her own.

Peter Fuller (1980) makes a very readable investigation of the *Venus de Milo*, tracing its history, damage and installation in the Louvre. He outlines attempts to date it, place it, and the varieties of reconstruction in following decades with their justifications which makes a fascinating detective story. He questions how it is that the fragmented *Venus* can appear to us as more 'vivid and authentic than the lost whole'. He finally concludes, after an exposition of Kleinian thought, that the *Venus* is a representation of the internal mother who has survived the ravages of phantasised attack. Despite fragmentation the reparative element remains dominant – she has endured throughout the centuries.

For true reparation to take place there must be admission of the original destruction or there will only be denial. Elements of ugliness and beauty

need to combine in a picture, the destroyed and the made whole. For Segal a certain 'incompleteness' is essential in a work of art: 'We must complete the work internally; our own imaginations must bridge the last gap' (1975: 800).

Adrian Stokes (1972) took up a similar position to Segal on the depressive position and restoration of the mother's body but differed in finding elements also of the paranoid-schizoid position in both artistic creativity and aesthetic experience. He associated the two modes of art, carving and modelling, with the paranoid-schizoid and depressive positions respectively. The expression is of both fusion with mother and sadistic attacks. So one can experience both a feeling of 'oneness with the breast', and therefore the world, and recognition of a separate object, the whole person of the depressive position. Segal saw this as 'manic defence – the oceanic feeling against the depressive experience' and also manic reparation disguised in sentimentality and over-sweetness (Stokes 1972: 424).

Marion Milner

Marion Milner has been a central figure in any enquiry into art and psychoanalysis. Her work has linked the development of thinking about analysis, creativity and the artistic process. Starting her working career with children and research into learning and social experience in schools, she had a brief Jungian analysis before entering into a full Freudian analysis and eventually trained as a Freudian analyst. While training, and after, she attended supervision and seminars with both Melanie Klein and Donald Winnicott. Her personal explorations into painting and her analysis of the experience make absorbing and refreshing reading in *On Not Being Able to Paint* (1950). She later extended and revised the ideas through an illuminating presentation of a treatment of a schizophrenic patient who spontaneously began to draw in *The Hands of the Living God* (1969). Her collected papers, *The Suppressed Madness of Sane Men* (1989), complete her life's work on analysis, creativity and the artistic process and provide essential reading for any would-be art therapist. In her lifetime, as honorary president of the BAAT, Marion Milner was a figurehead for art therapists. Since her death in 1998, her work continues to have particular influence on our thinking and professional development (Edwards 2001).

Whereas previous analysts had seen psychic creativity above all to preserve and recreate the lost object, Marion Milner saw this as a secondary function of art. The primary function was in creating what has never been seen by means of a newly-acquired power of perception through the interaction of conscious and unconscious modes of thinking typified in the creative process. The controversy centres around whether one is merely re-making what one has previously had, but lost, or whether there is a creation of new attitudes and relationships on the basis of the newly-created powers of insight into the

inner world. This is, of course, of crucial importance to analysts and artists because it poses the question of whether change is possible. Can something new and original be made?

To trace the genesis of her ideas, it is useful to start with Milner's own experience as a novice painter. Through her own experience of painting, she realised that the artist's feelings could be conveyed through spatial representation. She discovered that artistic skills, such as how to draw outline or the nature of colour, are not only learnt about in the outside external world but 'underwent revisions and learning' in the inside world. She began by trying to draw spontaneously, not to have preconceived ideas, but she found that the drawings expressed the opposite of the moods and ideas she intended. The discovery of spatial relationships between objects in painting led her to an exploration of the relationship between the self and the world and problems around distance/separation, having/losing:

> In play there is something half way between day dreaming and purposeful instinctive or expedient action. As soon as a child has moved in response to some wish or fantasy, then the scene created by play is different, and a new situation sets off a new set of possibilities; just as in free imaginative drawing the sight of a mark made on paper provokes new associations; the line, as it were answers back and functions as a very primitive type of external object.
>
> (Milner 1955: 92)

She thus found that there are spiritual dangers in painting. Working with outline forces the knowledge that only an imposed outline separates the world of fact from the world of the imagination. New experiments in painting arouse such opposition because there is a fear of letting in madness. (e.g. young British artists such as Dinos and Jake Chapman, or Tracey Emin). Because the artist interacts with a painting during the process of making it, she gives it something of herself. This can take her by surprise, and the artist has to then face a loss of control of what is given. Monsters within the imagination can be discovered, 'the imaginative body could often feel contracted to a tight knot inside, like a spider hiding deep in its hole' (Milner 1955: 42). When a painter begins to work on something in the external world, the medium and the imagination work together to produce something not quite as one expected so that the artist has to come to terms with 'nature inside'.

Milner explores the early relationship between mother and child discussed in the previous section, the illusion of separateness and eventual disillusion and recognition of independent existence. She suggests that 'spreading the imaginative body around what one loves' is a way of dealing with separation and loss, and states one of the functions of painting is restoring and recreating what one had loved and internally hurt or destroyed.

Milner further discusses the educational tradition which separates subject

and object, fostering an intellectual knowing that is only half of our relation to the world. Reason and logic can make for a stultifying deadness when separated from feeling. What is the role of the intuitive image? She feels that it is quicker, and it takes much longer to describe something in logical terms. It is more comprehensive, stretching back through the whole of one's experience, connecting past with present. It also embraces a bodily experience, a deeper-rooted kind of knowing than any purely logical method. Drawings are intuitive rather than logical reflections about living, a 'wholeness of certain attitudes, experiences is expressed whereas logic abstracts from the whole, eliminating the personal' (Milner 1955: 123).

Milner stresses in her book the importance of the interplay between mind and body, a whole body attention is needed in order to let the 'spontaneous ordering forces' work. The attention that she gives to a biological function and experience was taken up and used by Peter Fuller in his explorations into *Art and Psychoanalysis*, particularly in his examination of abstract painting. In order to let the spontaneous ordering forces work, a mixture of conscious attention is needed with a certain absent-mindedness – dreams, but with action. In the drawing activity there is an antithesis between a pull to total merging – mystical union and to individual will – fear of loss of identity. This is experienced in all individual and group relationships and a similar antithesis is felt between dream and external reality. Drawing can be a bridge between these states and inner and external realities.

Milner connects with her earlier work in helping children to discover a social place in school. She feels that everyone's task is to find a niche in the social world as they pass through a transition from child to adult. She sees the primary function of the creative arts to provide a perpetual well for the renewal and expansion of our psychic powers both in our own making and in our aesthetic experience. In this earlier book (1950), she begins to explore 'frames in time and space'. What is within a frame is to be taken symbolically; what is outside, literally. What is inside is symbolic of feelings and ideas. In painting, one creates one's own gap and frame and fills it. In analysis there is a reflection of the framing made in the arts by the analytic time and space which becomes a constant for the client, framing a symbolic mode of relating in the transference. Her summary at the end of the book states: 'Then it is perhaps possible to say that what verbal concepts are to the conscious life of the intellect, what internal objects are to the unconscious life of instinct and phantasy, so works of art are to the conscious life of feeling, without them life would be only blindly lived, blindly endured' (Milner 1950: 159–60).

In *The Hands of the Living God*, Milner (1969) combines an unusual keenness of thought with a capacity for reflection and allows feeling to diffuse so that we are allowed into the client's and the analyst's experience of therapy. She saw her client's (Susan) drawings as containing the essence of what they were trying to understand and work with, but in a highly condensed form, with one symbol having many meanings. The drawings

were like Susan's private language and one needed to learn how to read and speak it. Milner discusses throughout the book the role and function of the therapist and the body/mind relationship, the need to have a whole state of attention in the client including a body-ego perception. In the preface she quotes Masud Khan saying of the book: 'This is not really an account of an analysis but of a research into how to let oneself be used, become the servant of a process'.

She believed that 'the process' was the client's 'self-cure', her belief in the possibility of living creatively and being able to review oneself psychically. Susan had an inability to accept duality of symbols and things symbolised. As a child she had been unable to be in a state of reverie, of absent minded-ness in which the distinction between phantasy and actuality can be tempor-arily suspended. She had been unable to leave the care of the outside world to others. Milner describes the need for this surrender of discursive logical thinking to allow the emergence of non-discursive modes of thinking and a surrender to creative force. She describes in detail the difficulty of allowing a 'not-knowing', the 'empty headedness' which is part of the rhythm of all creative activity. This can be difficult for the therapist too; there is a need to make interpretations as a defence against 'not knowing'. One had to give this patient a body attention – 'a kind of deliberate filling out of one's whole body with one's consciousness' (Milner 1969: 45).

From the richness of the book, the story and the treatment, it is interesting to see how Milner perceived the drawings – over 4000 – during the course of treatment. She saw Susan achieving a momentary integration through the medium of the painting. It provided an 'ideal' but also an 'other' with whom to have an interchange, 'even if, or perhaps because, it is only on a "part object" level . . . thus the finished picture can when successful . . . embody an ideal state of a restored self and restored inner loved object, a permanent monument to the ideal being striven for' (Milner 1969: 96).

Drawing gave Susan a bit of contact with external reality, which she was desperate for, which was 'other' and yet completely responsive to her. She saw the paper as having a particular role, as it was a substitute for the responsive ideal mother, receiving from her hands and giving back to her eyes, a give and take on a primitive non-verbal level. It could always be there as long as paper and pencils were available. The drawings were reparative for all destructive intentions or actions. They also created a bridge between the patient and the analyst, a basis for communication, having potential meaning. The drawings were a substitute for the mirror that her mother had never been able to be to her and a substitute for the analyst between sessions. There was also a defen-sive aspect to the work, in reliving feelings for her mother, she was saved from destructive rages. The drawings were a foundation in communication so that she was able to get in touch with the deep layers of her self-knowledge from which she had been cut off. The drawings could also be seen as a placatory gift; the drawings, instead of herself, also might avert phantasised aggression

from the analyst or aggressively make the analyst crazy. They were finally a non-discursive affirmation of her own reality.

Milner explores the frame of the protective environment that is needed by the baby from its mother, and how this framework is needed for analytic work and for artistic creative activity. This links also with her thinking on body/ mind relationships as she felt that one's own inner body awareness takes over the role of the external mother. With this framing, the two modes of thinking, discursive and non-discursive, conscious and unconscious, can alternate and allow a new ordering and integration to take place. She saw this interplay between articulate and inarticulate levels of functioning as basic in all creative activity. Intrinsic to this is a belief in a bigger self than the ego; in Susan's words, 'the Self which thinks and grows regardless of conscious choice' (Milner 1969: 376).

The *Suppressed Madness of Sane Men* (1989), Milner's collected papers, develops, completes and restates much of the theoretical material inherent in the earlier works. Art provides a method in adult life for reproducing states that are part of everyday experience in healthy infancy. The withdrawal from the external world and the temporary loss of self, as conscious control by the ego, is given up. Whereas classical analysis limits the symbol to a defensive function, it is seen by Milner and other analysts as being essential for healthy growth out into the world, not defensive regression but an essential recurrent phase of a creative relation to the world. Freud saw primary process thinking as a chaotic, undifferentiated state, an 'oceanic feeling', to be a regression to an early infantile state of consciousness rather than a process of psychic renewal, a constructive element in creative life. In this latter way of looking, the two processes – primary and secondary, conscious and unconscious – are seen as complementary, both having constructive aspects but also limits.

Adrian Stokes saw the finished work of art as an encouragement to the ego. Marion Milner described it as an enshrining of an ideal integration rather than necessarily a permanent achievement of it – the real work remained to be done in the analysis and also that the actual work of art, the finished creation, never heals the underlying lack of sense of self. In contrast to this view, the work of actually painting can be seen differently:

> Representation transposes a given state from the virtual to the actual, thus fixing it in the world of phenomena . . . Once he has exteriorised an inner state the latter state for him becomes a new point of departure . . . Under all circumstances the mere fact that an inner reality has been exteriorised means that growth has passed beyond it. Thus spirit must create world upon world in order to realise itself.
>
> (Von Keyserling 1932)

Milner's work on the creative process and symbolisation and those with whom she had ongoing dialogue and who influenced her – particularly

Stokes, Ehrenzweig and Winnicott – are taken up in the following section and in Chapter 7 (see also Edwards 2001).

Donald Winnicott

In the sections describing the work of Melanie Klein and Marion Milner, we discussed the interplay between inner and outer realities in the formation of the inner world and the interplay between the two modes of thinking and feeling, conscious/unconscious, discursive/non-discursive, primary and secondary mental processes. Winnicott's special contribution to a study of the artistic process is his delineation and description of an intermediate area of 'experiencing' between inner and outer realities. He started work as a paediatrician and has made an invaluable contribution to our understanding of the nature of mother–child relationship and the importance of the real external environment in the baby's growth, adding a balance to the Kleinian emphasis on the inner world. These issues will be the subject of this section and, with the study of transitional objects and phenomenon, the 'location' of cultural experience.

In his, at one time, unique position as paediatrician and psychoanalyst, Winnicott was able to make an extensive study of the early mother-child relationship. He developed the concept of 'primary maternal preoccupation' for a state of reverie which the mother has for the baby before and during the early months of life. During this time the mother is enabled to identify with the dependence of the baby, drawing on experiences, partially relived, as an infant herself. This preoccupation makes her vulnerable herself and she needs a father to take care of external reality and impingements on her primary task, the care of her baby. In placing importance on the actual environment for the healthy growth and development of the baby, Winnicott postulated that the mother was the earliest environment for the baby, who could not live without the care only a devoted mother could give. He coined the term 'good enough mothering' for the mother who was able to offer this support, protection and reverie for her baby to enable normal health and development. As the baby grows and begins to move on from this early state of merging, the supportive ego of the mother figure has to alter, allowing a carefully graduated failure of adaptation to the baby's needs.

It was at this stage, as the baby makes first moves towards independence and separation from the mother and the mother adapts to this, that Winnicott made such interesting observations of the interplay between them. He and Marion Milner have written on the importance of illusion in symbol formation (Milner 1955; Winnicott 1988). There is an early illusion between mother and baby that the breast is part of the infant, because, if the mother can adapt well enough, the gap between wanting the breast and it being there is necessarily small. Later, the infant can begin to develop a capacity to experience a relationship to external reality, as the mother's adaptation allows objects to be separate and real, hated as well as loved.

Winnicott postulated a 'play area' of intermediate experience that is not interrupted by adults, which relieves the strain of the infant of relating inner and outer reality. He studied the 'transitional objects' and 'transitional phenomenon', objects that the baby becomes possessively attached to – for example, blanket, teddy bear. He wrote brilliantly about the feeling relationship the baby has to them and how they were essential to a baby's growth and development.

Transitional objects are of significance both for the early stages of object-relating and because they are the earliest form of symbol formation. Some babies use their thumbs or parts of their hands to stimulate the oral-erotogenic zone; others use a special object or blanket fringe which Winnicott describes as the first 'not-me' possession. He wrote that transitional objects are evidence of the 'capacity of the infant to create, think up, devise, originate, produce an object' (Winnicott 1988: 2). The object is often used for comforting, stroking the baby's face and helps sleep. Transitional objects have special qualities. The parents and family allow the infant to have complete rights over the object and do not disturb illusions about it, an area that is not challenged. Therefore the infant has 'omnipotence' over it. It is affectionately cuddled and mutilated. It must never change unless changed by the infant and must survive loving and hating. It must be seen to have a vital reality of its own. It does not come from within or without; it exists in the space between mother and baby. It is gradually allowed to be decathected as the infant naturally matures.

Winnicott has made more accessible to the general public some of the innovations of Melanie Klein in her 'play technique' with young children in psychoanalysis. His own ability to play with children as an equal imaginative 'player' has been captured in the case study of *The Piggle* (1980). He has managed to maintain the freedom and delight of play while presenting it seriously and drawing from it theoretical points of importance to any study of art and culture generally, as well as to therapy and analysis in particular. The importance of play is that it erases the boundaries between inner and external realities. He could importantly distinguish it from 'fantasy': 'It will be observed that creative playing is allied to dreaming and to living but essentially does not belong to fantasising'. He saw fantasising as interfering with actions and with life in the real external world, 'but much more so it interferes with dreams and with personal or inner psychic reality, the living core of the individual personality' (Winnicott 1988: 32).

Fantasy is seen as wish-fulfilment; that is, instead of action, an alternative to an interaction with the real world: 'in fantasy an object has no symbolic value as in a dream'. He saw that playing has a space and a time. It is a development of earlier transitional phenomena and takes place in the 'potential space' between mother and child – that is, it is not 'inside' or 'outside' a person but in the 'place' in between. He felt that it is only by 'doing' things that one can control what is outside, and 'playing is doing'. Play facilitates

growth, is universal and leads into group relationships. He saw it as being the basis of communication in psychotherapy and that psychoanalysis is a highly specialised form of play: 'Psychotherapy takes place in the overlap of the two areas of playing, that of the patient and that of the therapist. Psychotherapy has to do with two people playing together' (Winnicott 1988: 44). He saw that, where play was not possible, the work of the psychotherapist was directed to bringing the client 'into a state of being able to play'. He knew that children played more easily when the other person also has the freedom to play. In play, the child is free to be creative. For both children and adults, in creativity there is the use of the whole personality and one can discover the 'self': 'Playing is always the precariousness of the interplay of personal psychic reality and the experience of control of actual objects' (Winnicott 1988: 55).

The transitional object is the child's first use of a symbol and the first experience of play. At the stage of separation of mother and baby the transitional object becomes a symbol of union. The 'potential space' designated as the play area between mother and child becomes and develops as the 'location of cultural experience'. Both Milner and Winnicott have written about the interplay between originality and the acceptance of a tradition as the basis for inventiveness – the precursor of this is the experience of separateness and union with the mother. Winnicott saw creativity as a feature of life and total living. Like Milner, Winnicott saw the need for experience of a non-purposive state, a ticking over of the unintegrated personality, experience of formlessness. This needs to be reflected back, a role that is performed by mother in infancy and the therapist in analysis, and by the conscious mind in a healthy growing individual. It is the mirror role of the mother and therapist in treatment. Winnicott saw that cultural experience begins with creative living first manifested in play:

> Freud did not have a place in his topography of the mind for the experience of things cultural. He gave new value to inner psychic reality, and from this came a new value for things that are actual and truly external. Freud used the word 'sublimation' to point the way to a place where cultural experience is meaningful, but perhaps he did not get so far as to tell us where in the mind cultural experience is.
>
> (Winnicott 1988: 112)

In summary, Winnicott explored and gave names to a series of concepts of importance to art therapy, from the child's first use of symbol, transitional object, the necessity of illusion, the importance of play to the location of cultural experience. As the child matures, this area of experiencing widens to take in experience of art, religion, philosophy – all ways of 'working' with inner and outer realities. This can be seen by Winnicott's idea of art as a vital aspect of man's adaptation to the world. This is clearly expressed in his views of artists:

They do something very valuable for us because they are constantly creating new forms and breaking through those forms only to create new ones. Artists enable us to keep alive, when the experiences of real life often threaten to destroy our sense of being alive and real in a living way. Artists best of all people remind us that the struggle between our impulses and a sense of security (both of which are vital to us) is an eternal struggle and one that goes on inside each of us as long as our life lasts.

(Davis and Wallbridge 1981: 50)

Jung, symbols and the transcendent function

We began this chapter with the idea that the explorations of psychoanalysis into the artistic processes was a search for the meaning of the component of desire in a painting. Up to now we have been intensely aware of the loves and hates of the infant and their permeation through adult life. One of the differences between Freud and Jung was in their understanding of personal development: 'Neurosis is the result of the compromises and distortions which personal history forces on our archetypal nature' (Stevens 1986: 135).

Jung agreed with Freud that the origins of neurosis lay in childhood but felt that the aim of treatment was to discover what aspects of the archetypal programme for the individual life cycle had not been activated or experienced. Therefore the aim of analysis was not to purge clients of infantile frustrations but to release blocks and aid them to live unlived lives. He felt that the key to treatment lay in a dialogue between analyst and client and, conscious and unconscious, through the language of symbols.

Jung's ideas developed partly through his special concern with patients of middle age. He saw neurosis as a 'self-division' or the suffering of a soul that had lost its meaning. The purpose of therapy was to heal this split, to re-establish the natural dialogue between conscious and unconscious in order to obtain 'psychic' equilibrium; a balance could be achieved through mobilising the 'transcendent function' of symbols. In working with his clients he felt that it was 'less a question of treatment than of developing the creative possibilities that live in the patient himself' (Jung 1970: 70). Many of his clients would come to analysis feeling 'stuck' in their lives and he would work with dream images to reveal hidden possibilities, what was forgotten or lost in the personality which had led to a one-sided development. They would experience this one-sidedness as a feeling of 'senselessness and emptiness' (1970: 70).

In exploring a Jungian approach to imagination one is immediately involved in a whole new terminology. Central is the importance of a search for meaning, encompassing religion and concepts of soul and spirit. In this section we will describe some of Jung's key concepts to allow his picture of the mind to contribute to our understanding of creativity, symbols and the

workings of the unconscious. Mental illness was seen as having a subjective meaning representing an individual's solution to the problems of life at a particular stage in that person's personal history. Jung saw 'the psyche' as a self-regulating system that maintains itself in equilibrium 'as the body does'. He felt that when a narrow one-sided conscious attitude to life developed, the individual's unconscious would attempt to balance this by giving a true picture of the subjective state. Dreams could therefore be seen as compensating a conscious attitude. His idea of psychic energy can be seen as a play of opposites.

The inherent goal of the human psyche is seen as a quest for wholeness, for individuation which would usually be a process developing in the second half of life. Jung differentiated stages of life, in that the young develop particular aspects of themselves in order to establish life in their work, family, social relations etc. The ideals and values that they build on become unsatisfactory in the second half of life when people often feel a need to find a new purpose and meaning. It is often in the 'neglected, inferior and undeveloped' side of the personality that the qualities they now need are to be found: 'The individuation process is sometimes described as a psychological journey' (Fordham 1966: 79). During the journey the individuals meet with their shadows (all the unrecognised aspects of themselves) and the archetypes of the collective unconscious. If they are able to meet and understand these unlived contents of their unconscious the goal of individuation, selfhood or self-realisation will be known, often designated as the self. By this term Jung suggests that the ego is a *part* of the self and not the whole. But it is a dangerous and difficult path presenting the travellers with fear and madness as they encounter all the terrifying and unwelcome aspects of themselves in chaotic dreams and fantasies:

> The psychological elucidation of these images, which cannot be passed over in silence or blindly ignored, leads logically into the depths of religious phenomenology. This history of religion in its widest sense (including therefore mythology, folklore and primitive psychology) is a treasure-house of archetypal forms from which the doctor can draw helpful parallels and enlightening comparisons for the purpose of calming and classifying a consciousness that is all at sea. It is absolutely necessary to supply these fantastic images that rise up so strange and threatening before the mind's eye with a sort of context so as to make them more intelligible.
>
> (Jung 1980: 33, CWI2: para. 38)

Jung felt that the best way to do this was to make use of comparative mythological material as well as to work with the parallels he discovered between individual dream symbolism and medieval alchemy. Alchemical symbolism could provide a key to the symbolism in dreams. Jung saw it as essentially a

philosophical system inspired by the hope of solving one of the mysteries of life, the connection between good and evil, or how base aspects of life can be transmitted into the noble. Clearly, within the unconscious the neglected and unwanted aspects of ourselves, if accepted consciously, could provide the key to meaningful life in the future, within a new organisation of the personality.

In Jungian terms the psyche is seen as having a symbol-forming capacity, symbols being the natural mode of psychic expression. Jung rejects the Freudian idea that symbols are forbidden wishes in a disguised form. He saw them as having a 'higher' purpose than a manifest content concealing a latent or repressed desire. Symbols were channels for unconscious processes to become conscious. He found that it was very limiting to attempt to pin down a meaning of a symbol in words, and that it was possible to express dream images directly in visual forms rather than sentences. In this way their emotional charge was kept alive, as was the possibility of many meanings which might emerge. When working with people who felt stuck, ill and divided, out of touch with their vitality, Jung would see his work as mobilising inner psychic resources through the transcendent function of symbol-making towards greater integration and individuation.

Being trapped in a play of opposite feelings, of ambivalences, often makes human problems seem insoluble. If this happens, one needs a new perspective; perhaps they cannot be solved as such, but outgrown or transcended. Symbols are a unification of opposites in a single entity. They can be seen as natural attempts by the psyche to reconcile and reunite often widely separate opposites. This capacity of symbols to unite conscious and unconscious into a new synthesis is what Jung called the transcendent function. In his work Jung made use of two techniques. One was the way of creative formulation which encompassed phantasy, dreams, symbols, art and active imagination. The second was the way of understanding which used intellectual concepts, verbal formulations, conscious awareness and insight. He felt that these two capacities of the mind were bound in a compensatory relationship. Jung felt that the creative activity of the imagination freed man from his critical stance towards the 'playful' side of his nature, the dismissive 'nothing but' with which one could ignore dreams, phantasies etc.: 'My aim is to bring about a psychic state in which my patient begins to experiment with his own nature – a state of fluidity, change and growth, in which there is no longer anything eternally fixed and hopelessly petrified' (Jung 1970: 176). One of his methods was that of 'active imagination' where he would try to release creative possibilities latent in the client, a deliberate use of phantasy and dream as a method of healing.

Jung's method of treatment was firmly based in a sense of self-healing being possible. If analysis was necessary to define conflicts and complexes, then after that the main body of work consisted of activating unlived elements of the self. Stevens (1986) suggests that in Jungian work there is less dependence on the transference relationship with the analyst as the clients

have increasing security in their inner relationship to the archetypal components being activated in their lives and their growing recognition of the creative potential of the self. When individuation is on its way, transference is superseded. It is essential for clients to learn to 'let things happen' in the psyche. The art of action through non-action could be seen as a basic tenet of art therapy too. Jung (1972) describes in very human terms the enormous difficulty of letting things happen because consciousness is always interfering. He goes on to describe the objections of the cautious mind, however determined the individual is to continue, and the criticisms and depreciations afterwards – all states of mind familiar to the the artist and art therapist. It is because of the difficulties in learning this process that he introduced the idea of writing, visualising, drawing and painting the fantasy fragments.

Jung felt that while the client relied on the analyst to explain dreams, they would remain in a state of childhood dependence. He would wait for the client to have a special or colourful dream and then suggest that they paint it:

> Although from time to time my patients produce artistically beautiful creations which might very well be shown in modern 'art' exhibitions, I nevertheless treat them as wholly worthless according to the tests of serious art . . . It is not a question of art – or rather it should not be a question of art – but of something more, something other than mere art: namely the living effect upon the patient himself. The meaning of individual life, whose importance from the social standpoint is negligible, is here accorded the highest value, and for its sake the patient struggles to give form, however crude and childish, to the 'inexpressible'.
>
> (Jung 1970: 79)

Like all the clearest and most inspired writers about art, Jung based his theories on his own experience of painting and reflections on the process. His 'Red Book' contains images made during a disturbed period of his life, after his split with Freud. He therefore had his own experience to draw upon when encouraging his patients to paint. In painting, his patients left a childish passive state for an active one; busying themselves with the fantasy increased its effect upon them. It also taught them a method that they could use again and so aided a growth of independence on the way to psychological maturity. He thought that the pictures patients painted of dream images had special qualities. They had often barbaric colours and an intense archaic quality, a primitive symbolism. They were formed from symbolistic currents in the evolution of man, from the collective unconscious. These pictures spring from a need to reconcile the psyche part of our primitive past with present-day consciousness. In treatment the pictures needed to be intellectually understood as well as accepted emotionally and then they could be consciously integrated, helping to form a new centre of equilibrium in the personality.

Jung posited a division in the unconscious between a personal unconscious – containing repressed memories, wishes and emotions as well as subliminal perceptions of a personal nature – and a collective unconscious.

The collective unconscious contains psychic contents which are not common to one individual, but to many. These he perceived to be at a deeper level to the personal unconscious. An archetype is a content of the collective unconscious which is the psychological counterpart of an instinct. Archetypes are expressed as collective images or symbols. This can be understood not so much as a question of inherited ideas but of a functional disposition to produce the same or very similar ideas. Symbols, therefore, can be either collective or individual.

In 'Psychology and Literature' (1970), Jung turned his reflections to looking at art made outside the analytic context. Jung saw the work of art, 'the vision', as coming from outside personal experience. He argues that if we look at 'the vision' as coming from personal experience it then becomes 'a substitute for reality', stripped of its primordial quality, it is 'nothing but' a symptom of the artist's disposition. It becomes impossible for us to explore the work of art in its own right. He argues that 'the vision' 'is true symbolic expression – that is, the expression of something existent in its own right, but imperfectly known' (Jung 1970: 187). He thought that it was contents from the collective unconscious that formed 'the vision' and that these manifestations of the collective unconscious were compensatory to a conscious attitude, bringing a one-sided consciousness into equilibrium in a purposive way:

> The personal idiosyncrasies that creep into a work of art are not essential; in fact, the more we have to cope with these peculiarities, the less it is a question of art. What is essential in a work of art is that it should arise far above the realm of personal life and speak from the spirit and heart of the poet as man to the spirit and heart of mankind. The personal aspect is a limitation – and even a sin – in the realm of art.
>
> (Jung 1970: 194)

Jung saw the artistic disposition as involving 'an overweight' of collective psychic life as against the personal. He thought that art was a kind of innate drive, an instinct, that seized a human being and made him its instrument. Artists were not people endowed with free will who could seek their own ends, but people who allowed art to realise its purposes through them. He therefore saw a 'ruthless passion for creation' and the artists' 'personal desires' as being at war within them. Rather than art arising from the artists' personal problems, he saw art giving rise to problems in the artists by the developments of their abilities in one direction leading to a heavy drain on their other capacities which gave rise to difficulties in the personality.

Jung therefore saw artists as drawing upon the healing and redeeming

forces of the collective psyche that underlies consciousness. Artists are subordinate to these forces and through their work bring a balance to an epoch.

The work of Jung was a major influence on the early development of art therapy in Britain, particularly inspiring the Withymead Centre where art therapy acted as an adjunct to psychotherapy during its 25 years. Irene Champernowne was instrumental in the founding of Withymead and starting the work of the Champernowne Trust, which still continues. She painted a great deal in her training analysis with Jung and felt that it had a profound effect upon her. She was aware that words were a difficult medium through which to convey our deepest experience of life: 'It was clear that the mind was filled with visual and oral images, which are comprehensive and suitable containers for emotions and ideas that are otherwise inexpressible' (Champernowne 1969: 1). She was also aware of the compensatory nature of the arts to the current conscious attitude which valued words and logic: 'Perhaps even more today when the intellect and cerebral activity is too highly valued to the exclusion of feeling, man is turning for very life to the means of expression in the arts' (p. 2). She did, however, characterise the work of art therapy and psychotherapy as an 'uneasy partnership'. She felt anxious about art therapy without the support and help of psychotherapy because of the possibility of the overwhelming nature of images produced. As the profession has developed in Britain, so has the understanding of the importance of experience of personal therapy for art therapists whereas, in the early days, in outside special situations, like Withymead, there was considerable overlap of art therapy, remedial art, recreation and art teaching so that the role and functioning of art therapists was less clear.

Summary

This chapter has attempted to encompass a range of psychoanalytic thinking about art processes, starting with Freud and moving through the object-relations school into the analytical psychology of Jung. Many art therapists work within one of the analytical frameworks described and many also draw inspiration and understanding from more than one. It is unfortunate that the split between Freud and Jung seems to have cut off Jungian insight into the spiritual dimension of man's life from British mainstream psychoanalysis. It is often difficult to find bridges between a classical analytical approach and his work, which had such early influence on an older generation of art therapists, and which still permeates art therapy in Britain today.

'The Arts, coupled with Psychotherapy, is a road to greater consciousness and brings about a more creative participation of each human being in their individual spiritual destiny within this world of time and space' (Champernowne 1969: 10).

References

Champernowne, L. (1969) Art therapy as an adjunct to psychotherapy, *Inscape*, 1.

Davis, M. and Wallbridge, D. (1981) *Boundary and Space*. London: Karnac.

Edwards, D. (2001) On re-reading marion milner, *Inscape*, 6(1): 2–12.

Fairbairn, W.R.D. (1939) The ultimate basis of aesthetic experience, *British Journal of Psychology*, XXIX: 100.

Fordham, F. (1966) *An Introduction to Jung's Psychology*. Harmondsworth: Penguin.

Freud, A. (1979) *The Ego and Mechanisms of Defence*. London: The Hogarth Press.

Freud, S. (1907) Delusions and Dreams in Jensen's *Gradiva*, in *Art and Literature*, Pelican Freud Library, Vol. XIV. Harmondsworth: Penguin.

Freud, S. (1910) Leonardo da Vinci and a Memory of his Childhood, in *Art and Literature*, Pelican Freud Library, Vol. XIV. Harmondsworth: Penguin.

Freud, S. (1914) The Moses of Michelangelo, in *Art and Literature*, Pelican Freud Library, Vol. XIV. Harmondsworth: Penguin.

Freud, S. (1916) Lecture XXIII: The Paths to the Formation of Symptoms, in *Standard Edition*, Vol. XVI. London: The Hogarth Press.

Freud, S. (1923) The Ego and the Id, in *Standard Edition*, Vol. XIX. London: The Hogarth Press.

Freud, S. (1925) An Autobiographical Study, in *Standard Edition*, Vol. XX. London: The Hogarth Press.

Fuller, P. (1980) *Art and Psychoanalysis*. London: Writers and Readers.

Gombrich, E.H. (1966) Freud's aesthetics, *Encounter*, XXVI, 1(January).

Jung, C.G. (1970) *Modern Man in Search of a Soul*. London: Routledge & Kegan Paul.

Jung, C.G. (1972) *The Secret of the Golden Flower*. London: Routledge & Kegan Paul.

Jung, C.G. (1980) *Psychology and Alchemy*. Princeton, NJ: Bollingen Series.

Klein, M. (1948) Infantile anxiety situations reflected in a work of art and in the creative impulse (1929), in *Contributions to Psycho-Analysis 1921–1945*. London: The Hogarth Press and the Institute of Psychoanalysis.

Milner, M. (1950) *On Not Being Able to Paint*. London: Heinemann.

Milner, M. (1955) The role of ilusion in symbol formation, in M. Klein *et al.* (eds) *New Directions in Psychoanalysis*. London: Maresfield Reprints.

Milner, M. (1969) *The Hands of the Living God*. London: Virago.

Milner, M. (1989) *The Suppressed Madness of Sane Men*. London: Tavistock.

Rycroft, C. (1977) *A Critical Dictionary of Psychoanalysis*. Harmondsworth: Penguin.

Rycroft, C. (1985) *Psychoanalysis and Beyond*. London: Chatto & Windus.

Segal, H. (1975) Art and the inner world, *Times Literary Supplement*, No. 3827 (18 July): 800–1.

Segal, H. (1991) *Dream, Phantasy and Art*. London: Tavistock/Routledge.

Stevens, A. (1986) *Withymead: A Jungian Community for the Healing Arts*. London: Coventure.

Stokes, A. (1972) *The Image in Form: Selected Writings of Adrian Stokes*. Harmondsworth: Penguin.

Von Keyserling, E. (1932) *South American Meditations*.

Winnicott, D.W. (1980) *The Piggle*. Harmondsworth: Penguin.

Winnicott, D.W. (1988) *Playing and Reality*. Harmondsworth: Penguin.

Wollheim, R. (1970) Freud and the understanding of art, *The British Journal of Aesthetics*, X(3) (July): 211–24.

The image in art therapy

Images made in art therapy embody thoughts and feelings. The image mediates between the unconscious and conscious, holding and symbolising past, present and future aspects of the person who has made it. In this sense the image acts as a bridge between the inner world and outer reality. In a picture, ambivalence and conflict can be stated and contained. Through the process of making an image in art therapy, the client gives form to what seems inexpressible or unspeakable through the process of making. Also important is the inner experience of seeing outwardly – the aesthetic experience. Through an aesthetic experience, the art therapist, with the client's permission, can enter and share the client's world and the client can make herself known and found: 'In art, maker and beholder share the comprehension of an unspoken idea' (Langer 1963: 250).

To describe the therapy process, let us follow an image in the way it was made, as observed by the art therapist, and the client's subsequent understanding of its significance and the insight that was gained when he came to speak about it. A young man, in his early twenties, was attending an art therapy group for the first time. He made the following model during one session. He took some clay and shaped it into a bowl. He then made a figure bending over the bowl as if vomiting into it. The 'vomit' was made of curled up tissue paper of different colours, adding paint to make a rich mixture. Another figure was made to one side, watching. He then moved the second figure to feed the first figure with a spoon from the bowl. The contents of the bowl had changed from 'vomit' to 'food'. He added another hand to the second figure who now was also feeding itself. Sitting back from the scene he had made, the client, as though feeling vulnerable, took a piece of very fine transparent film to put a cover over the bowl. Sitting back from his model again there was a sense of awe as the 'vomit-food' had now changed as if it were glittering precious jewels (the paint was wet on the tissue). The model felt extraordinarily important to him; he had made a profound discovery during the process of making.

This describes the therapeutic process using the analogy that Jung often used comparing therapy and alchemy, the transmutation of base matter into

gold. In therapy, angry, sad and difficult feelings can be 'spewed out' in a jumble like vomit. These feelings are contained by the therapist within the room, the bowl. The therapist helps the client reincorporate these unwanted thoughts and feelings, to understand them, the food. The understanding of these unwanted or unliked aspects of self is reincorporated at a different level of meaning and, becoming precious matter, is experienced like 'jewels' in the development and growth of the individual. The client is actively engaged in this process. The healthy part of the client aids the sick part, feeding it and, in doing so, feeds itself.

The image presented these thoughts and the accompanying feelings to the client during the process of making and afterwards in exploring it with the group. What qualities do images have that enable them to do this? It is useful at this point to picture the mind as having two processes or ways of working. These were described by Freud as primary process and secondary process thinking and have been explained fully in Chapter 5. The symbolism of the secondary process is discursive, conscious rational thinking which is described through words which have a linear, discrete, successive order. The image itself, however, presents its constituents simultaneously, not succes-sively; it operates imaginatively but cannot generalise. The symbolism of the primary process is therefore non-discursive, expressed in visual imagery rather than words. Its complexity is not limited by what the mind can retain from the beginning of an apperceptive act to the end (see Chapter 7).

Images made in art therapy continue to reveal new meanings or suggest different thoughts and feelings as they continue to be worked with through the therapy process. They are a concrete product at the end of the session that can be referred to later or seen afresh as they take their place within a sequence of images made. Several authors (Milner 1950; Langer 1963; Rycroft 1985) have written about the difficulty of using words to describe image-experience. In this chapter we shall attempt to struggle with this dif-ficulty and present ways in which the image works in art therapy and ways in which the art therapist works with the image.

In art therapy both therapist and client are responding aesthetically to the image made. It is being perceived and re-perceived by therapist and client, entering our imaginative lives on a different level from a verbal exchange. We are sharing an experience, an unspoken idea. The value of this exchange is not lost for those clients who have no speech, are inarticulate about feelings or do not trust words. The client mentioned above had already been 'influ-enced' by previous images made in his group. They had entered his imagina-tive life. He had unconsciously taken in parts of other people in the group. These dynamics will be described more fully in Chapter 10. Here let us look at two aspects of this influence.

Earlier in the group, another man had made a clay model of a dream he had had the previous night. In the dream he had gone into a restaurant and asked for a particular fruit to eat, but he had been given a strange fruit which

he had never tasted before, in a bowl. This dream and the making of it in clay within the group helped to give meaning to the art therapy process he was experiencing for the first time. Here the dream image presents the thought of it being like a strange fruit which tasted good. One can see how this dream experience had entered the imaginative life of the first client and how he had taken it from the containing bowl. The fine plastic film used by the first client had entered the group after being requested by a woman who wanted something to protect her clay model. It was then used by another woman to cover bare legs painted in a picture, because they felt exposed and vulnerable. The first client then used the film to cover his bowl which transformed its contents to precious jewels and protected his own feelings of vulnerability.

In an art therapy room the contents of the room, practical art materials and the psychic content of the group interact and affect each other and influence the imaginative lives of each individual that uses the room. The art therapist is also part of this process. In the first image described, the therapist appears as the watching figure, which is also the part of the client which forms a working alliance with the therapist. By processing this through thought, the therapist 'digests' the material in the image in a way that can be given back to the client. The 'spewed-out' material is transformed into a form of food that is 'digestible' and therefore meaningful. The image becomes a container for these undigested feelings which can then be transformed into meaning (Dalley 2000). In order to be a 'container' for the patient and the image, the therapist also feeds herself. The therapist has previously worked in her own therapy and has made a similar 'journey' to the one the client is making. She also continues to learn by going to supervision and continuing her own therapy when necessary. In this way she feeds herself while feeding the client who is also feeding himself in the image.

Mess and materials

The materials in art therapy can be used in many different ways to indicate states of mind, profound feelings, thoughts and ideas. The room must feel safe enough to do this and open access to materials makes available many possible avenues of expression. Clients will often use quite different materials in each session or within the same session. Their style of working may well change considerably through a period of time, at different stages of the therapy.

Let us first of all look at the power and qualities of some different mediums that will form part of the choice offered to the client. We have already seen that clay has the advantage of being a malleable three-dimensional medium. This can be of particular value with those clients suffering from psychotic symptoms or autistic states of mind and has been explored by various writers (Killick 1993, 1995, 1997 and Foster 1997 with adults; Case 2005 and Dalley forthcoming with children). Form can be made, figures

moved, new parts and colour added or taken away or it can be combined with many different materials. Clay can be hollowed out to contain, or one can use poles inside it to build a structure. New clays are available that are self-hardening so that a kiln may not be necessary. It can be kept damp at the end of a session and worked on over a period of time. Clay encourages a very physical involvement that aids release of body tensions which helps emotional release. For this reason it can be a most powerful medium with which to work.

Two further examples illustrate this process. A 5-year-old boy rushed into an individual session, eager to find the cup that he had made out of clay the previous week. On finding it he cried out with disappointment: 'Oh no, it's broken'. He showed the cup to the therapist in dismay, pointing to a tiny hole which was almost indiscernible to her. It was as if his whole world had shattered. The therapist recognised how much the broken cup reflected his own internal feeling of being broken. She responded to the boy's distress and anxiety by reflecting on how difficult it was for him to see his cup damaged, with a hole in it. She reflected on his upset feelings. He then suddenly said, 'I can paint it' and proceeded busily to mix thick paint and restore his precious object. Symbolically this was very significant for him. His experience of his external world was of being let down and disappointed. Defending against the pain of constantly feeling let down, his reaction to the 'broken' cup reflected an internal experience that had come to be his expectation of the world generally. In the transference the therapist had also become someone who let him down as his cup was not protected and kept safe enough for him. Doing something about it for himself enabled him to feel that he could control his world to some degree and this helped him to feel less hopeless and powerless.

Another example was a woman in her twenties who came to work in a five-day art therapy workshop. She came the first day and took clay from the bin and, sitting in the same place with her back to the therapist and most of the rest of the group, began making what looked like a small figure. For the whole week she worked on this figure, only four inches long, taking great care over details of features of the face, ears, hair, fingers. She made a perfect figure, and crying silently throughout began to tear sheets of material and bind it round and round. She then made a small box out of cardboard and placed the embalmed figure into it, shaking with grief. At the end of the five days, she had completed what was now obviously a coffin. The group respected her sadness and did not enquire too deeply about her image, but at the end she was able to tell the group that the figure she had made was that of her younger sister to whom she was devoted, and who had died as a young girl. In their grief the family had sent the other siblings away, preventing them from attending the funeral and therefore mourning her death. Making the image had enabled her to look at this again and say 'goodbye' to her sister. It was as though the group became her family in the sharing in and support of her grief.

In both these examples, reconstruction can enable reparation and working through of loss. In other circumstances, art may be used to explore other issues for which a specific medium might be chosen. An adolescent girl of 14 made the image shown in Figure 6.1 using felt-tip pens. The stencils were part of an 'infant set'. Each one was carefully placed on the A4 paper and drawn around. Then it was coloured in with pink felt-tip. Finally, each item was carefully framed in its own square. During this session, a court hearing was taking place to decide whether she would remain in care, as she was currently under a 'place of safety' order, or whether she was to go home. Her intense anxiety about the hearing was contained through the making of this image.

We have already seen how the art therapist and room act as a container for the client. The picture or model act as a further frame within which emotions may be disclosed and held. In her intense anxiety each item from her child-hood, kitten, home, ball, teddy, doll and pram is framed within the picture frame so that nothing might break out. The babyhood items are comforting, filled in with baby pink, but also communicate her level of need to be held and contained by the therapist as if she were a baby. In drawing round and filling in these stencil items her more mature self shelters and cradles the baby parts inside. Felt-tips are a useful medium for this purpose because they are controllable, feel safe and are more predictable. Unlike paints and paint brushes, one colour will not suddenly run out and mix with another.

It may take many months of working in therapy until a client feels ready to disclose emotions. During this long waiting process the images may embody and reflect, as well as present to the client, the defended position taken by her. A first sign of a growing relationship with the therapist is sometimes shown quite simply by the patient experimenting with mixing colours. The making of a new colour from two given colours may symbolise the meeting of two minds and the creation of a new perspective. Schaverien (1992: 102) has described two different kinds of image to do with the 'life in the picture': 'The embodied image *embodies unconscious processes,* while the diagram may *evoke unconscious processes through associations made in relation to it.* Thus the diagram depends for its therapeutic effect on discourse subsequent to its creation. The embodied image, on the other hand, reveals the links and unconscious connections within itself; so discussion of the embodied image may serve to reduce rather than amplify meaning'.

Schaverien suggests that the diagrammatic image is an illustration of a mental image and may be indicative of a certain detachment in the thera-peutic process. This kind of image is sometimes supplemented by words. The embodied image occurs when there is a more intense engagement by the client in the therapy process. The picture embodies the transference and is intensely symbolic, holding meaning on different levels which cannot be reduced to words. Both kinds of picture may occur in art therapy (Schaverien 2005).

It is not the job of an art therapist to encourage the spilling out of

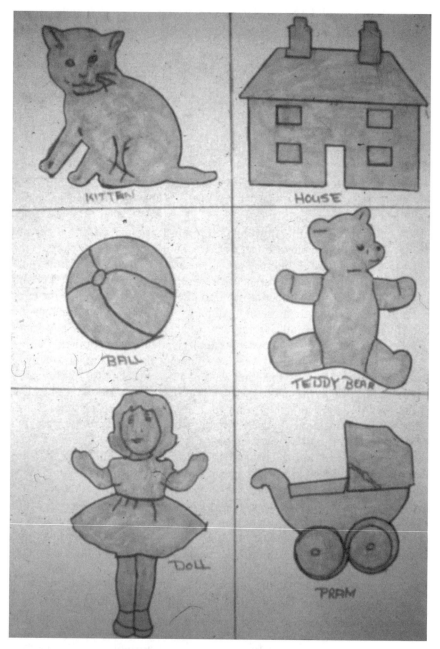

Figure 6.1 Stencil.

emotions but, in fact, to help the client feel that her feelings, however difficult to express, will be contained, listened to and understood. Each person in therapy will develop at her own pace, when she has trust in the therapist and setting and feels ready inside. A child of 10 made the three images of castles shown in Plate 1. The first was made on grey paper reflecting his sad, angry feelings. The portcullis on the doorway can be seen like teeth barring entry to the castle. It reflects that he was unable to talk about his situation to the therapist. The uneven black windows stare like sad upset eyes at the viewer. The tower of the castle stands up, a phallic shape, pushing into the black sky which rages like a tempest above. This child was in the difficult situation of being the only offspring of parents who had divorced and remarried, both having started new families within their new marriages. He lived alternately with each parent for six months. The strain of this way of living with no settled home took its toll and his unhappiness was expressed by his delinquent behaviour. He was eventually taken into care and the pictures were made in an assessment centre. He dressed as a miniature 'skinhead' with cropped hair and large boots. His pictures of castles seemed to present a similar 'fortress' in terms of his self-image. The upstanding phallic towers reflect his macho stance to the world of invulnerability and toughness, hiding the sad little boy inside. The next image is calmer, on white paper. He painted his name above it but wiped it out in an arc, like a black rainbow. It has no windows, as if the 'child inside' has retreated, but to a safer place; the fortress image remains like a statement.

He continued to draw castles. The next uses colour for the first time and larger paper. The doorway is blank but there is a drawbridge into the castle, suggesting a possible way of making contact. He is beginning to feel more secure with therapy and more contained in the sessions. It sometimes feels as though clients are not progressing in therapy when they draw repetitive images. This could indicate that they feel stuck, but it is usually found that each picture is different and that tiny changes will reflect movements internally in the client's understanding or progress. This child was stuck with a defended image of the castle which reflected his internal defences to a situation in the external world. It didn't change during his short time at the assessment centre because his external situation was at an impasse at the time. However, the changes shown reflect his entry to the centre and the way that he was able to become a part of that community in that the castles grew larger and larger and became peopled. His defences were needed until he would be able to explore his family situation in depth.

We can see from the above description how colours take on a symbolic value that has individual significance to the client and they may also reflect cultural values. This child used black paint on grey paper to express his initial angry sadness. The pictures lightened and became coloured as he felt more stable and had a place within the centre. Paint has more subtle possibilities in aiding the expression of feelings than, for example, felt-tip. It flows more

readily and large areas can be covered with a variety of brush sizes and paper sizes. Clients may change mediums within a session as they search for the material that will match their mood or feeling. It is a common experience when one has been immersed in a painting with intense involvement to feel that it was as if the medium, clay or paint, has taken one over, directing one in what to do. It is at times like this, when one starts out to consciously make one thing and then finds something else being made, that unconscious preoccupations surface.

An adolescent girl who had been referred to a mixed age art therapy group helped some younger children to use finger paints (see Figure 6.2) over several sessions, spending time playing with them and not directly working on her own problems. She had been referred after the death of her mother. When her mother died, the girl had gone to live with her father and his girlfriend but had not been able to settle into the new order of life. In one session, after helping the younger children to use finger paints, she started to use them herself, creating a line of happy people and a smiling sun. As the picture seemed to come to an end she moved on to the other paints and swiftly painted another two pictures. The first is an extraordinarily vivid portrait of her mother (Plate 3) who had frequently been drunk and had died of alcohol-related problems. The clownish smiling face of her mother, the eyes lacking focus, is a skilled portrayal of someone suffering alcohol

Figure 6.2 Finger paints.

abuse. The second picture, of a death's head mask (Figure 6.3), was an attempt to give form to her loss. When one feels a loss it often doesn't have a shape in the mind, but an emptiness. Her interaction with the medium enabled her to personify death. Once these 'inexpressible' feelings have a shape she begins to be able to explore them verbally as well as through a sequence of images.

Many types of materials will be available in an art therapy room. Here we have just looked briefly at the qualities of clay, felt-tips, paint and finger paints. Artists considering training will already have experienced the different qualities of various mediums making their own art work and will be familiar with the usual range available for clients' use. Each art therapist will make available as wide a choice as possible, depending on the environment and resources, as we have already seen in Chapter 2.

The work in the art therapy room involves deep exploration and expression of feelings within the space, using the materials freely for this purpose. But the reason for choosing certain materials and the way the feelings are expressed are essential parts of the communication. While the therapist is working towards the containment of anxieties, when spilling out and messing occurs to an unacceptable level, this is thought about within the relationship as an important communication. One example is a child who took bottles of paint and squeezed them out, one after the other, as if with no intention of using the paint for any other purpose. The therapist came to understand that the child was experiencing acute anxiety. Without intervention by the

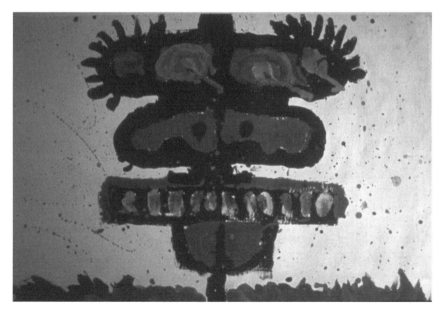

Figure 6.3 Death's head mask.

therapist, she had given permission to continue doing this, which made the anxiety intolerable. The therapist had to decide whether it was her own anxiety about waste of paint or something that was being communicated by the child in terms of her inner chaos and fear of lack of control. Did she feel that she was emptying out or being emptied out? These were questions that the therapist had to consider in her own counter-transference response. By intervening and thinking with the child about her actions, maybe asking her why she was doing this and what it meant to her, the child was able to get hold of something for herself. Rather than just let it pour out, and use the external container of the therapist to place limits on this, she was able to feel what it was like to put a limit on herself and feel internally contained – something she found very difficult.

These incidents are part of the process of working with the client's interaction with the materials and facilitating an understanding. Another example is the child or adult who resists using other materials except felt-tip or crayon to prevent getting dirty or in a mess. Anxiety about mess and losing control can be explored through experimenting with different materials. Risking losing control by using paint, mixing the colours and so on can enable the successful negotiation of regaining it. With clients who are tightly controlled, the way they use, or resist using, materials is often a useful indicator of the inner feelings that are being experienced at the time. The dread of getting dirty, feeling clay on hands, or being able to put hands into the clay bag are developments that only alter through time with a reduction of anxiety. The role of 'mess' within the therapeutic process is important as this conveys 'messy' inside feelings and also a difficulty in putting these feelings into thought. Children who have poor ego structure, have suffered deprivation and neglect or abusive experiences find the communication of their experience through this medium when no verbal or thinking interaction can take place (Case 2003, 2005; O'Brien 2003).

The interesting thing about art materials is that 'accidents' can happen and this often leads to deeper understanding, even though difficult at the time. One 10-year-old boy cut into a padded envelope and was very surprised to discover small polystyrene granules which began to spill out and cover his sweater. His anxiety and distress at the event was obvious as he hopped about in great distress trying to remove them, worrying that it was harmful and poisonous. It felt as if he was expressing quite intense anxiety about contamination. When he was able to think about this experience, with understanding and containment by the therapist, this enabled some thinking about the meaning of his distress and how he found unpredictable situations which were beyond his control intolerable.

If working in a group, members might choose to work together, and profound points of interaction can take place. One person may help a less able one to do a particular piece of clay, for example. This opens possibilities for cooperation, building self-esteem, feeling able to ask for help, looking

at dependency and independency issues. The materials or the tasks open channels of communication for this to happen. With children working in groups, interaction using the materials tends to reflect the group dynamics and also the building of interpersonal relationships, as is clearly described in Chapter 10. For example, two boys, of similar age but different ethnic origin, chose to make a ship together using black and white paint. The disputes and bitterness with which this project was accomplished, in terms of how much of which colour was to go where, was a most complex and deep exploration of some personal issues for them both. Unconsciously the racial tension between them was worked out and the end product was to some degree a resolution of it. The process in which they became engaged was a fascinating and interesting one.

In a less competitive situation with two boys, one timid 7-year-old decided to work with a 'macho' yet deeply vulnerable 9-year-old. On the paper they shared their passion for football by drawing a match with two teams playing hard and tackling each other fiercely, saving goals and being offside. In this interaction, each child looked to the other for aspects of self which they felt they lacked. The feelings between them would probably have been enacted in the playground in the antisocial behaviour that each had been displaying there. This could now be channelled and expressed within the safe bounds of the therapy room and by the containing presence of the therapist. They could experience that their feelings and also their internal conflicts were understood by an adult. Likewise, copying and wanting to do the same as the others is a strong dynamic in some groups and again brings up issues of assertiveness, creativeness, independence, self-confidence and so on. These are enacted openly and it is interesting to work with this, particularly when the child or adult might not be speaking. When this takes place at a non-verbal or unconscious level, it gives an indication of the power of using materials when closely observed in this way.

The following short vignettes illustrate the importance of the non-verbal communication that is conveyed through the use of the art materials.

An anorexic girl had found it very threatening to make any spontaneous move at all. During one session she began to scrape the dry clay off the tools. She made heaps with the bits and began to play as a small child, transferring the bits from one heap to another. At the end of the session she swept all the bits into one tidy heap at the corner of the table. She was amazed when she returned to her next session to find the heap had remained untouched and this allowed her to make further spontaneous moves.

Similarly, another girl used a session picking at the paint on the palette and mixing it, not able to actually paint on the paper. It didn't matter – the mixing of the paint was relevant to the session. When she came to her next session she was delighted that the palette had remained unwashed. The paint was of a

particular quality that enabled the client to lift the paint off the palette as one whole piece, and this piece of paint became precious to her.

(Letter to the authors from Claire Skailes (1990))

Arthur is a 29-year-old man who could be described as having moderate learning difficulties. He resides in the locked ward because his violent behaviour is regarded as being dangerous to others. He is a large person and physically well developed, although one arm is slightly withered. Arthur has difficulty in coordinating his movements and controlling his enthusiasm for tasks. This combination often results in him knocking things over or breaking delicate mechanisms. He enjoys working on several sheets of paper joined together to make a larger sheet. In the room, this large sheet is placed over the three tables and powder paints are mixed in tins by the sink with the help of the art therapist. Arthur uses large house-painter's brushes. We move the chairs to the side of the room and he works round the three tables, calling out for more paint as he busily and excitedly adds colour to his picture, using large expansive movements. Sometimes he knocks a tin over and it spills on the floor; sometimes he splashes the wall or chest with his brush. The large sheet of paper usually has a life-sized figure outlined upon it; sometimes this is drawn by the art therapist tracing around his (Arthur's) body and sometimes it is drawn by Arthur himself without any tracing. The figures are cut out and pinned on the wall. They represent his father and sometimes his mother and he talks to them. He can get angry with the figure of his father, swearing at him for not visiting.

William is 25 years old and has severe learning difficulties. He has no speech and does not use a conventional sign language. When he wants to go to the toilet he pulls his trousers down. He can become very anxious during a session, biting his hand and crying out in protest if he feels unduly pressured. The activity that seems least demanding and most comforting for him is water play. He sometimes pours water over his head and he blows into the water held in the can making 'raspberry noises'. By allowing him periods of free play with the water and cans, he can be persuaded and cajoled into more constructive and creative play, experiencing materials he would otherwise deny himself. William is an absconder, and if the doors are left open he would run off down the road. The large room allows him space to retreat from an interaction and sometimes he sits on the easychair, rocking until he feels confident enough to use the materials again.

(Letter to the authors from Robin Tipple (1990))

Meaning within a relationship

The process of using materials and the completed images which may emerge happens within a relationship with the therapist. Let us look at this process through the work of two clients in therapy. The first image made in an art therapy session has similar significance to the emergence of a first dream in psychotherapy. It may contain a coded statement of the presenting problem, although this will not be known at a conscious level to the client and may take weeks or months of unpacking through a further sequence of images and interactions with the therapist. Images have personal meaning for the client which is symbolically presented in the picture (Schaverien 2005).

Four siblings were taken into care by social services and referred to the art therapist. These children had parents who suffered psychiatric disturbance and resented and feared contact with the authorities. The children had been discouraged from attending school and were dressed eccentrically. The door to the house was never answered. The family lacked any social contact outside the home. Here, we are only concerned with the eldest girl, of 13 years, who had the physical weight and size of an average 9-year-old. In the presence of her mother it became apparent that there was a symbiotic relationship as they clung together, talking in a strange gutteral language of noises.

In art therapy the girl began by drawing 'elephant princesses', 'elephant babies' or 'elephant people'. The first of these is depicted in Plate 4. She seemed to have this as a schema, so that if asked to draw something else a row of 'elephant people' followed. Psychological tests concluded that she had moderate learning difficulties and her pictures with their crayon patterning suggested a mental age of 5 to 7. One can see from the picture that no arms, hands, legs or feet are apparent, just a face and long dress and crown.

The girl was very resistant to any attempt at normalisation or socialisation. She could in fact talk quite clearly when she chose. There were battles over anything that might aid her own independence, such as learning to tie shoe-laces. As the relationship developed it became clear that everything hinged or pivoted around 'babies'. The art therapist was called 'Baby Casey' with great affection and 'baby' prefixed any endearment to other staff too. One day the girl started to talk to the art therapist about the past and drew a picture of a time when she and two siblings had lived with nuns while their youngest sister was born (see Figure 6.4). This led to an exchange of baby memories: 'Tell me about the time when you were a baby.' The art therapist would recall a memory or incident, and the girl would tell the therapist about the time her mother thought she was the baby and put her in the pram instead of her little sister. Gradually it became clear that this regression to baby talk was a way of adapting to her mother's illness. This severe adaptation and accompanying deprivation of school and normal behaviour had stunted her mentally and physically, but made sense within the home environment. By being a 'big

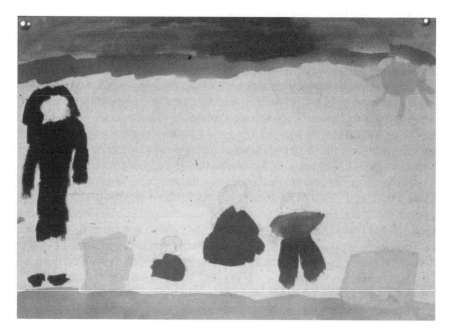

Figure 6.4 Nuns.

baby' she kept in contact with an otherwise uncontactable mother during psychotic episodes. She helped her mother in some way by being a 'more responsive baby' and also helped herself by staying loved and not alienated from her mother.

We can see from the illustrations shown in Plate 8 that an internal change might be shown through a change of style in painting or the way that things are made. (For a detailed exploration of the symbolism of style in painting see Simon 1992 and 2004.) In the following example development can be seen through four stages. A family of three children was referred to an assessment centre while their mother was unable to cope. Their father was frequently hospitalised with mental illness and their mother would take to her bed at these times, leaving Rosie, the eldest child of 9 years, to run the household. Rosie's first picture is of herself in a stormy forest. She is lost. One can see from the illustration that she feels lost in a storm of emotions and confusion, but on entry to the centre she is still in some control of herself and her siblings. Her figure has an outline that only just distinguishes her from the background.

As the staff at the centre took over her responsibilities Rosie regressed to ever younger stages, losing her veneer of maturity until she was crawling around the floor making animal and baby noises. During this quite manic stage of behaviour, when all her actions were quite unpredictable, she painted

the second picture. The figure is smiling, somehow orchestrating the chaotic background colours which show through the transparent body. The black outline to the figure, although apparently a firm boundary, shows the same chaos within and without so that actually there is no boundary between inside and outside. Her chaos inside is projected outside and she soaks up the reactions to her manic behaviour from those around her.

The third illustration is a picture of the therapist. She is surrounded by a protective arc. She is idealised with blonde hair in pigtails and has a row of 'baby' buttons down her front. In the transference the therapist is holding and representing the sane good little girl that is trying to work with the therapist to explore the chaos. The protective arc is separating this part off, in the form of the therapist, to keep it safe from the manic, often destructive, behaviour. Case studies in the literature show other aspects of transference phenomena held in the images (Case 1987, 1990, 2005; Dalley et al. 1993).

The fourth illustration, later in therapy, was made using an animal stencil and pen and ink. The pen and ink medium aided a reverie for Rosie on the death of a pet rabbit and what it had meant to her. A stencil was chosen so that it should look exactly like a rabbit and the long doodling marks and patches of ink suggest her despondency and digging at the paper as she allowed herself to feel its loss. It also represented the loss of her own cuddly soft self, not allowed to be while she held such family responsibility, and a gentle part that was hidden during her manic behaviour. Some order is beginning to emerge in that a specific loss and feelings attached to it can be discriminated from a general emotional state.

Communication with the image

Clients quite often come into therapy having been under enormous strain in trying to hold together some disparate elements in their lives. This is true of children as well as adults. Under these conflicting wishes, children and adults often regress in therapy, as the therapist takes some responsibility for containing these mixed feelings. Regression is the returning to an earlier stage of development so that one can be in control of it; it is easier to master this earlier known role and situation. Clients may go through a period of messy paintings or work with materials where the old order that enabled them to contain the conflicting emotions will be broken down. In Rosie's case this was a kind of false maturity, a pseudo-adulthood that she had to develop to try to cope with the demands made on her. Using the materials, and allowing them to be messy and chaotic, it is possible for a new order to develop.

Some case studies in the literature clearly describe this process where regression takes place to the point at which reintegration can begin to take place (Dalley 1980, 1981). Kris (1953) has called this 'regression in the service of the ego' and describes how the creative process is so important to facilitate this (see Chapter 7). The image enables a series of reflections and

powerful feelings to be experienced. Images sometimes replace or supplement words or actually have words on them to call the therapist's attention to something the client wishes to talk about. In this way they can be a signal to the therapist.

Figure 6.5 depicts two parents arguing. They are separated and about to divorce. Father has visited on a Sunday; they argue, Mother tells him to 'Get out', and he replies 'No'. This was drawn by their daughter, a client in therapy on a Monday morning. It enabled her to talk about her fears while her parents were arguing and her feelings about each of them and the separation. Naming the parts of the picture and giving it a date is an attempt to keep some control over events within which she feels powerless, in a similar way to the naming of the baby toys in the stencils picture discussed earlier.

We have seen how important the process of making is in therapy. It can enable many self-discoveries, such as when Rosie was making her rabbit stencil, the boys working together, the working through of grief in the symbolic 'burial'. Sometimes the completion of an image will present a thought to the person who made it. The abstract pattern shown in Plate 6 was made by a 16-year-old girl who had been taken into care and felt responsible for the break-up of the family. As she finished the picture, she stepped back and said 'everything inside is also outside' and realised that this applied to the people around her. It was important for her to understand that she was not all bad and everyone else good. This realisation gave her a sense of relief as it is easy

Figure 6.5 Divorce.

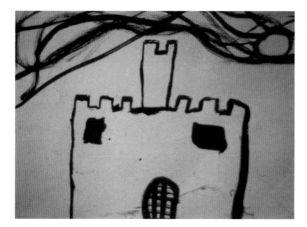

First

Second

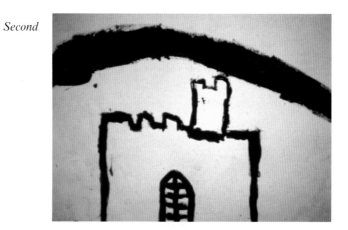

Third

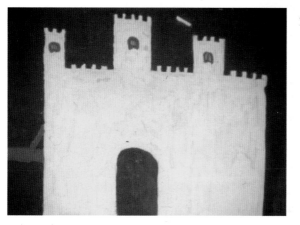

Plate 1 First castle, second castle, third castle

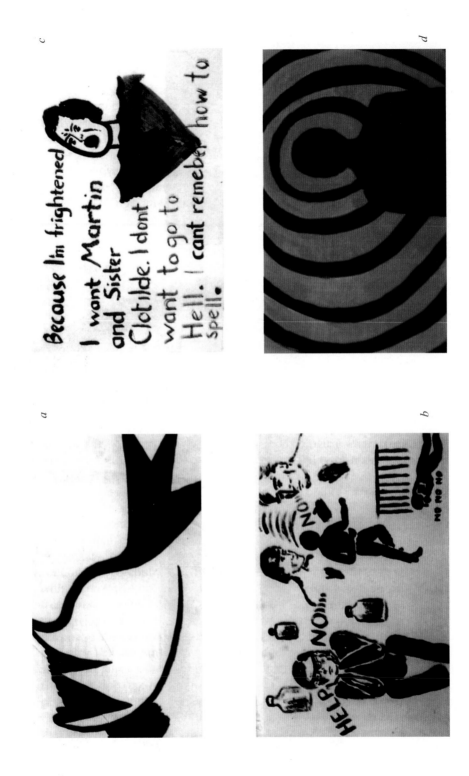

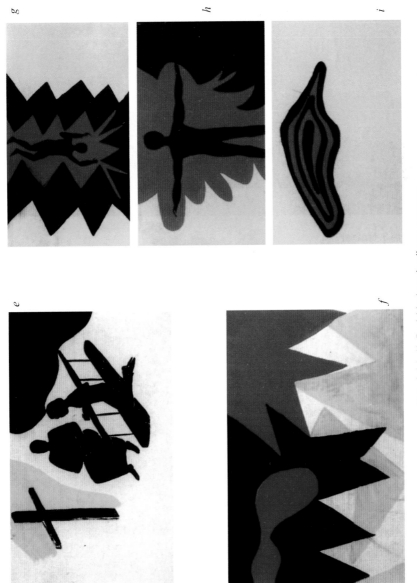

Plate 2 (a)–(i) Red, black and yellow sequence

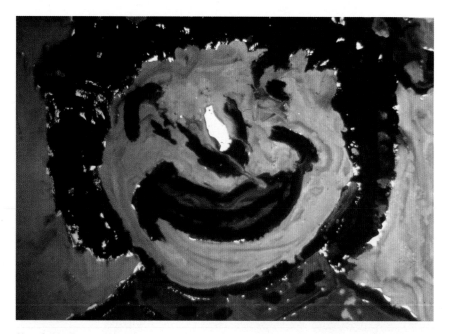

Plate 3 Mother

Plate 4 Elephant princess

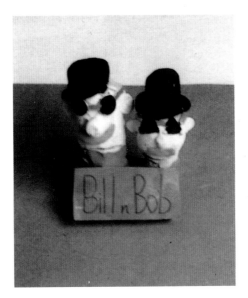

Plate 5 Bill 'n' Bob

Plate 6 Abstract pattern

Plate 7 (a)–(h) Windmills

a

b

c

d

e

f

g

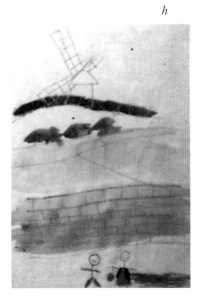

h

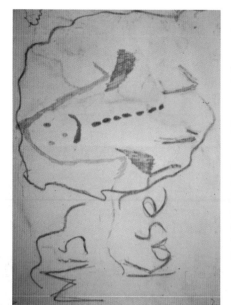

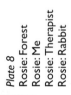

Plate 8
Rosie: Forest
Rosie: Me
Rosie: Therapist
Rosie: Rabbit

for an adolescent to feel the 'bad girl', especially when 'bad' feelings are projected onto her.

This brings into focus the whole question of interpretation. What is the therapist doing when she sees an image that is being made or is completed by a client? At the beginning of the chapter we mentioned the importance of the aesthetic experience. It is through the aesthetic experience that the therapist can enter and share the client's world; that is, it can be a non-verbal sharing. Part of art therapy could be said to be about acknowledging 'what the heart says', which might not be expressible in words. It might be necessary, through the making of a sequence of images by a client, to respond with a silent devotion to the images. The danger for the art therapist is getting wrapped in a web of silence because to speak too soon might betray the process. One must wait until the work is complete as it is so vulnerable while it is being made. The art therapist is part of the art process for the client, which is demonstrated by such comments as 'the picture we did last week' or 'the picture we did together' when in fact only the client painted.

During the process, the therapist may 'see' many different things in the image or have realisations about the image and the client. What is important is that the client is enabled to make self-discoveries rather than the therapist gaining satisfaction from clever interpretations. Verbal comments should clarify rather than impose, relieve tension rather than cause a client to withdraw. Part of the power of the aesthetic response for the client is seeing an aspect of oneself in an image, seeing that an image has been given life, seeing and knowing that the other (the therapist) has seen that which is normally hidden. This seeing and knowing that the other has also seen is a re-experiencing of one of our earliest responses, looking at our mother's eyes and seeing the reflection of her looking at us. She perceives 'a particular brightness' and we gain a sense of ourselves, of identity, worth, value, through this look. The image is the mediator of the 'looks' between therapist and client. The therapist gives value to the art therapy process by the quality of her attention.

Throughout the process of therapy images are made and when looked at in sequence they can be seen to embody the changes that have occurred during the therapeutic journey for both client and therapist. Images act as a means of recording this process and some clients choose to look back over their work, particularly after the therapy has finished. They hold their significance over time and are therefore extremely important for the understanding and insight gained during the weeks or months of therapy. The following examples illustrate clearly the way that the images have been used by the clients to work through their particular difficulties and are received by the therapist in her containing function. In a sense the pictures 'speak' for themselves but contain many different levels of meanings, both latent and manifest, which language cannot describe. The following four commentaries,

written by clients in art therapy, describe their experience of the process. The images depict distress, confusion and unhappiness which was beyond words.

Most of my paintings consist of only two or three colours – red, black and occasionally yellow [see Plate 2]. When I am depressed, black represents total despair and a great sense of personal worthlessness; red represents anger of an almost suffocating kind – anger directed mainly at myself because of this sense of worthlessness. The occasional use of yellow suggests feeble and rare glimmers of hope for a future. Where I have drawn a figure, it is usually a black silhouette. I think that the figure is a silhouette because I do not want to acknowledge that the figure bombarded by despair and anger is myself.

When I was in hospital I found art therapy very valuable, with an almost cathartic element. Frequently I went to the art therapy sessions in a very anxious, depressed frame of mind, not really wanting to make an effort to do anything. Yet, once I had made the initial effort – which I was allowed to do in my own time – I found that my hostile and even aggressive feelings were quickly translated into colour on paper [see Plate 2, a–f].

It is difficult to look back to a time when one was really unhappy, desolate, alone and remember how it felt. One sees days as grey, which were in fact blackest misery; one remembers only the paralysis of depression and forgets the turmoil. One forgets the aggression. It is especially difficult to remember how I hated myself; how sure I was that once I'd been obliterated, forgotten, the world would be a better place . . . And they tell you to paint . . . You resist . . . You feel ashamed as you sit numbed, stunned in front of a blank sheet . . . so you write your life upon it, perhaps you don't mean to but it happens. The painting cannot exist independently divorced from your life, it is a part of you and therefore a part of distress, fear, anger, frustration, past and future shock. And when these things appear on paper you may recognise them for the first time. I say you may, but it's a gradual process [see Figure 6.6 a–f].

Art therapy was very much my last hope, because I didn't feel I had the energy to carry on much longer. I had spent so many years trying to sort out my problems on my own, by avoiding them.

I can't remember if the first painting I did was at this session or not, but I do remember how I felt about illustrating something in front of someone. Initially I was very reluctant, I didn't have much regard for my illustrating abilities.

Once that was done and the therapist had accepted my drawing, I was then able to start loosening up because I knew I was going to be helped and that no one was going to laugh at my pictures. After that I gave the sessions

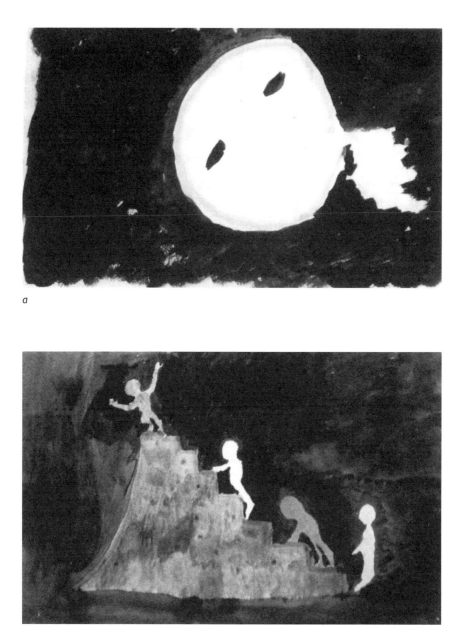

a

b

Figure 6.6 (a)–(f) Isolation, degradation, despair

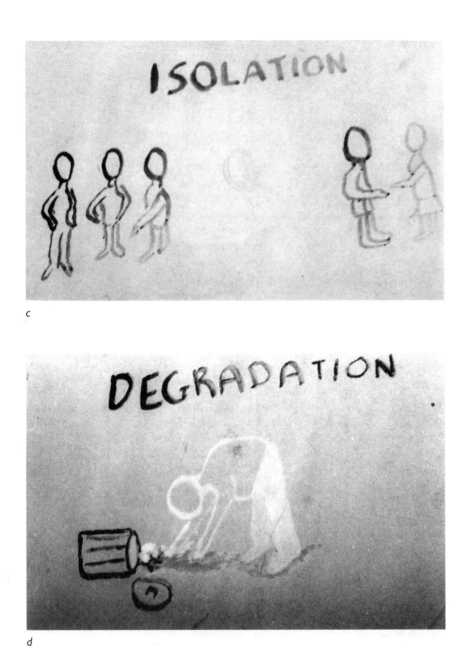

c

d

e

f

everything I had and started getting something in return. My pictures represent different aspects of my life and feelings about myself.

Some of the feelings shown are quite negative and are to do with situations I find difficult. I find making images in this way can be a way of putting things into perspective and seeing them in a different way.

Even if you are depicting something which is quite difficult, it can be quite satisfying to make an image about it. I find it often leaves me with a feeling that I am more in control of whatever feeling or situation is shown – channelling them into a different way of expression, something creative can be drawn from even the most difficult situation or feeling.

I attended art therapy for approximately one year, initially going because I had an obsession with food which had made my life a misery for ten years (I am 23 years old now). However, after my first couple of sessions the food problem was practically forgotten, as a host of other problems, of which the food had been the symptom, appeared. None of these was essentially serious, but I had let them take over my life to the point where I had twice seriously contemplated suicide.

I found it very hard to begin with, as I was not used to drawing or painting to express my emotions, but after a couple of sessions it became easier. I started to find painting very relaxing.

To begin with, therapy was relatively 'pain free' but after a while going there was really quite traumatic for me, and I wanted to give up. I think I was very honest with my therapist and told her how I was feeling throughout the treatment, and this helped me to realise that what I was experiencing was part of the process, that I almost had to get worse before I got better.

I developed a relationship with my therapist so that I trusted her with details of my life that no one else knew about, and with her help and my perseverance I saw it through.

I ended therapy before I thought I would. It was the hardest thing I ever did and also really the most selfish, but I am really proud of myself now that I have found the strength to seek help and accept it. My final day there was frightening and exhilarating, because I could now put into practice what I had learnt about myself. I still paint in order to carry on the therapy in a sense; it helps me to focus on my problems and sort them out. Now whenever I am particularly sad or depressed I mentally paint a picture if I cannot actually draw one, or imagine I am talking to my therapist and what she would say to me.

Finally Plate 7, a–h is a sequence of paintings, showing how the process of image-making can facilitate change. These were painted by a 15-year-old girl, mute and completely withdrawn in her psychotic confusion. She stood for

hours, on her own, staring out of the window. Without speaking, she made a series of paintings of the windmill that she could see from the window, leaving them for the art therapist in the art room. They show how she regained her sense of reality and emerged from inner chaos to an outer world of clarity, order, people and potential relationships.

References

Case, C. (1987) A search for meaning: loss and transition in art therapy with children, in T. Dalley *et al. Images of Art Therapy*. London: Tavistock.

Case, C. (1990) Reflections and shadows, in C. Case and T. Dalley (eds) *Working with Children in Art Therapy*. London: Tavistock/Routledge.

Case, C. (2003) Authenticity and survival: working with children in chaos, *Inscape*, 8(1): 17–28.

Case, C. (2005) *Imagining Animals – Primitive States of Mind, Art and Psychotherapy*. London: Routledge.

Dalley, T. (1980) Art therapy in psychiatric treatment: an illustrated case study, *Art Psychotherapy*, VI(4): 257–65.

Dalley, T. (1981) Assessing the therapeutic effects of art: an illustrated case study, *Art Psychotherapy*, VII(1): 11–17.

Dalley, T. (2000) Back to the future: thinking about theoretical developments in art therapy, in A. Gilroy and G. McNeilly (eds) *The Changing Shape of Art Therapy*. London: Jessica Kingsley.

Dalley, T., Rifkind, G. and Terry, K. (1993) *Three Voices of Art Therapy*. London: Routledge.

Foster, F. (1997) Fear of three-dimensionality: clay and plasticene as experimental bodies, in K. Killick and J. Schaverien (eds) *Art, Psychotherapy and Psychosis*. London: Routledge.

Killick, K. (1993) Working with psychotic processes in art therapy, *Psychoanalytical Psychotherapy*, 7(1): 25–38.

Killick, K. (1995) Working with psychotic processes in art therapy (updated), in J. Ellwood (ed.) *Psychosis: Understanding and Treatment*. London: Jessica Kingsley.

Killick, K. (1997) Unintegration and containment in acute psychosis, in K. Killick and J. Schaverien (eds) *Art, Psychotherapy and Psychosis*. London: Routledge.

Kris, E. (1953) *Psychoanalytic Explorations in Art*. London: Allen & Unwin.

Langer, S.K. (1963) *Philosophy in a New Key*. Cambridge, MA: Harvard University Press.

Milner, M. (1950) *On Not Being Able to Paint*. London: Heinemann.

O'Brien, F. (2003) Bella and the white water rapids, *Inscape*, 8(1): 29–41.

Rycroft, C. (1985) *Psychoanalysis and Beyond*. London: Chatto & Windus.

Schaverien, J. (1992) *The Revealing Image: Analytical Art Psychotherapy in Theory and Practice*. London: Routledge.

Schaverien, J. (2005) Art and active imagination: reflections on transference and the image, *International Journal of Art Therapy: Inscape*, 10(2): 39–52.

Simon, R. (1992) *The Symbolism of Style-art as Therapy*. London: Routledge.

Simon, R. (2004) *Self Healing through Visual and Verbal Art Therapy*. London: Routledge.

Development of psychoanalytic understanding

When working with images made in art therapy, the art therapist needs to be able to enter the 'world' of the client. She does this partly through an empathetic way of sharing image-experience with the client. To enter the process of image-making with the client it is essential to have felt the same stages of chaos, uncertainty and vulnerability as well as the experience that something has worked and been made successfully. The art therapist needs a theoretical understanding of the creative process together with her personal experience of her own work (Gordon 1989; Hershkowitz 1989). This chapter will start with a tracing of the understanding of the creative process through psychoanalytic writers, which may be less accessible to the artist considering training and the general reader than artists' own accounts of their working processes. We continue with an introduction to some related work on the aesthetic experience as this is the twin component to the creative process, being the way that the client can make herself known, externalise previous internal thoughts and feelings, and be seen and comprehended by the art therapist. We then begin to explore the changing and developing theory about the symbolisation process by which one object can come to stand for another, carrying with it the feeling force originally attached to the first object. The last section of the chapter looks at the processes behind the extraordinary power that can be felt and held in a picture as invested emotionally by its maker.

The creative experience

The experience of creativity is not limited to artistic activity. Indeed, Winnicott saw it as a feature of life and total living. Cultural experience begins with 'creative living first manifested in play'. However, in this section we are going to restrict ourselves to the more immediate concerns of artists and art therapists and attempt to explore the nature of creative experience and motivation in the making of a piece of art work. We have seen previously that Freud felt unable to apply psychoanalysis to creativity. Psychoanalysis is able to take the interrelations between the impressions of the artist's life, chance experiences

and works, and from those things to construct the (mental) constitution and the instinctual impulses at work in it, but, as previously quoted, 'it can do nothing towards elucidating the nature of the artistic gift, nor can it explain the means by which the artist works – artistic technique' (Freud 1925: 65). Freud felt that artistic talent and capacity were intimately connected with sublimation and that they were inaccessible to study. However, later analysts have built on these tentative conclusions of Freud and have been able to use his deeper work on dreams and jokes as patterns for exploration, particularly in aesthetics (Mann 2006).

Kris (1975) suggests that there is a subjective experience common to all manifestations of creative imagination. The characteristics are a limitation of conscious effort, a high emotional charge and a mind working with high-precision problem-solving. To illustrate the second point, he takes Freud's study of Leonardo as an example. In the history of Italian painting there had been little previous solution to the artistic problem of arranging a composition for *Mary the Virgin, St Anna and the Infant*. Leonardo's personal history gave him compelling inner necessity for finding a solution as he had experienced 'two' mothers as an infant. Kris sees form and content being united and both a personal and artistic solution found.

There has been some opportunity to study artists in psychoanalysis, also artists who have become psychotic and psychotic patients with no previous art training who start to paint spontaneously during their illness. The artist has 'the capacity of gaining easy access to id material without being overwhelmed by it, of retaining control over the primary process' (Kris 1975: 25).

Kris suggests that artists may have psychological characteristics of a definite kind. It seems that they have the capability of making rapid shifts in levels of psychic function. The only statement that Freud really made on this issue was to comment on the artist's 'flexibility of repression'. Kris expanded his influential ideas of the artist's ability to tap unconscious sources without losing control by 'regression in the service of the ego'. The artist/client can be seen as someone who 'lets go', allowing aspects of personality, other than the social aspect, to take over. It is because of this collapse of ego control that it is essential for the therapist to have empathy with the creative process. Kris did not depart from Freudian principles of free association in a controlled situation, but speculated that the relaxation or regression in all artistic activity, in contrast to the phantasy or dream, is purposive and controlled. He suggests that this happens in a continual interplay between creation and criticism and implies a 'controlled regression of the surface faculties towards a primary process'. This idea that creativity not only controls the regression but also the work of the primary process itself points to a more dynamic role of the ego which departs from Freud's more pessimistic view of involuntary unconscious. Kris believes that the unconscious 'turns its potentially disruptive effect into a low structure and highly efficient instrument for making new links and shaping new, more comprehensive concepts and images. The

conscious and unconscious are not merely linked. Surface thought is wholly immersed in the matrix of the primary process' (1953: 262).

Kris traces back the role and function of artists in society to antiquity. He particularly explores the artist's mythological base. He starts by looking at the Greek division of poets and musicians as 'inspired creators' and of painters and sculptors as 'great artisans'. He feels that this reflects mythological traditions where painters and sculptors are descendants of cultural heroes, who competed with the Gods – Prometheus, Hephaestus, Daedalus: 'artist as a creator is endowed with the powers of a magician and is penalised by the Gods for rebellion and rivalry' (Kris 1953: 150). He suggests that this is the foundation for the artist living on the fringe of society in a Bohemian reservation. It is the ramifications of the belief in image magic; firstly, the power over memory and, secondly, the ability to externalise human appearance. 'Gestures must be seen when they are made; words must be heard when they are spoken. Pictures can be read in aftertime. They persist, control time, and overcome its passage. In this very fact there is magic' (Kris 1953: 50).

The artist is able to preserve that which vanishes. Kris sees a close relation of mythological tradition concerning the artist and the psychological processes active in the artist:

> The artist does not 'render' nature, nor does he 'imitate' it, but he creates it anew. He controls the world through his work. In looking at the object that he wishes to 'make', he takes it in with his eyes until he feels himself in full possession of it. Drawing, painting and carving when it has been incorporated and is made to re-emerge from vision, is a two-pronged activity. Every line or every stroke of the chisel is a simplification, a reduction of reality. The unconscious meaning of this process is control at the price of destruction. But destruction of the real is fused with construction of its image. When lines merge into shapes, when the new configuration arises, no 'simile' of nature is given. Independent of the level of resemblance, nature has been recreated.
>
> (Kris 1953: 51)

Ella Sharpe (1950a, 1950b) was also writing papers on art and psychoanalysis over a similar period to Kris (1930–1950s) but with a Kleinian rather than Freudian perspective. She describes how art makes 'representations of life', suggesting that 'Sublimation and civilisation are mutually inclusive terms; cannibalism and civilisation mutually exclusive. Civilisation begins with the first art forms, and these first art forms are inseparable from the problems of food (life) and death' (Sharpe 1950a: 9). She felt that art provided a service to the community, a magical reassurance and that great art has a self-preservative function: 'From a world of apprehensions and anxiety, a world of temporal things, of vicissitudes and death, we temporarily escape. In these few moments of conviction, immortality is ours' (1950a: 128).

Through art, a delusion of omnipotence can find a reality channel. The ego seeks relief from the hostility of the incorporated parents by the power to externalise into an art form. The creative experience is of 'omnipotent life giving' to these internal images, a 'restoration, milk, semen, child'. Sharpe suggests that pictures were originally outer images, the images of infancy, incorporated then in adult life and projected out onto a blank sheet:

> Art, I suggest, is a sublimation rooted in the primal identification with the parents. That identification is a magical incorporation of the parents, a psychical happening which runs parallel to what has been for long ages repressed, i.e. actual cannibalism. After the manner of cannibalistic belief, psychically the same magical thing results, vis omnipotent control over the incorporated objects, and a magical endowment with the powers of the incorporated.
>
> (Sharpe 1950a: 135)

During creative periods, the omnipotence of the superego, needed to counter-act anxiety about the hostile incorporated objects, is transferred to the ego and makes a symbolic recreation of the images that have been destroyed in phantasy. Art, therefore, has to be seen as an ordering of emotional experience.

The work of Ella Sharpe links with Marion Milner in an exploration of the 'body-basis' of the art process. This is an interest in the biological base of art, not just in the sense of having a self-preservative function but also in how the artist works with body perceptions, an inner knowledge and experiencing based on the body's sensations. For instance, Milner writes of 'spreading the imaginative body around what one loves' as a way of dealing with separation and loss. She too felt an imaginative connection between this spiritual envel-oping and eating. Milner also writes of this experience both in feeling oneself into the object one is trying to create while painting, as well as using the deep body ego to enter imaginatively the experience of the analysand in analysis.

In *The Hands of the Living God*, Milner (1969) explores this question in terms of techinique, feeling that it was only by giving this type of attention to her client that the client was able to get in touch with primitive psychic and body-ego experiences. Sharpe saw the artist as having vivid sensuous response and 'body knowledge' so that he or she can produce lifelike representation in any sensuous medium. She felt that the sublimation of the artist arises from the early stages of infancy, before speech is acquired. Therefore the artist is communicating an experience which did not occur in words:

> The child communicates it by crooning, gurgling, crying, screaming, by gesture, urinating, defecating. The artist, the 'pure' artist, communicates his emotional experience by manipulation of sound, gesture, water, paint, words. The same bodily powers are used as in babyhood but infinitely

developed, the same substances, symbolically (as in water and oils) are used.

<div align="right">(Sharpe 1950b: 142)</div>

If the artist is able to maintain contact with reality through sublimation, then art has to be seen as a self-preservative impulse. Sharpe felt that creative art represented a triumph over aggression and gave a repeated assurance of the ability to restore the good introjected object, in Kleinian terms, which is a restoration of the good experience threatened by hate and fear. To sum up her view on the artistic process and creative experience: 'the artist deals with his instinctual problems and the psychical phantasies allied to them in terms of his body. He uses a knowledge that is diffused in his body, a body intelligence and bodily experience in dealing with emotional states' (Sharpe 1950b: 148).

Marion Milner shared with Anton Ehrenzweig and Adrian Stokes the deeper understanding of the creative process that comes from making art works at first hand. All three combined this inner knowledge with a full experience of psychoanalysis and their writings challenged existing theories and pushed forward a re-evaluation of the functioning of the primary process by other questioning analysts. In *The Hidden Order of Art* Ehrenzweig (1967) attempts an 'aesthetic analysis of art's deep substructure'. Ehrenzweig was interested at first in exploring the two modes of thought of the primary and secondary processes and how they interacted in creative work. He thought that in creativity there was a conflict between conscious and unconscious control. Conscious thought is sharply focused and highly differentiated analysis. Unconscious thought is syncretistic, having the ability to comprehend a single structure rather than analyse details. It branches in unlimited directions so that in the end the structure appears chaotic. Ehrenzweig thought that creativity requires a diffuse, scattered kind of attention that contradicts our normal logical habits of thinking. He saw a 'deceptive chaos in art's vast substructure', deceptive because there was a 'hidden order in this chaos', the hidden order of the unconscious. He took the explorations of Frazer in *The Golden Bough* around the theme of the dying god as a mythology of the process of creating itself. The 'self-destructive' imagery of the dying god can be read as the self-destructive attack of unconscious functions on the rational surface sensibilities. So, to create anew means casting aside old patterns of thought and being.

Ehrenzweig explores a child's early vision of the world, which he describes as 'global'. It is syncretistic, with an undifferentiated structure. He feels that there is a change to an analytic vision at latency with the weakening of libidinal drives, vision detached from concrete individual objects to generalised patterns. The ability to select a form from a background, a good gestalt, is encouraged educationally. Yet, the original syncretistic vision is the base of artistic vision; it can, for example, accommodate a wide range of incompatible forms. The artist needs to be able to move freely between attention to

detail and to scatter attention over the whole picture plane: 'It is the privilege of the artist to combine the ambiguity of dreaming with the tension of being fully awake' (Ehrenzweig 1967: 12).

Ehrenzweig thought that during the artistic process there was a time of 'unconscious scanning' where integration of the work, the picture and of the artist's personality took place: 'This total integration can only be controlled by the empty state of unconscious scanning which alone is capable of overcoming the fragmentation in art's surface structure' (1967: 30).

During the artistic process a conflict between the two types of thinking is experienced, as one or the other is in ascendancy. The medium in which the artist is working plays an important part. Ehrenzweig has written that 'something like a true conversation takes place between an artist and his own work' (1967: 57). The interaction of artist, idea and medium allows contact with the unconscious:

> The medium, by frustrating the artist's purely conscious intentions, allows him to contact more submerged parts of his personality and draw them up for conscious contemplation. While the artist struggles with his medium, unknown to himself he wrestles with his unconscious personality revealed by the work of art. Taking back from the work on a conscious level what has been projected into it on an unconscious level is perhaps the most fruitful and painful result of creativity.
>
> (Ehrenzweig 1967: 57)

Ehrenzweig postulated three phases in creative work. The first phase is one of projection of fragmented parts of the self into the work, and because of the fragmentation it has a schizoid character. The second phase is one of unconscious scanning and integration where an unconscious substructure is formed. This gives the work of art an independent life. This he described as a 'manic phase'. The third phase is one of secondary revision. There is a partial reintrojection of the work into the surface ego. So there is feedback on a higher mental level. This is a depressive phase as the gap between the ideal and real is come to terms with, mixed with acceptance of imperfection and hope for future integration.

We have already come across the problem of how to observe the workings of the primary process in secondary process terms. Here the problem is how to observe the unconscious structure of art with the gestalt techniques of the secondary process. Ehrenzweig feels that the 'integration of art's substructure is only observed through its conscious signal: pictorial space' (1967: 76).

Ehrenzweig thought that the bulk of creative work was carried out in oceanic states of undifferentiation. The creative ego rhythm swings between this and a focused gestalt. The art work acts as a receiver, a womb for the artist's projections. He comments on the work of art having a life of its own, which is similar to Adrian Stokes on the 'otherness of a work of art'.

Anna Freud (1950), Marion Milner (1950) and Ehrenzweig (1967) have all made comparisons and comments on the relationship between the analysand in the analytic situation and the artist and their works of art. What are the creative characteristics which they share? Anna Freud saw the same need to be absent-minded, for conscious logic and reason to be absent. There was the same unwillingness to leave secondary process and to accept chaos as a temporary stage. The same fear to plunge into no-differentiation and disbelief in the 'spontaneous ordering forces' which emerge. The same terror of the unknown was experienced. Just as the painter interferes with the process when they cannot bear uncertainty, prematurely seeking a whole in the painting, so does the analysand interfere with the process and the analyst, through premature interpretation. Ehrenzweig examines the role of the analyst's 'free floating' attention. Like the artist the analyst's attention refuses to focus on the obvious, dissipates and scatters impartially over the entire material. The analyst will extract some inconspicuous detail that may contain the most significant symbols. The detail is fitted into place in the interpretation and the client reintrojects her own fragmented projection on a higher structural level. All three phases of creativity are present and the analyst, like a work of art, serves as a receptacle to receive the projections. In Milner's words: 'to receive the pain, when it became unbearable, and then give it back to her in a more bearable form – as the tragic work of art does, *Macbeth*, for instance' (1969: 219).

There is some controversy among analysts over whether psychic creativity seeks above all 'to preserve, recreate the lost object' or, as Marion Milner suggests, whether this is a secondary function of art, the primary function being to create 'what has never been seen'. However, Anna Freud concludes that both the creative venture and the analytic process aim at more than mere recovery of lost feelings and abilities but for the creation of new attitudes and relationships on the basis of the newly-created powers of insight into the inner world. Interestingly, whereas Freud found the most fruitful comparison between psychoanalysis and the arts to lie in creative writing, later analysts have found these most productive parallels in the visual arts.

Another large area of interest is that of 'outsider art', 'art brut' and 'psychotic art'. This is not within the bounds of this chapter to explore, although it is of interest to us in the motivation for creative activity. Kris devotes a section to psychotic art in *Psychoanalytic Explorations in Art* (1953). His findings differ from the enthusiasm of a collector like Prinzhorn (1972), who saw art as redressing a balance, a force for healing in the psychotic. He rather sees the psychotic loosening his relation to the world and making vehement attempts to recathect objects outside, e.g. in an increased production of pictures. Storr (1978) has tried to delineate the many varied reasons why people might wish to create, exploring types of personality and giving examples of famous artists and scientists. He sees that creativity can be for wish-fulfilment, imagination used to create substitutes for reality, as

abreaction, the ridding of the psyche of impulses which cannot find expression in ordinary life. He investigates an area which Kris thought should be explored – that is, 'the character traits of the artist'. One discovery is that artists are thought to have a 'strong ego' and that this separates them from persons with equally fluid boundaries between id and ego who might get overwhelmed by primary process.

With a strong ego an artist might have the following traits: independence, inner direction, aesthetic sensitivity, ability to tolerate tension and anxiety. The artist, genius and madness have often been connected yet Storr considers 'One of the reasons that creative people are apt to be labelled neurotic even when they are not is that their psychopathology is also showing; but it is showing in their works, and not in the form of neurotic symptoms. The work is a positive adaptation whereas neurosis is a failure in adaptation' (1978: 204). He found that, usually, the creative person had easy access to their inner world and did not repress it as much as most people. He concluded that 'creative work tends to protect the individual against mental breakdown' (1978: 31).

Storr suggests that creativity can be used as a defence to ward off 'unpleasure and anxiety'. The depressive personality may try to replace a world they feel has been destroyed by creating something. The schizoid personality will seek for meaning and significance in things rather than other human beings and will need to create an internally self-consistent system, whereas the obsessional personality may start creative work as an action for defence or insurance, a protective measure. Part of the process may be symbolic, ritualistic activity that may be linking the outer and inner worlds of the subject. Storr's examples of famous artists and scientists perhaps only conclude that we might all have a reason to create, whatever our basic personality.

Storr also enquires into our babyhood. He suggests that a 'divine discontent' may be inherent in our long infancy. It is likely that the price of our developed and inherited culture is our delayed maturity. Human children have a long dependence on adults and, in consequence, a long period of frustration. He sees our 'inner world' developing as a direct result. There is a need for imaginary satisfaction: 'It is not the suppression of adult sexuality which leads to creativity but of its childhood precursors' (1978: 181).

Storr posits a childhood residue of dissatisfaction which is carried into adulthood and which can only find resolution in symbolic ways. Perhaps creative people have less secure identities, more of a divided self, but a greater tolerance of ambiguity which allows them to move flexibly between conscious and unconscious processes. Storr makes a firm link to the work of Jung. He finds particular correspondence in the Jungian approach of trying to develop the creative possibilities latent in the client. The concept of 'individuation' – the coming to terms with oneself by means of reconciling opposing factors within – is crucial here. For through this, the work of art is seen to be adaptive, to unite opposites within the self, and to integrate the personality.

The aesthetic experience

Discussion of the 'aesthetic experience' historically centres around concepts of the 'sublime' and the 'beautiful'. The sublime was originally thought of as an experience seated in feelings aroused and produced by contemplation of nature in her deeper awe-inspiring moments, whereas the beautiful was to be found in contemplation of artefacts, man-made objects that had character- istics of being felt complete or perfect. Difficulties arose over what is thought to be beautiful, what is good 'taste' and how to find a general agreement. Psychoanalytic writings on aesthetics have partly side-stepped issues of whether aesthetics can be reduced to ideology by their focus on the mental processes through which emotions are felt. Questions still remain over whether the art of a particular period is structured to represent the dominant factor in a society or whether art struggles to subvert the dominant con- sciousness. Possibly it emerges from the fusion of the conflict of opposing trends. Adrian Stokes (1978: 110) comments: 'The sublimation is highly wrought. Art is, of course, a cultural activity; the "good" imagos at the back of Form are identified with the actualities or potentialities of a particular culture'.

In this short section we are only able to trace some development of psy- choanalytic contribution from within the vast subject of aesthetics. It might seem strange to begin with Freud's paper on 'The Uncanny', which does not have an inspiring opening: 'It is only rarely that a psychoanalyst feels impelled to investigate the subject of aesthetics, even when aesthetics is understood to mean not merely the theory of beauty but the theory of the qualities of feeling. He works in other strata of mental life and has little to do with the subdued emotional impulses which, inhibited in their aims and dependent on a host of concurrent factors, usually furnish the material for the study of aesthetics' (1919: 219).

The subject of 'The Uncanny' deals with experiences that are frightening, familiar, concealed and usually hidden. Examples that Freud discusses are doubts as to whether something is animate or inanimate, experiences of meet- ing one's 'double', experiences of coincidence and repetition. It is a fascinat- ing paper, though one might wonder about the precise connection between these experiences and the aesthetic experience. Interestingly, Peter Fuller (1980) in *Art and Psychoanalysis* begins his analysis of Natkin's paintings by discussing them in terms of desire. He describes the sensual, almost sexual, experience of his painting, penetrating the skin, being drawn in to reach the illusionary space 'contained within the painting'. He finds it 'tinged with an elusive unease', 'familiar' and evoking 'fear' – precisely Freud's description of 'the uncanny'. We shall return to Fuller later, but first follow through Freud's formulations in his paper.

Many instances of 'the uncanny' can be explained by the general term 'omnipotence of thoughts' – the old, animistic conception of the universe

where the world was peopled with the spirits of human beings, by the 'subject's narcissistic over-evaluation of his own mental processes; by the belief in the omnipotence of thoughts and the technique of magic based on that belief; by the attribution to various outside persons and things of carefully graded magical powers or "mana" ' (Freud 1919: 240).

All of us, in our individual development, have been through one animistic phase and have preserved certain traces of it. Freud concludes that the secret nature of the uncanny is that it is something frightening and repressed, which recurs. So it is something that has been familiar and has become alienated through the process of repression. Thus when an uncanny experience happens to us, it is an infantile complex revived by an impression or association.

Freud made a further contribution to the study of aesthetics in two further papers, 'Creative Writers and Day Dreaming' (1908) and 'Jokes and their Relation to the Unconscious' (1905). Later writers, such as Gombrich (1966) and Wollheim (1980), have built on these and extended them to consider the aesthetic experience in art particularly.

Kris suggests that the public view in reverse order to the artists making their work; they move from the edge to the centre. They move from passivity to activity. The audience experiences some of the excitement and release of tension which arises when barriers between conscious and unconscious are loosed. The public is identified with the artist, and is also re-creative. There is a large emotive potential because the audience reaches unconscious mechanisms, and mastery of them experienced by the artist and their reactions may be richer. Kris (1953: 25) partly explains this by a comparison of dream work and art work: 'What in the dream appears as compromise and is explained in terms of overdetermination appears in the work of art as multiplicity of meaning, which stimulates differentiated types of response in the audience'. Kris also discusses the importance of the 'aesthetic illusion', 'a firm belief [that] the "reality of play" can coexist with a certainty that it is play only. Here lie the roots of the aesthetic illusion' (1953: 42). Kris looks at the use of the word 'kathartic' by Aristotle and, later, Freud and how art is often viewed as releasing unconscious tensions and 'purging the soul'. The 'purging' enables the ego to re-establish control which is threatened by clammed-up instinctual needs: 'The maintenance of the aesthetic illusion promises the safety to which we were aspiring and guarantees freedom from guilt, since it is not our own fantasy we follow' (1953: 45–6).

Kris engages in an interesting discussion on caricature, in many ways related to the psychological mechanisms behind the making of jokes. He explores the psychology of caricature and the technique behind it of 'unmasking' another person, a technique of degradation. In relation to caricature there is a saving in mental energy, a saving of energy for suppression as aggression is liberated. Kris describes it as midway between pleasure and unpleasure. The caricature traces back to the world of effigy and magic. The most primitive attitude towards image magic is to act upon the image in the

belief that image and person are one, e.g. 'hurting' a wax doll to hurt an enemy. The next stage would be to make an effigy and to make hostile action on the image instead of on the person. Kris describes this as a communication rather than an action. The third stage is the caricature proper where hostile action is confined to an alteration of the person's likeness. Here, Kris suggests, aggression remains in the aesthetic sphere; we laugh rather than make a hostile act against the person. It is not uncommon to find all these stages at work in art therapy and the popularity of caricature and effigy can be seen for instance in relation to political figures, where the audience's frustrations and feelings of impotence are relieved.

We shall now consider the contributions to the study of aesthetics by two interesting papers which have had influence on later writers. The first is Fairbairn's 'The ultimate basis of aesthetic experience' (1939) and the second Rickman's 'On the nature of ugliness and the creative impulse' (1940). Fairbairn bases his whole thesis around the surrealists' use of 'found objects' in their art work. Freud had been very hostile to the surrealists despite their efforts to contact him because of his pioneering work into the unconscious. Gombrich comments that 'clearly to Freud there was no artistic value in the primary process as such' (1966: 35). Freud dismissed expressionists and surrealists as lunatics because he suspected they confused the mechanisms of the primary process with art, rather than using technical mastery to invest a preconscious – that is, a communicable idea with a structure devised from unconscious mechanisms. Fairbairn, however, sees the surrealists using 'found objects' in which they discovered a hidden symbolic significance which the artist 'preserves and frames'. To those who discover a found object, it represents a union between the 'world of outer reality and the inner world of dream'. Fairbairn continues to describe how the discovery is accompanied by an intense emotional experience. He suggests that the emotional attitude to the found object represents 'an intermediate point between the attitude of the artist and that of the beholder'. The found object possesses features which enable it to represent a fulfilment of the artist's emotional needs. He then widens out his 'found object thesis' to encompass all art, wherein lies the weakness of the paper because it does not allow for the capacity to create something new, posited by later writers such as Milner (1950), Ehrenzweig (1967) and Stokes (1978). In terms of creativity, this paper is interesting as a stage on the way to later thinking and offers thoughts on the aesthetic experience which are of value: 'Aesthetic experience may accordingly be defined as the experience which occurs in the beholder when he discovers an object which functions for him symbolically as a means of satisfying his unconscious, emotional needs' (Fairbairn 1939: 173). In his discussion of the 'failure' of aesthetic experience Fairbairn suggests (a) an over-elaboration of disguise which precludes any appeal to the repressed urges, i.e. symbolism has 'form without content', or (b) inadequacy of disguise, where the requirements of the superego are unsatisfied, i.e. symbolism has 'content without form'.

Fairbairn sees artistic activity as having a double function of providing a means of expression for the repressed urges of the artist and of simultaneously enabling the ego to pay a tribute to the supremacy of the superego – essentially a means of restitution. The ego making atonement to the superego for the destruction implied in the presence of repressive destructive impulses: 'The aesthetic experience is thus seen to be an experience that occurs when a person finds himself confronted with an object which presents itself to him, not simply as a "found object" but also as a "restored object" (Fairbairn 1939: 178).

Ultimately, then, a work of art is a synthesis of the life and death principles or of destruction and restoration. In aesthetics the concept of beauty is defined through such terms as order, symmetry and wholeness, and supplies the need for restitution in the beholder. Catharsis is also experienced through such emotions as pity and fear as, for instance, in tragedy. Tragedy needs to unite a sense of uncontrollable destruction at work but to impress the beholder must also produce an impression of completeness and perfection, an impression of 'the integrity of the object': 'to appear beautiful, the work of art must be able to produce in the beholder an impression of the "integrity of the object"; but, in order to do so, it must at the same time provide a release for the emotions which imply the destruction of the object. Otherwise the conditions of restitution remain unsatisfied, and aesthetic experience is accordingly precluded' (Fairbairn 1939: 180).

The artist represents in a neutral medium the interplay of creative and destructive instincts and this allows us, the beholders, to comprehend better our conflicts. Rickman saw art as the triumph of the creative forces over destruction, not a denial of pain but a determination to master it. In his paper he explores the quality of feeling we experience on seeing something ugly and looks at the underlying mental processes which are at the base of these feelings. It is an area of experience connected to Freud's exploration of the uncanny as roots of the word 'ugly' come from Icelandic words meaning 'fear' and 'like'. One experience he studies is of feelings aroused by the 'incomplete image', i.e. ancient broken statues (Fuller 1980 elaborates on this beginning in his chapter on the *Venus de Milo* in *Art and Psychoanalysis*). Rickman suggests that such statues can arouse unconscious phantasies of remutilation from infancy. The reawakened phantasy of destructive impulses is more disturbing than the defects in the object itself. The phantasy remains unconscious and the effect of fear or horror becomes attached to the statue: 'the phantasy is kept from consciousness at the expense of the richness of the subject's emotional relation to an external object' (Rickman 1940: 298). (Art therapists will be familiar with the difficulty of getting clients to 'own' disturbing pictures.)

Rickman suggests that there are three satisfying factors in a work of art. There is, firstly, sensuous pleasure from viewing. Secondly, relief of tension gained from the solving of a conflict through the interplay of constructive and destructive tendencies: 'a work of art appeals to us in proportion to the

depth of emotional level which is stirred in our minds, the artist cannot take us where he himself has never been' (1940: 307). Thirdly, there is an 'eternal' factor. In seeing the triumph of creative forces over destruction we are helped to struggle with despair. Artists are driven to create to make sure their internal objects are alive and healthy and not destroyed by hate and envy: 'In all nature death is the only irreversible reaction, the triumph and the illusion of art is that it can turn back the dead into the world of the living' (1940: 308). Rickman concludes that 'fear which ugliness arouses is due to the irrefutable evidence which it provides that the will to destructiveness has been let loose' (1940: 234).

It is useful at this stage to recap some of the thinking on aesthetics from writers we have already looked at – Hanna Segal, Marion Milner and Donald Winnicott – before going on to look at the contribution from Adrian Stokes. We have seen that in Kleinian terms the artist is working again through the infantile depressive position: the stage of development where the infant becomes aware of love and hate directed towards the same object. Total desolation is felt at the destructive impulses to hurt the loved object, so these are followed by impulses to reparation, to recreate, reconstruct and regain the harmonious inner world. Hanna Segal sees these reparative impulses as a 'fundamental drive in all artistic creativity'. In making a work of art, its independent external existence is important, it is allowed to be separate, as a mother had to be allowed to be separate. Hanna Segal thought that in the aesthetic experience we identify with the artist's inner world. This is not, as Rickman suggested, to do with sensuous pleasure but involves psychic work; and from this work comes our feeling of enrichment and lasting satisfaction. Segal thought that a necessary condition for a work of art, for reparation to take place, was the admission of the original destruction, otherwise there could only be denial of destructive impulses. She felt that an element of ugliness, which corresponds to what is destroyed or fragmented in the inner world – as well as an element of beauty, which corresponds to what is whole, the experience of a loved whole good object in the inner world – were both essential as part of the aesthetic experience. Like Ehrenzweig she thought that the viewer of the work of art must complete the work internally: 'our own imaginations must bridge the last gap'. This suggests a necessary incompleteness on the part of the artist, psychic work for the beholder, as an integral part of the aesthetic experience.

Donald Winnicott and Marion Milner have both contributed to the psychoanalytic understanding of aesthetics by particularly commenting on the role of the 'illusionary area' and the role of 'framing' respectively (Milner 1950; Winnicott 1958). Winnicott, in his study of 'Transitional objects and transitional phenomena' (1958) delineated the inner world, outer reality, and a third area of experiencing to which both the former contribute. An area that is not challenged, it exists as a 'resting place' for the individual in the perpetual human task of keeping inner and outer reality separate yet related.

This intermediate area, the 'illusionary area', is in direct continuity with the 'play' area of the small child who is 'lost' in play: 'At this point my subject widens out into that of play, and of artistic creativity and appreciation and of religious feeling and of dreaming' (1958: 233).

Marion Milner saw the withdrawal from the external world as a necessary part of play or art so that inner work of integration could be carried out. The aesthetic moment for maker or viewer was during this temporary loss of self. She thought that art provided a method in adult life for reproducing states that are part of everyday experience in healthy infancy. By using art one could keep the perception of the world from becoming fixed and no longer capable of growth. Paint, a pliable medium, provides feedback; it is a basis of communication, waiting for the painter to become more sensitive to its real qualities, and by this means it does some of the things that a good mother does for her baby. The painting provides a framework of time and space, what is within is to be taken symbolically; what outside, literally. Inside is symbolic of feelings and ideas. Many forms of therapy give a similar 'framing' to experience. She thought that in creative activity one was trying to find an order in one's own loves and hates, in appreciation observing how someone else has tackled the problem and sharing their experiences imaginatively.

The writings of Adrian Stokes, painter and aesthetician, contributed to and influenced psychoanalysis as well as artistic thinking. He had similar ideas to Hanna Segal on the depressive position and the reparation and restoration taking place in both artistic creativity and the aesthetic experience (but differed in also finding elements of the paranoid-schizoid position). He thought that we could also experience a feeling of fusion, at oneness with the breast and the world, as well as recognition of a separate object, the whole person of the depressive position in both art and appreciation. The artist strives to recreate a sense of fusion, thus renewing the oceanic feeling but combined with object 'otherness'. It is from this state of fusion, in which ideas are interchangeable, that 'poetic identifications' can flow. Stokes saw the work of art itself as an individual separate object, differentiated, yet made of undifferentiated material: 'We can always discover from aesthetic experience that sense of homogeneity or fusion combined in differing proportions with the sense of object-otherness' (1973: 104). And:

> Because it combines the sense of fusion with the sense of object-otherness, we might say that art is an emblem of the state of being in love: this seems true if we emphasise the infantile introjections and reparative attitudes that are strengthened by that state. These attitudes are the fount of Form. When the artist joins them in the creative process, infantile psychic tensions concerning sense-data renew in him some freshness of vision, some ability to meet, as if for the first time, the phenomenal world and the emotion it carries.
>
> (Stokes 1973: 110)

In his writings on aesthetics, Stokes also spoke of the 'invitation in art'. He saw this as an invitation to identify empathetically, and of the 'process of heightened perception by which the willing spectator "reads" a work of art'. He saw it as an 'inner' as well as a 'physical' process. The value of an art object was a 'model of a whole and separate reconstituted object'. Hanna Segal differed from Stokes in seeing the 'oceanic feeling' as a manic defence against depressive experience and also manic reparation resulting in senti-mental 'over-sweet' works of art. Stokes, however, associated two modes of art, the modelling and the carving, with the paranoid-schizoid and the depressive positions respectively. He therefore saw a return to a much earlier mode of experiencing to be one possibility of artistic and aesthetic ways of being. He thought similarly to Hanna Segal on the necessity for an element of destructiveness to be present, to have left its traces in the art work, but describes it more in terms of the problem facing the artist: 'I believe that in the creation of art there exists a preliminary element of acting out of aggres-sion, an acting out that then accompanies reparative transformation, by which inequalities, tensions and distortions, for instance, are integrated, are made to "work" ' (1978: 275). As Fairbairn, earlier, had explored when an art work 'worked' or not, Stokes describes it thus: 'But we soon reach the strange conclusion that if attack be reduced below a certain minimum, art, creative-ness, ceases, equally, if sensibility over the fact of attack is entirely lulled, denied' (1978: 276). Art is seen integrally to be about the work of uniting conflicting trends: 'The homage to Eros would be formless were the heavier gifts from Thanatos excluded' (Stokes 1973: 115).

Adrian Stokes makes a bridge from the psychoanalytic view of the inner world to the outer world where art objects also exist in a particular culture and point in historical time. His contribution is important because it is based on his experience as a practising artist, as well as trying to develop thought about aesthetics through his writing.

Peter Fuller's interest in art and psychoanalysis (Fuller 1980) is partly an exploration of 'abstraction', asking the question 'Why do certain types of art which seem to bear no discernible relationship to the perception of the object-ive world appear good and give intense pleasure?' In his book, Fuller is trying to find a materialist basis to aesthetics. He explores how object-relations theory may illuminate his enquiry. Here we can only pick out some stages of his thinking in the space available. He is led to explore abstract art as being about the affective meaning of space through the influence of Marion Milner's work. Cubism was an attempt to struggle out of the old perspective-based fine art conventions towards a half-expression of a new way of seeing. He sees Cézanne painting landscapes in a stage of change and becoming a mingling of inner and outer worlds.

Fuller finds object-relations theory of interest, particularly its focus on a transient stage of development between the 'subjectivity' of the earliest moments and the more objective perceptions of late childhood. Fuller sees

that, from Cézanne onwards, some painters are not just involved in an 'epilogue to fine art' but are exploring a new capacity of painted images to explore aspects of human experience; in Stokes' terms, fusion and object-otherness. This is in line with Milner's view that painting is a way of experiencing relationships. We return to Fuller's description of the experience of viewing particular paintings by Natkin, mentioned earlier in connection with the uncanny. Fuller felt the painting drawing him into an illusionary space 'contained within the painting'. His experience of the painting was almost as if a person was in relationship to the viewer. Fuller discusses the ideas of Winnicott on 'potential space', the hypothetical area of me and not-me, and on the two experiences of mother: object mother (use of mother at height of id tension) and environment mother (mother warding off the unpredictable and actively providing care in handling) (Winnicott 1965b, 1988). He suggests that the two aesthetic experiences, beauty (classical, order, form, carving mode) and sublime (romantic, fusion, colour, modelling mode) correspond to experiences of the object mother and environment mother respectively. Returning to Natkin's painting which inspired his investigations, Fuller describes it as giving an experience of 'potential space' in the emotions and paradoxes it arouses in the viewer. In exploring these early experiences Fuller follows the work of Milner and Ehrenzweig in seeing the creative potential working with the primary process rather than seeing it as archaic and regressive (Milner 1950; Ehrenzweig 1967). We shall be looking at the work of Rycroft who sees the two processes as complementary – creative people hold onto the imaginative in the midst of the rational – in the next section, on symbolism. It is possible that abstract painting is a necessary phase of 'emptiness' and 'exploration of inner space' on the way to a new integration.

Symbolism

The analogy of art being a bridge between inner and outer worlds is sometimes used by art therapists to describe their role as mediator and to describe the function that a picture can have, holding and symbolising past, present and future aspects of a client, linking unconscious to conscious imagery. All this, with its ambivalences and conflicts, can be mutely 'said' in a picture. Theory about the symbolisation process has changed significantly since Freud. Charles Rycroft (1968), in *Imagination and Reality*, delineates past and present thinking concerning this subject with great clarity. He begins by describing Freud's classical theory of symbolism which rests upon one of his earliest and most fundamental ideas, mentioned earlier in Chapter 4, of a primitive psychic apparatus which regulates states of tension by discharging instinctual impulses. Symbols are formed by the displacing of investment of psychic energy from the object of primary instinctual interest onto other objects that have been seen in the outside world. Once it has been formed, a symbol can be used by either the primary or the secondary process. If it is

used by the primary process, its meaning becomes independent of the object originally represented and it becomes joined to the fantasy systems underlying neurosis and dreaming. If it is used by the secondary process, it continues to represent the object it is linked to in the outside world and becomes part of our adaptation to reality serving conscious and unconscious imaginative processes.

Impulses discharged by way of the primary process bring immediate but temporary relief of tension but remain unrelated to the outside world, e.g. tension is relieved through dreams to guard our sleep; in psychosis fantasy is used in the forming of a defensive denial of reality. In infancy, the immature ego hallucinates wish-fulfilment; in neurosis, a fantasy life is developed to fulfil wishes. However, impulses taking the pathway of secondary processes become conscious wishes. There are two parts to this process. Firstly, external reality is perceived and analysed in the search for an appropriate object and then skills are used so that the wish is satisfied. It can be seen that the secondary process leads to communication, contact and interaction with an external object.

Rycroft feels that the classical theory of symbolism became untenable with the changes and developments made in Freud's metapsychology described in 'The Ego and the Id' (1923). In this paper his ideas became less rigid, suggesting that

- what is unconscious is not necessarily repressed;
- the ego (replacing the conscious) is not necessarily conscious;
- instead of a clear duality of conscious and unconscious, the ego becomes 'that part of the id which has been modified by the direct influence of the external world'.

Before moving on to look at Rycroft's revision of the classical theory of symbolism we would like to look at some of the influential writers who have contributed to present-day thinking.

The seminal paper is Ernest Jones' 'The theory of symbolism'. He approaches the subject with a global vision: 'If the word symbolism is taken in its widest sense, the subject is seen to compromise almost the whole development of civilisation. For what is this development but a never-ending series of evolutionary substitutions, a ceaseless replacement of one idea, interest, capacity, or tendency by another?' (1919: 181). Jones explores the many uses of the term 'symbolic' and finds six common attributes. A symbol is a representative or substitute for some other idea. A secondary element represents a primary idea by having something in common, which can be internal or external, i.e. significance of feeling. A symbol is characteristically sensorial and concrete whereas the idea symbolised may be relatively abstract and complex, and therefore has been condensed. He considered symbolic modes of thought to be more primitive and to represent a reversion to some simpler

and earlier stage of development. They are therefore more common in fatigue, drowsiness, illness, neurosis, insanity or dreams. In most cases a symbol is a manifest expression for an idea that is more or less hidden, secret or kept in reserve. Lastly, he thought that symbols 'resemble wit', in being made spontaneously, automatically and unconsciously.

Jones makes a distinction between two different kinds of symbolism. The first is 'true symbolism' which arises as the result of intrapsychical conflict between the repressing tendencies and the repressed. The interpretation of the symbol usually evokes a reaction of surprise, incredulity or repugnance. Feeling has been undersublimated and repressed. In the second, 'functional symbolism', regression proceeds only to a certain distance, remaining conscious or preconscious; it becomes metaphorical. Inhibition is overcome and some feeling force is released. In the formation of metaphor, feeling is oversublimated. Jones thought that the same image could be employed for both of these functions but that they are different.

In his paper he distinguishes operative factors in the genesis of symbolism. Firstly, 'mental incapacity', by which he means that it is *easier* to symbolise, it is a mental process costing least effort. Secondly, the 'pleasure-pain' principle: what interests the mind is easier, so that to find 'likenesses' takes less effort than to perceive something in its separate qualities if it is strange or new. Thirdly, the 'reality principle': the appreciation of resemblances facilitates the assimilation of new experiences. He sees symbolisation as a regressive phenomenon – for instance, the identification of 'likeness' was originally useful to children but should be outgrown. He sees it as a primitive means of adaptation to reality. To summarise, Jones saw that ideas that are symbolised are the most primitive and the most invested, the result of intrapsychical conflict between repressing tendencies and the repressed. All symbols represent ideas of the self and immediate blood relatives, or of the phenomena of birth, love and death – the most primitive ideas and interests imaginable.

Jones' paper on 'symbolism' is interesting historically because it is quite a vigorous examination of what he calls the 'post-psycho-analytical school of writer' (Jung is included among those to whom he is referring). He says that what they are doing is to reinterpret the psychoanalytical findings back into surface meanings. One of their interests in the value of symbolism was to explore the mystic, hermetic or religious doctrine contained in a symbol. Here the symbol would be understood as a striving for a higher ethical ideal which fails to reach this ideal and halts at the symbol instead. The ultimate ideal is seen to be implicit in the symbol and to be symbolised by it. But to Jones this was simply sublimated interests and activities. He disagreed also with Jung on the subject of 'anthropological symbolism', which Jung thought to be inherited. Jones believed instead that individuals recreate afresh in each generation and that stereotyping is due to the 'uniformity of the fundamental and perennial interests of mankind'.

The idea that symbols are innate implies either the 'inheritance of acquired

knowledge' or a 'collective unconscious'. Rycroft (1956) has also explored this question, agreeing with Jones but also adding that the 'universality of symbols' is better explained by the uniformity of the effects and sensations accompanying instinctual acts and the uniformity of the human mind's capacity for forming gestalts and seeing resemblances between them than by a 'collective unconscious'. Jung's distinctive approach to symbolism and its place in analytical psychology was outlined in Chapter 4.

These classical approaches to symbolism were challenged by later analysts, particularly of the object-relations school. For this reason it will be useful to recap briefly on the work of Melanie Klein, Marion Milner and Donald Winnicott and to look at the thinking of Susan Isaacs on 'Phantasy' (1970). The theory that it is only secondary process thinking that is concerned with reality adaptation was turned about by the studies of mother–infant behaviour of the object-relations theorists who saw that the infant engages in realistic adaptive behaviour from the beginning. As Rycroft explains in *Beyond the Reality Principle* (1962), present-day thinking now starts from an assumption of primary integration and regards maturation as proceeding not from chaos (the id) but from simple to complex forms of organisation.

Klein discovered in the analysis of small children the richness and dynamic importance of unconscious phantasy. In her paper 'The importance of symbol formation in the development of the ego' (1930) she starts by looking at the work of Ferenczi who held that 'identification, the forerunner of symbolism, arises out of the baby's endeavour to rediscover in every object his own organs and their functioning' (Klein 1930: 237). She was also influenced, as were all later writers, by Ernest Jones' work on symbolism – his view that the pleasure principle 'makes it possible for two quite different things to be equated because of a similarity marked by pleasure or interest' (Klein 1930: 237). Klein concludes that symbolism is the foundation of all sublimation and of every talent, since it is by way of symbolic equation that things, activities and interests become the subject of libidinal phantasies. Klein thought that the anxiety arising from the sadistic phase sets going the mechanism of identification. Anxiety equated with the organs in question equates them to other objects and forms the basis of interest in new objects, so that through a spread of feeling there is an enrichment of new objects encountered by means of symbolism: 'Thus, not only does symbolism come to be the foundation of all phantasy and sublimation but, more than that, upon it is built up the subjects' relation to the outside world and to reality in general' (1930: 238). Klein thought that for a favourable development in the child there needs to be a balance between anxiety, abundance of symbol formation and phantasy, and an adequate capacity on the part of the ego to tolerate anxiety. Klein saw the compulsion to make symbols and their constant development as 'the driving force in the cultural evolution of mankind'.

One way of understanding autistic children is that they have never been able to form appropriate symbolic relationships, firstly with the mother and

then subsequently with other objects. Klein showed that from the earliest stages the infant begins to search for symbols and does so in order to be relieved of painful experiences. The conflicts and persecution in the phantasy with primal objects (i.e. the mother's body) promote a search for new relationships with substitute objects (symbols). These conflicts tend to follow and often affect the relationship with the substitute object (the symbol), which eventually sets up a further search for yet another substitute. In this case she described a process of substitution similar to displacement, which Freud also thought was one of the factors underlying the process of dream symbolisation.

In her astute analysis of Dick, Klein describes how this child showed absolutely no emotion about anything and therefore at first how difficult it was to build any therapeutic alliance. He showed no feeling as he was not attached to anything – his early infancy had been fairly traumatic and he showed no emotion towards either his mother or his nanny. His interest was in trains and door handles and it was starting at these points that Melanie Klein gradually built up a relationship with him so that he could begin to show anxiety, guilt, love and other feelings towards people and things (Klein 1930).

In her paper on 'The nature and function of phantasy', Susan Isaacs makes an important distinction between 'phantasy' which is unconscious mental content and 'fantasy' such as conscious daydreams, fictions and so on. Also, in *Playing and Reality*, Winnicott states: 'It will be observed that creative playing is allied to dreaming and to living but essentially does *not* belong to fantasying' (1988: 32).

Unconscious phantasies are a mental representation of instinctual life; they are active from birth. For instance, the comprehension of words long antedates their use; phantasies are active along with the impulses from which they arise. Unconscious phantasies colour the infant's experience of real objects and the impact of reality constantly modifies phantasy life. Phantasy life expresses itself in symbolic ways, as Hanna Segal says, on art: 'All art is symbolic by its very nature and it is a symbolic expression of the artists' phantasy life' (1975: 800).

Susan Isaacs' definitions of phantasy and fantasy are important in clarifying the difficulties that can arise when 'phantasy' is used as a contrast to reality. By this she intends external, material or objective facts. It then denies to psychical reality its own objectivity as mental fact. Or, she goes on to say, it can undervalue the dynamic importance of phantasy, physical reality and the significance of mental processes as such. Isaacs describes how the earliest phantasies 'spring from bodily impulses and are interwoven with bodily sensations and affects' (1970: 88). An infant has few ways of expressing desire and aggression and has to use bodily products and activities to express powerful, often overwhelming wishes and emotions. These primary phantasies are far removed from words and conscious relational thinking. Both Freud (1923) and Jones (1919) have commented on how much older 'visual

memory' is than thinking in words. Freud states: 'It approximates more closely to unconscious processes than does thinking in words, and it is unquestionably older than the latter, both ontogenetically and phylogenetically' (1923: 23). Isaacs (1970: 99) sees phantasy as the 'operative link between instinct and egomechanism':

> An instinct is conceived as a border-line psycho-somatic process. It has a bodily aim, directed to concrete external objects. It has a representative in the mind which we call a 'phantasy'. Human activities derive from instinctual urges, it is only through the phantasy of what would fulfil our instinctual needs that we are enabled to attempt to realise them in external reality.

It can therefore be seen that reality-thinking or secondary process thinking is inextricably linked to supporting unconscious phantasies – primary process thinking. The theory about phantasy and unconscious processes is based on direct observation of children's play and inferences drawn from it. Susan Isaacs describes how the spontaneous make-believe play 'creates and fosters the first forms of "as if" thinking'. In 'make-believe' a child will select elements from past experience which can embody their emotional and intellectual present needs. Isaacs continues:

> This ability to evoke the *past* in imaginative play seems to be closely connected with the growth of the power to evoke the *future* in constructive hypothesis, and to develop the consequences of 'ifs'. The child's make-believe play is thus significant not only for the adaptive and creative intentions which when fully developed mark out the artist, the novelist and the poet, but also for the sense of reality, the scientific attitude and the growth of hypothetical reasoning.
>
> (1970: 111)

We saw earlier that Winnicott's particular achievement and contribution to the theory of symbolism has been to explore this intermediate area of experiencing between inner and outer realities. Inventing the term 'transitional object' in looking at the significance of the early stages of object-relating and of symbol-formation, he was therefore able to 'locate' the area of cultural experience and to explore the necessity of 'illusion'. Many writers have built on aspects of his work. Bollas (1987) explores transformational objects in relation to aesthetic experience. He posits that the first aesthetic experience is that of 'mother's form of relating'. The adult may search for an object that will be transformational based on the mother's original way of transforming states of being for the infant. The finding of the right object may allow fragmented parts of the self to be integrated. Schaverien (1994, 1995) suggests that the picture can act as a transactional object (a term borrowed from

anthropology) through which unconscious transactions may be channelled and acted out. Schaverien has discussed the art object mediating as a transactional object in anorexia, where it can take the place of food and the way that the picture can mediate in psychosis, as a fetish and as a talisman (Schaverien 1992; Killick and Schaverien 1997). In Winnicott's exploration of 'true' and 'false' selves the importance of early relations and the capacity to use and to form symbols is poignant (Winnicott 1965a). He describes how a true self begins to have life through the strength given to the infant's weak ego by the mother's implementation of the infant's omnipotent expressions. A false self develops when a mother repeatedly fails to meet the infant's gesture and substitutes her own gesture. This is given sense by the compliance of the infant. The true self has a spontaneity. The infant is able to abrogate omnipotence and can begin to enjoy the 'illusion' of omnipotent creating and controlling, through playing and imagining. This is the basis for the symbol 'which at first is both the infant's spontaneity or hallucination, and also the external object created and ultimately cathected'. The healthy individual develops a capacity for using symbols in this intermediate area between dream and reality and this is the basis of cultural life. The infant who has developed a false self has a poor capacity to use symbols and, therefore, a poverty of cultural living. Winnicott describes the resulting behaviour as extreme restlessness, an inability to concentrate, a need to collect impingements from external reality and a living time filled by reactions to these impingements.

Let us remind the reader of Marion Milner's particular contribution to this discussion. She was able to mesh her analytic insights with her experience of practising as an artist and, like Adrian Stokes, was able to push thinking further forward with a fresh and original vision. She saw that one continually works on the inner and external world and that there is a free movement possible between them by which they can enrich one another. One is able to assimilate and integrate new experiences into the gradually growing self, to form an inner constant core. An encounter with reality might take prolonged activity to work through in the inner world. The reverse also happens, new motivation comes from the inner world through dreams, art and phantasies and leads to reality-oriented behaviour. Most importantly she gave a new positive emphasis to the primary process as being the necessary other half to a way of functioning healthily. She saw the art process as being able to create something 'new' through the process of symbolisation. Like Winnicott, she drew many parallels between the healthy mother–child relationship and its framework, to that of the analytic session and also, of course, the similar necessary framework that is needed for creating something new in art. Instead of the symbol being limited to a defensive function it is now seen as being essential for healthy growth out into the world. Milner saw through her clinical and artistic practice that a regression to the infantile unconscious tendency to note identity in difference may be to take a step forward (1955).

Rycroft, in *Imagination and Reality*, suggests that Jones' distinction of two different kinds of symbolism is in fact the same process of symbolism but is being used in different ways. He then formulates a theory of symbolism as a general tendency or capacity of the mind which can be used by primary or secondary process, neurotically or realistically, for defence or growth; for self-expression or to maintain fixation. He summarises: 'The process of symbol formation consists in the displacement of cathexis from the idea of an object or activity of primary instinctual interest on to the idea of an object of less instinctual interest. The latter then operates as a symbol for the former (1968: 54). A symbol carries affect displaced from the object it represents.

Both Milner's and Rycroft's theories have been influenced by Suzanne Langer, whose study of symbolism, *Philosophy in a New Key*, is relevant here (1963). Part of her argument is to look at various impractical, apparently unbiological activities of man – i.e. religion, art, magic, dreaming – as languages arising from a basic human need to symbolise and communicate. With the re-evaluation of the primary process and the acceptance that its manifestations are not necessarily unconscious, dreams, imaginative play and artistic creation are able to be looked at anew. Langer discusses discursive and presentational forms of symbolism. The symbolism of the secondary process is discursive; conscious rational thinking is symbolised through words which have a linear, discrete successive order. The symbolism of the primary process is non-discursive, expressed in visual and auditory imagery rather than words. It presents its constituents simultaneously not successively, it operates imaginatively but cannot generalise. Therefore complexity is not limited by what the mind can retain from the beginning of an apperceptive act to the end.

Language is the only means of articulating thought; in this picture Langer draws of the mind, everything which is not speakable thought is feeling. She describes this as the inexpressible world of feeling: 'Not symbols of thought but symptoms of inner life' (1963: 85). From this sphere of subjective experience only symptoms come to us in the form of metaphysical and artistic fancies.

In defining 'a picture' as an example of 'non-discursive symbolism' Langer describes it as having units which do not have independent meanings like a language, i.e. the vocabulary. There is no fixed meaning apart from content: 'It is first and foremost a direct *presentation* of an individual object' (1963: 96).

In responding to presentational symbolism the mind reads in a flash and preserves in a disposition or attitude: 'Feelings have definite forms which become progressively articulated'. Or, in the words of Adrian Stokes, 'the insistence by its form that distinguishes the communications of art from other embodiments of phantasy or of imagination' (1978: 266).

Rycroft sees the function of the primary process, of non-discursive symbolism, as being expression, explication and the communication of feeling attached to experience. The secondary process has the function to analyse

external reality into discrete elements, to categorise them and formulate statements about the relations existing between them. Both have a realistic function and are adaptive. If the secondary process is disassociated it becomes intellectual defence and if the primary process is disassociated it becomes pre-logical animistic thinking. Rycroft in his revisioning of theory around these processes concludes that 'the aim of psychoanalytical treatment is not primarily to make the unconscious conscious, not to widen or strengthen the ego, but to re-establish the connection between disassociated psychic functions, so that the patient ceases to feel that there is an inherent antagonism between his imaginative and adaptive capacities' (1962: 113).

This leads us back to the beginning of this section where we suggested the image of art therapy as a bridge between inner and outer worlds, between imagination and reality.

References

Bollas, C. (1987) *The Shadow of the Object: Psychoanalysis of the Unthought Known*. London: Free Association Books.

Ehrenzweig, A. (1967) *The Hidden Order of Art*. London: Paladin.

Fairbairn, W.R.D. (1939) The ultimate basis of aesthetic experience, *British Journal of Psychology*, XXIX: 100.

Frazer, J.G. (1987) *The Golden Bough* (abridged). London: Macmillan.

Freud, A. (1950) Foreword to Marion Milner, *On Not Being Able to Paint*. London: Heinemann.

Freud, S. (1905) Jokes and their Relation to the Unconscious, in *Standard Edition*, VIII. London: Hogarth Press.

Freud, S. (1908) Creative Writers and Daydreaming, in *Standard Edition*, IX. London: Hogarth Press.

Freud, S. (1919) The Uncanny, in *Standard Edition*, XVII. London: Hogarth Press.

Freud, S. (1923) The Ego and the Id, in *Standard Edition*, XIX. London: Hogarth Press.

Freud, S. (1925) An Autobiographical Study, in *Standard Edition*, XX. London: Hogarth Press.

Fuller, P. (1980) *Art and Psychoanalysis*. London: Writers & Readers.

Gombrich, E.H. (1966) Freud's aesthetics, *Encounter*, XXVI(1): January.

Gordon, R. (1989) The psychic roots of drama, in A. Gilroy and T. Dalley (eds) *Pictures at an Exhibition*. London: Tavistock/Routledge.

Hershkowitz, A. (1989) Symbiosis as a driving force in the creative process, in A. Gilroy and T. Dalley (eds) *Pictures at an Exhibition*. London: Tavistock/Routledge.

Isaacs, S. (1970) The nature and function of phantasy, in *Developments in Psycho-analysis*. London: Hogarth Press and the Institute of Psychoanalysis.

Jones, E. (1919) The theory of symbolism, *British Journal of Psychology*, IX.

Klein, M. (1930) The importance of symbol formation in the development of the ego, in *Contributions to Psycho-Analysis 1921–1945* (1968). London: Hogarth Press and the Institute of Psychoanalysis.

Killick, K. and Schaverien, J. (1997) *Art, Psychotherapy and Psychosis*. London: Routledge.

Kris, E. (1953) *Psychoanalytic Explorations in Art*. London: Allen & Unwin.

Kris, E. (1975) Psychoanalysis and the study of creative imagination (1953), in *The Selected Papers of Ernst Kris*. New Haven, CT: Yale University Press.

Langer, S. (1963) *Philosophy in a New Key*. Cambridge, MA: Harvard University Press.

Mann, D. (2006) Re-imagining a psychoanalytic perspective – a reply to David Maclagan, *International Journal of Art Therapy: Inscape*, 11(1): 33–40.

Milner, M. (1950) *On Not Being Able to Paint*. London: Heinemann.

Milner, M. (1955) The role of illusion in symbol formation, in M. Klein *et al.* (eds) *New Directions in Psycho-Analysis*. London: Maresfield Reprints.

Milner, M. (1969) *The Hands of the Living God*. London: Virago.

Prinzhorn, H. (1972) *The Artistry of the Mentally Ill*. Berlin: Springer-Verlag.

Rickman, J. (1940) On the nature of ugliness and the creative impulse, *International Journal of Psychoanalysis*, XXI: 294–313.

Rycroft, C. (1956) Symbolism and its relationship to the primary and secondary processes, in *Imagination and Reality: Psychoanalytical Essays 1951–1961*. London: Hogarth Press.

Rycroft, C. (1962) Beyond the reality principle, in *Imagination and Reality: Psycho-analytical Essays 1951–1961*. London: Hogarth Press.

Rycroft, C. (1968) *Imagination and Reality: Psychoanalytical Essays 1951–1961*. London: Hogarth Press.

Schaverien, J. (1992) *The Revealing Image: Analytical Art Psychotherapy in Theory and Practice*. London: Routledge.

Schaverien, J. (1994) The transactional object: art psychotherapy in the treatment of anorexia, *British Journal of Psychotherapy*, 11(1): 46–61.

Schaverien, J. (1995) *Desire and the Female Therapist: Engendered Gazes in Psychotherapy and Art Therapy*. London: Routledge.

Segal, H. (1975) Art and the inner world, *Times Literary Supplement*, 18 July.

Sharpe, E. (1950a) Certain aspects of sublimation and delusion (1930), in *Collected Papers on Psychoanalysis*. London: Hogarth Press and the Institute of Psychoanalysis.

Sharpe, E. (1950b) Similar and divergent unconscious determinants underlying the sublimations of pure art and pure science (1935), in *Collected Papers on Psychoanalysis*. London: Hogarth Press and the Institute of Psychoanalysis.

Stokes, A. (1973) Form in art: a psycho-analytic interpretation, in *A Game that must be Lost: Collected Papers*. Manchester: Carcanet.

Stokes, A. (1978) The invitation in art, in L. Gowing (ed.) *The Critical Writings of Adrian Stokes*, vol. III. London: Tavistock.

Storr, A. (1978) *The Dynamics of Creation*. London: Secker & Warburg.

Winnicott, D.W. (1958) Transitional objects and transitional phenomena, in *Through Paediatrics to Psychoanalysis*. London: Tavistock.

Winnicott, D.W. (1965a) Ego distortion in terms of true and false self (1960), in *The Maturational Process and the Facilitating Environment*. London: Hogarth Press.

Winnicott, D.W. (1965b) Communicating and not communicating, leading to a study of certain opposites (1963), in *The Maturational Processes and the Facilitating Environment*. London: Hogarth Press.

Winnicott, D.W. (1988) *Playing and Reality*. London: Tavistock.

Wolheim, R. (1980) *Art and its Objects*. Cambridge: Cambridge University Press.

Chapter 8

The art therapist

The art therapist faces a complex and difficult task in her clinical work. The theory and practice of art therapy has evolved to require that practitioners are highly trained and experienced people whose skills continue to develop after their initial training and qualification.

The development of art therapy training

Art therapy has emerged as a profession through the two disciplines of art and psychiatry and this tends to reflect the interests of those entering the profession. Most art therapists have an art training but there are some who have other relevant degrees such as social work or psychology. However, all applicants for the various training courses must show an ongoing commitment to their own art work and its development.

The importance of this stems from the early days of art therapy when theories in art education were making links between primitive and child art and a growth of interest in expression and imagination among art educators (Viola 1944):

> Art was a means for developing a seeing, thinking, feeling and creative human being, a logical development of the ideal of the early twentieth century American philosopher John Dewey and an ideal well suited to a world war and immediately post-war period: let the children, at least, have their freedom.
>
> (Waller 1984: 4)

In the 1940s writers such as Herbert Read and John Dewey saw art as vital in developing the 'whole' personality. The idea was that the person concerned, either teacher or therapist, was to stimulate this development by holding back and not influencing, by providing materials and a stimulating environment. Followers of the Dewey school could be identified within the education system as progressive art teachers, but in the health service the role of artists in hospitals was far more uncertain. Were they art therapists merely

because they could bring educational ideas about art into the treatment set-ting, which also involved encroaching on the existing occupational therapy services?

At that time paintings were only being used for analysis and diagnosis by psychiatrists with little understanding of the need for the patient to make sense of a painting, or to see that the picture was made within a relationship and must necessarily reflect the dynamics of this relationship. The first art therapist, Edward Adamson, who was employed at Netherne Hospital in 1946, adopted the recommended approach of Dewey and advocates of the child-centred approach. For although he was working in a hospital, Adam-son provided an environment which facilitated the creative process but he did not intervene (Adamson 1984).

As Waller (1984) explains, the doctors at the time of his appointment had quite clear views about his role – he was to produce paintings under standard conditions with minimum intervention. They were anxious that he should be more than an occupational therapist but should not analyse, interpret or show any special interest in the psychological problems of the patients. This was the job of the doctors who thought that art works were pure representa-tions of the patient's state of mind which completely denied the presence or absence of the therapist and the effect this had on the output of the patient.

This position was frustrating for artists and art teachers working in hos-pitals and led them to form a central association in 1964, the BAAT, with a view to clarifying the role of the art therapist in hospitals. Part of this clarifi-cation would be to initiate a suitable training and structure for employment. Originally, the BAAT was affiliated with the National Union of Teachers. It then joined with ASTMS, now Amicus, to reflect its more central role as a paramedical profession. State registration for art therapists became manda-tory in the 1990s with the establishment of the CPSM. This organisation has been superceded by the HPC. Membership of this body demands high stand-ards of education and clinical practice and ensures public protection. All practising art therapists are bound by law to be registered with the HPC.

When the BAAT was formed in 1964, the Department for Health and Social Services (DHSS) still had the official view of art therapy as an ad hoc grade of occupational therapy, maintaining the view that art was merely a hobby or form of recreation and was only used as a diagnostic aid for doctors. The link with teachers evolved through the need of those artists and art teachers who saw themselves as having a more dynamic role in the possibilities of using art in the treatment of patients and did not believe they were primar-ily the passive providers of art materials. At that time, art teaching provided the nearest model for the development of art therapy as a separate profession.

Art therapy theory and practice developed gradually in the direction of psychotherapy in the 1970s. This indeed reflected the shifts in thinking in the increasingly professional body of practising art therapists. The gradual separation from art teaching came about as the practice of teaching became

more curriculum-based, geared to active participation in the classroom with clear goals and objectives. This was not felt to be such fertile ground for the development of art therapy. The growing understanding that art therapy had many basic links with psychotherapy led to the establishment of specialist training in art therapy in the early 1970s (Waller 1991).

Thus, training courses for art therapists were set up, two of which evolved out of existing art education establishments (Birmingham and Goldsmiths College, London). The essence of the training relies on the requirement of a first degree in art design (or equivalent) where much of the foundation work in terms of personal understanding, aesthetic appreciation, critical awareness and creative problem-solving will be achieved. Without this foundation, the art base of the profession of art therapy is eroded. It also requires art therapists to have gained a high degree of personal understanding in terms of their own creative and internal processes (Gilroy 2004):

> At the best art colleges in the UK, the student learns to court discomfort, to abandon obvious or well-tried solutions and to test that which is new and different in her experience. Such an approach fosters emergence of inner reality, however chaotic, this being shaped into outer, more objective, imagery and objects once the raw material is manifest.
>
> (Schaverien 1989: 147)

The experience of an art training will also have allowed the future art therapist to develop in an environment which is to some degree an anarchic one. This ensures that the student emerges with some understanding of how one proceeds in this environment and, as a result, has come to some personal decisions as to issues such as resourcefulness, the need for boundaries, limits and rules and so on. An art student cannot fail to have confronted at least some of these issues in her educational journey.

This is essentially a different experience to that of a psychiatrist whose background is one of a medically trained doctor. In contrast to the artist, the formative experiences of the medical training are scientific, where knowledge is gained from facts and learning that is taught through books, lectures and observation of other people's behaviour. There is little onus on the medical trainee to reflect or analyse, or time for thinking and reflection. More emphasis is placed on the 'here and now' and coping with the immediate demands of the situation: 'To become a psychotherapist such a person will need to relinquish the primacy of the outer world to allow space for acceptance of inner experience' (Schaverien 1989: 147–8).

Schaverien suggests that the artist/therapist may feel the need to relinquish the artist part of her experience in the face of an institution or system dominated by the scientific approach. In this situation it is imperative to establish that what we bring as artists to therapy is special and unique in terms of its therapeutic value and contribution (Maclagan 2005).

It is within this difference of experience and cultures that art therapists may face misunderstanding and potential difficulties within their working environment. The art therapist is usually the only one in the team whose background is of art training. She articulates this experience by informing and communicating her thinking in the approach to her work. One important task of the art therapist is to promote understanding throughout the institution in which she is employed. This can take the form of leaflets or handouts. Many art therapists set up staff training days or in-service education and training (INSET) days for colleagues. There may be a general knowledge about art therapy but sometimes other professionals remain uninformed of what actually happens in art therapy sessions.

In his chapter about surviving the institution as an art therapist, David Edwards (1989) points out that the problems art therapists face appear to fall into three main areas: the problems of recognition, integration and validation. He argues that many of the problems are not misunderstanding of their work, but often institutionally-based in terms of the isolated location of some of these departments in huge psychiatric institutions. This sense of isolation does not necessarily only have a geographical basis. Similar feelings of being 'isolated' can happen when working in a team of people whose approach is perceived to be different in the fundamental approach to practice.

In the smaller institutions and clinics, some art therapists are working alongside colleagues who work from a psychoanalytic framework and might be taking a Freudian or Kleinian view of art which does not fully take into account the impact of the visual component of the image in the therapeutic process. These colleagues may be perceived as critical of notions of creativity and the articulation of unconscious processes through imagery. The art therapist is trained to be available to the multiplicity of meanings contained in the image and to hold the image central in her mind in the understanding of the processes involved. The ambiguity of images and remaining open to many possibilities of meaning, without a definitive interpretation, sometimes make the art therapist appear vague or inconclusive about her theoretical approach or position.

In the early formation of the BAAT, it was felt that art therapists should be qualified teachers, and the establishment of the professional art therapist was under similar scrutiny (Waller 1987). In her chapter, Waller writes in depth about the internal ramifications and also the part played by the professional association in establishing the profession within the NHS. Art therapy, unlike psychotherapy, has developed a structure within the NHS and has produced a register of qualified practitioners belonging to its professional organisation:

An art therapist is a person who is responsible for organising appropriate programmes of art activities of a therapeutic application with patients, individually or in groups, and possesses a degree in art or design or a qualification considered equivalent for entry to an accepted postgraduate

training course, and also a qualification in art therapy following the completion of an accepted course at a recognised institution of further or higher education.

(DHSS 1982)

The training courses for art therapists combine theoretical and clinical components. The postgraduate courses at MA level are completed over two years full-time or three years part-time. The qualified art therapist becomes a member of the BAAT which has its own *Code of Ethics of Professional Practice*. Aspects of this work will be considered in the following sections.

Referrals

In all clinical settings, patients are referred to art therapy for an initial assessment to establish suitability for treatment. According to the way the art therapist works, she must have an appropriate procedure for these referrals. If working in the health setting, most art therapists are clinically responsible to the consultant psychiatrist and managerially responsible to the head art therapist. Generally art therapists will accept referrals from a multi-disciplinary team in which consideration is given to the appropriate therapeutic approach. If working in education or in the voluntary sector, a clear referral procedure, such as a referral form which includes relevant background information and reasons for referral, is helpful.

In the early days of art therapy, the idea was prevalent that referrals were made on the basis that the patient was good at art – or showed some interest in this activity. Many times the comments have been overheard that 'This patient should go to art therapy', 'Have you seen how good she is at art?' or 'She really enjoys it'. However, the criteria for accepting patients into art therapy are manifold and require careful consideration by both therapist and patient. Each art therapist will manage referrals according to the clinical setting, client group and demands on the service (see Stott and Males 1984; Lillitos 1990).

A short period of assessment is important to establish a therapeutic contract. In this way, the patient does not feel coerced into coming and entering into a contract – nor does the therapist feel obliged to accept the patient. There can be pressure in an institution to accept referrals, as staff and resources are limited. Long waiting lists add considerable weight to allocation decisions. The assessment for art therapy takes into account the patient's presentation, symptoms and current situation. Taking on the assessment will depend on the therapist's case load. She will liaise with colleagues and gather information from the referring agent or other professionals already involved. This will help in building up an overall picture of the client and her suitability for art therapy.

Some art therapists work in an environment such as a therapeutic

community or day centre in which all members are involved in the treatment programme. This does not allow for the same degree of selection of clients although when they enter the community, the knowledge that art therapy is part of the programme will be specified for both staff and members.

The art therapist might work in a closed community such as a secure unit, a geriatric ward or a school for severely physically disabled children. Some of these clients cannot move and have little choice about the activities they are involved in. The art therapist makes herself available and generally comes to the client, sensitive and aware of their need to make choices within the confines of their own environment. In this situation the art therapist makes a commitment in terms of a regular time which can be a powerful experience in the routine of the lives of these people. In our experience some non-ambulent, psychogeriatric patients who seem unapproachable, enclosed in their own worlds, become accustomed to the visits by the art therapist and begin to unfold in their art activities (Rothwell 2005).

Meeting the client: Initial assessment

First impressions of the client are very important. The first meeting in any relationship has an effect on both people. The same happens between therapist and client – what is the response of the therapist to the client and what is the client's response to the therapist? This will mark the beginning of the therapeutic relationship which can, for some, be a long journey.

The art therapist assesses aspects of the client's situation, bearing in mind the background to the referral and the amount of detail she already knows. She will explain the assessment procedure – perhaps four sessions which will be followed by a review meeting and feedback of the assessment. At the review, an agreement to enter into treatment will be made with client and therapist. The therapist will explain what is involved in coming to art therapy and the required commitment. Details about time, place and day for the assessment are worked out together to establish a therapeutic contract. Boundaries of confidentiality are explained in that the content of the sessions is confidential unless there is disclosure of material that poses a risk or danger to the client or to others. In consultation with the client this information will be shared with relevant others for the safety and protection of the client. Details about managing the art work are agreed. The art work is kept safely by the therapist for the duration of the assessment and subsequent treatment and does not leave the therapy room.

Following the assessment, if appropriate, a therapeutic contract is mutually agreed. This involves timing and frequency of the sessions and, if necessary, external considerations like transport. The decision to enter into an art therapeutic contract depends on a whole range of factors including motivation and wish to change, and a 'good enough' fit between therapist and client based on the preliminary assessment process. Sometimes the art

therapist reaches the conclusion that another treatment modality would be better suited to the patient's needs, such as cognitive behaviour therapy, verbal psychotherapy or another form of creative therapy such as music therapy. The assessment helps to form these impressions and important decisions about treatment are made during this process. Treatment will begin from the first arranged session and review dates will be planned if appropriate.

Where assessment for an art therapy group is concerned, either for the first time or where vacancies have occurred in an ongoing group, the same criteria apply. Prospective members are interviewed and the whole group is kept in mind in terms of numbers, gender balance and presenting problems, and these are used as a basis for acceptance into the group. Details of boundaries, time and attendance are explained to all potential members before they commit themselves to joining the group (Murphy *et al.* 2004).

Approach of clinical team

Where the art therapist is a member of a multi-disciplinary team, the work is shared between colleagues of different disciplines and there is a good professional understanding between them. The referral to the art therapist will arise out of discussions and decisions in the team. Their support will be helpful in setting up the art therapy contract and beginning the relationship between client and therapist. Support between colleagues also facilitates the work in progress, particularly if another colleague is seeing another member of the family such as the parent of a child in individual therapy.

The art therapist might be working in isolation, in a large hospital for example. Even though staff nearest to the interests of the patient might be supportive of the referral, it is sometimes the case that due to changing shifts, different ward personnel do not have the same understanding and therefore the work will not be so clearly supported. This can be avoided by maintaining good communication. So often one hears of situations of non-attendance by new patients, and the ward staff say, 'Oh, he has gone to the dentist' or 'He is just seeing the doctor for a moment'. This is rather unsatisfactory, particularly at the beginning of therapy when the regularity of the sessions is being established. Where there is a group running on a ward where the patients are resident, such as in a secure setting, the boundaries need to be discussed with the staff concerned. These may include keeping interruptions, noise level and general ward activities to a minimum. It is helpful if the membership of the group is established before the work begins. The art therapist who works in an outpatient setting is reliant on regular attendance by the client or, in the case of children, good collaboration with parents or carers to ensure the child attends. If it is not possible to attend on one occasion, it is helpful if the client gets a message to the art therapist, preferably in advance of the session.

Case conferences

One of the main responsibilities of the art therapist's work is the attendance and contribution to multi-disciplinary case discussions and clinical meetings. Hearing from the different clinical perspectives gives a valuable insight into how a client is progressing. Art therapists offer an integral part of the thinking in devising the client's treatment or care plan. Attendance at care plan reviews or equivalent clinical meetings and discussion is an integral part of the art therapist's task (Wood 1990).

Some art therapists are working in situations where change is minimal (Miller 1984; Stott and Males 1984; Rabiger 1990). Feedback between colleagues helps understanding of the patient from everyone concerned, which promotes the coordination of treatment and consistency of approach. Working with very old people or children who are severely physically and learning disabled, for example, can involve unspoken and at times unacknowledged frustrations. Therapists are sometimes understood to have the answers or cures. Sharing the difficulties and frustrations of working with a client in whom there has been little change can help the whole team to come to some understanding about this (Sinason 1997; Waller 2002).

Feedback

Regular meetings, case conferences and feedback incorporate all aspects of the therapeutic and care input for the particular client concerned. Depending on the setting, some art therapists attend daily staff meetings, others attend more formal case conferences which are organised in advance to ensure attendance of all the necessary people, which might include other professionals and members of the family. The art therapist gives an account of the development of the relationship between herself and her client. In order to maintain confidentiality, a résumé of the process and overall themes is given. With permission from the client, feedback may include using the images made in the sessions.

Another form of feedback is the use of clinical notes held in a central case file. This is standard practice in most hospitals, assessment centres, outpatient clinics and residential settings. Usually each client contact is recorded either by short process notes or longer documentation of a whole session. Soon, all client notes will be held electronically on a central database and the art therapist will have to adapt to using this method, keeping issues of confidentiality in mind. The Data Protection Act and the new Information Act entitle patients to have access to their medical records. Notes and reports, either internal to the institution or external reports to other clinicians, such as general practitioners, are also written with this in mind.

When the art therapist has terminated work with a client, a final report will be added for the file so that other professionals can have access to this in the

future. Confidentiality is maintained as reports include the main themes in the work, the changes that occurred and the resolution of the conflicts that brought the client to therapy. Where one art therapist is handing over to another, the details can be made more explicit in terms of the materials, the use of the sessions and the approach the art therapist took. For other colleagues this does not have to be so detailed and the reports are written in a way that can assist the understanding of the process. For example, within a school setting, short interim reports can be written on a termly basis.

Occasionally the art therapist is put in a difficult situation in terms of providing 'evidence' that children have been able to articulate through their imagery or in the sessions. For example, for children who have been physically or sexually abused, the containment of art therapy has facilitated a trusting and safe enough environment for the child to make disclosures which may include some graphic imagery. When this occurs, there are standard child protection procedures to be followed in which information is given to the appropriate professional responsible for the care of the child. Sometimes children are asked, by other professionals, to draw their experiences as concrete evidence. This diagnostic approach, where the child is aware of judgement and may experience a degree of coercion, is a different process to when the child is able to express aspects of inner experience that may have emerged into consciousness in the safe containment of a relationship with a therapist. This is clearly pointed out by Case and Dalley (1990: 3):

> Art therapists do not accept that drawings can be used automatically as literal statements and put the sanctity of the therapeutic relationship, trust, and space as paramount. There may be pressure from other members of the therapeutic team to contribute 'evidence' of this because of the urgency and concern for the child, but what is fundamental is that the information is derived through the relationship and might be communicated through the images.

In the case of child abuse, for example, it is far more likely that the abuse will be expressed through 'making a mess' and an understanding can be reached through the transference and counter-transference process, rather than through a drawing graphically depicting who did what to whom, on a particular occasion (Sagar 1990):

> The art therapist is trained to pick up communications of great sensitivity through the processes of image making, and more importantly waiting with, holding and containing the anxiety and uncertainty of the child struggling with their deepest difficulties. Therefore most art therapists hesitate to leap into early interpretation and judgement as to the meaning of the communication. This would suggest that the art therapist may need to work to a point where the child can verbalise the experience

through the ensuing months rather than use the actual art material obtained from one particular session.

<div align="right">(Case and Dalley 1990: 4)</div>

This point is illustrated up the following clinical vignette. The art therapist is working with a 10-year-old boy in a school.

Michael arrived late for his session, having missed the last one, which was quite unlike him. He was jumpy and unsure of what to begin to do – he seemed distracted and aimlessly leafed through a book, seizing on a picture of a man beating a dog, trying to copy it exactly. He worked on it with great care and attention, but began to get extremely upset and could not complete the image. He was also unable to speak about his feelings, and dismissed them as 'nothing'. It emerged in the conversation about his image with the therapist that he had stayed away from school as he had been physically beaten by his father but was unable to talk about it to anyone – the marks on his body were evidence enough. This raised important child protection issues which were necessary to discuss with his social worker who already had doubts about his father's capacity to care for Michael. Michael's predicament was very distressing. His picture expressed the conflict of his wish to stay with his father but also his fear. The art therapist was obliged to explain to Michael that, because they had spoken about something that had happened that was harmful to him, she would let his social worker know in order to keep him safe.

Recording

The art therapist will make clinical notes, contributing to case files or 'day sheets', and reporting to case conferences. She will also make process notes for her own use. This is time-consuming but necessary in order to fully process and reflect on the material in the session. These process notes are used for discussion in the presentation of case material in the art therapist's clinical supervision. In the case of Michael, it was important to record the content of this session in detail to be able to reflect on the situation and process the complex feelings involved.

Here we are going to look at some different approaches to recording art therapy sessions with individuals and groups. Working with groups it is often difficult to get a clear sense of both the group dynamics and the individual process for each member at the end of a busy session and in a busy day. Working with children's groups, for example, each individual may be making pictures, using sand trays, telling stories or play enacting apart from the interactions and interventions between group members and group and therapist. Group themes will also emerge, with individual significance for

each member. Equally, working individually with adults, sessions can vary enormously in content and activity. One could be working with a client with learning difficulties, without speech, painting swiftly, using 15 sheets of paper, making many non-verbal forms of communication or with a depressed adult patient slowly painting in one small area of a sheet of paper or another psychiatric client talking non-stop throughout the session, briefly making a mark before leaving.

In the early days of art therapy, when work was largely studio-based, the ratio of clients to art therapists was huge, and any recording was necessarily brief, at the simplest, dating and storing pictures with perhaps a few words scribbled down about the main topic of conversation. Indeed, why record at all when it could be argued that the product of the session, often a picture, contains in coded form the image of the relationship between therapist, client and group. If a record of a session remains in the form of an image, this can disguise all other forms of symbolic communication taking place, which contribute to the understanding of the image. Experience of relying on the image to do the work of recording, thinking at the time, 'It would be difficult to forget this session', is rarely borne out several months later when the therapist will be thinking, 'If only that had been written down in detail'. Part of the work of the therapist is to make connections for the client so that within a session the therapist is recalling earlier events and themes, and retrieving past images. If the recording is done well, then this later work of retrieving is easier. Recording enables reflection, patterns of behaviour and emotional disclosure to emerge. Probably most importantly, it feeds back into the work itself by keeping the sessions 'alive' in the therapist's mind.

All recording is going to be subjective and open to personal bias but the aim is to make an objective summary. There are several methods available. The current and flow of a session may suggest which pattern would be most appropriate. Here we are going to look at three different methods of recording the same session material, and the advantages and disadvantages. This by no means exhausts possible methods; each therapist will develop her own style to suit her client group.

We begin by looking at the 'observation' method which is like traditional notes in longhand but which tries to 'develop a capacity to suspend judgment when writing . . . notes and to record observable data irrespective of their relevance at the moment' (Henry 1975). This method is an adaptation of a note-taking method from the Infant Observation Course at the Tavistock Institute (Waddell 1988; Miller 1990). This approach to a session and method of recording has a particular usefulness when the therapist is receiving a battering of projections from child or children. To draw from examples of a group of children in art therapy at a mainstream primary school, one child in the group of three had been coming for several weeks saying he 'didn't want to come', he 'would rather stay in the classroom, it's much more interesting',

he got 'bored all the time in this group, there's nothing to do'. At the time of this example the therapist had begun to take this in, doubting her capacity as a 'good enough' therapist.

Short observation recording of a session

A group of three children: Hassan, Betty and Imran aged 8

Hassan said 'Oh no!' dramatically as I came to collect them. Betty greeted me, friendly and normal. Imran too, but he seemed quiet, subdued and didn't really answer my questions about his being ill and absent last week. He decided to paint his horse yellow, then orange, then red base. Betty sat beside him painting her money-box, both steadily absorbed. Imran next began to make a tree, feeling very certain of using clay, confident. Betty said she would make a pig money-box. Talk of going to sell them, of starting a shop. Imran joined in saying he and his brother wanted to have a shop – a sweet shop, then later a restaurant.

Hassan was very dominant through all this time: loud, showing off, shouting, provoking and angry. Talking and walking like a robot around the room, and pacing up and down. Saying he didn't want to come because Imran was here, singing loudly and making robot noises, speech. Tales of his uncle in Morocco giving him everything to eat, of his uncle in USA being Knightrider. Writing on the blackboard: 'I love Mrs C', 'I love Mrs M'. He interrupted every time Imran or Betty spoke to me.

Imran suddenly smashed his fist on the tree saying he couldn't do it, he wanted to make a farm. I sat by him encouragingly and he began the tree again. Clearly affected by Hassan's bombardment of noise, he sometimes echoed him. Hassan either laughed or rounded on him saying he would hit him. Imran finally made a branch upwards and a nest, with three birds (see Figure 8.1). He began to dig a hole in the tree – saying it was a tree house. He put a boy outside and inside a bell – alarm – magic – something about if someone was there, he would know. He made a perch for the birds to land and stuck white polystyrene chips as the bell, as snow all over. A sort of fence around the tree. He seemed older today.

Betty began her pig, telling me how she was going to make it, she had seen on TV two cup shapes joined with paint. This went smeary, she used brown paint, later 'dirty pig'. She put the face on last, for the first time suddenly asked for help with the ears, suddenly decided it was a dog, 'dirty dog', much laughter and very pleased with it.

Hassan finally gathered up scraps of polystyrene and clay (the remains of Imran's materials) and asked for plasticine and said he was going to make

Figure 8.1 A tree, a nest, and three birds.

something. He made a woman with body and head, no legs, arms or facial features. He laughed at it mockingly (?), then said it was me. Having decided this, he added squidges of plasticine as eyes, mouth and gave it to me as a present as he left very amused.

Observation method

1 In running the session like a film through her head, the therapist is enabled to have a reverie about the group of children or individual with whom she is working.
2 It gives an opportunity to reflect on the therapist's interventions and in this way gives the 'therapist part' feedback from the 'critical observer' part.
3 The whole child in the whole session can be seen. For instance, through the hour, Hassan's need for constant movement and accompanying noise as a way of containing his fear of unintegration can be traced. He is an only child living with his mother, gaining much structure from the visits from an uncle abroad. The mention of the uncle causes the therapist to speculate that he has recently departed, causing Hassan's present

anxiety and lack of boundary. He therefore feels an intolerable split between the art therapy room and classroom: 'I love Mrs C', 'I love Mrs M'.

4 The way Hassan finally makes something is very informative. He gathers up the debris left by Imran's concentrated work, makes a pathetic figure, rubbishy, of scrap materials, saying it is the therapist, and giving it to the therapist, really an evacuation of pain, a mocking of that inept part of himself, that for the time being is being held for him.

5 Allowing the therapist to observe, to try to be receptive, rather than to feel that she must do something with Hassan's anxiety, allows her to see more clearly, to see where the rubbishy thoughts of 'I'm not being a very good therapist' are coming from. Now that these are embodied in an object we can begin to work with them.

6 If the therapist can suspend immediate judgement on what is significant in the session, observable data is recorded, irrespective of their relevance at that moment. For example, Imran is not really answering the concern about his absence the week previously. It emerged later in the year that he missed days at school in order to do a part-time job and earn money because his father was ill and off work.

7 Careful observation and reflection enables patterns to emerge; for instance, how little one child may figure in the observations, and why there is nothing to record.

8 Gaps in memory after a session become clear. One week in recording a session the therapist wrote, 'Betty told a dream she had had the night before'. Then the therapist realised she couldn't remember the dream and that another child had knocked over a water-pot immediately following it. This had literally wiped out the memory. Some days later it floated back into her mind and the therapist realised its disturbing content had caused the 'accident' at that moment.

9 This method of recording enables focus on what was said, when things were made.

10 Good for recalling detail, in order, and for rhythm through a session.

11 Very time-consuming.

12 There are no easy comparisons between sessions.

Photograph/drawing and checklist method of recording

This method involves taking one child from the same session using a number of predetermined headings. With this method photocopies can be prepared, ready to fill under whatever headings one wants to focus upon.

Name	Imran.
Group	9.30–10.30.
Materials	Clay, polystyrene chips.

Verbalisation	Talk with Betty, sweet shop, restaurant with brother. Story around the tree.
Body language	Inward, subdued, but brightened, alternating tense/giggles, smashed clay.
Interactions	Betty – over shop fantasy, projection into the future. Hassan – copying actions, shadow-like, would like to let rip? Therapist – sharing difficulties, needing me by him, telling the tree story.
Choice	Confident decisions.
Attitude	Involved in the work, upset by Hassan's disturbances, retreat into magic? Pleasure in end product.
Process	Rare moment of anger expressed, frustration; otherwise very solid, clear working atmosphere around him.
Product	Painted last week's flying horse, yellow, orange, base red. Tree, one strong branch, nest, three birds, boy, bell, alarm. Fence around it, snow. Well made, strong, kept.
Content	3 children = 3 birds? Possible defence, Hassan, refuge in magic, wish for containment, link with magic flying horse.
Insight	No quiet moment possible to discuss story further.

1 This method is probably most useful for individual clients or for an individual 'look' at a group member. For instance, in a group such as this with one very anxious active member, the more contained children can be overlooked.

2 Comparisons between different sessions are quite easy – the therapist can see, at a glance, patterns of behaviour and unusual occurrences.

3 It is fairly quick to fill in, which is an advantage when rushed for time; end products can be hand-drawn or photographed.

4 It reminds the therapist to think under these categories, literally a checklist, so it can often broaden the scope of the observation method.

5 Thinking under categories focuses attention on parts of behaviour rather than a whole, e.g. it gives little sense of what was said while something was being made.

6 It makes clear what the therapist has missed, and the 'missing' child from the attention in a group.

7 It gives focus to the child, not the therapist and child or children.

8 It is hard to show group interactions in complexity.

9 It gives no sense of time within the session.

Group therapy interaction chronogram

The last example of a recording method is an adaptation of the group therapy interaction chronogram borrowed from the writings of Murray Cox

Figure 8.2 Group therapy interaction chronogram.

(1978). This is usually used for recording verbal therapy, but if accompanied by drawings or photographs it adapts quite well to art therapy.

Figure 8.2 shows how a basic unit of the chronogram is used. A circle represents each person's therapy hour, the first quarter, (I), the initial phase of the session. The following half hour (II) is the main substance and the last quarter (III) the terminal phase. Depending on the membership of the group, photostated sheets can be prepared in advance, ready to fill in, so that, for example, a group of eight members including the therapist can be mapped as shown in Figure 8.3.

Arrows between the circles can show simply the positive or negative communication. Content of images made can be put in thumbnail sketches beside each circle, representing a member of the group. If pictures are discussed in a circle on the floor by the group, they can reflect the actual positioning, i.e. put away from the person, under or behind the chair, hidden under another person's work or across the whole circle dominating the space. Figure 8.4 is an example of this method used to record an earlier session of the same group of three children.

1 Chronograms are quick to fill in.
2 The method breaks up the session into a focus on phases, and time particularly.
3 It gives equal attention to the therapist as part of the group.
4 It enables the therapist to focus on ending and beginning as there are often outbursts of behaviour at these moments of change.
5 It gives focus to the interaction between group members quite simply in terms of positive and negative.

Figure 8.3 Mapping the progress of group members.

6 It gives focus to the isolated or, as in this case, two members apparently unaware of each other.

7 It shows clearly how the group is able to feel contained and as 'one' at the story time.

8 It records the main actions, rather than any detail or conversation.

9 Images made and clay work would have to be recorded separately by drawing or photograph.

10 Reasonable easy comparison of patterns of behaviour between different sessions.

11 It is difficult to record the odd comment of significance, e.g. in this session a previous group member who had left three months previously was

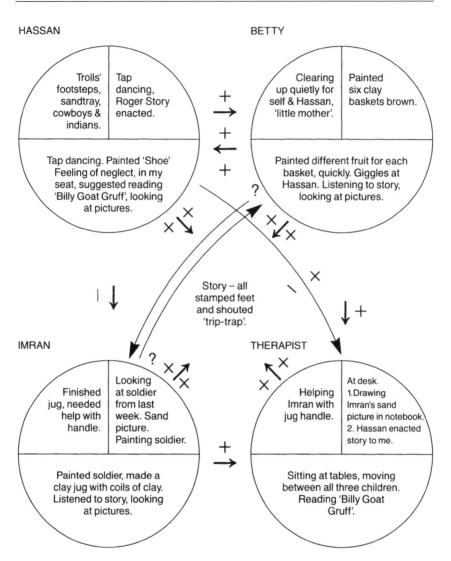

Figure 8.4 Recording the work of three children and the therapist.

mentioned in a derogatory way by one child, then hotly defended by another, which was all over in a few seconds.

12 It is difficult to record body language, e.g. in this session, Hassan's facial grimaces at the pictures of the ogre which appeared in altered form in his drawings the following week.

In this session Imran made a 'picture' in the sand tray. Images like these and fragile clay constructions are better recorded by diagram, thumbnail

sketch or Polaroid photograph. Some art therapists, particularly those working within a family therapy framework, may video sessions to explore with the team and family during the treatment process. This method of recording is integral to the theoretical orientation of family therapy or systemic approach using a one-way screen. Video may also be used for recording group work for supervision or training purposes. Permission, using written consent forms, needs to be obtained from the family at the outset.

Supervision

Qualified art therapists continue to discuss their clinical work in depth. The emphasis and approach to their clinical practice is influenced by the client group, the workplace and the ethos of the multi-disciplinary team. Access to regular, good supervision is important for ongoing working practice and extending the dialogue of understanding.

Supervision of the clinical work in art therapy is a requirement for all practitioners. After qualification and during the first years of work, the art therapist needs not only support and guidance but also a contained supervision relationship that can enable the processing of the complex issues that emerge in the process of the sessions and in the development of the relationship between art therapist and patient. Even experienced art therapists have regular supervision sessions built into their working week (see Dalley, in press; Schaverien and Case, in press).

What is supervision?

Supervision provides a regular space with a set time and place to which the therapist can bring either clinical or managerial aspects of her work. The relationship between supervisor and art therapist is an important component of supervision work. It involves a working contract in order to reflect on and understand the issues being discussed. The supervisor may be a more experienced art therapist working within the same team or art therapists may make their own supervision arrangements with an outside supervisor, as agreed with their workplace. Frequency of supervision varies but weekly or fortnightly is preferable.

An art therapist may bring to supervision aspects of the work with which she is having difficulties, or she may want to explore the dynamics of a therapeutic relationship in more depth. A newly-appointed therapist might have an interest in establishing an art therapy session with a particular client group. This needs careful planning and discussion with relevant staff, and in the first instance is talked through with her supervisor. Most usually, an art therapist will bring detailed process notes and paintings of a particular client or group from one session. It is normal practice in supervision to follow one client in depth each week. The supervisee might come with feelings about the

work – for example, that she feels worried about the client and cannot stop thinking about her, or that the paintings worry her or mystify her. She might feel flooded with involved feelings or feel unable to enter the client's world. She might present doubts about her ability to work with a client and feel a lack of confidence. On exploration it might become apparent that past parts of her life are being transferred onto present-day interactions. It is one of the main focal points of supervision to explore counter-transference, particularly in relation to clients, so that it may inform and aid the progress of the work rather than impede it. Within the supervision itself, issues, possibly unconscious, might emerge out of the discussion which again can bring understanding and clarity to the therapeutic relationship. If the sessions are presented in detail, preferably in the form of process notes, this allows close scrutiny of the material which can facilitate a deeper understanding of what is happening.

A third area that might be brought to supervision is staff relationships and the therapist's general working life. In some institutions the therapist may not be the client's sole therapist; for instance, a client may have individual art therapy and also group psychotherapy. A disturbed client might find it difficult to integrate two approaches, two 'parents', and exploit the differences. This last example shows clearly how all three areas inevitably overlap and cannot usefully be looked at separately; they are part of a whole process. Part of the supervisor's task is to help the therapist in supervision to integrate the different areas of her work life.

The boundary between supervision and therapy

Peter Hawkins describes how a therapist needs to 'establish and negotiate the boundaries between his private world and that of his work life' (Hawkins and Shohet 1989). One way that the supervisor can help the supervisee to enter the world of the client, but not to get lost in it herself, is to be clear about what is material for supervision and what is material for therapy. The supervisor is able to assist a supervisee into her own therapy when appropriate.

Let us look at two scenarios from supervision sessions. In the first example, the supervisee began to present material only to break down in tears. Exploring these feelings it became apparent that the therapist had been dealing with an absent ill colleague and an escalation of potentially violent incidents in the hospital art therapy room. This situation had led to a build-up of stress. It became apparent that the incidents had been dealt with extremely well. The tears were largely relief at being able to share aspects of anxiety. The therapist needed help to cut down the number of sessions or clients she was seeing single-handedly while her colleague was ill. She was able to explore her guilty feelings about this and was helped to see that her own health must be given priority or the quality of her work would deteriorate. Her confidence in her ability to defuse potentially violent incidents and to work with the residual

anger was reinforced. This exploration of exposed feelings is clearly to do with institutional issues.

In the second scenario, at the beginning of a supervision session the art therapist began to present material and broke down in tears. Here, the content of her distress seemed to be totally about her home situation. It became apparent that she was in the middle of a divorce after deciding that she could no longer live with a partner with long-standing drug-related problems. She expressed a fear of being alone. Then for the first time she mentioned work in the context of not wanting to take holiday leave as she couldn't bear to be at home. A fruitful area of exploration proved to be the way that her work had become a shield for her private life. Her lack of confidence in living alone was another aspect of having to be needed by others, reflected in her original choice of partner but also a factor in her work situation. In this session she was helped and encouraged to re-enter therapy and support for her work was reiterated, confirming her knowledge and experience. Other structures of support were examined.

After this crisis she used the supervision creatively to explore all aspects of her work. In subsequent sessions it became very clear that the home situation paralleled changes at the hospital. The art therapy department was moving into the community and her fear of leaving the 'safety' of the hospital to 'set up alone' outside the hospital environment could be explored. In this exploration of exposed feelings the move from the hospital to the community and the ensuing crisis of confidence, dependence on the mother institution and fear of going it alone were clearly material for supervision, whereas the decision to attempt to change a repetitive cycle of dependence and support around an 'ill' partner was more suitable material for personal therapy.

The border between therapy and supervision can be quite difficult for the supervisor to negotiate, partly because similar skills are used in the supervisory and therapeutic roles. It is 'easier' to step into this at times than to withdraw from the material being presented and look as objectively as possible at the issues that need to be confronted. The nature of supervision is not just to look at the work 'out there'. The relationship between therapist and client can resonate in the relationship between supervisor and supervisee. Often, the dynamics of the clinical session are mirrored in the supervision session itself. For instance, a supervisee brought a long detailed account of several sessions which she ploughed through in a monotonous voice. There was much talk of arrangements but little discussion of content. The paintings from the group had been 'forgotten' and left at the hospital. In the session, the supervisor was feeling sleepy, lulled by the presenter's voice which suggested that 'everything was all right'. When the supervisor emerged from this soporific encounter and was able to question herself on what was happening, it gradually became apparent that these feelings mirrored the art therapy sessions described. Fear of taking the work deeper was keeping the art therapy group on a surface level; the art therapist was colluding with the dynamic

that 'everything was all right' and that nothing beneath the surface needed to be explored. At this point the art therapist's fears could be explored, and ambivalence about re-entering personal therapy emerged which again reflected the ambivalence of going deeper into the art therapy group that was first brought for discussion.

The image in supervision

It is helpful if images are brought to supervision although this is not always possible. Transportation of fragile pieces or work on a large scale can be complicated. However, the process of supervisor and supervisee looking together and sharing responses to the images made in a session is an integral part of the process of understanding the material at a deeper level. Progress in the supervision work may be impeded if the images are not present. Art therapists may have different approaches to the manner in which they bring the art work to supervision. For example, some are reluctant to bring the images out of the secure treatment framework. The situation can arise in which the art therapist brings the images to supervision to 'show' her supervisor without putting herself sufficiently into the relationship and giving an account of the clinical interaction. Others believe that process notes are enough and that the 'internal image' the therapist brings with her in the counter-transference is the real guide to the nature of the therapeutic interaction.

Let us look at an example of this complex process. An art therapist brought a dream of a client to supervision. In the dream the two of them were painting side by side as members of a group. The client had painted a picture of a girl with a rope around her neck. The client commented half jokingly, 'Look at her, she's in real trouble'. The solution would be to unwrap it. The picture then came to life and the girl climbed up out of the picture. The dream continued; but let us stop here, already a wealth of material has emerged. In exploring the dream the art therapist was reminded of a childhood friend and of a parallel feeling about the friend and client that both hid a childhood deprivation under a jokey manner. This led her to realise that she had been unable to comment on a real painting the client had made in an art therapy group that week that suggested a 'sleeping' undeveloped part of the client. She had been unconsciously protecting her 'deprived friend'. Here it can be seen that a 'phantasy' painting in a dream is as valid an item for exploration as a real painting by a client; and the therapist's response to the client's picture is as valid as the exploration of the picture itself.

Supervision in the three main areas of practice

In an NHS setting the concept of clinical and managerial supervision has been firmly established. Supervision is arranged by the art therapist who may

contact a more experienced art therapist working in a similar field, or a psychotherapist or analyst who would be prepared to work with images in a psychodynamic framework. Large hospitals or art therapy departments may have several art therapists who are supervised by the head art therapist.

The situation in a social services department is different, partly because it is unusual to find anyone working with a job description of art therapist. People with art therapy training are likely to be working with various titles: group worker, project worker, residential worker etc. They may be switching roles throughout the work, i.e. working as a centre worker with some sessions of art therapy. Supervision in a social work setting has been usefully explored in Peter Hawkins' 'Mapping staff supervision' (1982) where he discusses the types of content of supervision and the difficult nature of social work settings where the supervisor may have a complexity of roles to the supervisee, e.g. immediate line manager (power of promotion, references etc.), colleague and working together clinically.

There is less of an established culture of supervision within education. Art therapists working in schools, either mainstream or special, will find management support from their immediate colleagues but will need to find a supervisor for the clinical work outside the institution. Schools for children with emotional and behavioural difficulties which are dynamically orientated may provide supervision for the whole staff group via a visiting psychologist, psychiatrist or psychotherapist. These sessions tend to concentrate on general reviews of particular children and attention to the dynamics of the staff group.

Qualities and responsibilities of a good supervisor

The supervisor keeps to the agreed boundaries of space and time. In the setting up of the supervision, a contract is agreed in the first session. The supervisor is responsible to the clients and to the referring agencies and sometimes for the work of staff and students. She will work closely with the supervisee in processing the clinical material presented and to help in the learning from the experience of the therapeutic encounter. This will include consideration of the transference and counter-transference process and how the unconscious communication in the session is understood. The supervisor is also responsible for providing support and professional contact beyond herself, i.e. to know when a supervisee could be better aided in her work by another professional. This could happen if a supervisee's job changes or a new aspect develops in her work which is unfamiliar to the supervisor.

What are the qualities of a good supervisor? She needs to have a strong theoretical and practical background and above all an interest in the work which will contribute enthusiasm and imagination to the sessions. She needs to have empathy, a capacity to enter the other person's experience, to be open to both supervisee and the client being discussed. Keeping the boundaries

should create a feeling of safety to enable the supervisee to bear self-exposure but also both sides need to feel safe enough to risk saying difficult things. A supervisor doesn't have to be omniscient! Confusion and doubt are part of the process but they can provide a model to the supervisee on how to deal with this. A supervisor needs to know what the supervisee is doing, but not to swamp her with theory. There needs to be a pace of learning that will extend both participants' experience. The supervisee needs to feel that she is accepted, supported and cared for.

Supervision in groups or individual supervision?

Supervision can be carried out either in a group or individual situation. Both have advantages and disadvantages. In individual supervision, it is easier to build a closer working relationship which may enable counter-transference issues to be explored. The supervisee presents at each meeting, which builds up a continuity of experience for both participants in the process. In group supervision it may take longer to establish a feeling of trust and safety. The advantage is sharing clinical discussion with peers and group members learn from the experience and contribution of others. There is less likelihood of supervisor and supervisee sharing blind spots or of an authoritarian/ dependence relationship being established. Group supervision is more economical in terms of time and money.

Problems in the supervisor/supervisee relationship

'The supervisor . . . is an active participant in an affectively-charged helping process, the focus of which is learning and personal growth' (Ekstein and Wallerstemn 1958: 178). Supervision can swing between extremes of the supervisee 'being treated' for therapy to a 'didactic' approach which avoids the therapist's emotional life at all costs. Like all relationships, the developing dynamic will be influential to the therapist's individual style of working. If the supervisor has an authoritative approach there is the danger of the therapist getting into a dependent relationship with strong transference responses. Art therapists can experience problems if the supervisor is unfamiliar with working with images. Either party in the relationship can feel mystified, devalued or defensive about her own or the other's approach. It is helpful if these difficulties are resolved within the 'here and now' of the supervision relationship.

Art therapy training

Pre-course experience

Entry to the postgraduate art therapy training programmes requires a first degree in art and design. There is a special entry criteria for teachers and

honours graduates from medicine, social science and humanities, and those without degrees but with a working background. The minimum age for applicants is 23 but maturity and life experience is seen as a valuable asset. A minimum of one year's clinical experience within the NHS, education, social, community, prison services or voluntary sector is required. An art portfolio will need to be presented at interview to show an ongoing commitment to the personal art process. It is preferable that applicants have previous or current experience of personal or group therapy. Personal therapy is a requirement for the duration of the training and is seen as a necessary component to the students' learning process. The courses are demanding both personally and academically. The student has to make fundamental adjustments in developing a professional identity as an art therapist during the training.

Before applying for training it is wise to gain some experience of art therapy. There are several well-established residential and weekend courses including foundation courses for future applicants. The Art Therapy Summer School at Leeds Metropolitan University runs annually and offers an intensive week of experiential groups, lectures and workshops. There is a Jungian week in the summer at Cumberland Lodge. The University of Hertfordshire offers introductory Easter and summer courses on the art therapy process and practice. The Foundation Certificate in Arts Therapies is a good introduction to the art therapy process and its clinical applications. The BAAT also offers short courses on a variety of different topics. Attendance on these courses is highly recommended prior to making an application to the MA in art therapy.

MA in art therapy

The philosophy of the MA programme places the making of art and its relationship to therapeutic practice as central to the training, which is primarily experiential. The programme offers students a broad theoretical foundation in the key principles of art therapy theories relating to psychodynamic and humanistic psychotherapies. Art therapy research relevant to clinical practice and the ongoing development of the artist within the art therapist is also a key element to the training. The integration of the programme's three components is regarded as essential in the development of a trainee art therapist.

Units of postgraduate training

1 Experiential learning

Studio practice provides students with the time and space to develop their own art practice within the context of therapeutic training. Workshops give experience of a range of art therapy approaches and therapeutic interventions used in different clinical settings. A training group offers experience

of an ongoing closed group where students can develop an understanding of psychotherapeutic group processes that are both verbal and non-verbal.

2 Art therapy theory and research

Art therapy theory is based on the two main components of the art therapeutic relationship – the relationship between client and therapist and the image made. The theory of psychotherapy and psychoanalysis, with transference and counter-transference phenomena, is combined with understanding of symbolism and symbolic communication, be this in words, pictures or through the making of objects. This includes an understanding of pictorial imagery and its interrelationship with intrapsychic and interpersonal dynamics. Lectures and seminars introduce the students to psychotherapeutic principles and concepts of art-making that provide a framework for understanding the context in which art therapy is practised and researched. University staff, invited art therapists and other professionals working in the field present the theoretical modules. Tutorial support is provided for all students.

3 Clinical placement and supervision

Clinical placement experience is a total of 120 days, 60 days per year for full-time students and 40 days for part-time students. The clinical placement settings range from mental health and learning disability services, prisons and secure provision for adults and adolescents to special education, palliative care and children and family centres. Students will have weekly on-site supervision with either an art therapy or another professional and in a small clinical group in college. Towards the end of the training, workshops are provided to prepare students for practice and seeking work.

Even though observational studies is not a course requirement, many art therapists, particularly those interested in working with children, undertake some training in the practice of infant observation. The practice of systematic observation of the development of infants provides the observer with an opportunity to encounter primitive emotional states in the infant and family. The observer's own response to this experience is helpful in preparing potential therapists for clinical work.

Continual professional development (CPD) is an essential component of post-qualification experience and is a requirement for ongoing registration with the HPC as a practitioner. The art therapist must demonstrate a commitment to CPD by attending further training courses, seminars and supervision.

There are five main training centres in the UK which offer standard MA qualifying courses according to the criteria laid down by the BAAT. These are currently located in Edinburgh, Sheffield, London, Derby and Hertfordshire.

Each course has a slightly different emphasis according to the particular orientation of the staff, available resources and so on. The history and background to the training programmes are described in depth by Waller (1991), who provides a useful introduction to the particular nature of the various courses. Prospective candidates are advised to get information from each course and preferably to visit in order to understand the particular aspects of each. After qualification at MA level, further training is available on advanced training courses in the MA in Advanced Clinical Studies, M.Phil. or Ph.D. level. The addresses of the main courses are detailed on pages 293–5.

References

Adamson, E. (1984) *Art as Healing*. London: Coventure.

Case, C. (1987) Group art therapy with children: problems of recording, in *Image and Enactment in Childhood!*, Hertfordshire College of Art and Design Conference Proceedings.

Case, C. (2005) Observations of children cutting up, cutting out and sticking down, *International Journal of Art Therapy: Inscape*, 10(2): 53–62.

Case, C. and Dalley, T. (eds) (1990) *Working with Children in Art Therapy*. London: Tavistock/Routledge.

Cox, M. (1978) *Coding the Therapeutic Process: Emblems of Encounter*. London: Pergamon.

Dalley, T. (in press) Piecing together the jigsaw puzzle: thinking about the clinical supervision of art therapists working with children and young people, in J. Schaverien and C. Case (eds) (forthcoming) *Supervision in Art Psychotherapy*. London: Routledge.

DHSS (Department of Health and Social Security) (1982) *Personnel Memorandum PM (82)* (6 March).

Edwards, D. (1989) Five years on: further thoughts on the issue of surviving as an art therapist, in A. Gilroy and T. Dalley (eds) *Pictures at an Exhibition*. London: Tavistock/Routledge.

Ekstein, R. and Wallerstemn, R. (1958) *The Teaching and Learning of Psychotherapy*. New York: Basic Books.

Gilroy, A (2004) *On Occasionally Being Able to Paint* revisited, *Inscape*, 9(2): 69–71.

Hawkins, P. (1982) Mapping staff supervision, unpublished paper from Richmond Fellowship.

Hawkins, P. and Shohet, R. (1989) *Supervision in the Helping Professions*. Milton Keynes: Open University Press.

Henry, G. (1975) The significance of the insights in both infant observation and applied psychoanalysis in clinical work, unpublished paper.

Lillitos, A. (1990) Control, uncontrol, order and chaos: working with children with intestinal motility problems, in C. Case and T. Dalley (eds) *Working with Children in Art Therapy*. London: Tavistock/Routledge.

Maclagan, D. (2005) Re-imagining art therapy, *International Journal of Art Therapy Inscape*, 10(1): 23–30.

Mann, D. (2006) Art therapy: re-imagining a psychoanalytic perpective, *International Journal of Art Therapy Inscape*, 11(1): 33–40.

Miller, B. (1984) Art therapy with the elderly and the terminally ill, in T. Dalley (ed.) *Art as Therapy*. London: Tavistock.

Miller, B. (1990) *Closely Observed Infants*. Perth: Clunie Press.

Murphy, J., Paisley, D. and Pardoe, L. (2004) An art therapy group for impulsive children, *Inscape*, 9(2): 59–68.

Rabiger, S. (1990) Art therapy as a container, in C. Case and T. Dalley (eds) *Working with Children in Art Therapy*. London: Tavistock/Routledge.

Read, H. (1943) *Education through Art*. New York: Pantheon.

Rothwell, K. (2005) Mind the gap: art therapy with a violent offender patient, unpublished thesis, Goldsmiths College, London.

Sagar, C. (1990) Working with cases of child sexual abuse, in C. Case and T. Dalley (eds) *Working with Children in Art Therapy*. London: Tavistock/Routledge.

Schaverien, J. (1989) The picture within the frame, in A. Gilroy and T. Dalley (eds) *Pictures at an Exhibition*. London: Tavistock/Routledge.

Schaverien, J. (2005) Art and active imagination: further reflections on transference and the image, *International Journal of Art Therapy: Inscape*, 10(2): 39–52.

Schaverien, J. and Case, C. (forthcoming) *Supervision in Art Psychotherapy*. London: Routledge.

Sinason, V. (1997) The psychotherapeutic needs of the learning disabled and multiply disabled child, in M. Lanyado and A. Horne (eds) *Handbook of Child and Adolescent Psychotherapy*. London: Routledge.

Stott, J. and Males, B. (1984) Art therapy for people who are mentally handicapped, in T. Dalley (ed.) *Art as Therapy*. London: Tavistock.

Viola, W. (1944) *Child Art*. London: University of London Press.

Waddell, M. (1988) Infantile development: Kleinian and post-Kleinian theory of infant observational practice, *British Journal of Psychotherapy*, IV(3): 313–28.

Waller, D. (1984) A consideration of the similarities and differences between art teaching and art therapy, in T. Dalley (ed.) *Art as Therapy*. London: Tavistock.

Waller, D. (1987) Art therapy in adolescence, in T. Dalley *et al. Images of Art Therapy*. London: Tavistock.

Waller, D. (1991) *Becoming a Profession: History of Art Therapy 1940–1982*. London: Routledge.

Waller, D. (ed.) (2002) *Arts Therapies and Progressive Illness: Nameless Dread*. London: Routledge.

Wood, C. (1990) The beginnings and endings of art therapy relationships, *Inscape*, autumn: 7–13.

Chapter 9

Art therapy with individual clients

In this chapter, the process of working with an individual client in art therapy will be considered in some depth. Published case studies describe the detailed process of working with one client in art therapy (e.g. Dalley *et al.* 1993; Schaverien 2002; Meyerowitz-Katz 2003; Case 2005a). Reference to these will enable an understanding of the wide range of clients in art therapy and also the variety of different approaches used by art therapists working in many clinical settings. More and more art therapists use a psychoanalytic framework as a means of understanding the dynamic process of the sessions. Ideas such as resistance, negative therapeutic reaction, acting out, working through, the uses of interpretation and insight were all explained originally by Freud, but more recently some have been revised to be used in a broader context (Sandler *et al.* 1973). Some art therapists use a Jungian or Kleinian approach and, as has been discussed in the theoretical chapters in this book, these different theoretical positions provide the basis for informing the ongoing practice of our work (Nowell Hall 1987; Weir 1987; Simon 1992; Schaverien 2005; Mann 2006). For the purposes of this chapter, one case of a 7-year-old child, John, will be described in detail. This is to provide an example and is not necessarily the definitive model.

Patients are referred to art therapy from many different sources. Referrals usually come through ward rounds, case conferences and multi-disciplinary discussions. Ward managers, social workers and other professionals can make direct referrals to the art therapist and occasionally some self-referrals are considered. In outpatient clinics, CAMHS teams and other settings where intake meetings take place on a weekly basis, and are attended by a multi-disciplinary team, patients are allocated to the art therapist for an initial assessment.

John was referred by the school nurse to a local CAMHS team. He was showing signs of aggression, fighting with peers and not able to concentrate in the classroom. In school, his teacher reported his behaviour as difficult to manage. He was becoming increasingly restless, disruptive and defiant. John was an only child and, at the time of the referral, his parents were engaged in an acrimonious custody battle following their separation six months earlier.

John was confused, angry and worried about his parents, as he wanted them to get back together. However, this was not a realistic hope. He was bottling up his feelings and not able to talk about his distress. The educational psychologist, part of the multi-disciplinary clinic team, had already assessed him in school and found him to be an intelligent but verbally inarticulate child. During that assessment, John had drawn several pictures to describe his experience. He showed anxiety about getting things right and not making mistakes, which made him jumpy and appear lacking in self-confidence. At the intake meeting, it was felt that John would benefit from an art therapy assessment as he could make good use of imagery and had difficulty in articulating his feelings.

The reasons why a patient is considered more suitable for one type of therapy than another are complex. For example, cognitive behaviour therapy might be more appropriate for specific problems such as phobias. Where problems are located externally in the family system, and the child is caught up with these dynamics, a family therapy systemic approach might be indicated. The child's problems may have become internalised, i.e. the problems reside in conflicts that are particular to the child's emotional and psychological development. This would indicate an individual therapeutic approach to help the child to understand and make sense of his or her emotional world. It is important to evaluate whether a difficulty is transient or fixed with repercussions for future development:

> The aim of an assessment is to consider the nature and extent of the child's disturbance and then to decide on the most appropriate form of treatment. This is normally done within the multi-professional child and family mental health team. It is important to take into account all aspects of the child's internal and external world, the developmental stage he has reached, and the child's problems as perceived by the child himself and by significant adults in his environment (such as parents and teachers), as well as his strengths and capacities.
>
> (Parsons 1999: 218)

When undertaking an assessment of any child or adolescent, the therapist looks for deviations in the child's behaviour from the generally expected norm for their age, gender and culture. She uses her knowledge of typical development to pinpoint the deviations, irregularities and deficiencies shown in such aspects as relationships, behaviour patterns and symptom formation (Freud 1965, 1974). For adult patients, the same criteria are used for assessment. A patient is referred for many reasons which may include a range of psychiatric disorders and mental health problems, family breakdown, social isolation, antisocial behaviour or trauma-related difficulties. If a psychiatric diagnosis has been made by a psychiatrist, this will inform the assessment process (Case 1998; Tipple 2003).

Suitability of clients for art therapy

Art therapy offers the opportunity to work non-verbally, through image-making, which forms a central consideration of potentially suitable clients. Art therapy is indicated, for example, if there are speech and language difficulties, for patients who are confused, withdrawn, psychotic or depressed, children with emotional and behavioural difficulties who are possibly less articulate and sophisticated in speech and language skills but are more able to express their experience through the art work made in the session (Case and Dalley 1990).

Assessment

Consideration for art therapy is based on background information from the referrer and the presenting issues. In most CAMHS teams assessment begins with family meetings. Everyone living at home is usually invited to attend the first meeting. Such meetings are useful in gaining insight into the views of all the family about what is problematic and enable the symptoms the child presents to be seen in the context of the expectations and anxieties of the family system.

For John, detailed information was provided by the school and the educational psychologist. An initial family meeting was arranged with John, his mother, the educational psychologist, and the art therapist. John's father did not attend. This meeting gave John's mother a chance to talk about her concerns and to feel listened to and understood. She gave her account of the background to John's difficulties which provided an opportunity for the therapist to build up a picture of John's psychosocial and developmental history, his family situation and his mother's perception of her child. This also enabled an assessment of John's mother's capacity to work with the therapist in what might be recommended to help John and to discuss the assessment procedure.

An assessment for art therapy is a time-limited process which usually takes place over two or three sessions. This period can be extended if a decision regarding treatment needs more time. First impressions are important in noticing how the client presents and manages initial anxieties. The therapist makes use of outside information provided at the time of referral which is additional to the material from the assessment sessions. The child or adult client is seen on their own at the same time in the same room to promote continuity and a chance for both therapist and client to get to know each other. During the assessment the therapist observes how the child relates to her and communicates through play and use of the art materials. The therapist will explain what is involved in art therapy with the use of the art materials available. It can be difficult to explain what the process will involve at this stage. It is possible to allay some initial anxiety by creating an atmosphere of

the art therapy room being a safe space in which to explore and try to make sense of what is troubling the particular client and what has brought them into therapy.

John's initial meeting

John's initial meeting took place in the art therapy room to familiarise him with the space. The assessment procedure was outlined. His mother gave an account of her concerns about her son. She was worried that he was deeply unhappy but his defiance and aggression made it hard for her, or his father, to talk together. She had given up hope of his behaviour getting better. When asked about his developmental history, his mother described John as a very active but loving child who had met all his developmental milestones. She had no concerns about him as a young child. His behaviour at home deteriorated when the relationship between his parents became distant and arguementative with his father spending long periods of time away from the home. His mother was left to manage his increasingly aggressive outbursts.

John's mother had some questions about the assessment and why the art therapy sessions should be any different from doing art at school. The therapist explained that the sessions offered John a separate space to use the art materials and enable him to come to some understanding about his confused and angry feelings rather than become uncontrollable in aggressive outbursts. He was in trouble at school and becoming ostracised by his peers. He was confused about how he felt towards both his mother and father which he could not articulate in words. His mother also used the opportunity to talk about her own distress and it was felt she might need some help and support. She could not control John or make any sense of his behaviour, particularly after staying with his father. His mother was seeking help for John but was working full-time and did not know if she could take time off to bring him. These practicalities were important in providing his mother with an outlet for her ambivalence and uncertainty of committing herself and her son to the sessions.

Throughout the meeting, John sat restlessly, constantly moving around and being told to sit still by his mother. He only spoke when spoken to, looked around the room with interest, nodding when asked if he wanted to attend the assessment sessions. While his mother was talking, he began to explore the art materials in the room. He began to draw with the pencils and felt pens, and found some toys. He asked if he could use some clay. He was absorbed in his clay work until the end of the interview, by which time the day, time and duration of the sessions was decided. It was agreed that John would attend for two assessment sessions. Following this, a further ten sessions would be offered until the court case to decide the custody arrangements. Pending this decision, it was agreed that another meeting would be set up to review the sessions, and whether further work was required. It was agreed that the

school and the GP would be informed of the outcome of John's assessment and his attendance.

In this first meeting, the therapist gathers some initial impressions to make an early formulation of the problem. John's current predicament was confusing and complicated, but his behaviour was an expression of this rather than a more internalised difficulty. This indicated that the work would only be short-term. The restlessness and difficulty in engaging with his mother in the initial meeting indicated underlying distress when the painful situation he was facing in his daily life was overtly discussed. He was an active, lively and curious child; exploring the therapy room enabled him to find the clay which provided a link for him for the first session – asking if he could use it when he came next time.

In the assessment period, some rapport is established between therapist and client which will influence the beginning of the therapeutic relationship. First impressions, expectations and even some preconceptions might be at work in influencing the therapeutic alliance. Three important variables inevitably influence the meeting of the client and therapist: what the client brings, what the therapist brings and the setting in which they meet. Wherever this happens, each views the other through the eye of the past, which colours present expectations. There is thus an emotional impact of the client on the therapist and vice versa. As Cox (1978: 120) points out:

> It is impossible to discuss structuring the therapeutic process and the therapist's use of time, depth and mutuality without describing those essential prerequisites, namely the patient's emotional impact on the therapist and the therapist's impact on the patient. Adequate emotional work cannot be done in any therapeutic situation without thoughtful consideration being given to the Siamese twins of transference and counter-transference.

There is a need for a degree of flexibility in therapeutic approach according to the needs of the client. The therapist knows about the client, while the client is in possession of few facts about the therapist. The client is encouraged to express their associations, thoughts and feelings using the materials provided. The first images produced will contain overt or covert reference to the therapist and, in the course of these associations, a therapeutic relationship begins to develop.

John's first assessment session

From the therapist's process notes:

He came down to the room eagerly and when he came in said 'Where is Mr T?' [the educational psychologist]. He sat down, looked around and

without taking off his coat his eye was caught by the communal box of cars, toys, trains and other playthings. He went over and began playing – taking the cars out in turn. 'I've got one like this – this is a police car – this is like my friend Nick's.' He pushed some across the room away from him, keeping hold of others. He took one of the racing cars out of the box and it jumped over the track as he whizzed it round the room. 'You said last week we would do some painting – shall we do some?' 'I was wondering whether you want to do some?' and he replied, 'I don't know – could do.' He mumbled, 'Is Mr T coming?' 'It feels as if you would like him to be here, as if someone is missing.' He quickly denied his wish: 'Not really.' After playing with the cars, pushing them towards the therapist, he left them by her feet. He went over to the table and said, 'Shall we do some painting?'

John's entrance and questioning about Mr T seemed to indicate his need for familiar male figures in his life and some anxiety about permanence. Asking the therapist about painting suggested that he was able to express his wishes and an experience that these will be heard. In art therapy, engaging with the therapist is often focused on tentative steps to use the art materials. For children, this may involve playing with toys, sand and so on. In John's case, he played with cars and trains. The game with the cars felt like some testing out about space with the therapist before he felt safe enough to ask for and experiment with the art materials. He needed to know that the activity of painting could be contained. The therapist observes and reflects at this early stage in the relationship. Interestingly John did not remember about the clay.

Some adult patients who have not used art materials for many years may comment, 'I feel I am back at school' or 'I don't know what to do' or 'I can't draw you know'. These statements made to the art therapist may be an expression of some resistance, anxiety or conflict about expressing some regressive wishes. There are sometimes very different beginnings – some equally anxious clients cannot wait to begin and make images without stopping throughout the session. Parallels can be drawn with clients who are initially silent and reticent to speak and those who begin by talking so much that the therapist does not feel able to get a word in. The art therapist observes and waits for the process to unfold. When the client begins to use art materials, therapist anxiety may interfere with the client's process of allowing the imagery to emerge. There may be a temptation to interrupt, to prompt, to help the client out with suggestions or freeing exercises. This does not address the real feelings of the client but instead attends to the therapist's difficulties in containing the anxiety, waiting with the silence.

For example, it might have been easier for the therapist to mention to John that he had wanted to use the clay – instead he chose to play with cars and then trains as a way to affirm his situation and express some ideas of

familiarity, travel, reaching destinations. On building the train, he had asked, 'Is this a nice train – it's a very long train – is it a nice train?' – needing reassurance from the therapist. This play helped him express some initial anxieties and test out the space before committing himself to anything that felt more uncomfortable for him. The therapist was able to wait for this process to happen.

In this way, the art therapist attends to the non-verbal cues of the client. For example, where the client chooses to sit, do they have eye contact with the therapist or are they more interested in avoiding that and exploring the room and its contents? Do they ask for reassurance or how to begin from the art therapist? Do they pick up one material and then change it for another, showing uncertainty or hesitation about what to choose or commit to? How do these clues manifest themselves in the shared space between therapist and client? The art therapist observes and reflects on all these subtle communications.

The following describes how John began to use the materials (from the therapist's process notes):

After talking about his T-shirt, which his nan had given him, he asked for an apron, which he took off the peg, and sat down at the table, began to squeeze out some paints into the palettes – red first, then yellow – blocked. The therapist helped him take off the top and the yellow flowed out. The black – 'I like black' – then brown and blue. The palette was completely full. He asked, 'Have you got any more of these?' The therapist responded 'Do you feel you need some more?' He replied, 'I want to make grey.' He took a paint brush and put it into the black and then into the white and put it straight onto the paper – making a circle with thick paint. 'It's all black,' he said in dismay. He tried again – and repeated it the same way. 'Oh no, that's wrong.' He stood there anxiously holding the paint brush. 'I'll have to throw it away.' He didn't seem to know what to do with the brush but decided to put it into the water and folded up the paper carefully, asking where the bin was.

This process felt, to the therapist, as though he was trying to mix together two different components of his life without success – the mess made him worried and anxious, which perhaps mirrored his internal experience. John went on to make a cracker out of folded paper and asked the therapist to pull it with him. He made a black mark to show the middle and he found some scissors in order to cut it. The therapist had in her mind how this seemed to represent John's feeling response to being cut in half himself (by his parents). This seemed to free some of John's immediate anxiety. Using some of the pieces of paper that accidentally fell into the paint, some printing followed with which he then began to experiment and use for his picture. He was more

relaxed, playful and less anxious about making mistakes as he became involved in the activity and with the interaction with the therapist. It may be that he was experiencing the therapist as someone who could help him with his feeling of 'being cut or pulled in half'.

(For a more detailed account of the use of scissors in therapy see Case 2005b.)

The picture surface has a 'voice' of its own and gradually a dialogue builds up through which both client and therapist communicate. The image or art form, in this case the cracker, provides a third dimension in the relationship. Aspects of the client's experience, feelings and situation, previously hidden or unconscious, will begin to emerge. The art therapist waits for these to be fully formed as the client completes the image or decides on its course. The client engages in the image-making process, although configurations in the image might not yet be clearly understood or indeed consciously made. The therapist waits with this uncertainty, lack of clarity, even ambiguity as images contain complex meanings on many different layers. As this process unfolds, the picture surface begins to speak to the therapist's inner experience and feelings as well. It is most beneficial if the client arrives at their own personal insight into the meaning of the image. It may be that they do not fully share their thoughts with the therapist at this particular stage. The meaning or impact of the image might change over time and again the permanence of the image allows for this ongoing work to be done (Schaverien 2005).

The process notes continue:

Throughout his second session, John continually made reference to things 'in the middle'. He was feeling more comfortable with the therapist *and* becoming curious, asked her what her middle name was. She reflected on this request by wondering aloud why he wanted to know as he seemed to feel it was important. He made a folder for his art work and put his name on it, adding his middle name. As he was washing out his paint brush, he began to flick it into the basin and then holding it up, pretended to flick it first at himself and then at the therapist. He said: 'Shall I flick it at her or him?' The therapist replied, 'That paint brush seems as though it's in the middle – it doesn't know which way to go.' She commented on the 'flicky feelings' that were being expressed. Several other references to his experience of being stuck in the middle became overtly expressed through his interaction with the medium. The therapist was able to make sense of this and reflect it back in a way that he could understand.

Transference and counter-transference responses begin to be established between therapist and client and to the images produced. These relationships

unfold as the art activity proceeds. The therapist will be affected by her counter-transference response: what are the feelings evoked in the therapist by the images? These are important in the communication of the client's experience and inner processes that are emerging into consciousness. At this stage, it seemed that John had some sense that the therapist was 'in the middle' – he was not sure who she was for him – perhaps both mother and father. John could identify with the paint brush that was able to flick paint, his underlying aggression, 'at him or her'. There was a question about whether he might also experience the therapist as being 'in the middle', perhaps some neutral person who ultimately might make some decision about his future. (For a clear and thorough account of transference processes in art therapy, see Schaverien 1987, 1992.)

Following the assessment sessions, the therapist will gather together her thoughts on the basis of the material from the meetings with the child, information from the referrer, parents and other sources. From this, the therapist makes a formulation of the problem and recommendation for treatment. John had developed a good relationship with the therapist and he wanted his sessions to continue. The therapist's view was that John was already engaged in a process of using the art materials to express his predicament. He was also already much calmer and less angry. At the review meeting with the therapist and his mother, it was agreed that he would attend further sessions with a decision to review again after ten weeks.

If the recommendation is for art therapy, the art therapist can discuss with the client the details necessary to set up the therapeutic contract, such as frequency and timing of sessions. Most sessions last for 50 minutes, but many art therapists prefer to work for a whole hour as the painting process generally takes longer to develop and the material to unfold through the images. This decision is also based on the needs of the client – aspects of restlessness, poor concentration, physical constraints. The time boundaries of the session are made using these considerations. Once agreed, the time and space of the session remains consistent.

Another factor is length of treatment. The therapeutic work may be time-limited, short-term or long-term. With the pressure of waiting lists, there is often pressure to offer brief therapy interventions such as up to 20 sessions. Ongoing therapeutic work can last for a number of years. Other significant external factors such as discharge from hospital, change of foster carer and reliability of transport need to be considered as well. Confidentiality is stressed and other boundary issues are worked out such as safe-keeping of the art work by the therapist until the therapeutic work comes to an end. These components add up to the establishment of a therapeutic contract which, by definition, is mutually agreed at the outset by client and therapist. This has been defined as 'the nonneurotic rational reasonable rapport which the patient has with his analyst and which enables him to work purposefully in the analytic situation' (Greenson and Wexler 1969).

The art therapy sessions

In art therapy the art materials become the focus for working out the relationship between client and therapist. As the client chooses what media to work in, this gives an indication of process as the image builds up and develops. The therapist observes how the activity is undertaken – i.e. with hesitation, or enthusiasm; there may be long periods of talking before any decision about art activity is made. Some children get very excited by what they have achieved in their work, when in previous weeks they were more worried about making mistakes, about doing nothing, or making a mess. At first, John was very worried about making mistakes or doing things wrong. This occurred when he was more anxious, perhaps feeling that the therapist was judging him in some way. His critical superego was projected onto the therapist. Over time, once the therapeutic contract had been made and the work was underway, he felt safer, more contained and freer to use the materials. This helped him to manage his anxiety, which had been overwhelming, and to express many different feelings which were coming to the surface. He became absorbed in his activity and 'lost' in his image-making and his thoughts. At first he was preoccupied with his experience of being 'in the middle', but he moved on from this as deeper feelings about himself and his predicament began to emerge. There was a development of trust with the therapist as the therapeutic space felt safe for him to explore his confused, upset and angry feelings.

In some art therapy sessions, there may be no art activity at all. Where verbal exchange between therapist and client is predominant, or where there may be long periods of silence, the dynamics of this process can be explored. Some clients refer back to earlier work, available in their folders; they might walk around the room, picking up and looking at things but not engaging with anything in particular. The therapist may experience this as a communication about her availability and what she 'gives' to her client.

The response to the setting and the art materials is an important aspect of this communication. When the art therapist is asked for some art materials that she cannot provide, she may feel like a mother who does not provide sufficiently for her infant. A client may pick this up unconsciously and it may have the effect on the therapist of not being 'good enough'. If the materials seem ample, wide-ranging and generous, the therapist might be perceived as all giving, intriguing, exciting or even indulgent. The opposite can occur in the situation when the same selection of materials is perceived by a client as not enough. The anxiety of not having enough is transferred to the therapist and may be linked to some early experience of deprivation. Other clients might inwardly register some lack of materials but 'make do' with what they have – another aspect that manifests itself within the therapist–client relationship.

John said initially he would like to use clay. When he first came he played with cars and chose to do painting. In subsequent sessions, he would begin by playing with the cars but then chose to experiment with the clay. John spoke more about his absent father who began to emerge as an important figure. This coincided with making two round objects in clay which he made into faces. He called them 'mummy' and 'daddy'. He proceeded to make a third which he called 'baby'. He left them and moved on to some more playing with the trains, making the track, anxiously wanting it to be complete. In the next session, he went straight to the faces, took them off the shelf, got out the paint and added two blue marks to the baby's face. When the therapist wondered aloud about this, he retorted 'tears of course'. He then began to make crying noises like a baby. This was a poignant way for him to describe his lost and unhappy state – crying like a baby. He felt caught and needed to be looked after. He made several other things out of clay – a car, a football post, but many of these did not survive from week to week. The faces survived, which he looked at most weeks. They were very important to him.

The therapist understood this material as John beginning to move more into three-person relatedness. She reflected on the prescence of his mother and father and the expression of his oedipal conflicts that were beginning to emerge. His regressive wish to become the baby was his way of managing the emotional pressure to become the grown-up boy who then had to face the problems at home and the relationship between them.

The following week he came in and started to make something with clay. He quickly gave up, frustrated, saying he could not do it. Instead, he turned to the plasticine and made several objects out of plasticine. Speaking about the book *The Enormous Crocodile* [Dahl 1978], he carefully made two men holding guns behind a wall. A crocodile with a small one beside it was placed next to the wall. He said they were hunters shooting at the crocodile with her baby. He then made two tiny objects, separate from the rest, which he said were breasts for the mummy crocodile to feed her baby. He spoke spontaneously about what he had made. He described in detail how the hunters were shooting at the mummy crocodile but added they were behind a wall and so they were safe. The breasts were placed slightly away from the scene. It looked as though they would be hard to reach. It seemed as if he had been able to make a separation between the part of his vulnerable 'baby' self that he experienced being under attack and the dependent hungry part that was waiting to be fed. The scene described conflicts with his oedipal aggression, in his masculine identification with the hunters and his regressive wish to be protected from this.

John made the scene with great care and delicacy. This was a significant session. He became very absorbed in the making but, at the same time, was able to put words and a narrative to his internal experience. He was able to move on from the clay which had become a frustrating medium for him to work in. Like his internal world, it 'fell apart'. The plasticine, with the different colours and durability, was safer for him to allow strong conflictual feelings to emerge. He kept these tiny things carefully, and every time he returned to the room he would make sure they were still there. The therapist held, in her mind, various thoughts about this intricate scene while waiting for her client to discover for the meaning for himself. His internal confusion about who was fighting who seemed to resonate with the external situation with the impending court case. Was he the 'daddy hunter' with a penis/gun fighting for his 'mummy/crocodile', or the baby being protected? Or did the hunter in some way represent his father fighting his mother for custody? Either way the situation was aggressive and frightening. The nurturing breasts were placed safely away from the battle zone. In her counter-transference response, the therapist wondered if she represented some part of the more separate, but safe, nurturing environment.

As the sessions were coming to an end, John again became worried about doing things right. For example, he tried to make a book for his baby cousin but constantly rubbed out the lines and soon abandoned the idea. In one session he did a picture of Batman, The Joker and other figures, again with great emphasis on getting it right. During this session he spoke about the fact that his mother was in court today and expressed some anxiety about her and his situation. He said he worried about his mum when she got upset. At the end of the session he asked to take his drawing to show her, expressing his need to connect with her and give her something. He was in touch with his anxiety about the separation between his parents but also from the therapist. The therapist thought about his request which they discussed together. They thought about his need to take something concrete from the therapy room which might help him with his worries and make him feel safer. He also wanted to help his mother with her worries. They came to an agreement that he should ask his mother down into the room to show his drawing to her. He readily agreed to this, possibly feeling that he could connect together the disparate parts of himself and address his intense anxiety.

The provision of art materials forms an important dimension in the relationship between art therapist and client. The medium that the client chooses to use, and how she uses it, is a means of expression in itself. Does she stay with one type of material or explore many different ones? Does the way she uses them develop over time or is this process a static one? Is there a lot of

mess and chaos in handling the materials or is there a concentration on keeping neat and tidy? The significance of the symbolic meaning held in the images will emerge over time so that the client can make her own links towards internal resolution of conflict.

John was able to explore and use different materials. Using the paint, he was able symbolically to express being 'blocked' but also his 'flicky' aggressive feelings. His clay and plasticine objects emerged in a solid and delicate way, indicating deeper, inner experience. His use of pencil and rubbers expressed underlying anxiety about ending, saying goodbye to the therapist and thinking about the future as well as his identification with his baby cousin and his own frustrated baby needs and regressive wishes.

John became able to express his confused and angry feelings about his parents. In the process, he brought deep infantile conflicts about needing to be fed and cared for by his mother but fearing that this would cause him to be annihilated or shot by the hunters (father?). He felt in the crossfire which he had not previously been able to clarify in his mind. The therapeutic contract was to work over a short period of time to address the external situation of his parents' separation. There was enough time for him to allow internal conflicts to emerge and work towards some resolution in himself with significant improvement in his behaviour both at school and at home.

The therapist follows the client throughout the process, being available with a capacity to receive, reflect back and interpret the most subtle communications. Safety and trust is established in the therapeutic alliance. By keeping to the boundaries, the therapist offers containment as the client struggles with difficult, sensitive and sometimes painful issues in the work. The images also hold these painful feelings and survive over time. These feelings may remain unconscious and cannot be put into words. It is possible to return to them in later weeks when the client feels more able to look at the meaning of the imagery. For example, John made his faces, and then the next week returned to them to add the tears which enabled him to communicate his experience of being the sad baby caught in the middle. It took several weeks before he could express this in words.

Art therapy may be offered on an open-ended basis and may last for several years. The process of change can be seen in the images or art work produced over time. The sequence can be looked at in a review session with the art therapist and client. Some art therapists like to review the work with the client as a way of clarifying the process of the work. This has the advantage of bringing aspects of the work into consciousness, but has the disadvantage of interrupting the flow or process and ongoing nature of the therapeutic work in the sessions. The purpose of reviewing clients' art work can be powerful but it may also serve a defensive function such as dealing with a difficult ending or preventing more painful issues to emerge in the present.

During the process of the therapy, associations to images may change, reflecting internal change in the client. A flower is drawn to depict the person

who has died during an intense period of bereavement. The same flower takes on a new significance once the grief and mourning has been worked through. A house drawn at the outset of therapy is empty, dead and remote in the client's view. As the therapy proceeds, it becomes possible to think about inhabiting the same house with fantasies about moving into it, living in it with the therapist, even having a relationship inside it. The house changes from a cold shell to having a habitable inside – an indication of how the client has moved in terms of her capacity to look inside, to make internal shifts, to feel contained and not shut out. The image remains the same throughout.

Endings

The ending of the therapeutic relationship is planned together. There are various reasons for working towards an ending but normally there is significant change in the client who may not need to attend further sessions. Initial symptoms and problems have been worked through and some resolution, both internal and external, has taken place. Personal cirumstances of either therapist or client – such as job changes, moving house etc. – might promote a decision to end working together. Where a set number of sessions have been completed, the ending takes a different shape but involves the same disengagement from the therapeutic process.

John was aware that he was to attend initially for ten sessions with the possibility to extend following a review. Throughout the course of his therapy, the therapist reminded him through the use of a calendar how many sessions were remaining. He was reluctant to attend his last session, but once in the room enthusiastically expressed the wish to finish his model aeroplane that he had started and asked for the therapist's help in doing so. When reminded by the therapist that this was his last session he said 'I know' very firmly, and then began to work in pencil, making lines on paper. 'That's wrong,' he said in frustration. He started again and asked the therapist to hold the ruler. After doing several lines he said he wanted to write the story of Thomas's train. He picked up a stencil set of letters and wrote ONE DAY, scratching on the stencils. By asking the therapist to hold the ruler and then confining his writing to the stencils, it felt as though he needed to be held together. She was able to offer him some solid structure at the time of ending when the structure of the sessions would no longer be there for him.

At the end of the session, he wanted to take the stencil with him. The therapist commented on this as she thought that he was wanting to take something from the session in order to manage his feelings about the ending and saying goodbye. He then anxiously asked if he could show his mother the

work in his folder. The therapist reminded him that as it was the last session, he was able to take any of his work with him. The therapist had kept it safely thoughout but now he was able to choose what he wanted to take with him. Looking through the objects and pictures, John chose what he wanted to take. The fragile objects were carefully wrapped. This can be an important part of working towards a resolution of the ending process and saying goodbye. At the end of the session, he took his precious objects to the waiting room and showed his mother in the prescence of the therapist. His mother looked at the various objects and images and, pointing to the tiny breasts, asked what they were. John whispered in her ear. In the review meeting that followed to assess the need for further work for John, his mother asked about the meaning of the images. The therapist was able to offer her understanding of John's need to think about himself as a baby in the face of having to be tough and brave. His vulnerable, dependent and baby feelings could then be acknowledged by his mother.

To work through the ending of a therapeutic relationship it is helpful to give as much notice as possible. Where the ending is in control of both client and therapist, it can be worked through in a mutually agreed way. When clients are abruptly discharged, for example, this is not possible. The termination phase is an important part of the therapeutic work as it addresses issues of separation and loss. For some clients who have had traumatic loss and endings in their life, a planned termination of therapy can provide the opportunity to rework this experience in order to say goodbye. Feelings about the ending may be expressed through significantly changed imagery such as doodling or cartoons, indicating that the deeper issues that have emerged in the work have been resolved. Some children turn away from using the materials altogether and concentrate on playing with toys or other objects in the room to re-establish their defences and prepare for leaving.

The sequence of images produced in therapy illustrates the process of ending and the closing down of the therapeutic relationship, and the feelings that this evokes (see Chapter 6). This was evident in John's material: he wanted to play with a car, to make things for other people, and show his work to his mother to connect the sessions with her rather than with the therapist. Saying goodbye stirred up difficult feelings for him. There are other examples, such as the child who had produced many spontaneous paintings during the therapy and began drawing instead with a pencil and ruler, repeating patterns starting on the outside and going into the middle as if to gain control. Peter, who was mentioned in Chapter 3, spent his final session drawing intricate details of flowers on a minute 'postcard'. This had a multitude of possible meanings – flowers on the grave, message from afar, closing down of personal statements and so on. Other children are more expansive – a tiny model

aeroplane is made in the first session and, in the last session, an enormous one is made to hang from the ceiling to make sure the therapist does not forget: a sign of greatly improved self-esteem. Endings are complex as feelings of sadness and loss may be mixed with a wish to move on.

At the end of therapy the client is asked if she wants to take her art work or whether she wishes to leave it with the therapist. If the paintings are left, the therapist will keep them, according to her code of practice, for three years. They are records of the work and are stored and kept safely, as in any filing system of past therapeutic contact. John chose to take away his models and left his drawings and paintings. The clay and plasticine became the medium which, for him, most significantly expressed his experience. He had indicated this in the first meeting but the significance was made clear as the therapeutic process developed over time.

The images, models and the other objects made or destroyed or allowed to disintegrate are records of the process of the art therapy sessions. The containment by the art therapist of the therapeutic space allows this process to develop. Intense, painful emotional experiences are sometimes graphically exposed in the images. Some paintings can be horrific. The therapist's counter-transference response may be of horror or disgust but the therapist remains receptive and available in a way which does not cut off from the experience. A response to looking at paintings that evoke difficult feelings is to turn away. There is a need to process and digest these frightening feelings for the client. If the images are not so explicit but chaotic or messy it is helpful to stay with this mess and destructiveness rather than offer some intervention to intrude on the process. The therapist receives the image through her own aesthetic response. Her capacity to reflect on the feelings evoked are an essential part of enabling the client to make sense of the symbolic communication between them and the long visual journey they undertake together (Schaverien 2002).

References

Case, C. (1998) Brief encounters: thinking about images in assessment, *Inscape*, 3(1): 26–33.

Case, C. (2005a) *Imagining Animals: Art, Psychotherapy and Primitive States of Mind*. London: Routledge.

Case, C. (2005b) Observations of children cutting up, cutting out and sticking down, *International Journal of Art Therapy*, 10(2): 53–62.

Case, C. and Dalley, T. (eds) (1990) *Working with Children in Art Therapy*. London: Tavistock/Routledge.

Cox, M. (1978) *Coding the Therapeutic Process: Emblems of Encounter*. Oxford: Pergamon.

Dahl, R. (1978) *The Enormous Crocodile*. London: Puffin.

Dalley, T., Rifkind, G. and Terry, K. (1993) *Three Voices of Art Therapy: Image, Client, Therapist*. London: Routledge.

Freud, A. (1965) *Normality and Pathology in Children: Assessments of Developments.* London: Hogarth Press.

Freud, A. (1974) *Diagnosis and Assessment of Childhood Disturbances in Psychoanalysis: Pathology of Normal Development.* London: Hogarth Press.

Greenson, R. and Wexler, M. (1969) The nontransference relationship in the psychoanalytic situation, *International Journal of Psychoanalysis*, L

Mann, D. (2006) Art therapy: re-imagining a psychoanalytic approach: a reply to David Maclagan, *International Journal of Art Therapy: Inscape*, 11(1): 33–40.

Meyerowitz-Katz, J. (2003) Art materials and processess – A place of meeting: art psychotherapy with a four year old boy, *Inscape*, 8(2): 60–9.

Nowell Hall, P. (1987) A way of healing the split, in T. Dalley *et al.*, *Images of Art Therapy*. London: Tavistock.

Parsons, M. (1999) Non intensive psychotherapy and assessement, in M. Lanyado and A. Horne (eds) (1999) *The Handbook of Child and Adolescent Psychotherapy*. London: Routledge.

Sandler, J. *et al.* (1973) *The Patient and the Analyst: The Basis of the Psychoanalytic Process*. London: Maresfield Reprints.

Schaverien, J. (1987) The scapegoat and the talisman: transference in art therapy, in T. Dalley *et al.*, *Images of Art Therapy*. London: Tavistock.

Schaverien, J. (1992) *The Revealing Image: Analytical Art Psychotherapy in Theory and Practice*. London: Routledge.

Schaverien, J. (2002) *The Dying Patient in Psychotherapy: Desire, Dreams and Individuation*. London: Palgrave Macmillan.

Schaverien, J. (2005) Art and active imagination: reflections on transference and the image, *International Journal of Art Therapy: Inscape*, 10(2): 39–52.

Simon, R. (1992) *The Symbolism of Style*. London: Routledge.

Tipple, R. (2003) The interpretation of children's art work in a paediatric setting, *Inscape*, 8(2): 48–59.

Weir, F. (1987) The role of symbolic expression in its relation to art therapy: a Kleinian approach, in T. Dalley *et al.*, *Images of Art Therapy*. London: Tavistock.

Working with groups in art therapy

A company of porcupines crowded themselves very close together one cold winter's day so as to profit by one another's warmth and so save themselves from being frozen to death. But soon they felt one another's quills which induced them to separate again. And now, when the need for warmth brought them nearer together again, the second evil arose once more. So that they were driven backwards and forwards from one trouble to the other, until they had discovered a mean distance at which they could most tolerably exist.

(Freud 1921: 33)

Introduction

In this introduction we are going to consider the question of why one might decide to work with a group of clients or patients, rather than with an individual. The philosophy underlying all group therapy is that man is a social being. Humans generally live in family and social groups with the wider community supporting the parenting of children. Early internalised family relationships that were dysfunctional can distort experience of current relationships so that there is a good argument for the corrective potential of group work. Co-therapists can allow a modelling of parental figures working together and provide opportunity for fruitful transferences to occur. More widely, the whole group can become engaged in working together with many different possibilities of relationships and learning from each other. We are all members of a series of institutions: nurseries, schools, colleges, workplaces and associations; all of which will have their small group dynamics and institutional dynamics affecting our lives. Therefore a basic knowledge of group theory is essential for all therapeutic work both to aid our understanding of our own and our clients' experiences in the past and to help us understand our experiences of being art therapists and clients within the institution in which we are working. A study of institutional dynamics and how this impacts on our work as therapists is an essential aspect of training.

Central to group art therapy is the healing capacity of the artistic process,

the release of unconscious material which, when consciously assimilated, can lead to the release of creative potential for the individual. The artistic process is able to facilitate the expression of ambiguous feelings and conflicts. It frees inhibitions or blocks and provides the possibility of reintegration of previously split-off parts of the personality. The making of art objects can be an acceptable way of expressing 'unacceptable' emotions, whether they are love, hate, envy, jealousy or aggression. The physical nature of making can contribute to a release and relief of tension. Group members also react physically to the art objects of other members. It is an extraordinary powerful moment when paintings and models are laid within the group circle as participants re-form the group after separating to paint. Many emotions are possible: pleasure and relief in sharing, a sense of belonging, of excitement, exposure or fear. The images work on each other as they reveal the unconscious themes in the group in that session.

Within the art therapy group there are different forms of self-disclosure, either through the making of art objects or through verbal interaction. The flexibility of movement and seating within the group may make this a less threatening experience than the fixed mode of verbal therapy. The art objects give a concrete product for discussion. All members in the group contribute just by sharing their objects within the circle; they need not necessarily speak. Similarly, an object can be withheld from the group by being left on a table or wall or hidden beneath another member's piece of work. The art objects provide a record of the group's journey together and also form the basis of the group's culture in the way the group chooses to explore them. Everyone's difference or uniqueness is instantly seen when the paintings are placed on the ground, but almost paradoxically the universality of experience is recognised through the sharing of paintings – one person's emotion and life events bringing forth another's.

Generally, group work is thought to have many potential curative factors. Waller (1993), Yalom (1995) and Liebmann (2004) list these in detail; here we will select some potential benefits more briefly. Firstly, a lot of our social learning takes place in groups and secondly, group work evokes family dynamics which can then be worked with. Group members learn from each other, can try out new roles and can be mutually supportive. Some clients may find the intimacy of individual work too intense and feel more at ease in a group. Groups may draw on the resourcefulness of group members and so allow them to be active in the therapy rather than encourage a nurturing dependency. Groups can foster hope for change through the mutual sharing and discovery that one is not alone with a problem.

During the interaction of the group, much interpersonal learning will take place. People make immediate appraisals of each other on first meeting, based on appearance, age, style of dress etc. These become adjusted as the group works together, and respect will be gained as others observe and benefit from particular skills that members will find they have. There is the

opportunity to find out how one makes judgements and to try out different aspects of oneself; to take risks. It is possible for members to get feedback from the group about themselves, either through exploring the images or through an exploration of developing relationships within the group which will be encoded in the pictures. The group offers the opportunity to improve general life skills and also to leave with an internalised group experience which can help members to deal with issues in the future. This can be true in every sense from the gaining of some basic trust in a group of people, to having learnt to use making art objects within a relationship as a way of healing dis-ease by sharing the most intimate thoughts and feelings of others.

The development of group art therapy derives from the two main bodies of knowledge: art therapy and verbal group therapy. The basic difference between all forms of group art therapy and all forms of verbal group therapy is that at some point in group art therapy each member becomes 'separated' from the group to work individually on her own process through the medium of art. This has a profound shaping on the group dynamics and on the art object formed.

All groups express a tension between dependence, the desire to merge into a group identity and separation – a wish to express individual difference, as expressed in the quote at the start of the chapter. Art therapy groups uniquely differ from verbal groups in having a structure which can give time and space for each side of this tension to be explored. Several different formats have become established in art therapy practice and we shall be considering them in turn, looking at influences upon them and the role and function of the art therapist in each.

The studio-based open group

The studio-based open group could be described as the classic form of art therapy where the art process is seen as a curative factor and was the main way of working before training was available in the early 1970s (Wood 2000). There has been a huge change in art therapy practice with the movement of patients out of large hospitals into the community, discussed in the Introduction. However, the roots of art therapy practice lie in this way of working and there has been a 'revival' and renewed interest in studio-based work. Luzzatto (1997) discusses the 'open session' on acute psychiatric admission; Deco (1998) argues for a return to studio-based groups but with more defined boundaries; Wood (2000) explores the importance of 'place' and how a studio facilitates exploration, play and reverie. Almost uniquely in British literature she brings political insight to the climate of the 1980s and 1990s that led to the hospital closures and loss of studios. Hyland Moon (2004) argues for cultivating the artist identity in the art therapist through working from an art-based model of practice. Gill (2005: 1) describes the 'studio upstairs' approach in London and Bristol which provides 'environments for people

dealing with mental or emotional distress, or people in drug or alcohol recovery, who find that through creating art, both privately and publicly, they can transform their lives'.

Before formal art therapy training was established, a therapist's art school background and individual experience of therapy largely informed her practice. It therefore had antecedents in the studio or workshop tradition. In hospitals or large institutions where this type of group evolved, a group of patients would come to work in the studio with art being regarded as the medium of treatment rather than the group. The therapist related to each member working individually and would probably talk to each one in turn, sometimes at some length, or there may have been an alternative private space available, an office for example, for individual discussion of work. There was a communal feel in that there may have been music playing and shared coffee breaks during the long session which might last a whole morning or afternoon. The patients in the group may all have come from the same ward, having a morning session assigned to them, or they could be individuals from many wards who had been referred and accepted into the department. These groups were usually composed of long-term residents living in psychiatric hospitals or secure units for people with learning disabilities (Molloy 1984).

Within the hospital this may have been the only 'private' and 'personal' space a resident had in an institution. For those who were long-term and institutionalised, the studio offered an important possibility for individual decision-making and an outlet for creativity. Some patients worked as artists in the studios with their own space as if in an art school. As in any studio, group processes affected the use of the space, the phases and pace of work and the images made. The art therapist worked with individuals within the group rather than with group processes.

The theoretical orientation of the art therapist decided how the art objects were explored. For example, a Rogerian approach is described in a psychiatric hospital by Warsi (1975a, 1975b). The most comprehensive account is given in Lyddiatt (1971), who worked from a Jungian framework with emphasis on 'spontaneity', the release of hitherto unrecognised feelings. The whole curative factor was seen to rest on the effect of the patient in contact with their unconscious through the making of art objects. Lyddiatt was particularly influenced in her style of work by the Jungian concepts of 'amplification' and 'active imagination' (see Chapter 6). There was little emphasis on understanding and reflection between therapist and client, and more on helping patients to treat themselves through painting. Lyddiatt was reluctant to interpret patients' work, feeling that projection was all too easy: 'The idea, i.e. the "technique", is to watch what one's imagination is doing ... Yet patient, therapist, or onlooker can unwittingly kill the spark unless experienced in this inner way – kill it because the patient is tentatively trying to find, feel and experience for himself new values through his painting, and this, in fact, is

exceedingly difficult' (Lyddiatt 1971: 4). In this way of working an art therapist would not be working directly with the transference although an individual personality theory would be illuminating the therapist's relationship to the client group. In this kind of 'open group', where individuals may also drift in and out during a session, staying for three minutes to three hours, the kind of ambiance built up in the studio is extremely important because this is a group who will feel that this is 'their' room. Many relationships will be developing and changing between the members – some, for instance, always painting side by side. One client's decision to use clay, for example, may be a catalyst for many other people's development and change. The art therapist will be creating an atmosphere of trust and acceptance, receiving and valuing the products and experiencing them largely non-verbally. A further account of this type of work in hospitals is given by Edward Adamson (1984) and the products of many years of these sessions can be seen in the Adamson Collection, which is well worth a visit.[1]

Other settings that run this type of group can be schools, social services day centres, therapeutic communities, some youth programmes and residential children's homes. In fact, wherever there is 'free time' in therapeutic programmes, patients are often permitted to use the studio for their own private work.

In an effort to reach patients not able to leave the wards where they live, art therapists frequently run an open studio session taking a mixed range of materials with them. For instance, the following describes the use of such sessions by three clients on a psychogeriatric ward. These often institutionalised, non-ambulant residents normally spend a large part of the day sitting in chairs. It was possible, by using a regular meeting area (the dining tables), to attract the participation of those able to benefit. 'Place settings' were equipped with paper, brushes and pencils and clients would tentatively begin mark-making at their own pace and level. In one such group an elderly man, who had had a stroke, was able to scribble with one hand, gradually extending to a range of colours, developing an investment in the pictures as well as developing his coordination and motor skills. He also became involved with conversations around the table and benefited socially.

On the same ward, a middle-aged man who had entered the hospital in adolescence, due to shell shock, began a huge output of colourful paintings of vehicles and fires on black paper, often making 20 to 25 pictures a session. It became apparent that he was reliving experiences of bombing at night. He was mute and habitually avoided all personal contact. He made sense of the experience by one day printing 'SCHOOL' on a painting which

1 Adamson Collection, Ashton, near Oundle, Northamptonshire. People wanting to visit the gallery should write to: Adamson Collection, 16 Hollywood Road, London SW10.

began a long series of cryptic communications. The development of this patient was very gradual – 40 years of institutional life had taken its toll, but the quality of his life improved with the introduction of the sessions. Socially he had a sense of belonging to the group and the paintings clearly had a meaning for him.

A further example was a depressed elderly man who had suffered multiple bereavements. After a slow beginning, copying scenes from calendars, he began to paint small pictures of remembered scenes from his life and would allow memories and feelings to surface to share with the group. The group can be seen to support very individual use by its members, cooperation by simple sharing of materials and care for others through positive comments on each other's work.

Working with children in groups

When working with children in a group, the art therapist will be working with the group but be informed by individual psychological theory as well as group theory. This way of working is probably most successful with small groups of pre-latency or latency children. Each group is not just a collection of individuals but a coherent whole with its own laws, group culture and unique dynamics. Although it is not possible to look at the behaviour of one group member independently of other group members, it is necessary to have developmental theory in mind when working with children as well as commenting on group interaction generally.

Children work very successfully together in an art and play therapy room context. The children identify with the group which takes place at a particular time on a particular day but will usually very quickly disperse to work individually on their own current themes and preoccupations. Children may pair and group in different ways but with the development of a good 'work group' atmosphere there will be a sense of acceptance and tolerance for each child to pursue her own ends without interference. The group will often be useful for the children's social development and understanding as they take in the therapist's model of relating and acceptance of differences. They also learn from each other and begin to negotiate their relationships, as the therapist might address and work through with the group areas of conflict, difference or cohesion that will inevitably arise as the group interacts. The child can also benefit from some personal space to explore preoccupations within the protective group atmosphere. The trust that is established enables the children to tolerate differences but also to begin to understand and help each other. Prokofiev (1998) offers a clear overview of how adult group psychotherapy models have been adapted to similar work with children as well as case examples.

Murphy (1998, 2001) puts forward some compelling reasons for considering group work with child and adolescent survivors of sexual abuse. It

prevents the 'replicating of the potential imbalance of power of the individual relationship' and can help to lessen the sense of isolation and stigma. The possibility of two therapists is helpful in that it can offer a model of healthy, non-abusive adults working together. Adolescents may find working with a peer group more palatable than either being in individual therapy with an adult only, or family therapy (Riley 1999). Buckland and Murphy (2001) discuss a group for young latency girls that worked with art and play and comment on the resourcefulness of the children in their own and each other's recovery from abuse. Aldridge and Hastilow (2001) explore work with a boy group of siblings and the benefit of having male and female therapists, but also the intensity of the work and the anxiety that it arouses. Brown and Latimir (2001) posit the benefits of working with a therapist from another discipline, in this case art therapy with cognitive therapy, with a group of adolescent girls. This was particularly helpful in addressing 'distorted beliefs' resulting from sexual abuse.

In a different context, of looked-after children, Boronska (2000) also worked with a colleague from a different discipline. She puts forward a persuasive case for working with groups of siblings (who are looked-after children) as a way of improving their capacity to form 'enriching relationships'. In the group she is able to foster their relationship to their art work and to begin a reflective stance towards their work, themselves and others. There is the possibility to use symbolic communication where previously there may have been acting out. Dalley (1993) works with the use of art within a psychotherapy group framework to provide a corrective experience through the role of the group as a social microcosm. Dalley's chapter is very helpful in exploring the intensity of expression through art work and in behaviour, and the need for a robust response from the therapists.

Several writers have articles or chapters on work with children suffering from attention deficit hyperactivity disorder (ADHD). Murphy *et al.* (2004) describes work in a CAMHS team with groups of impulsive children diagnosed with ADHD. These children frequently have difficulty in forming satisfactory relationships, find it hard to take turns, share or listen and usually have low self-esteem and are isolated. Safran (2002) looks at group approaches and family therapy approaches with this client group. Several authors (e.g. Woods 1993; Prokofiev 1998) comment on the structure needed for such groups to be successful and how creative freedom can on an instant turn into chaos, so thinking on one's feet is needed. Henley (1998), having recognised this, built time for free play, time for expressive arts activities and a 'friendship circle' into the programme he devised for children with ADHD. Riley (2001) has chapters on: work with children with early attachment difficulties; support groups for children suffering severe burns; social skills for children with autism (Noble 2001); a combination of art with cognitive-behaviour therapy for children with ADHD (Rozum 2001); and also discusses adolescent groups in a book which focuses on the adding of the

language of art to group therapy. Bissonnet (1998) gives an example of clinical work with adolescent boys in a social services setting.

Clinical examples

The following two examples are taken from educational settings. The first shows a group of young children alternating between art and play; the second a group of older children more aware of themselves consciously as a group and working through art.

Example from a group in a primary school, age 7

In this setting the art therapist worked with small groups of children with special educational needs referred by the head teacher and class teacher. This was reviewed at the end of each term; the three children described came for an hour a week and this was the fifth group. Tracey was referred because her parents were in the middle of a bitter, argumentative divorce. Dean was referred for impulsive behaviour with additional symptoms of lying and stealing; his family life was chaotic. Louis was a shy, introverted child, withdrawn in the classroom. His academic progress was very poor.

Group

In this session the children had a brief discussion around the table and had decided unanimously to paint. The two boys originally went to the sink to fetch water, but were diverted and became involved in some water play. At Dean's instigation, toys were fetched from the sand tray and they played at Tarzan and animal fights: Tarzan, leaping off the taps, fights with crocodiles under the water. Tracey began a picture of her friend in a very watery style, saying, 'She's black but I'm doing her white'. She gave a wry smile to the therapist to communicate that she'd drawn the head rather big. Reflecting on the image, she did 'freckles on her face', then said, 'Not freckles – just watermarks.'

Commentary

It can be seen at this stage that an unconscious theme around water has arisen. Louis taking the part of Tarzan; Dean identified with the 'aggressive' crocodile; each boy is carrying a part of the other's projection. Dean needs to control his 'wild' impulses but with Louis taking the part of Tarzan he can 'play' them out. Dean, however, is expressing much 'wild' feeling that Louis is unable to contact for himself. It is happening largely beneath the water. Although Tracey is working alone, her watery painting starts simultaneously

with the water play and the comment on colour contains many possible meanings. It comments on 'difference' in her sense of being left out or not included in the game, her different gender and also her different colour. She was the only white child in the group, which was emphasised by her picture of her friend whom she wants to be 'the same'. Tracey may have been painting an aspect of herself – 'she's black but I'm doing her white' – in that she feels guilty, as if she might be to blame for the divorce. The aspect of herself is confirmed by the freckles, which she has, but her friend does not. These then transmute to watermarks, i.e. tears.

Group process can enable children to express their own difficulties and the unconscious dynamics and interactions within the group facilitate the expression of problems faced in their daily lives.

Group

Tracey began to talk about the death of her cat's mother. This happened when Tracey was 5. She then became even more sad and preoccupied because she had forgotten the cat's name. She had been going to do a dog in the picture but now did a cat instead. She told the therapist about her cat called 'Kitty', saying, 'People called her "Kit-e-Kat" to annoy me.' She then said, 'A lot of pets have died.' The painting finished, she moved to the sand tray. Meanwhile Dean had begun to dip the animal's feet in the paint by the sink and was walking them over the table tops in a trail and back to the sink. As the paint on the animal's feet 'coloured' the water it became apparent that getting the water dirty was important: an emphatic 'Yes' as the therapist commented on the dirty water and mess. A lot of excitement as the fights under the murky water continued with no clear outcome. Dean, attracted to the involved demeanour of Tracey at the sand tray, said he wanted to use it but before this developed into an argument his eye caught a picture of Superman drying from a previous group, and he went to look in his folder for a picture of Superman he had started the previous week.

Commentary

In this part of the group, Tracey's sadness emerges and is shared with the therapist. Dean's approach, as the animal footprints, makes contact but does not disturb her. The talk of cats is quite complex and perhaps represents in her mind a way of exploring the changes in her own mother and herself since the fights and arguments started two years ago (when she was 5). She seems to have lost contact with that earlier, happier self, 'forgotten the cat's name', and her anxiety is expressed about whether she will be looked after properly 'in between the parents' through the divorce as 'a lot of pets have died'. Forces in

conflict in the boys are being fought out, but it is a murky area – the water gets very dirty and it all reaches an impasse.

Group

At the sand tray Tracey puts an igloo in the corner and builds a fence around it. She fills a small bowl with water and places it in the sand, like a breathing hole in the ice. She places an Eskimo figure with a spear surrounded by encroaching animals – seals, polar bears, a walrus and a crocodile. Dean finishes off last week's picture of Superman and asks the therapist to write his name on it. He is pleased with this and wants it up on the wall. Louis started and finished his own picture of Superman which he copied off one already on the wall, done by an older child. He is very anxious about his drawing although it is competently and carefully executed.

Commentary

Unable to solve the conflict under water the boys separate and move into fantasy. Superman does not have to work things out on a real level but can rise above these problems. In identifying with the older boy's Superman, Louis shows a wish to be mature and 'in control'. His need to copy or imitate indicated his lack of self-confidence, and he was not able to feel that what he had done was good enough, in spite of the fact that he had done a more competent drawing than the one he copied. Tracey and the boys swap kinds of activity, and by changing places attempt to resolve the issues that have emerged for each of them, aware of each other but not interacting very much in this session. Tracey's frozen landscape and Eskimo figure might indicate her feelings of being 'out in the cold' and 'under siege' both within the group and in her family. But the crocodile was there and her breathing hole in the ice, which might indicate signs of hope and life. Her play could be seen as a metaphor for the group where contents of the unconscious meet in the art therapy room and are then reintegrated. The hole in the ice could be seen as the link to the unconscious under the frozen 'conscious' wasteland. She is using the sessions slightly differently from the boys at this time. The igloo in the corner gives her a safe space within which she can reflect, withdraw to and emerge when ready, whereas the boys choose a more active form of drawing for their own sense of space.

Example from a group in a primary school, age 9–11

The art therapist worked with a group of children referred for learning difficulties and it was felt that their difficulties were compounded by the fact that they had all experienced significant loss in their lives. The children had one

individual session per week and one session a week as a group. This built up a strong, but rivalrous relationship between therapist and group, although they knew they were being seen for equal amounts of time. This enabled more opportunity for self-disclosure as well as aiding further understanding through their interactions as a group. The group had been formed for one term and was to be reviewed at the end of term.

Abdul, age 11: older siblings in care, father deserted, mother physically damaged by accident. Obsessive child, uncontrollable temper (see Figure 10.1(a)).

Colin, age 10: mother died when very young, now lives with father and siblings (see Figure 10.1(b)).

Graham, age 9: mother white, father black African, worried about father who visits but does not live with them, macho cover hides sensitivity (Figure 10.1(c)).

Susie, age 9: divorce after father violent to mother and children, speech defect psychologically based on experiences as a young child, clings to adults, silently cries (see Figure 10.1(d)).

Jane, age 11: divorce after father violent to mother who suffered partial deafness as a result. Stepfather and new sibling (see Figure 10.1(e)).

Georgina, age 9: mother does not speak to her following birth of several siblings in close succession. All contact is through her father and siblings (see Figure 10.1(f)).

Group week 7

In this first meeting after half-term, the children all rushed to look at folders and pieces of work in progress from before the half-term break. They all remembered what they had been working on and exclaimed at finding it safely kept. They chose to sit around a group table and began to finish paintings, paint pottery and so on.

Twenty minutes into the group the three older children, Abdul, Colin and Jane, began a round of sniping attacks on each other, expressing the rivalrous undercurrent of who will dominate the group. Abdul was causing disturbance in the group, behaving with continual, minor destructiveness, splashing paint and water near or over people's work. At the beginning of the group he had started to make a machine-gun from pieces of wood. The therapist had intervened, reminding him of basic rules when he had tried to break up another child's model to get a piece of wood he wanted. By making derogatory comments on other children's work, he ignored the therapist's comments about his anger really being directed at her. Jane kept up an intermittent 'If you want to be in our group . . .' which irritated him further.

Colin worked with solid involvement, letting Abdul's aggressive criticisms

slide off him, until Abdul returned to the group and, beginning to paint a witch, used it to make comments about Colin's dead mother. Colin left his previous painting and began to paint a 'lone' shark 'which is a dangerous fish'. The younger boy, Graham, had retreated to a desk apart, making a dinosaur, a Tyranosaurus Rex with open mouth and full of teeth. He came growling with it to the group, where seeing a lot of 'fish' painting going on, he began to paint a 'goldfish'. The 'fish' painting had been started by Susie who had drawn, then painted a 'fish in a net'. She said of it, 'It's a flat fish [a plaice], a lifeboat's caught it in a net, he's happy because he's caught. He doesn't want to have to live.' Jane, admiring the fish, got Susie to draw her one too. She then added sharp teeth, half painted it brown with spots, and left it. Graham's fish is in the sea, painted blue, no nets in evidence. 'It's a spotty goldfish.' While this is going on around her, Georgina has been struggling to draw a 'cow being milked'. She had a lot of trouble both drawing and painting it. It had to have horns, but no ears, like all her animals made in art therapy. She commented, 'This is a cow getting milked in her barn and a little girl is bringing another bucket because one of them is overflowing.' She wrote 'MILK' on the picture. She interacted a little with Jane and Susie, but mostly all her energy went on the drawing.

Commentary

This older group of children are coming to an age where they can begin to respond to simple comments on group process. Colin, for instance, listened to the therapist's comments to Abdul, took them in and remained solid and in control over Abdul's aggression. His work, however, was a direct response to the group situation and encoded the need for defence. A 'lone black shark' both says something about Abdul and himself, in his depression after his mother's death. Abdul's witch is used to try to taunt Colin, a projection of Abdul's aggressive feelings to his own mother. He is haunted by obsessive anxiety about her and this is transferred onto the therapist. Graham's dinosaur expressed and is formed partly by the free-floating aggressive bickering from Jane and Abdul, his defence in the face of it. It also parallels his 'macho' image in the face of difficulties and shows how he retreats behind it.

It is the quiet Susie who instigates a creative flow within the group. In some ways the sparring between the older children going on over her head has made a cover for both her and Georgina to work to an individual depth. The fish painting suggests the net reflecting the boundaries of the art therapy session, felt by her as a respite from the normal struggle with speech and life generally.

Identifying with the 'happy fish', Jane tried to emulate its qualities but the teeth which emerge show her very different feelings. At home she is struggling with jealousy with her stepsister and this rivalry is being played out in the

a

b

c

Figure 10.1 (a)–(f) Six group pictures: (a) Abdul, (b) Colin, (c) Graham, (d) Susie, (e) Jane, (f) Georgina.

d

e

f

group. Georgina has been struggling with the complex 'mother' image of the cow. Both Georgina and Jane share the problem around 'hearing' or being heard, with Jane's mother being partially deaf and Georgina's mother electing 'not to hear her'. The mother cow is overflowing with milk and has horns but no ears. In her pictures, which are made in the classroom, all the animals have ears but in the art therapy sessions the pictures silently state part of her problem at home. The paint runs and is smeared and mixed up over the cow so that in the end it has no facial features. Clearly painted and standing out are the cow's pink udders and a green bucket containing milk beneath them. Attention is focused on the breast and the milk, the object of most envy at home as the babies have been fed, but she is no longer 'fed' by mother.

As in all groups the members have different ways of sharing feelings and expressing pain and happiness. Some paintings seemed to be more about the experience of being in the group and interpersonal relationships, affected by familial patterns. Others seemed to withdraw into an individual process, their contribution to the group tests the willingness of the group to receive it and work with what it arouses. Susie's last comment on her fish, 'He doesn't want to have to live', seems to speak for the life and death struggle she went through in infancy.

The influence of verbal group therapy

Various forms of art psychotherapy groups have developed. These groups have been influenced directly by analytic group therapy. The therapist will be aware of group processes though may choose to work with either the individual in the group, with the individual and group processes or only group processes. The 'analytic' group has a similar respect and trust for the art process and will be non-directive about the content of paintings, working with the unconscious themes that arise from the group each week. Some art therapists also work with set themes or combine an approach for specific client groups.

Early developments in theories of group psychotherapy have contributed to influencing different styles of analytic group art therapy. Freud and Adler were among the first people to apply psychoanalytic insights to social groups (Adler 1929). In 'Group Psychology and the Analysis of the Ego', Freud (1921) explored both crowd behaviour and the relationships of groups and leaders. Adler was to attribute greater importance to social factors than Freud and innovated groups in kindergartens for children and child guidance clinics for mothers. Moreno (1948) coined the term 'group therapy' and developed psychodrama. In psychodrama the members of the group are used as both cast and audience for the exploration of individual problems.

Group methods were used by psychoanalysts and psychiatrists for officer selection purposes in the War Office Selection Boards. The psychoanalysts Bion, Rickman, Foulkes and Main were given the opportunity to run army psychiatric units along group lines. From these two 'Northfield Experiments'

came the impetus for social therapy through the therapeutic community movement (Main 1946) and the use of small groups for the treatment of neurotic and personality disorders (Foulkes 1964).

Kurt Lewin, a psychologist, termed the expression 'group dynamics' and inspired the development of 'sensitivity training groups' (T-groups). He developed his own field theory of social interaction which emphasises the 'here and now' more than the influence of past events. He is best known for a fascinating experiment comparing the effects of autocratic, democratic and *laissez-faire* styles of leadership on groups of children (Lewin *et al.* 1939). In this experiment, and in later work in industry, he explored the effects of leadership on the functioning and social climate of groups.

Here we look briefly at three models of analytic group psychotherapy. For a fuller exposition of different models of group therapy, the reader is referred to Shaffer and Galinsky (1974), Yalom (1975) and Brown and Pedder (1979).

Analysis in the group

This way of working has developed particularly in the USA (Schilder 1939; Wolf and Schwartz 1962) with patients already in individual therapeutic relationship with the group analyst. Emphasis is put on individual transference relationships and the therapist has a very active role in directing therapeutic work on transference and resistance.

Analysis of the group

A style developed at the Tavistock Clinic where group processes are seen to reflect the common motives, anxieties and defences of the individuals in the group. Ezriel (1950) invented the term 'common group tension' to describe the group conflict resulting from a shared wished-for but 'avoided' relationship with the therapist (to be their only child). This arouses fear of the consequences if it were to be acknowledged – 'the calamitous relationship' (fear of retaliation by abandonment) – and is resolved by a compromise – 'the required relationship' (concealing resentment under an attitude of helpful compliance). In some ways Ezriel combined analysis of the group and in the group, working with each individual's contribution to the common group tensions (Ezriel 1950, 1952). In this way of working, the therapist has an impassive exterior, actively encouraging transference to herself.

Bion contributed the idea of basic assumptions, or primitive states of mind, which are generated automatically when people combine in a group. The fantasies and emotional drives associated with these basic assumptions unconsciously dominate the group's behaviour in a way that is apt to interfere with its explicit work task and so prevent creative change and development (Bion 1961). The basic assumptions are:

1 Dependence: expecting solutions from the therapist leader.
2 Fight/flight: fleeing from or engaging in battle with adversaries particularly outside the group.
3 Pairing: encouraging or hoping for a coupling of individuals which could lead to the birth of a person or idea that would provide salvation.

Bion's ideas have had influence on the study of the dynamics of institutions, including therapeutic communities and training groups.

Analysis through the group

This is particularly associated with Foulkes, who founded the Group Analytic Society in 1952. A psychoanalyst, he was influenced by gestalt psychology and its interest in the interrelation of sum and part. He regarded the group as the therapeutic medium and the therapist's task as that of nurturing therapeutic potential by allowing individuals to function increasingly as active and responsible agents themselves. The analysis of the individual remains a primary concern: 'The individual is being treated in the context of the group with the active participation of the group' (Foulkes and Anthony 1973: 16). Foulkes came to see the individual as one point in a network of relationships, and illness as a disturbance in the network that comes to light through the vulnerable individual. This approach antecedes family therapy. Foulkes described the four levels on which a group functions:

1 Current adult relationships, social, cultural, political and economic contexts.
2 Individual transference relationships.
3 Shared feelings and fantasies, intrapsychic processes.
4 Archetypal universal images.

For a full exposition of this approach the reader is referred to Foulkes and Anthony (1973).

The various theories on group psychotherapy have informed and influenced the styles of art therapy groups. The essential difference and additional complexity, however, is how the art process and object made within the group is worked with. The therapist must therefore work with the group and with the images of the individuals within the group and those of the group as a whole, and how the transference relationships that develop within this are understood.

Art therapy groups with adult clients

Different theoretical approaches have shaped the way art therapists have developed working in groups with adults. The range of different names

reflects this and these include analytic group art therapy, group interactive art therapy, art psychotherapy groups, group art therapy and theme-centred groups. It is a complex process working with both art therapy and verbal group therapy within a matrix of group art therapy and several models and theoretical stances have developed which are reflected in the literature. The mode of communication will change from free-floating verbal interaction to making an art object, to verbal discussion. Individuals can leave the fixed circle seating of verbal therapy and change and shift their physical relationship to each other. While making an art object individuals withdraw internally to express themselves in the space of their choice, whereas if one moved to another part of the room in verbal therapy it would be material for interpretation. Although the positions of the group members will be observed and sometimes commented on by the therapist, it does allow a more flexible flow of possibilities. There is also more opportunity for physical interaction from a simple sharing of materials or bumping into another member at the sink, to helping solve a technical problem or holding something in place. One is able to express and maintain individuality while still identifying and working with the group.

There is usually a sense of joint sharing through getting materials, sharing tools and clearing up, which establishes a sense of intimacy that comes from physical work together. One is aware of the opportunity for accidents. These happen on every level from the spilt paint that reminds someone of something in its own right, to the water 'accidentally' knocked over another member's work, and form part of the dynamics of the group.

Clients are more able to control how much they are active in an art therapy group and to which part they actively contribute. They can participate with a 'speaking' picture without actually speaking. They may actively help other members to explore their images while their own has no time for attention that week. They might move the group on at the beginning by contributing how they are feeling or some useful comment from the previous week.

Having two clearly different modes of communication makes the group dynamics very complex. If, for example, the group is avoiding an issue because they do not feel safe or strong enough to confront it, they could equally talk to avoid painting or paint to avoid talking. Of course each group will develop its own rhythm and flow and the therapist will learn to understand the changing pattern of confronting or avoiding issues and be aware of superficiality in either medium. One advantage of working with a concrete medium in a group is that everybody's work will have been seen, even if they do not speak. Where the paintings are brought into the circle for discussion there will be an immediate 'here and now' reaction to the painting receiving the focus of attention. Part of this will be an 'aesthetic' reaction. This is complex because an individual painting will be seen in a 'field' of other art objects, all influencing each other visually and each group member's perception of them. Each person in the group will be interacting not only

interpersonally but also interpictorially. Pictures may be attracting them or repelling them. They will also be projecting into them as well as into other group members. Anyone who has worked in a shared studio will know the special quality of painting with others. It is an experience that offers time alone while being in the presence of others. It powerfully relates and offers the opportunity for transferences to early relationships through sensations and memories of playing in the presence of an adult. During painting time the therapist will be having a reverie about the group members, about the art objects being made as they unfold before her, about individuals' painting processes and relation to materials. Some members may find it difficult 'to come out of the painting'. They may have experienced this individual time so intensely that they will feel 'lost' in the painting as they emerge from a state of being in touch with the unconscious into consciousness. Others will feel unable to enter the process and may sit with a blank piece of paper.

There is probably less chance of polarised roles in relation to each other becoming fixed in an art therapy group because of the stimulus of paintings and media available, unless there is some investment psychically in staying in a known role. For instance, one member's decision to work largely in blues and reds will have an unconscious effect around the studio. In this way members are influenced and creative opportunities occur quite subtly, although people may be consciously unaware of why they suddenly feel a release through using a different colour combination or new medium.

A group culture is established and develops in the way that the group can be open to explore the images in depth and allow both a personal and a group meaning to be felt. The group culture is based on the way that the images are formed and worked with and how this is facilitated by the therapist. The images develop both as an expression of and a concrete holding of the history of the group. Each image holds meaning for the past, present and future of each group member and the group as a whole. Meanings will gradually unravel within the matrix of the group process which the therapist will comment on in terms of the dynamics of the group and also how the images contain these dynamics.

Different approaches to working in art therapy groups

Art therapists may utilise several approaches with differing client groups over a working week; much will depend upon the context within which the therapist is working. In a series of papers, Gerry McNeilly has developed thinking about a style of working he has called 'group analytic art therapy' (McNeilly 1983, 1984, 1987, 1989, 1990, 2005). This way of working combines group analysis and art therapy. The works of Foulkes and Bion are central to his thesis: 'The approach is psychodynamic allowing for the totality of the group experience' (McNeilly 1987: 9).

He developed his approach through working within a psychotherapeutic community which functions on group analytic principles. The time for painting and discussion is roughly divided in half and no theme is given, no verbal interventions being made in the painting time. He allows the group to find its own direction and treat itself. It is a mutual learning process with communication being the most important factor. His aim is to aid neurotic symptoms to transform to shareable experience.

Basing his theory on Foulkes, McNeilly sees the task of the group to be 'analysis of the group by the group, including the conductor' (McNeilley 1984: 10). Working non-directively, he leaves the group to struggle with their dependency wishes. By refusing to take on responsibility for this, he therefore seeks a greater understanding by the group of the group process. When a group intervention is made it will be a 'group interpretation' as comments to individuals are seen to encourage dependency. The group is encouraged to use its own self-healing capacities as the conductor cannot be an individual therapist to each member. The conductor does not need to say anything that cannot be said by another group member.

McNeilly challenges the practice of providing a theme for the group; he argues that this is directly due to the therapist's own needs. By not allowing the group to feel anxiety, the therapist is seen as gentle, nurturing and caring and therefore defends against any group anger. The conductor's role is 'to nurture the group dynamics'.

As in all approaches to art therapy, the image-making is set within a relationship to the individual, group or institution or aspects of all three. In group analytic art therapy the image-making is given a particular role and, as McNeilly describes, the individual image is not explored: 'However I would concede that I do not chase the in-depth symbolic nature of the individual image and some pictures are not commented upon by me at all' (McNeilly 1987: 9), but 'with the applied use of art materials, the process will be illuminated, leading to understanding of the collective imagery' (McNeilly 1984: 10).

This particular style of working is most likely to be used with psychoneurotic patients in a therapeutic community, with outpatients, in staff groups and in art therapy training. Members of these groups need to have sufficient ego-strength to be able to articulate and show a capacity for insight. Other art therapists work from a group analytic base but explore the individual image in more depth. This in fact is more in keeping with Foulkes' original premise of the deep 'respect for individuality', although McNeilly rarely comments in this way.

Group analytic art therapy essentially allows feelings to emerge from the group by the group. In the 1980s there was much discussion of the rights and wrongs of different ways of working with a group and those favouring theme-centred groups became polarised as to which approach was potentially more raw or exposing (McNeilly 1983, 1984; Thornton 1985; Molloy 1988).

When looking at each counter-argument, the undesirability of a blanket

approach in art therapy for all client groups becomes clear. Thornton has developed his ideas which incorporate family and systems theory through work in short-term settings and crisis work, where the aim is to engage people directly on core issues. In this context, the internal dynamics of the group are not the key concern. As well as the influence of context on practice, there is the personal background of the therapist. Some therapists will have lived through the 'human potential movement' of the 1960s and their group practice may have been influenced by experience of 'encounter groups'. These encouraged a nurturing, positive transference, a being 'there' and warm for somebody, rather than a more existential exploration of oneself in a group. This movement has undoubtedly been influential in the development of thematic groups.

The different styles of working can enable groups to have very different experiences. For instance, analytic groups allow unconscious themes to emerge and thematic groups use a 'set theme', either supplied by the therapist or chosen by the group. Therapists may be more likely to paint in thematic groups but in an analytic group remain in a separate role as leader or conductor to allow natural transferences to develop. Both, however, could be said to work largely with 'group' or 'social' factors rather than individual art therapy which helps the client to develop a relationship with her 'inner life' within the relationship to the therapist.

In a thematic group the therapist is more likely to encourage a positive social culture. The given theme structures any natural level of chaos in the group as the provided focus channels the group energies into a directed exploration. The group relationship may be masked by a clear struggle to gain a favourable relationship with the leader, who will be seen as the person to fulfil individual needs. Working analytically may be experienced as being more uncomfortable as members struggle with their inhibitions, restrictions and ability to take risks in a group. In an analytic group, many natural transferences, between different members as well as the group leader, will occur, and the potential richness of this experience can be explored. McNeilly (1989) has drawn attention to the phenomenon in analytic groups of people painting similar or closely related images and symbols quite unconsciously. This synchronistic process or resonance allows focus 'on the universality in the group and its symbolic life'. Roberts suggests that resonance is the 'language of the dynamic silence, and once it is shaped, it pulls with it the unconscious' (1985: 11).

During this process each member responds to an incident or event in group life and becomes highly charged with energy. A theme emerges and evokes powerful responses in each member. This experience often evokes new material, a recovered memory, new insights. It differs from the consecutive expression of shared, previously unconscious material of a verbal group as the images express this simultaneously. This links to Foulkes' 'foundation matrix' – what members have in common, culturally and constitutionally –

and to Jung's collective unconscious. This means that the group unconscious emerges in the images made by the individuals in the group and therefore the unconscious provides the 'theme' of the group. Alternatively, the group consciousness is imposed, to which the group unconscious then relates.

All later writers on groups owe a debt to McNeilly for pioneering theoretical development. Greenwood and Layton (1987) describe work with a community-based art therapy group for those with mental health problems. They have a 'side by side' approach of painting in their groups to facilitate the sharing of experience and opportunities for development of self in relation to others. In a later paper (1991), they describe the use of humour within an outpatient group for psychotic clients. Skailes (1990), writing from a Jungian perspective, combines themes, story-telling and patients themes in groups both within the psychiatric hospital and in the community. Strand (1990) explores how group interaction may be facilitated between institutionalised patients who are learning-disabled.

Waller (1993) gives a thorough introduction to group interactive art therapy in a book which has a good practical as well as theoretical base. Her approach draws on interpersonal group psychotherapy (Sullivan 1953) and systems theory (Agazarian and Peters 1989) as well as group analysis and art therapy. There is attention given to what is happening in the 'here and now' as well as repressed material. The client is able to experiment with new behaviour in the group after learning about and understanding patterns of interaction that cause difficulty in relating to others. Waller has illustrated her thesis with many case examples and in some ways healed the rifts from previous debates about groups by writing about the use of themes in interactive groups.

Skaife and Huet (1998) have a useful discussion about theoretical issues in art psychotherapy groups, particularly the relationship between the making of art work and verbal interaction, as well as chapters by various authors on the application of art psychotherapy groups with different clients: highly disturbed patients on a forensic ward (Sarra 1998); chronically psychotic institutionalised patients (Saotome 1998); cognitively impaired elderly people (Byers 1998); and patients in a drug and alcohol dependency unit (Springham 1998). This book built on earlier work with women's groups in different settings (Huet 1997; Skaife 1997). Skaife explored the effect of transference in the group on a therapist's pregnancy and Huet looked at the issues raised by a younger therapist working with older women. Skaife (1990, 2001) has also written about her thoughts on 'self-determination' in groups and on 'intersubjectivity', influenced by the work of Merleau-Ponty.

Riley (2001) contributes several chapters on work with adults to the literature; issues that arise with the elderly; groups in psychiatric hospitals; women with eating disorders; and bereavement. Liebmann (2002) discusses cultural issues in work with elderly Asian clients. In the literature there are different chapters that discuss all aspects of training in art therapy from the

introductory group (Dudley *et al.* 1998) to the supportive therapy group for therapists under stress (Riley 2001).

Example of group work in art therapy

At the beginning of a group, the therapist will have arranged the correct number of seats in a circle and the clients enter to take up a place. Respecting the time boundaries is important and the group will start and finish exactly on time, regardless of whether everybody has arrived, and ends even if conversation has suddenly become animated, intimate or emotional. By keeping to the boundaries of time and space and consistent behaviour, the group will come to build up a trust in this symbolic space to explore feelings and anxieties and the developing relationships in the group.

Group session 6

It is a closed group meeting weekly in a day centre. The group lasts for two hours. Talk may vary from ten minutes to one hour at the beginning. It is formed of seven clients and a therapist, and is for women who have felt threatened by male figures in their lives or are divorced or separated. It is an optimum size so that everyone can make eye contact in the circle and the pictures or art objects made can be placed and contained in the middle of the space for reflection and exploration. The therapist normally sits in the same place and remains there throughout the session.

Mrs B arrived first and told the therapist she was feeling nervous and worried about what might come up in the group.

Miss C asked, across this, to the therapist: 'Are we going to paint alone or together?' She said it had felt good last week (when she had been able to share her fear of talking in a group).

The therapist suggested she was feeling good from being able to share difficulties of talking.

Miss D was drawn in to say that she felt nearly the same as Miss C, but she would never be able to talk about some things ever.

Mrs A asked Mrs B how she was feeling after last week.

Mrs B burst into tears. (Last week she had shared some family history and the suicide of a relative.)

Mrs A and Miss C put arms across to touch her.

Mrs B, between tears, said, 'If only I had done more' about a friend's recent suicide attempt and linking back to relative's successful attempt. She had lost work through relative's illness and suicide: 'one had to go on'. Sometimes she 'felt nothing' when people told her things, unhappy things.

General talk about anxiety of helping friends, relatives, how they relied on you, how could one 'get it right'.

Therapist suggested 'hard to get it right' in the group, how much to say, how much to keep private. Talk then developed around crying. Miss D said she only ever cried alone, she wouldn't be able to bring it here, men couldn't bear you to cry, her family couldn't bear it. She always solved things alone.

Miss E said how affected she had been by Mrs B last week; she too could only cry alone. She could cry most easily at sad films, but only if alone. She had to keep it in.

Therapist commented on how it did seem possible to cry here, it took up a lot of energy to keep things in.

Miss C echoed: 'It was never done at home.'

Mrs F, speaking for the first time, 'I solve things alone.'

Miss G said in a whisper that she could cry easily, but not speak. Mrs A: 'I always say too much, I get nervous, it's hard not to talk.' Therapist made a general comment on the amount of pain and sadness, and suggested painting; as a distance seemed to be emerging from feeling.

The first part of the group is quite a free-floating discussion. Mrs B's disclosure last week has moved the group on so that a new depth of sharing has become possible, but this is also quite scary. Mrs B is feeling guilty at 'taking up time' at the beginning, worried that people will resent her 'talking' last week. Miss C is relieved that one can talk intimately but would half like to hide in a group painting.

Discussion on 'what it was right' to do contains fears of contamination by mental illness and an exploration of defences, 'feeling nothing', 'losing one-self in work', how to keep a boundary around oneself, outside the group, but also of course in the group, being affected by other members. In the discussion on crying is the shame of breaking down, a lot of loneliness revealed and 'holding things in'. The difference between 'family culture' – 'never done at home' – and the forming of the group culture where it is all right to cry and to share feelings is being established.

Art therapists will have different styles of working while people are painting. Some therapists argue the virtue of painting as a 'working' model for clients. The therapist will then also talk about her painting and this will help to create intimacy and trust in the group. This approach is more likely to be seen at work in a 'thematic' group, which will be discussed later. Generally, it might be thought to negate the difference between the role and function of therapist and client. However, if the therapist is working analytically, explor-ing differences which may be perceived both positively and negatively will be part of the work of the group. The therapist's stance will be central to the exploration of parental figures and authority in general as transference

relationships develop. So there is little point in trying to negate 'difference' if this exploration is seen as part of the task of the group.

An argument against painting in the group is that this cannot be done honestly at any level of depth without the clients 'going out of mind'. It is possible to paint in one's own style in a superficial way but this is hardly a good model for the group. However, some therapists use the art materials as their way of getting in touch with unconscious processes at work in the group and clarifying what is going on in the counter-transference response. The art therapist is likely to have a mature developed style of work, to be a competent artist which may equally provoke feelings of admiration, envy and despair in clients.

If the therapist is working analytically with transference phenomena both interpersonally and through the pictures, then her difference of role and function will be a crucial factor. The therapist will need to be free to observe clients' working processes, both the history and development of each art object and also the state of body tension and general atmosphere in the group. Clients will also place themselves in the room in relation to the therapist and to each other and this, over a period of time, will develop a slow-changing pattern. Group members might establish 'their' area or group according to events in the group. A client choosing to work almost under the therapist's feet or behind her will carry essential information about transference phenomena. They may quite unconsciously be painting 'by her skirts' for safety because the picture will make a breakthrough to previously undisclosed material.

Group

During the individual painting time, two of the members painted on the floor, and one gradually spread out around the therapist's feet. She had commented several times on a strong silent mother and during this period of the group, when a quiet working silence ensued, the therapist became centrally part of the quiet; sitting, observing, which gave this member an unconscious playful air. The transference was not ready to be acknowledged, however, as at this time she kept up a continual line of 'solving things alone'. Only two of the seven paintings were discussed this session although all carried individual contributions to the group themes that emerged of 'finding a balance' and of 'boundaries'. Three of the pictures were clearly about making a boundary between self and a sense of inner chaos which threatened to overwhelm and had clearly defined boundaries between self and the outside world. The energy needed to keep in the sensed chaos effectively formed a barrier with the outside world. An aspect of 'solving things alone' was these powerful boundaries which gave the members an outward feel of fierce independence.

There were two images of spinning and whirling. It was one of these pictures that was discussed for some time, returning to the theme in the first part of the group on how to support other 'ill' people. Feelings of guilt if one withdrew through lack of strength to be supportive, 'putting oneself first'. Mrs B's self-disclosure last week had thrown the group back on themselves in how were they able to deal with another member's distress, how they retained defence of their own pain while helping another. They had begun by looking to the therapist. Part of the 'I solve things alone' was a defence against longing for a one-to-one relationship. In a group this cannot be provided by the therapist. The group has to work with each other, pooling their abilities to find solutions.

This was reflected in one member's use of materials. She had painted a growing plant, but had been able to take more paper to give it more room, so that it bulged to the sides of the economical choice of original size of the picture. There is often an analogy between therapist's materials and food, another dynamic of family and group juxtaposed together in the group's mind. If the therapist is the provider of meals, 'is there enough to go round?', 'can one ask for more?', 'be greedy?'. The first undercurrents of transferred sibling rivalry may be expressed in this way.

In this session the first painting discussed concentrated on the boundaries between self and other, but all in terms of relationships in the past or outside the group. There was a lack of willingness to hear from the therapist that relationships inside the group could be causing these feelings of spinning and whirling, and guilt at not being able to do more. The second painting discussed centred on 'finding a balance' internally and was exploring the border between sanity and madness. It was an unusual picture in atmosphere, a mystical feel of light, blue, yellow and white, ill-defined shapes but also a partially obscured tangle of chaos. The picture brought forth many comments from other members about its semi-mystical religious qualities. The member who had painted it described a very painful situation at work in a competitive commercial environment and suddenly 'feeling nothing' one day as if she didn't exist. This loss of conscious attention of ego would have been acceptable as part of a religious occasion but not in a busy commercial venture and through fear of it happening again she had left. Her illness had a positive side in expressing the dis-ease she had always felt in working in commodities and how she felt life might begin again working with people.

The juxtaposition of light and tangle of chaos and the degree of interest expressed by group members perhaps indicated that it represented some feelings for the group as a whole – a relief at seeing the light ahead but also a wish to escape from the stressful feelings spinning around the group. The group

member's description of when she felt nothing was not a mystical joy but more a 'blanking out' under stress, a defence mechanism so as not to feel any more. The interest of the group showed them able to listen to the pain expressed, which suggested their wish as a group to find 'new values', but there could also be a wish to blank out the painful feelings in the group.

The placing of art objects in the middle of the circle ackowledges their central importance, gives them value and shows that they are owned by and are part of the group. Placing in the boundary of chairs also gives room for paintings to be left outside in some way, sometimes to communicate a need for attention (to be drawn in), or because it is felt they are unacceptable images to the group or feel too secretive, individual or personal to be shown. They may feel 'too large' for the group in the sense that the feelings might not be contained in the group.

Example of a theme-centred group

Thematic groups offer a specific issue, theme or direction to the group which will either be suggested by the therapist or arise out of an initial group discussion. Therapists working with this format argue that it is 'enabling', offering a starting point to those clients new to therapy or overcome with anxiety. They can be seen to give a safe structure, providing a leader in an authoritative or parental role or one actively including all in general decision-making rather than a conductor taking a more outwardly passive role as in an analytic group. A second argument used in their favour is that the art thera-pist can give suitable themes to allow people to understand the creative process in a fairly controlled way, so that they can 'see things happen' in a guided session. Themes can 'weld' a group together by their experiencing something in common. People can work intensely, and others more superficially, within the same group but can feel part of the same process. Themed groups are particularly suitable for short-stay clients who need to explore specific issues and for those not able to benefit from working with the anxiety that attends an analytically-oriented group.

The influence from encounter groups can be seen in the basic format of thematic groups, which are usually divided into three parts. They tend to begin with a 'warm-up' activity to facilitate a 'readiness' to explore or to promote group cohesion and direction: 'Sometimes a session would begin with "centring" or relaxation exercises, meditation or yoga (like looking into water – one can see into the depths and what lies below more clearly when the surface is calm). Sometimes we would begin with techniques designed to heighten sensory awareness and help energy to flow' (Nowell Hall 1987: 159).

The exercises used vary from quick paintings to physical activity, dance, movement, music, massage – a whole variety of possibilities, many of which involve putting people more in touch with body sensations and awareness of tension.

The group will then separate to paint to the chosen theme; the therapist may join in, or may talk to individuals or sit observing the work in progress using her impressions for the last part of the group session, which will be a discussion of the images. There tends to be a more didactic role played by the therapist as the discussion is more likely to be 'led' by her. There is less likely to be a full exchange between members in a short-term group as this will take time to develop and also the structure of the group with the leader directing more overtly will encourage a positive transference and 'knowledge' to be seen to be held by her. This can be a safe experience for those who are insecure or very anxious. The leader will structure the use of time to include all pictures. It is more likely that the pictures will be given an 'equal' consideration in a thematic group rather than it being the responsibility of the group to discuss whatever they choose to focus on.

Thematic groups have as much a 'social' function in helping people to contact each other in the 'here and now' as they do working with deeper levels of disturbance from specific client groups. They are more likely to be used in day and community centres or for general social purposes and widening of experience of those in longer-term care. The use of thematic groups can be deceptive because of the 'game and exercises' component which looks superficial but can plunge people into unexpected levels of intensity, but as Liebmann comments, 'there is a wide variety of group experiences using art structures which can be interesting and revealing and also enjoyable' (Liebmann 1986: 12).

The following illustrations are from a group run in a social services psychiatric day centre. The whole programme was run on therapeutic community lines. Members attended on a 'contract' basis which included an expectation that they would participate in all the therapeutic activities and maintain a regular commitment to the group. The group structure contributed to the whole ethos of self-help, cooperation and sharing between members of the community. All members attended the group, held once a week. Each session lasted two hours – the first was used for painting and the second for discussion. The theme was chosen by the staff team as a way of capturing or focusing on particular dynamics that were important. Anger, what makes you feel sad, how you would like to be, your ideal partner and a bad dream were some of the themes used. If a client suggested a theme, it would perhaps be taken up, but generally the staff, who all attended the group and fully participated in it, would put forward the theme at the beginning.

The members, who were of different ages with a wide variety and severity of problems, would all be seated at tables on which painting materials were readily available. If any new members or students were present they would be introduced to the rest of the group and told about the format of the group. There was an expectation that people would show their work if they felt they wanted to, but they were under no obligation to do so. Generally, during the painting time, silence fell, which seemed to be acceptable to all, and then at

the agreed time the painting would end, and the art therapist would ask members of the group to share their work. The therapist remained sensitive to the needs of the individual to take the appropriate amount of time in talking about the work and answering questions and comments from the rest of the group. The therapist would direct the group and take overall control of how the group was going, would comment on the contributions that were being made and connect certain images and emergent themes from the group discussion. The group would end on time, even if some people had not shown their work, as it was made clear that everyone had an equal opportunity for this and it was their choice to show it or not. The similarities and differences between the images form the focus of the discussion and, more importantly, what each member sees in her own and others' images that resonates with her own experience. Members therefore project onto others certain aspects of themselves, and this is one of the most useful functions of this type of group.

This particular group theme was 'Draw yourself as a tree'. This was chosen because several new members were joining the centre and were new to the group, and it was felt that this theme was relatively simple to understand and relate to in a personal way. The images speak for themselves in terms of how each individual described herself symbolically and further exploration was done to each individual piece. It is interesting to see how the different characteristics are clearly shown in the pictures. This way of working is helpful to enable people with identity problems to conceptualise themselves and come to understand a sense of self in these concrete but also abstract ways. Short comments are given to describe each picture, as a detailed process of the group would take too long to transcribe (see Figure 10.2).

Figure 10.2 (a): 45-year-old woman – rather confused and unable to articulate her feelings to any real depth. She was able to say that the three 'bits' at the top were new growth. (She had been a long-term patient, recently settled in the community.) Another woman asked if this was in any way hope for the future, and she nodded. She was asked about the small 'tree' on the left – she laughed and said it looks like a 'shadow'.

Figure 10.2 (b): Not discussed. (Man now living in the community after a long hospital admission.)

Figure 10.2 (c): 60-year-old woman, withdrawn and physically thin, lonely and silent. She was able to connect her picture with her feelings about 'being apart' from other people as if lost in a dark forest, but not knowing how to get out. Someone commented how it looked difficult to get in.

Figure 10.2 (d): 19-year-old. 'I couldn't draw a tree – wanted to do a pattern – I don't know what that says about me – I wanted to do pink behind to show the complex web of tangles in my life – leading nowhere.' (She had been in care, involved in petty crime and drug abuse.)

Figure 10.2 (e): 'A Christmas tree – the only tree I could draw but reminds

me of the good times with my family. I miss them and wish they would visit me, but I know they won't.' 'What about the decorations?' 'The star is bright and perhaps it will beckon them to come – I hope so – I hadn't thought of it like that but I know that's what I want.' (50-year-old man, living alone after chronic alcohol problem.)

Figure 10.2 (f): 'It's full – strong – how I feel now – blossom and spring – it's optimistic and filling the page. I am really looking forward to my new job.' (39-year-old secretary.)

Figure 10.2 (g): 'It's a pear tree – I don't know why I drew it like this – it's my face in the middle – smiling but I don't feel at all happy – in fact I feel miserable – it's like a mask – I feel I have to pretend to be happy with my family otherwise they will reject me completely and it's such a strain. I feel trapped behind the mask – I suppose they could be tears coming out from behind the face.' (25-year-old, young mother and housewife.)

Figure 10.2 (h): The group spent the longest time discussing this image as the woman who painted it told a long and involved story from her childhood. This is her climbing the tree, with her dog whom she adored. They were happy memories but she was lonely and felt as though she did not know what was happening in her life now. Staying with her, the group dwelt on the image, feeling that it contained great significance for her. There were a lot of questions about the tree: where it was, the branches, leaves and the dead spike coming off the trunk. She became tearful as she began to talk about the loss of her beloved brother, who used to climb with her and she had never been able to look at that loss and certainly not share it with anyone before. The group ended with this sense of sadness and loss that had been acknowledged.

Several collections of themes and exercises are available, among these are Liebmann (2004) offering practical advice on groups and many themes, particularly for adults. The paper is well illustrated by case material with different clients in many settings. Makin (2000) has a more arts therapy approach and Ross (1997) focuses particularly on children.

Other recent developments in working with groups include the art therapist's role in working in multi-family groups, a technique that involves working with a number of whole families together in a large group (Asen et al 2001; Dalley forthcoming). The art therapist works alongside other colleagues in the multi-disciplinary team and offers the possibility of creative activity and expression in the group. Another initiative is working with a whole class in a primary school setting which again lends itself to theories underlying large group dynamics (Reddick forthcoming).

Transferences and projective processes

References have been made to a number of interpersonal and intrapsychic processes during the chapter while discussing different aspects of group

a

c

b

d

e

g

f

h

Figure 10.2 (a)–(h) 'Draw yourself as a tree'

experience. In this section we shall outline the general understanding behind the terms used. It is complex to describe such processes because they take place simultaneously in the group. It may be easier to understand the nature of the processes by picturing them as happening on different levels. The first level is that of the current relationships, based in reality, at a conscious level. This reflects the social and cultural aspects as well as political and economic aspects of the members and the wider social content in which they are living. This level of relationships affects all interactions in the group but may be particularly resonant at the beginning of the group or when a new member joins a slow-changing group.

An example of this phenomenon can be seen in a group of children of mixed race in a multi-cultural school. The group had been depleted to two boy members, Paul, of African origin, and Imran from Pakistan, due to the girl members coincidentally leaving the area. A new girl member, Cathy, of West Indian origin, joined the group. During her first session when all the children were working in clay, Paul began a long anti-Indian talk directed at Imran. He attempted to pair with Cathy saying they were both from 'Africa' and despite Imran's protest that he was not Indian, and Cathy indignantly saying that she was British, this confused situation continued. Throughout the long exchanges, all the children continued to make their clay objects. The group leader made the comment that in spite of different backgrounds, everyone was a member of this group. The tension immediately eased and the group was able to accept that it sometimes made it easier to feel you were a member of a group by excluding someone else, as a new member made it feel as if there was not enough room in the group. In exploring each other's backgrounds, the boys discovered that they were both Muslim. This was not the end of an exploration of similarities and differences at a reality level as it needed to be addressed many times in different forms throughout the group.

While this exchange was happening, Imran was making a figure of a man in clay. As the argument progressed, the figure was gradually 'dressed' in a national costume, with spear, scimitar and shield, becoming a warrior, laid flat on the surface, not free standing (see Figure 10.3). This seemed to symbolise the forces at work in the group. It shows the taking on of national identity in defence but also the flattened feel of being used as a scapegoat for projections from the other boy. It held the ambiguity of being affirming in identity and also the difficulty of being in a racial minority in this particular institution.

The second level of interactions is concerned with transferences between therapist and members and between members themselves. Transference relationships can be understood in terms of feelings and wishes once experienced in relation to significant figures in the past. As we have seen, the placing of oneself in relation to the therapist in an art therapy room may reflect a transference to the therapist in relation to previous modes of relating to a parent and/or authority. For example, in an adult group, three women chose to work behind some partitions in a studio, forming a subgroup through their

Figure 10.3 Imran's clay soldier.

choice of work space. Their pictures remained hidden from the rest of the group and the therapist during the period of painting. Over the weeks it gradually became disclosed that all three were working on aspects of abuse as children. This was not known to the therapist or between themselves but they had unconsciously come together to work. The sharing of their different experiences enabled the complex issues to be explored. For all three the working 'together' reflected aspects of relationship to sisters, having secrets between them, and to the therapist as mother – did she know what was going on 'behind a screen'? The rest of the group reflected different aspects of 'maleness' and 'the public' in 'what they would think about this secret'. The transference will also be implicit or explicit in the images. For instance, in this case will mother/therapist recognise the 'signs' of abuse in the picture? The child tries to tell the mother by presenting self or tries to hide it in the picture encoded in a disguise. Just as the child may have desperately wanted the mother to know, the adult may desperately

want the therapist to know from an abstract picture. In thinking about transferences, the transference to the institution should not be forgotten and the way it is experienced in relation to past issues and incidents in other institutions.

The third level of interactions is concerned with intrapsychic processes where other members in the group, including the therapist, come to reflect unconscious elements of any one person. This is to do with the internal world of the individual and how internal objects are projected onto external members of the group. In individual psychoanalysis these processes have individual names as separate concepts such as projection, introjection and identification. In a group these processes naturally occur rather differently so are sometimes given the collective term of mirroring or the mirror reaction (Foulkes 1964). Mirroring can be seen as having a developmental aspect in that it originally occurs in every infant's experience as a way of learning from others and understanding the environment. It also has a therapeutic aspect in the way in which people recognise parts of themselves by first recognising them in others. It often takes hard work to analyse projective and introjective processes in a group before these recognitions can be made and understood.

All projective mechanisms are mechanisms of defence, to protect the ego from overwhelming anxiety. Part of the projective process is splitting. In this situation different parts of one person's inner experience can be experienced simultaneously but projected onto different people. When a person feels two perhaps very different emotions, to split in this way can be a defence against the anxiety. For instance, in the first group of children discussed, Louis and Dean were able to play out control of instinct versus aggressive instinct in the separate roles of Tarzan and crocodile, each child accepted the other's part and it was played out with no apparent outcome because it was battling equally inside them, but they were able to explore the two sides in the play. The projection has to 'fit'. In a projection; there is usually some characteristic of the person that 'hooks' that particular aspect. Projection between Louis and Dean happened at an accepted amicable level, which was workable until one person develops and wishes to change their role in a group.

In the second group of children discussed, Abdul was more disturbed than the other children. His feelings were frequently split off and denied, and perceived by him as being located in another. Intense anxiety did not enable him to locate in himself frustration, feelings of worthlessness and anger towards his mother, whom he also loved. These were constantly projected onto other children, via aggressive acts and taunts.

In this group we can also see another process at work, of identification. For instance, Susie drew a fish and Jane, admiring it, asked her to draw her one too. She was trying to emulate Susie's qualities but, in the process of painting the fish that Susie drew, transformed it into a very different fish with sharp teeth and spots. The fish combines the ambivalent feelings as she may wish to emulate Susie's qualities, but also envies them and wish to spoil them.

Graham also admires Susie's qualities and paints a fish. Susie has a real and deep investment in the work of the group and this is felt by the other children.

These projective processes are very powerful as they can lead to someone being allotted a role in a group that they outgrow. If the projection, however, stays on them they can lose their 'freedom' to develop. This is perhaps most powerfully seen in the mechanism of projective identification which is the transforming of unwanted mental contents onto another by projection. The other person identifies with the 'unwanted content' and begins to behave in that way. It can be seen to be both an intrapsychic mechanism and an interpersonal transaction.

An example of 'unwanted mental contents' being transferred onto the group leader can be seen in Chapter 8 in the section on recording (page 202). Here the therapist had been feeling 'ineffectual' and 'no good'. Hassan made a figure from the pieces of 'rubbish' and 'left overs' from Imran's clay work, saying to the therapist 'It's you'. The difficult nature of working with these powerful group processes can leave the group leader very vulnerable, which is why supervision and monitoring of counter-transference responses is so necessary. Hassan had been projecting these feelings to the group leader for some weeks but it had been hard to see it clearly among the other exchanges and activities in the group. Its sudden embodiment in an image, given with amusement to the therapist as a 'gift', crystallised a whole series of previous interactions so that these 'worthless feelings' could be talked about with Hassan and he could be helped to own them.

The fourth level is sometimes called the primordial level or foundation matrix (Foulkes), which roughly corresponds to Jung's collective unconscious. The phenomenon of resonance has been discussed when members in a group paint a similar theme apparently coincidentally. This is sometimes an unconscious response to an incident in the group's life and really shows the universality of human experience at a deeper level. This can also occur in the therapist, as the following example illustrates.

The group leader heard that a relative had died and her feelings of loss were compounded on learning that there would be no funeral because the relative had left her body to medical research. The group began to talk about 'children leaving home', talking of losing their old rooms; that there was no longer room for them. However, as the group began to speak about their images, each one contained different aspects of funerals with different religious and cultural backgrounds being displayed. Deaths of young people and old people were discussed and the rituals surrounding the loss.

A connection could be made with the earlier discussion as, for the loss or death of a person, a funeral exists in whatever cultural form, but there is no ritual for the loss of childhood, the loss of one's continued symbolic space at home, one's childhood bedroom. Beneath these interactions lay a common or collective mourning for loss of childhood and the lack of ritual to express these feelings which linked unconsciously to the therapist's feelings of the

lack of opportunity to mourn the relative at a funeral. Various group members had been unable to negotiate the developmental move from family home to independence successfully and had broken down and been hospitalised for short periods of time. The complexity of the different levels discussed is vast and are all seen to be taking place simultaneously.

Practical issues for group work

In whatever form the art therapy group might take, the art therapist is faced with some practical decisions which are informed by theoretical orientation. For example, the selection of members for each type of group. After a referral is made the art therapist will conduct an assessment for the groups in the same way as individual work. The assessment is based on various factors, in particular, whether group therapy is the most appropriate treatment of choice. This may need more than one meeting as the client may be considering joining a new group that is being established or an existing group that is already running.

In most groups there needs to be a capacity to form and sustain relationships, although this may not be needed in an open group which works less tangibly with group processes. For analytic art therapy groups there needs to be sufficient ego-strength to evaluate internal and external reality and to form a working alliance, and yet also contact the disturbed and helpless parts of the person. Members need to be able to function between sessions. For this reason, clients with psychotic disorders, severe depression, schizophrenic breakdown, repeated hospital admissions, severe learning difficulties, severe psychopathy and hyperactive children are contra-indicated, although, as seen in the literature, there has been pioneering work in many of these client groups.

Developmental crises, neurotic and character problems can be treated very well in a number of different group styles. Art therapists might either run outpatient groups or groups on wards with one type of disorder, problem or crisis, such as eating disorders, alcoholism, drug-related difficulties, bereavement and some adolescent problems. Group therapy is very useful for people with problems in relating because of the possibilities for interpersonal learning. It may be a useful mode of treatment for those who feel life is meaningless, who have general dissatisfaction with relationships and those inhibited or anxious. Many clients have problems with intimacy, either remaining aloof, cold and preoccupied with self or with unrealistic demands for instant intimacy which cannot be satisfied and may lead to their premature leaving. Other problems of relating in a group may therefore be of emotional contagion or being overwhelmed by images of other clients, although if this can be contained in the group the client's sensitivity and openness to the images may be a very positive factor for all members. Clients who cannot share the therapist or who have difficulty in tolerating other

members in a group, or whose needs are very great, might be better off in individual therapy. The client's needs must be taken into consideration when choosing the right type of group. A client may need a supportive group to express feeling and to receive positive encouragement. She may benefit from airing her problems with people available to listen and understand. An open studio setting or a thematic group will allow both a growing awareness of the complexity of working with images and an individual exploration to different depths. Clients gain a sense of mutual encouragement, a sense of belonging and a growing awareness and interaction with other members. They may begin to see how they contribute to difficulties. Such groups may be open groups with a short-stay, regularly altering membership.

Other groups, which will be closed, will work actively with the relationship between therapist and group members. These groups will work with awareness of past life, how childhood experiences affect the present, and transference material within the images and interpersonally will be recognised and commented on. Some less dynamically oriented groups may work with a positive transference to reinforce a working alliance. Here, the work with the client will be going mainly into the exploration of the image, and the relationship with the therapist is less fully explored. In an analytic group, however, there is greater emphasis on the client's responsibility to face herself and the interpersonal relationships with members, including the therapist. The client will be able to work with the whole group and its images to explore different aspects of relationships, intrapsychically and interpersonally.

The size of a group depends on the group style and the membership. For instance, an analytic group traditionally comprises six to eight members to allow verbal and visual contact and the containment of the images made within the circle. This allows a suitable dynamic to foster group cohesiveness and gives the opportunity and time for all to be involved in the discussion. However, if one was working with clients with severe physical disabilites, the numbers should be much smaller, with other staff present to aid the therapist in basic preparation of materials. Other clients might need assistance from the ward to the art therapy room, and the nursing staff may stay for the duration of the group. Other groups may have a co-leader, either another art therapist or a colleague from a different discipline. Open studio groups may be as large as 12 members – a combination of clients and staff.

We have discussed the art therapy room (Chapter 2) in some depth and mention was made of areas for group work. All arrangements in a room are dictated by theoretical bias as well as the physical constraints of the room available. It may be useful to have a separate painting and discussion area, or members may paint and discuss around large tables. The room may need to be large enough to allow all members to sit in a circle containing the images made. It may be important that individual spaces are available for people to be 'private' in their working area, or that the therapist has a clear view to observe all the clients working. Access to the sink and materials is always

important and it is essential that the room is neither a thoroughfare nor overlooked by glass partitions, otherwise the sense of containment and symbolic space will be lost. It is better if there is only one entrance and quiet can be maintained, as noise is very intrusive. The floor covering should be washable. Unless the floor can be dripped on or splashed upon, there will be no sense in letting the medium 'take one over' and no true interaction will be possible. It is helpful to have space for work to dry afterwards, near the storage of clients' work, so that very wet paintings can be left undisturbed as they dry.

The duration of the group and the timing of different activities within this period will depend on group style. An open-based studio group may last all morning and in a sense be 'all painting time', with the therapist circulating gradually to talk to members. Analytic and thematic groups will vary from one and a half to two and a half hours in duration. There will either be a structure suggested by the therapist for a certain length of time for painting and talking or this might be left entirely to the group to decide and negotiate, and the therapist might comment on the process of doing this. For example, there might be complete avoidance of using any time for image-making in the group, or the group may decide to paint immediately and use the majority of time in their private work without coming together to discuss it. The art therapist's task is to point this out and make the group aware of these dynamics and think about why they might be happening.

The therapist's task is also to set up and maintain the symbolic space for the group. The group leader will explain time boundaries, and the breaking of these boundaries becomes material to be worked with during the course of therapy. Other boundaries include those of confidentiality so that anything that belongs to the group is kept within it and not discussed outside.

Adolescent groups may particularly challenge the boundaries but all groups will have a member who takes on this type of role. The exploration of the symbolic meaning of breaking a particular role will be useful for the whole group, as the group will have feelings about it and this is a way of treating the symbolic space for all members. By testing the limits of the group, they can be found to be firm and reliable and safety can be felt to be established. Limits also include interference with individuals and property and disruptive behaviour may lead to exclusion. All group members need to feel secure from physical harm, and limits must be set by the therapist for the group as a whole. Mess, graffiti and destruction of consumables may all be tolerated, but again the extent of limits must be made clear before there is an overwhelming sense of chaos and lack of control. Some rules might also be set concerning clearing up and protecting the space in the room for the next group.

We hope that this chapter will have given an introduction to group work but also a sense of its complexity and the need for further training in group work for therapists intending to specialise in this mode of working.

References

Adamson, E. (1984) *Art as Healing*. London: Coventure.

Adler, A. (1929) *The Practice and Theory of Individual Psychology*. London: Routledge & Kegan Paul.

Agazarian, Y. and Peters, R. (1989) *The Visible and Invisible Group: Two Perspectives on Group Psychotherapy and Group Process*. London: Tavistock/Routledge.

Aldridge, F. and Hastilow, S. (2001) Is it safe to keep a secret? A sibling group in art therapy, in J. Murphy (ed.) *Art Therapy with Young Survivors of Sexual Abuse: Lost for Words*. London: Routledge.

Asen, E., Dawson, N. and McHugh, B. (2001) *Multiple Family Therapy: the Marlborough model and its wider implications*. London: Karnac.

Bion, W.R. (1961) *Experiences in Groups*. London: Tavistock.

Bissonnet, J. (1998) Group work with adolescent boys in a social services setting, in D. Sandle (ed.) *Development and Diversity: New Applications in Art Therapy*. London: Free Association Books.

Boronska, T. (2000) Art therapy with two sibling groups using an attachment framework, *Inscape*, 5(1): 2–10.

Brown, A.M. and Latimir, M. (2001) Between images and thoughts: an art psychotherapy group for sexually abused adolescent girls, in J. Murphy (ed.) *Art Therapy with Young Survivors of Sexual Abuse: Lost for Words*. London: Routledge.

Brown, D. and Pedder, J. (1979) *Introduction to Psychotherapy*. London: Tavistock.

Buckland, R. and Murphy, J. (2001) Jumping over it: group art therapy with young girls, in J. Murphy (ed.) *Art Therapy with Young Survivors of Sexual Abuse: Lost for Words*. London: Routledge.

Byers, A. (1998) Candles slowly burning, in S. Skaife and V. Huet (eds) *Art Psychotherapy Groups: Between Pictures and Words*. London: Routledge.

Dalley, T. (1993) Art psychotherapy groups for children, in K. Dwivedi (ed.) *Groupwork for Children and Adolescents*. London: Jessica Kingsley.

Dalley, T. (forthcoming) Multi family groups with young people with anorexia, in C. Case and T. Dalley (eds) *Art Therapy with Children: Through Development*. London: Routledge.

Deco, S. (1998) Return to the open studio group: art therapy groups in acute psychiatry, in S. Skaife and V. Huet (eds) *Art Psychotherapy Groups*. London: Routledge.

Dudley, J. *et al.* (1998) Learning from experience in introductory art therapy groups, in S. Skaife and V. Huet (eds) *Art Psychotherapy Groups*. London: Routledge.

Ezriel, H. (1950) A psycho-analytic approach to group treatment, *British Journal of Medical Psychology*, XXIII: 59–74.

Ezriel, H. (1952) Notes on psycho-analysis group therapy: II: interpretations and research, *Psychiatry*, XV: 119–26.

Foulkes, S.H. (1964) *Therapeutic Group Analysis*. London: Allen & Unwin.

Foulkes, S.H. and Anthony, E.J. (1973) *Group Psychotherapy*. Harmondsworth: Penguin.

Freud, S. (1921) Group psychology and the analysis of the ego, in *Standard Edition*, XXIII. London: Hogarth Press.

Gill, D. (2005) Studio upstairs: mission statement, Bristol: Studio Upstairs.

Greenwood, H. and Layton, G. (1987) An outpatient art therapy group, *Inscape*, summer: 12–19.

Greenwood, H. and Layton, G. (1991) Taking the piss, *Inscape*, winter: 7–14.

Henley, D. (1998) Art therapy in a socialization program for children with attention deficit hyperactivity disorder, *American Journal of Art Therapy*, 37: 2–12.

Huet, V. (1997) Ageing another tyranny: art therapy with older women, in S. Hogan (ed.) *Feminist Approaches to Art Therapy*. London: Routledge.

Hyland Moon, C. (2004) *Studio Art Therapy: Cultivating the Artist Identity in the Art Therapist*. London: Jessica Kingsley.

Lewin, K., Lippitt, R. and White, R.K. (1939) Patterns of aggressive behaviour in experimentally created social climates, *Journal of Social Psychology*, X: 271–99.

Liebmann, M. (1986) *Art Therapy for Groups*. London: Jessica Kingsley.

Liebmann, M. (2002) Working with elderly Asian clients, *Inscape*, 7(2): 72–80.

Luzatto, P. (1997) Short-term art therapy on the acute psychiatric ward: the open session as a psychodynamic development of the studio-based approach, *Inscape*, 2(1): 2–10.

Lyddiatt, E.M. (1971) *Spontaneous Painting and Modelling*. London: Constable.

Makin, S. (2000) *Therapeutic Art Directives and Resources: Activities and Initiatives for Individuals and Groups*. London: Jessica Kingsley.

Main, T.F. (1946) The hospital as a theràpeutic institution, *Bulletin of the Meninger Clinic*, X: 66–70.

McNeilly, G. (1983) Directive and non-directive approaches in art therapy, *The Arts in Psychotherapy*, 10: 211–19.

McNeilly, G. (1984) Directive and non-directive approaches in art therapy, *Inscape*, December: 7–12.

McNeilly, G. (1987) Further contributions to group analytic art therapy, *Inscape*, summer: 8–11.

McNeilly, G. (1989) Group analytic art groups, in A. Gilroy and T. Dalley (eds) *Pictures at an Exhibition*. London: Tavistock/Routledge.

McNeilly, G. (1990) Group analysis and art therapy: a personal perspective, *Group Analysis*, 23: 215–24.

McNeilly, G. (2005) *Group Analytic Art Therapy*. London: Jessica Kingsley.

Molloy, T. (1984) Art therapy and psychiatric rehabilitation: harmonious partnership or philosophical collision? *Inscape*, summer: 2–11.

Molloy, T. (1988) Letter to *Inscape*.

Moreno, J.C. (1948) *Psychodrama*. New York: Beacon.

Murphy, J. (1998) Art therapy with sexually abused children and young people, *Inscape*, 3(1): 10–16.

Murphy, J. (2001) *Art Therapy with Young Survivors of Sexual Abuse: Lost for Words*. London: Routledge.

Murphy, J. *et al.* (2004) An art therapy group for impulsive children, *Inscape*, 9(2): 59–68.

Noble, J. (2001) Art as an instrument for creating social reciprocity: social skills group for children with autism, in S. Riley (ed.) *Group Process Made Visible: Group Art Therapy*. London: Brunner-Routledge.

Nowell Hall, P. (1987) Art therapy: a way of healing the split, in T. Dalley *et al.*, *Images of Art Therapy*. London: Tavistock.

Prokofiev, F. (1998) Adapting the art therapy group for children, in S. Skaife and V. Huet (eds) *Art Psychotherapy Groups*. London: Routledge.

Reddick, D. (forthcoming) Art based narrative: working in the whole class in a

primary school, in C. Case and T. Dalley (eds) *Art Therapy with Children: Through Development*. London: Routledge.

Riley, S. (1999) *Contemporary Art Therapy with Adolescents*. London: Jessica Kingsley.

Riley, S. (2001) *Group Process Made Visible: Group Art Therapy*. London: Brunner-Routledge.

Roberts, J.P. (1985) *Resonance in art groups, Inscape*, 1: 17–20.

Ross, C. (1997) *Something to Draw On: Activities and Interventions Using an Art Therapy Approach*. London: Jessica Kingsley.

Rozum, A.L. (2001) Integrating the language of art into a creative cognitive-behavioural program with behaviour-disordered children, in S. Riley (ed.) *Group Process Made Visible: Group Art Therapy*. London: Brunner-Routledge.

Safran, D.S. (2002) *Art Therapy and AD/HD: Diagnostic and Therapeutic Approaches*. London: Jessica Kingsley.

Saotome, J. (1998) Long stay art therapy groups, in S. Skaife and V. Huet (eds) *Art Psychotherapy Groups: Between Pictures and Words*. London: Routledge.

Sarra, N. (1998) Connection and disconnection in the art therapy group: working with forensic patients in acute states on a locked ward, in S. Skaife and V. Huet (eds) *Art Psychotherapy Groups: Between Pictures and Words*. London: Routledge.

Schilder, P. (1939) Results and problems of group psychotherapy in severe neurosis, *Mental Hygiene*, XXIII: 87–98.

Shaffer, J.B.P. and Galinsky, M.D. (1974) *Models of Group Therapy and Sensitivity Training*. New Jersey: Prentice-Hall.

Skaife, S. (1990) Self-determination in group analytic art therapy, *Group Analysis*, 23: 237–44.

Skaife, S. (1997) The pregnant art therapist in an art therapy group, in S. Hogan (ed.) *Feminist Approaches to Art Therapy*. London: Routledge.

Skaife, S. (2001) Making visible: art therapy and intersubjectivity, *Inscape*, 6(2): 40–50.

Skaife, S. and Huet, V. (eds) (1998) *Art Psychotherapy Groups: Between Pictures and Words*. London: Routledge.

Skailes, C. (1990) The revolving door: the day hospital and beyond, in M. Liebmann (ed.) *Art Therapy in Practice*. London: Jessica Kingsley.

Springham, N. (1998) The magpie's eye: patients' resistance to engagement in an art therapy group for drug and alcohol patients, in S. Skaife and V. Huet (eds) *Art Psychotherapy Groups: Between Pictures and Words*. London: Routledge.

Strand, S. (1990) Counteracting isolation: group art therapy for people with learning difficulties, *Group Analysis*, 23: 255–63.

Sullivan, S. (1953) *The Interpersonal Theory of Psychiatry*. New York: W.W. Norton.

Thornton, R. (1985) Letter to *Inscape*.

Waller, D. (1993) *Group Interactive Art Therapy*. London: Routledge.

Warsi, B. (1975a) Art therapy in a large psychiatric hospital, *Inscape*, 12: 17–21.

Warsi, B. (1975b) Art therapy – a way to self-knowledge, *Inscape*, 14: 3–16.

Wolf, A. and Schwartz, E.K. (1962) *Psychoanalysis in Groups*. New York: Grune & Stratton.

Wood, C. (2000) The significance of studios, *Inscape*, 5(2): 40–53.

Woods, J. (1993) Limits and structure in child group psychotherapy, *Journal of Child Psychotherapy*, 19(1): 63–78.

Yalom, I. (1975) *The Theory and Practice of Group Psychotherapy*. New York: Basic Books.

Bibliography

Books on Art Therapy Theory and Related Areas

Further introductions

Dalley, T. (ed.) (1984) *Art as Therapy: An Introduction to the use of Art as a Therapeutic Technique*. London: Tavistock.

Edwards, D. (2004) *Art Therapy*. London: Sage.

Malchiodi, C. (2002) *Handbook of Art Therapy*. New York: Guilford Press.

Rubin, J. (1999) *Art Therapy: An Introduction*. Philadelphia: Brunner-Mazel.

Rubin, J. (2001) *Approaches to Art Therapy*, 2nd edn. New York: Brunner-Routledge.

Waller, D. and Gilroy, A. (1992) *Art Therapy: A Handbook*. Buckingham: Open University Press.

History and historical

Adamson, E. (1984) *Art as Healing*. London: Coventure.

Barnes, M. and Berke, J. (1973) *Two Accounts of a Journey through Madness*. Harmondsworth: Penguin.

Barnes, H.G. (1940) *The Mythology of the Soul*. Tindall and Cox.

Cardinal, R. (1972) *Outsider Art*. London: Studio Vista.

Hill, A. (1941) *Art versus Illness*. London: Allen & Unwin.

Hogan, S. (2001) *Healing Arts: The History of Art Therapy*. London: Jessica Kingsley.

Jung, C.G. (1963) *Memories, Dreams and Reflections*. London: Collins.

Junge, M. and Asawa, P. (1994) *A History of Art Therapy in the United States*. Mundelein, IL: The American Art Therapy Association.

Kramer, E. (1973) *Art as Therapy with Children*. London: Elek.

Kramer, E. (1979) *Childhood and Art Therapy*. New York: Schocken.

Kris, E. (1953) *Psychoanalytic Explorations in Art*. London: Allen & Unwin.

Kwaitkowska, H. (1978) *Family Therapy and Evaluation through Art*. Springfield: C.C. Thomas.

Laing, J. (1979) *The Special Unit, Barlinnie Prison, its Evaluation through its Art*. Glasgow.

Lyddiatt, E. (1971) *Spontaneous Painting and Modelling*. London: Constable.

May, R. (1976) *The Courage to Create*. Bantam.

Melly, G. (1986) *'Its all writ out for you': The Life and Work of Scottie Wilson*. London: Thames & Hudson.

Milner, M. (1977) *On Not being able to Paint*. London: Heinemann.

Naumburg, M. (1973) *Introduction to Art Therapy*. London and New York: Teachers College Press, Columbia University.

Neumann, E. (1959) *Art and the Creative Unconscious*. Princeton, NJ: Princeton University Press.

Prinzhorn, H. (1972) *The Artistry of the Mentally Ill*. Berlin: Springer-Verlag.

Rhodes, C. (2000) *Outsider Art*. London: Thames & Hudson.

Rhyne, J. (1973) *The Gestalt Art Experience*. Monteray, CA: Books/Cole.

Waller, D. (1991) *Becoming a Profession: A History of Art Therapists 1940–82*, London: Routledge.

Working with adults

Dalley, T., Rilkind, G. and Terry, K. (1993) *Three Voices of Art Therapy: Image, Client, Therapist*. London: Routledge.

Killick, K. and Schaverien, J. (eds) (1997) *Art, Psychotherapy and Psychosis*. London: Routledge.

Levens, M. (1995) *Eating Disorders and Magical Control of the Body: Their Treatment through the Body*. London: Routledge.

Pratt, M. and Wood, M. (1998) *Art Therapy in Palliative Care*. London: Routledge.

Schaverien, J. (1992) *The Revealing Image: Analytical Art Psychotherapy in Theory and Practice*. London: Routledge.

Schaverien, J. (1995) *Desire and the Female Therapist: Engendered Gazes in Psychotherapy and Art Therapy*. London: Routledge.

Working with children

Bach, S. (1990) *Life Paints its Own Span: On the Significance of Spontaneous Pictures by Severely Ill Children*. Switzerland: Daimon Verlag.

Case, C. (2005) *Imagining Animals: Art, Psychotherapy and Primitive States of Mind*. London: Routledge.

Case, C. and Dalley, T. (eds) (1990) *Working with Children in Art Therapy*. London: Tavistock/Routledge.

Case, C. and Dalley, T. (eds) (forthcoming) *Art Therapy with Children: Through Development*. London: Routledge.

Evans, K. and Dubowski, D. (2001) *Art Therapy with Children on the Autistic Spectrum: Beyond Words*. London: Jessica Kingsley.

Gardner, H. (1980) *Artful Scribbles*. New York: Basic Books.

Henley, D. (2002) *Clayworks in Art Therapy*, London: Jessica Kingsley.

Kramer, E. (2000) *Art as Therapy: Collected Papers*. London: Jessica Kingsley.

Malchiodi, C. (ed.) (1999) *Medical Art Therapy with Children*. London: Jessica Kingsley.

Matthews, J. (1999) *The Art of Childhood and Adolescence: The Construction of Meaning*. London: Falmer Press.

Murphy, J. (2000) *Art Therapy with Young Survivors of Sexual Abuse*. London: Routledge.

Rubin, J. (1984) *Child Art Therapy*. New York: Van Nostrand Reinhold.

Group work

Dwivedi, K. (ed.) (1993) *Groupwork for Children and Adolescents*. London: Jessica Kingsley.

Liebmann, M. (2004) *Art Therapy for Groups*. London: Routledge.

McNeilly, G. (2005) *Group Analytic Art Therapy*. London: Jessica Kingsley.

Riley, S. (2001) *Group Process Made Visible: Group Art Therapy*, London: Brunner-Routledge.

Skaife, S. and Huet, V. (eds) (1998) *Art Psychotherapy Groups*. London: Routledge.

Waller, D. (1993) *Group Interactive Art Therapy: Its Use in Training and Treatment*. London: Routledge.

Yalom, L.D. (1975) *The Theory and Practice of Group Psychotherapy*. New York: Basic Books.

Art, psychoanalysis, psychology

Adams, L.S. (1993) *Art and Psychoanalysis*. New York: Harper Collins.

Chasseguet-Smirgel, J. (1985) *Creativity and Perversion*. London: Free Association Books.

Douglas, M. (1984) *Purity and Danger*. London: Ark.

Ehrenzweig, A. (1967) *The Hidden Order of Art*. London: Paladin.

Fitzgerald, M. (2005) *The Genesis of Artistic Creativity: Asperger's Syndrome and the Arts*. London: Jessica Kingsley.

Fuller, P. (1980) *Art and Psychoanalysis*. London: Writers and Readers.

Gordon, R. (1978) *Dying and Creating*. London: Society of Analytical Psychology.

Gosso, S. (ed.) (2004) *Psychoanalysis and Art: Kleinian Perspectives*. London: Karnac Books.

Jung, C.J. (1978) *Man and his Symbols*. London: Picador.

Koestler, A. (1976) *Act of Creation*. London: Hutchinson.

Kuhns, F. (1983) *Psychoanalytic Theory in Art*. New York: IUP.

Langer, S. (1980) *Philosophy in a New Key*. Cambridge, MA: Harvard University Press.

Maclagan, D. (2001) *Psychological Aesthetics*. London: Jessica Kingsley.

McDougall, J. and Lebovici, S. (1989) *Dialogue with Sammy: A Psychoanalytic Contribution to the Understanding of Child Psychosis*. London: Free Association Books.

Milner, M. (1969) *The Hands of the Living God*. London: Virago.

Milner, M. (1989) *The Suppressed Madness of Sane Men*. London: Routledge.

Segal, H. (1990) *Dream, Phantasy and Art*. London: Routledge.

Shakespeare, R. (1981) *The Psychology of Handicap*. London: Methuen.

Sinason, V. (1992) *Mental Handicap and the Human Condition*. London: Free Association Books.

Stevens, A. (1986) *Withymead: A Jungian Community for the Healing Arts*. London: Coventure.

Storr, A. (1972) *The Dynamics of Creation*. Harmondsworth: Penguin.

Szasz, T. (1962) *The Myth of Mental Illness*. London: Secker & Warburg.

Vernon, P. (ed.) (1970) *Creativity*. Harmondsworth: Penguin.

Wollheim, R. (1971) *Freud*. London: Fontana.

Wollheim, R. (1980) *Art and its Objects*. Cambridge: Cambridge University Press.

Winnicott, D.W. (1980) *The Piggle*. Harmondsworth: Penguin.

Winnicott, D.W. (1988) *Playing and Reality*. Harmondsworth: Penguin.

Wright, K. (1991) *Vision and Separation – Between Mother and Child*. London: Aronson.

General

Campbell, J., Liebmann, M., Brookes, F., Jones, J. and Ward, C. (eds) (1999) *Art Therapy, Race and Culture*. London: Jessica Kingsley.

Chetwynd, T. (1982) *A Dictionary of Symbols*. London: Paladin.

Circlot, J.E. (1971) *A Dictionary of Symbols*. London: Routledge & Kegan Paul.

Dalley, T. *et al.* (1987) *Images of Art Therapy*. London: Tavistock.

Gerity, L.A. (1999) *Creativity and the Dissociative Patient*. London: Jessica Kingsley.

Gilroy, A. and Dalley, T. (eds) (1989) *Pictures at an Exhibition*. London: Tavistock/ Routledge.

Gilroy, A. and Lee, C. (eds) (1994) *Art and Music: Therapy and Research*. London: Routledge.

Gilroy, A. and McNeilly, G. (eds) (2000) *The Changing Shape of Art Therapy*. London: Jessica Kingsley.

Goldstein, R. (ed.) (1999) *Images, Meanings and Connections: Essays in Memory of Susan Bach*. London: Daimon Press.

Hiscox, A.R. and Calisch, A.C. (eds) (1998) *Tapestry of Cultural Issues in Art Therapy*. London: Jessica Kingsley.

Hogan, S. (1997) *Feminist Approaches to Art Therapy*. London: Routledge.

Hogan, S. (2002) *Gender Issues in Art Therapy*. London: Jessica Kingsley.

Kalff, D. (1980) *Sand Play – A Psychotherapeutic Approach to the Psyche*. Killick: Third Eye Publications.

Kalmanowitz, D. and Lloyd, B. (eds) (2005) *Art Therapy and Political Violence: With Art. Without Illusion*. London: Brunner-Routledge.

Landgarten, H. (1988) *Family Art Psychotherapy*. New York: Bruner Mazel.

Liebmann, M. (1990) *Art Therapy in Practice*. London: Jessica Kingsley.

Liebmann, M. (ed.) (1994) *Art Therapy with Offenders*. London: Jessica Kingsley.

Liebmann, M. (ed.) (1996) *Arts Approaches to Conflict*. London: Jessica Kingsley.

Malchiodi, C. (ed.) (1999) *Medical Art Therapy with Adults*. London: Jessica Kingsley.

McNiff, S. (1988) *Fundamentals of Art Therapy*. Springfield, MA: C.C. Thomas.

McNiff, S. (1992) *Art as Medicine*. Boston, MA: Shambhalla.

McNiff, S. (2000) *Art-Based Research*. London: Jessica Kingsley.

McNiff, S. (2004) *Art Heals: How Creativity Heals the Soul*. Boston, MA: Shambhalla.

Milia, D. (2000) *Self Mutilation and Art Therapy: Violent Creation*. London: Jessica Kingsley.

Miller, A. (1990) *The Untouched Key*. London: Virago.

Moon, C.H. (2002) *Studio Art Therapy: Cultivating the Artist Identity in the Art Therapist*. London: Jessica Kingsley.

Rees, M. (1998) *Drawing on Difference: Art Therapy with People with Learning Difficulties*. London: Routledge.

Robbins, A. (1986) *The Artist as Therapist*. New York: Human Sciences Press Inc.

Rubin, J. (1984) *The Art of Art Therapy*. New York: Bruner/Mazel.

Sandle, D. (ed.) (1998) *Development and Diversity: New Applications in Art Therapy*. London: Free Association Books.

Schaverien, J. and Case, C. (eds) (forthcoming) *Supervision in Art Psychotherapy*. London: Routledge.

Simon, R. (1991) *The Symbolism of Style: Art as Therapy*. London: Routledge.

Simon, R. (1996) *Symbolic Images in Art as Therapy*. London: Routledge.

Simon, R. (2002) *Self Healing through Visual and Verbal Art Therapy*. London: Routledge.

Thomson, M. (1990) *On Art and Therapy, an Exploration*. London: Virago.

Wadeson, H. (1992) *A Guide to Conducting Art Therapy Research*. Mundelein, IL: The American Art Therapy Association.

Wadeson, H. (1994) *The Dynamics of Art Psychotherapy*. New York: Wiley.

Wadeson, H. (2000) *Art Therapy Practice: Innovative Practice with Diverse Populations*. New York: Wiley.

Journals

American Journal of Art Therapy: www.norwich.edu/about/resources/pubs/ajat.html.

Art Therapy: Journal of the American Art Therapy Association: www.arttherapy.org.

International Journal of Art Therapy: Inscape: www.baat.org/inscape.html.

The Arts in Psychotherapy: www.elsevier.com/locate/issn/01974556.

The Canadian Art Therapy Association Journal: http://home.ican.net/-phanesan/pages/ATjournal.html.

Videos

Art Therapy (1985) Tavistock Publications.

Art Therapy – Children with Special Needs (1987) Tavistock Publications.

Glossary

This glossary is of mainly psychoanalytic terms used in the book. It is intended to aid a basic understanding of the text and does not enter into the history and development of quite complex concepts. For further elucidation, the reader is referred to:

Hinshelwood, R.H. (1989) *A Dictionary of Kleinian Thought*. London: Free Association Books.
Laplanche, J. and Pontalis, J.B. (1980) *The Language of Psychoanalysis*. London: Hogarth Press.
Rycroft, C. (1972) *A Critical Dictionary of Psychoanalysis*. Harmondsworth: Penguin.
Samuels, A., Shorter, B. and Plaut, F. (1986) *A Critical Dictionary of Jungian Analysis*. London: Routledge.

Abreaction An emotional discharge which frees the subject from a previously repressed experience. It may happen spontaneously after the original trauma or come about during therapy. See **Repression**.
Active imagination A Jungian term for a method which tries to release creative possibilities latent in the patient. This technique involves intense concentration on the 'background of consciousness' starting with a dream or phantasy image and allowing it to develop through further images that are noted down.
Amplification A Jungian term for the elaboration and clarification of a dream image by ideas associated to it and by parallels from mythology, folklore, ethnology etc.
Analysand A person who is being treated by psychoanalysis.
Analytical psychology Jung's term for his own approach in treating the psyche, a way of healing but also of developing the personality through the individuation process. The symptoms of a neurosis are an unsuccessful attempt to compensate for a one-sided attitude to life. Jung placed more importance on the cultural or spiritual drive than the sexual drives, particularly in the second half of life.

Anomie In therapy this refers to a condition of hopelessness in a person through loss of belief and sense of purpose.

Anxiety A response to something as yet unknown, either in the environment or by the sensation of unconscious repressed forces in the self. Anxiety is the response of the ego to increases of instinctual or emotional tension which are impending threats to its equilibrium. The ego can then take defensive precautions. See **Repression**.

Archetype A Jungian term for the tendency to organise experience in innately predetermined patterns. The archetypes are contents of the collective unconscious.

Autism Sometimes referred to as childhood schizophrenia, a childhood psychosis. The child or older patient lacks capacity to trust or communicate and may be mute or have very disturbed speech. It may be an organic disease which causes these symptoms or it may sometimes have a psychological explanation based on early patterns of relating with the family.

Behaviour therapy A form of treatment based on learning theory. Symptoms are seen to be caused by faulty learning and conditioning and the therapy aims to remove them by deconditioning and reconditioning methods. It differs from analytic methods of working in rejecting the idea that there is an underlying process of which the symptoms are a manifestation. To a behaviourist the symptom is the illness.

Catharsis The purging of emotions through the therapeutic effect of abreaction.

Collective unconscious Jung divides the unconscious into a personal unconscious and a collective unconscious. The collective unconscious is a deeper stratum of the unconscious. It contains psychic contents common to many, not to one individual. It is not so much that experience is inherited but rather that the mind has been shaped and influenced by our ancestors.

Condensation The process by which different images can combine to form a new composite image which takes meaning and energy from both. It is one of the primary processes and characteristic of unconscious thinking. It can be observed in dreams and symptom formation.

Conscious In psychoanalytical theory mental activity can take place in two modes, one conscious, the other unconscious. Conscious mental activity is what one is immediately aware of and knows and works through secondary processes.

Containing A term developed by Kleinians and Bion particularly to describe the way in which one person can contain and understand the mother's experience. It relates clearly to the concept of projective identification. Bion used the term 'maternal reverie' to describe the mother's state of mind when she contains the infant's projected anxiety, enabling it to be reintrojected by the infant, from the mother, in a bearable form.

This concept also extends to the analytic situation where the analyst allows the same process to take place for the person being treated. Both mother and analyst allow infant and patient to introject an object capable of containing and dealing with anxiety.

Counter-transference The process by which the analyst or therapist transfers thoughts and feelings from her past relationships onto the client. By working with this process in supervision particularly, one can clarify and elucidate the progress of the therapeutic relationship.

Defence A general term for all the techniques and mechanisms which the ego makes use of in conflicts which might lead to a neurosis. The function of defence is to protect the ego against anxiety. See **Denial**, **Regression**, **Repression**, **Splitting**, **Projection**, **Introjection** and **Idealisation**.

Dementia An organic disease of the brain characterised by progressive mental deterioration.

Denial A defence mechanism by which either a painful experience is denied or some aspect of the self is denied.

Depressive position A Kleinian term for the position reached, normally at four to six months, when the infant realises that her love and hate are directed towards the same object. The mother is earlier experienced as 'good' and 'bad' part objects but at this stage is experienced as a whole object. It gives rise to sadness, guilt at earlier attacks and a sense of the whole object being damaged by these attacks. There is a desire to make reparation. It also gives rise to manic defences.

Deprivation This generally refers to a lack of something that is needed by a person. In this book it is usually maternal deprivation which is referred to, i.e. physical absence of the mother, lack of emotional holding, lack of love received from mother. Deprivation beyond a certain threshold will initiate defences leading to the development of neuroses.

Displacement Through this process, energy is transferred from one mental image to another. It is one of the primary processes and enables one image to symbolise another, in a dream. Symbolisation and sublimation depend on serial displacements.

Dream Mental activity in the form of pictures or events which are imagined during sleep. Dreams have meaning to the individual which is arrived at through exploration and interpretation. See **Manifest content**, **Latent content**, **Wish fulfilment** and **Primary processes**.

Ego A Freudian term for that part of the id that has been modified by the direct influence of the external world, i.e. the organised parts of the psyche in contrast to the disorganised id. Representing reason and common sense in contrast to the id which contains the passions. It can be seen to mediate between the demands of the id, superego and external world. See **Reality principle** and **Secondary processes**.

Ego–Kleinian The Kleinian concept of the ego differs from classical analysis in that she understood it to exist at birth rather than develop some

months later. The ego develops by a continual process of projection and introjection of objects.

External object An object is recognised by the subject as being external to herself in contrast to an internal object. In Kleinian terms the patient's perception of an external object may be distorted by his projection onto it which will include unconscious phantasies.

Family therapy Looks at the whole unit of the family if one member is disturbed. It focuses treatment, after diagnosis, on something being disturbed in the natural system formed by the family members in relationship, rather than on individual psychopathology. See **Systems theory**.

Fantasy Tends to be used as a term for a conscious wish to daydream by British writers. The *Oxford English Dictionary* distinguishes its use as a term for caprice, whim, fanciful invention as contrasted to phantasy as a term for imagination, visionary notion. See **Phantasy** and **Unconscious phantasy**.

Free association A Freudian term. The analysand is encouraged to talk spontaneously, just speaking her thoughts as they come, making no attempt to strain for connections or to concentrate.

Freudian A follower of Sigmund Freud (1856–1939), the founder of psychoanalysis, who was born in Moravia but spent nearly all his life in Vienna until forced to seek asylum in London in 1938.

Id A Freudian term for the psychic apparatus which begins undifferentiated but part of it develops into the structured ego. Its contents – the instinctual part of the personality – are unconscious, partly hereditary and innate, partly repressed and acquired. Described as being full of energy, chaotic and striving to fulfil instinctual needs. See **Pleasure principle** and **Primary processes**.

Idealisation This is a defence mechanism by which an internal object to which one feels ambivalent is split into two part objects, one ideally good and the other completely bad. It avoids the disillusion and depression at recognising the inherent ambivalence one feels towards loved objects.

Identification Refers to a psychological process where one assimilates desired characteristics or aspects of another person, and is changed by modelling oneself upon these aspects. Identification with parental figures is part of normal development and helps to form personality.

Incorporation A Kleinian term which refers to the phantasy of taking an external object into one's inside. It is felt to be physically present inside one's body. It is related to the concept of introjection, which is a defence mechanism, being the person's experience of introjecting an external object. See **Introjection**.

Individuation process As used by Jung, a quest for wholeness, linking conscious and unconscious aspects of the psyche, one of the tasks of middle age.

Instinct An innate biologically determined drive to action. In Freudian terms, an instinct has a biological source, an aim, energy, and an object. Failure to find an object leads to instinctual tension. See **Pleasure principle, Sublimation** and **Instinct theory**.

Instinct theory Freud proposed a dual instinct theory, i.e. two groups of instincts which were opposed to each other. Usually referred to as life instincts and death instincts. The life instinct includes both sexual and self-preservative instincts and the death instinct the drive to return to the inanimate state.

Internal object A Kleinian term which refers to an unconscious experience of a concrete object which is reacted to as real and as being physically located in internal psychical reality. Although it is a phantasy, it is experienced as having independent motives and intentions. Internal objects have a relationship to external objects. Internal objects partly mirror external objects and are derived from them by introjection.

Interpersonal Refers to the interactions of people upon one another.

Interpretation (reductive, premature, projective, group) The process by which the analyst finds meaning in the dreams, free associations and symptoms of a client. The client may be aware of the manifest content but working with the analyst may discover the latent content. The client needs to respond to the interpretation to verify its accuracy. Freudian or classical psychoanalysis is sometimes criticised for offering reductive interpretations, i.e. which refer everything back to infant sexuality rather than allowing a symbol to say 'something new' to the person. Premature interpretation refers to an interpretation made to a person in therapy before they are ready to understand it. In art therapy one might also refer to projective interpretations where members of a group might 'project' an aspect of themselves into a picture and attribute it to the person who made the picture under discussion. Group interpretation refers to either group art therapy or verbal group therapy where the leader makes an interpretation of the group process rather than addressing an individual.

Intrapsychic Refers to processes occurring within the mind.

Introjection A Kleinian concept which describes the process by which the ego develops, taking into its boundaries external objects. These introjected objects populate each person's internal world. It is a defence mechanism in that external objects are introjected when anxiety is felt about 'bad objects' inside, i.e. 'good objects' are introjected at these times.

Jungian A follower of C.G. Jung (1875–1961), a Swiss psychiatrist who was a disciple of Freud from 1907 to 1913 but then founded his own school and system of analytical psychology.

Kleinian A follower of Melanie Klein (1882–1960), pioneer of child analysis. Kleinian theory both develops from and departs from classical Freudian theory of analysis. It ascribes to a dual instinct theory giving greater

emphasis to the death instinct. It is also an object theory. It rejects the concept of stages of development in favour of a theory of positions. It attributes greater importance to the first year of life than to childhood as a whole.

Latent content In Freud's investigations into dreams the latent content is the content which is discovered through interpretation. This content was originally a wish which has been fulfilled in hallucinatory form.

Learning disability Diagnostic criteria as outlined in 1987. (A) Significantly subaverage general intellectual functioning: an IQ of 70 or below on an individually administered IQ test. (B) Concurrent deficits or impairments in adaptive functioning, i.e. the person's effectiveness in meeting the standards expected for her age by her cultural group in areas such as social skills and responsibility, communication, daily living skills, personal independence and self-sufficiency. (C) Onset before the age of 18.

There are four specific levels of severity, reflecting the degree of intellectual impairment and designated as mild, moderate, severe and profound:

Mild learning disability IQ 50–55 to approx. 70
Moderate learning disability IQ 35–40 to 50–55
Severe learning disability IQ 20–25 to 35–40
Profound learning disability Below 20 or 25

The term 'learning difficulties' can be interchangeable with the term 'mental handicap' or 'mental retardation'.

Libido (oral, anal and genital phases) A Freudian term for inferred mental energy with which mental processes, structures and images are invested. Libido is imagined as having a source in the id. Oral stage: the first stage of libidinal and ego development in which the mouth is the main source of pleasure and hence the centre of experience. Anal stage: the second stage of libidinal and ego development in which the anus and defecation are the major source of sensuous pleasure and centre of the infant's self-awareness. Mastery of the body and socialisation of impulses are the infant's major preoccupations. Genital phase: the last stage of libidinal development after passing through the latency period into puberty, when relationship to another develops.

Mania A psychosis characterised by elation and acceleration of both physical and mental activity. It is one phase of manic-depressive psychosis.

Manic defences A Kleinian concept of defences mobilised in the depressive position. Defences are needed against anxiety, guilt and depression at the realisation of the harm done by one's earlier aggressive impulses towards one's objects – defences: denial, omnipotence, identification and projection.

Manifest content In Freud's investigations into dreams the manifest content is the dream content as is experienced on waking and remembered and told to the analyst. See **Latent content**.

Material In psychoanalysis and psychotherapy, 'material' usually refers to 'what the patient says' as this is the base from which an analyst makes interpretations. In art therapy it usually refers to pictures and models made in the course of therapy but also encompasses verbal utterances as the art therapist works between images and words.

Negative therapeutic reaction Refers to the increasing or worsening of the patient's symptoms in response to the treatment which is aimed at lessening them. Originally used only for interpretations having this effect in psychoanalysis but now a broader usage. The effect is explained in terms of guilt provoked by the idea of being healthy at the expense of someone else.

Neurosis Used to describe mental disorders which are not diseases of the nervous system. Neurotic usually describes behaviour which is not healthy or normal, not organically or physically based, not psychotic and which can be explained psychologically.

Object relations theory In the 1930s object relations became the major focus for the school of psychoanalysis developed particularly within Britain. Klein developed object relations theory but still remained firmly with Freudian theory in her belief in a theory of instincts. Major theorists in Britain include Fairbairn, Winnicott and Balint. In object relations theory, the subject's need to relate to objects occupies the central position, in contrast to instinct theory, which centres round the subject's need to reduce instinctual tension.

Object(s) A term used in psychoanalysis to refer to the object of an instinctual impulse, i.e. that towards which action or desire is directed. It nearly always means a person, or part of a person or symbols of one or the other.

Oceanic feeling A sense of oneness with the world, a loss of ego boundaries. A reliving of the experience when one was an infant at the breast before the ego was distinguishable from the external world. Can also refer to mystical or religious experience.

Oedipus complex A Freudian term for the desire to get rid of the parent of the same sex in order to possess the parent of the opposite sex, sexually. This is experienced by the child between the ages of 3 to 5. According to Freud a universal phenomenon. Resolution is achieved at puberty by identification with parent of same sex and eventual choice of sexual partner.

Omnipotence Thoughts and fantasies that one has unlimited power over the external world.

Ontogeny The development of the individual.

Paranoia See **Psychosis**.

Paranoid-schizoid position A Kleinian term for an early state of mind in the infant who deals with innate destructive impulses by splitting processes. Parts of the ego and object representations are split into 'good' and 'bad' parts. Bad parts are projected onto an object by whom the subject then feels persecuted, i.e. her own destructive impulses are felt as coming after her from outside. See **Projective identification** and **Splitting**.

Part objects A Kleinian term for the infant's experience of one part of the person who cares for her, e.g. a breast. The part object is experienced as being there solely to satisfy the infant's needs or as frustrating them, i.e. if the infant is hungry, she experiences a frustrating 'bad object', if she is warm and fed, a satisfying 'good object'. Her inner world is 'peopled' by her representations of her instinctual impulses, only later does she come to recognise the part objects as forming a whole object.

Personal unconscious Jung divides the unconscious into a personal unconscious and a collective unconscious. The personal unconscious belongs to the individual; it is formed from repressed memories, impulses and wishes, subliminal perceptions and forgotten experiences.

Personality disorder A term in psychiatric diagnosis which encompasses psychopathy, perversions and addictions. They have, in common, society's disapproval of their behaviour, which is also their form of symptom.

Phantasy British psychoanalytic writers invariably use phantasy to refer to the imaginative activity which underlies all thought and feeling. It can also be used to refer to imagining, daydreaming and fancying as contrasted to adaptive thought and behaviour. American writers may use phantasy and fantasy interchangeably. See **Fantasy** and **Unconscious phantasy**.

Phobia The experiencing of unnecessary and excessive anxiety in some specific situation or in the presence of some specific object, e.g. agoraphobia – anxiety in open spaces, or phobia of spiders. Schools of thought agree that the phobic situation or object arouses anxiety not for itself but because it has become a symbol of something else.

Phylogeny The development of the race or species.

Play technique Klein developed her play technique in order to analyse children younger than 3. Her technique used little toys in the psychoanalytic setting to allow the expression of unconscious phantasy. The children's play was regarded as the equivalent of free association in adults. Her interpretations addressed the unconscious anxiety expressed symbolically in the play. Her development of object relations theory is profoundly based on observation of children's play in analysis.

Pleasure principle A Freudian term for one of the two principles which govern mental functioning. Psychic activity is aimed at avoiding non-

pleasure and pain aroused by increases in instinctual tension by hallucin-
ating what is needed to reduce the tension. Pleasure principle is innate
and primitive. See **Reality theory**.

Pre-conscious Refers to thoughts which although at the moment
unconscious are not repressed and can therefore become conscious. They
conform to the secondary processes.

Primary processes The primary processes are characteristic of uncon-
scious mental activity. Images tend to become fused and can readily
replace and symbolise one another. Primary process thinking uses mobile
energy, ignores the categories of time and space, and is governed by the
pleasure principle, reducing instinctual tension by hallucinating wish ful-
filment. It is the mode of thinking operative in the id. Freud believed
them to be ontogenetically and phylogenetically earlier than the second-
ary processes. He thought they were maladaptive. This view has been
challenged by later thinkers developing theory of mental processes and
creativity. The primary process is exemplified in dreams. See **Secondary
processes**.

Projection The process by which aspects of the self or internal objects are
imagined to be located in some other person in one's environment. One
first of all denies that one has the feeling but then 'sees' it in another
person and reacts to it accordingly.

Projective identification A Kleinian term for an aggressive attack on an
object, forcing parts of oneself into it in order to take it over. See **Projec-
tion** and **Paranoid-schizoid position**. Projective identification relies on an
idea that it is possible to locate parts of the self 'somewhere else'. It leaves
the subject feeling depleted with loss of identity.

Psyche The soul, spirit, mind, encompassing mental and emotional life,
conscious and unconscious.

Psychiatrist One who treats diseases of the mind.

Psychoanalysis A form of treatment invented by Freud in the 1890s,
which explains psychic symptoms in terms of repressed infantile sexual
impulses, tracing neuroses back to their roots in infancy. Key concepts:
free association, interpretation, transference. Psychoanalysis could be
described as long-term, intensive, interpretative psychotherapy.

Psychoanalyst A person who practises psychoanalytical treatment after
receiving training at a recognised institute.

Psychologist A person trained in or practising any form of psychology.

Psychology The science of the mind, but also the science of behaviour.
Specialists may be qualified in one branch of the subject, e.g. child,
abnormal, educational etc., or in a particular system of thought, e.g.
Gestalt, Jungian, Freudian.

Psychopathology Refers to the study of abnormal mental functioning or
to a theoretical formulation of the abnormal workings of a person's
mind.

Psychosis Used to describe mental illnesses which are characterised by detachment from reality, a lack of insight into one's condition and bizarre symptoms such as delusions and hallucinations. Organic psychoses are due to organic disease of the brain. In functional psychoses there is no apparent organic lesion. Three of these are distinguished: (a) schizophrenia; (b) manic-depressive psychosis; and (c) paranoia.

Psychosomatic (psyche, soul, spirit, mind; **soma**, body) Therefore, psychosomatic, of mind and body as a unit, is concerned with physical diseases having emotional origin, from a patient's life situation as well as an organic or physical basis.

Psychotherapist Someone who practises psychotherapy, of any school, who could have a medical or a lay background and who has received a training at a recognised institute.

Psychotherapy The treatment of the mind or psyche by psychological methods which encompasses the concept of a 'talking cure'. Psychotherapy may be either individual or group, superficial or deep. It can have different intentions, being either interpretative, supportive or suggestive.

Psychotic art Refers to pictures and models made by someone suffering a psychotic mental illness.

Reality, external External reality refers to objective phenomena external to the subject.

Reality, internal Internal reality refers to images, thoughts, phantasies, feelings which are imagined to occupy a space inside the subject. Also refers to a psychical reality.

Reality principle A Freudian term for one of the two principles which govern mental functioning. After the ego has developed, the pleasure principle is modified by the reality principle which leads the individual to replace hallucinatory wishfulfilment by adaptive behaviour; e.g, one can postpone the attainment of a goal according to the situation in the outside world, whether conditions are right for satisfaction. See **Pleasure principle**.

Regression Going back to an earlier way or stage of functioning. A defence to enable the subject to avoid anxiety by returning to an earlier stage of libidinal and ego development. See **Libido**.

Reparation A Kleinian term for one of the main constituents of all constructive and creative urges. Distress is felt after aggressive impulses and there is an urge to make good the harm done to an object to which one has ambivalent feeling. If an internal object has been harmed or destroyed in phantasy, this refers to the process of recreating it.

Repression The process by which an unacceptable idea or impulse to action is made unconscious. It is a defence mechanism. Ego development, which means adapting to one's environment, involves the process of repression of unacceptable impulses.

Resistance A term in psychoanalysis which refers to a defence against

having unconscious processes made conscious, i.e. opposing the analyst's interpretations.

Restitution or **Restoration** A defensive process which is an impulse to make 'good' again after aggressive impulses. It reduces guilt felt towards an object to whom one has ambivalent feeling. See **Reparation**, which is more commonly used.

Schizophrenia See **Psychosis**.

Secondary processes The secondary processes are characteristic of conscious mental activity. Secondary processes are exemplified by thought, obeying the laws of grammar and formal logic. They use bound energy and are governed by the reality principle, reducing the non-pleasure of instinctual tension by adaptive behaviour. In Freud's view the secondary processes develop with the ego with adaption to the external world and have an intimate connection with verbal thinking. See **Primary processes**.

Shadow A Jungian term for the inferior parts of ourselves that we do not own up to. They are the primitive, uncontrolled and animal parts of ourselves that form the personal unconscious because they are incompatible with the chosen conscious attitude.

Splitting A defence mechanism. It refers to a process by which one mental structure is replaced by two part structures, i.e. in splitting of the ego, one part remains conscious, experienced as 'the self, the other 'unacceptable' part becomes an unconscious split-off part of the ego. If an internal object is split, one part is usually a 'good object' and the other a 'bad object'. See **Denial**, **Projection** and **Idealisation**.

Sublimation The process by which energy, originally instinctual, is displaced and discharged in ways which are not obviously instinctual. Sometimes seen as also being socially acceptable, e.g. energy is displaced from activities and objects of primary interest, the emotion becomes desexualised and deaggressified. Sublimation depends on symbolisation. Ego development depends on sublimation.

Superego A Freudian term. The superego is formed through the internalisation of parental prohibitions and demands. Its role in relation to the ego is of a judge or censor. It also contains the reflective activities, self-observation, self-criticism as well as being the basis for the formation of conscience and ideals.

Symbiotic relationship A union between mother and child where each depends totally and exclusively on the other, which becomes abnormal after the first few weeks of life.

Symbol A symbol is a way of indirectly, but figuratively representing something else, i.e. in psychoanalytic terms an unconscious idea, conflict or wish. It can be contrasted to a sign which can only indicate the presence of something. Psychoanalysis is concerned in symbolism with the unconscious substitution of one image or idea or activity for another. Theories of symbolism explore the constant relationship between the

symbol and what it symbolises in the unconscious. This constant relationship can be found in different individuals as well as in very different and widely separated cultures. Symbolisation is one of the primary processes governing unconscious thinking, e.g. dreams, symptom formation. See **Displacement** and **Condensation**.

Symptom formation Classical psychoanalytical theory looks at symptoms formed in neurosis as being on a par with dream work. The symptom is formed by a compromise made between the repressed wish and the defence mechanism which represses the wish. See **Repression** and **Defence**.

Systems theory In family therapy, systems theory has developed as a way of conceptualising what is happening to a family when they come with a disturbed member to therapy. A single family member cannot be understood without looking at the whole family. Their internal interactions as well as their interactions with the environment need to be studied before the disturbance is explicable.

The self A Jungian term for the centre of the totality of conscious and unconscious. It is the function which unites all the opposing elements in man or woman. To reach this position involves accepting what is inferior in our nature (the *Shadow*). To know it, is to know a sense of oneness with oneself and the world which is accepted as it is.

Therapy The process of treating or healing or curing. *Therapeutic alliance* refers to the alliance between the healthy part of the client in therapy and the therapist to treat or heal the sick part of the client. *Therapeutic relationship*, sometimes used interchangeably with therapeutic alliance or working alliance, refers to all other aspects of the treatment relationship with the exception of the transference and counter-transference relationships. *Therapeutic encounter* refers to the meeting of two people in the therapy relationship. *Therapeutic process(es)* refers to the events and stages that therapist and client pass through in the course of therapy, and also the psychic mechanisms that are brought into play during its course.

Transcendent function (of the symbol) In Jungian terms, a symbol can carry a wide meaning and express a psychic fact which cannot be formulated more exactly. The transcendent function of the symbol is its capacity to unite opposites within the psyche into a new synthesis which can become a new point of departure.

Transference Refers to the process by which a person in analysis or therapy displaces feelings onto the person of her analyst or therapist which were originally felt in relation to previous figures in her life, i.e. the client behaves as though her therapist were her father, mother etc. It is the resolving of conflicts dating from infancy and childhood through 'transference interpretations' that forms the basis of the work in psychoanalysis. In art therapy one works with the twin concepts of transference to the picture as well as transference to the person of the art therapist, i.e.

the picture embodies thoughts and feelings towards relationships in the past.

Transitional object (a term coined by Winnicott) This is an object which the child treats as being halfway between herself and another person; initially usually the mother. It can be any object, often a toy or piece of blanket, which is precious to the child but can be ill-treated because it is not a person. The child is able to express both feelings of love and hate to the object.

Trauma Refers to a completely unexpected experience which the client was unable to assimilate. When it happens, the immediate response is shock. One might either recover spontaneously or develop a neurosis because defences come into play and try to repress the experience.

Unconscious In psychoanalytical theory, mental activity can take place in two modes, one conscious, the other unconscious. Unconscious mental activity refers to processes of which one is not aware, and works through the primary processes. Some unconscious processes can become conscious easily but some are subject to repression.

Unconscious phantasy A Kleinian term which delineates the imaginative activity that underlies all mental processes and accompanies all thoughts and feelings. Unconscious phantasies are concerned with biological processes, body based, and relationships with objects to satisfy instincts towards them. Unconscious phantasies are therefore psychic representatives of instincts. The Kleinian working method is characterised by the interpretation of unconscious phantasy which releases inhibition, frees anxiety and allows further phantasy to emerge. See *Fantasy* and *Phantasy*.

Unspecified mental retardation This term should be used when there is a strong presumption of learning disability, but the person is untestable by standard intelligence tests. This may be the case when children, adolescents or adults are too impaired or uncooperative to be tested. This may also be the case with infants when there is a clinical judgement of significantly subaverage intellectual functioning, but the available tests, such as Bayley, Cattell, and others, do not yield IQ values. In general, the younger the age, the more difficult it is to make a diagnosis of learning disability, except for those with profound impairment.

Whole object A Kleinian term for an object which the person comes to perceive as a person similar to herself or as a person in his or her own right. The whole object is no longer either 'good' or 'bad' but the infant recognises that the 'good' and 'bad' part objects are one, i.e. she is able to accept ambivalent feelings towards a loved person, rather than defining them by her own instinctual needs.

Wish fulfilment A Freudian term associated with his theory of dreams. The products of the unconscious, i.e. dreams, symptoms and phantasies are all wish fulfilments wherein the wish is to be found expressed in a more or less disguised form.

The British Association of Art Therapists

The BAAT is the professional organisation for art therapists in the UK. This association was formed in 1964 from a group of artists and therapists interested in the development of art therapy. It formed a central organisation to which the general public and employing authorities could refer. To obtain current information visit the website at info@baat.org.

Since its inception, BAAT has concentrated its efforts in the following areas:

- Negotiating for members on questions of salary and conditions of employment.
- Suggesting criteria for training courses and standards of professional practice.
- Setting up a membership directory and negotiating the process of state registration with the CPSM.
- Publishing the *International Journal of Art Therapy, Inscape*, in collaboration with Taylor & Francis.
- Publishing a newsbriefing for members.
- Acting as a forum for ideas and organising conferences.
- Answering questions from the general public.

The current membership is: full members 1288 (of which 25 are international); associate members 50; overseas associates 13; trainees 250 (December 2005).

State registration

Art therapists attained state registration in 1997. This has a combined effect of protecting the professional title and also the giving of greater protection to the public and their interests by ensuring that art therapists are trained and practise competently. In 2002 the CPSM was replaced by the HPC which regulates 12 healthcare professions including the other arts therapies.

BAAT council

The council is an elected body consisting of four officers (chair, vice-chair, honorary treasurer and honorary secretary) who serve a term of two years. In addition, there are eight council members who are elected annually. These ordinary council members take on many different duties according to interest and may work as membership secretary, chairing sub-groups of BAAT, being BAAT's representative at meetings with professional bodies or regional group organiser. The Association has many different working parties and interest groups who have representatives at council. The interest groups help to pioneer and develop art therapy. Among the current groups are autistic spectrum disorders, art therapy race and culture, art therapy in education, art therapy and neurology, forensic art therapies advisory group, art therapists working with people who have a learning disability, creative response (palliative care), art therapy and therapeutic communities and art therapists working with children, adolescents and families. Interest groups give a forum for members to meet and discuss their work and also may organise events and conferences which may lead to publications in that particular field.

There are different categories of membership of the association: fellow (members who have made outstanding academic contributions to the profession); honorary member (who have rendered distinguished services to the Association); full member; associate or corporate member; and trainee member. In 1976 it was agreed that all full members should be trade union members. It is recommended that art therapists join Amicus, which represents the majority of members.

Directory of art therapists

The current directory of art therapists (updated annually) is available from BAAT. The directory is intended mainly for the use of employing institutions but also indicates people who will take self-referrals and individuals who may be contacted for talks, lectures or workshops. It is organised regionally, and within the regions alphabetically in order of surname. A regional contact name is found at the beginning of each section. These people have volunteered their time to organise local events. There are 22 regions altogether: 14 in England, 1 in Wales, 4 in Scotland, 1 in Northern Ireland as well as two further groups covering the European Union and International (rest of the world) regions.

Cornwall, Devon	Region 1
Dorset, Wiltshire, Hampshire, Isle of Wight	Region 2
Surrey, W. Sussex, E. Sussex, Kent, South London	Region 3
Bedford, Hertford, Essex, North London	Region 4
Gloucester, Berkshire, Buckingham, Northampton	Region 5

Worcester, Salop, Stafford, West Midlands, Warwick, Hereford	Region 6
Wales	Region 7
Norfolk, Suffolk, Cambridge	Region 8
Derbyshire, Nottingham, Lincoln, Leicester	Region 9
Lancashire, Cheshire, Greater Manchester	Region 10
N. Yorks, S. Yorks, W. Yorks, Humberside	Region 11
Tyne and Wear, Cleveland, Cumbria, Durham, Northumberland	Region 12
London	Region 13
Oxfordshire	Region 14
Clyde–Scotland	Region 15
Forth–Scotland	Region 16
Avon, Somerset, Bath and N.E. Somerset, S. Glos	Region 17
Highlands and Islands, Scotland	Region 18
Grampian, Shetland, Scotland	Region 19
Northern Ireland	Region 20
European Union	Region 21
International	Region 22

Any individual interested in art therapy can become an Associate Member. For an annual fee you will receive two copies of the *International Journal of Art Therapy: Inscape*, a quarterly newsbriefing and information regarding national and local meetings and events. Corporate membership is also open to any group of people.

If you wish to subscribe to *International Journal of Art Therapy: Inscape*, payment can be made to the BAAT. The BAAT also maintains a list of books and other publications dealing with art therapy and related issues as well as a list of publications by BAAT members. For a list of back copies of the journal and of other BAAT publications, send an SAE.

The address for all enquiries and orders, including the directory, is:

British Association of Art Therapists,
24–27 White Lion Street
London
N1 9PD
Tel: 020 7686 42 1
Fax: 020 7837 7945
Correct at the time of going to press, or visit the website at info@baat.org.

Code of ethics

The BAAT published the *Principles of Professional Practice* (PPP) in 1984 and the *Code of Ethics* in 1994. They are both part of the function of the BAAT in regulating the profession to ensure that the work of art therapists is professional and ethically sound. Working parties were set up for each of these as part of the development of the profession. The PPP were envisaged as a set of guidelines for the practice of art therapy rather than specific rules. As guidelines they were seen as being adaptable to meet the specialised therapeutic needs of a variety of institutions and organisations. They covered various aspects of clinical work such as confidentiality, record-keeping and the storage of work, exhibitions, referrals, caseload, professional support and supervision, and continuing professional development. These had a dual role of seeking to protect clients and also to establish standards of working to protect therapist and client, so there were recommendations for art therapy rooms and management structures. The PPP were revised and the *Code of Ethics* formulated in the early 1990s as art therapy changed to become a state registered profession. The *Code of Ethics* differs from the PPP in that it provides a set of rules for conduct rather than being a collection of agreed values and standards for practice. The *Code of Ethics* is regularly updated to keep in line with new legislation and can be accessed on the BAAT website at info@baat.org.

Colleges offering postgraduate training in art therapy in the UK

Belfast
Graduate School of Education
Queen's University Belfast
69–71 University Street
Belfast BT7 1HL
Tel: 02890 335923
Website: www.qub.ac.uk

Derby
School of Health and Community Studies
The University of Derby
Western Road
Mickelover
Derby DE3 5GX
Tel: 01332 592729
Website: www.derby.ac.uk

Edinburgh
School of Art Therapy
Queen Margaret University College
Leith Campus
Duke Street
Edinburgh EH6 8HF
Tel: 0131 3173806
Website: www.qmced.ac.uk

Hatfield
Department of Art Therapies
Faculty of Art and Design
University of Hertfordshire
College Lane
Hatfield
Hertfordshire AL10 9AB
Tel: 01707 285339
Website: www.herts.ac.uk

London
Art Psychotherapy
Unit of Psychotherapeutic Studies
Professional and Community Education
Goldsmiths College
University of London
23 St James
New Cross
London SE14 6AD
Tel: 020 79197230
Website: www.goldsmiths.ac.uk

Sheffield
Northern Programme for Art Psychotherapy
(Sheffield Care Trust and Leeds Metropolitan University)
Netherthorpe House
101 Netherthorpe Road
Sheffield
S3 7EZ
Tel: 0114 2264901

Information on short courses is available from the BAAT website at info@baat.org

Information on training outside of the UK

Europe: European Consortium for Arts Therapies Education (ECArTE): www.uni-muenster.de/Ecarte/index.html.

American Art Therapy Association approved courses: www.arttherapy.org/programmes.html.

Australian courses: www.anata.org.au/attraining.htm.

Canadian courses: http://home.ican.net/-phansen/pages/ATraining.html.

Author index

Adamson, Edward 92, 186, 234
Adler, A. 118, 244
Agazarian, Y. 251
Ainsworth, M.D.S. 99, 100
Aldridge, F. 5, 236
Amini, F. 105, 106
Anthony, E.J. 246
Arguile, Roger 5, 18–20

Bach, S. 92
Balbernie, R. 97, 99, 102, 103, 104
Baynes, H.G. 92–3
Bion, W.R. 80–1, 82, 85, 93, 94, 244, 245–6, 248
Bissonet, J. 8, 237
Bollas, Christopher 81, 180
Booth, Simon Willoughby 66
Boronska, T. 6, 106, 236
Bosquet, M. 104
Bowlby, John 99, 100, 101
Brenman Pick, I. 81
Brittain, W.L. 95
Broadbent, S. 21
Brown, A. 8
Brown, A.M. 236, 245
Buckland, R. 6, 236
Burkitt, E. 6
Byers, A. 251

Campbell, J. 5
Cardinal, Roger 69
Carrell, C. 9
Case, C. 4, 6, 9, 85, 90, 92, 93, 94, 96–7, 106, 146, 151, 192, 194, 203, 213, 214, 215, 220
Champernowne, Irene 92, 135
Circlot, J. 31
Cox, Murray 74, 77, 199–200, 217

Crittenden, P. 100–1
Cronin, P. 9

Dahl, R. 223
Dalley, T. 5, 6, 7, 8, 94, 139, 151, 192, 194, 203, 213, 215, 236, 259
Damarell, B. 7
Davis, M. 130
Deco, S. 6, 232
Dennis, W. 103
Department for Health and Social Services (DHSS) 186, 189
Dewey, John 185, 186
Donnelly, M. 6
Douglass, L. 6
Dubowski, J. 7, 94, 95, 98
Dudley, J. 2, 5, 252

Edwards, David 2, 10, 89, 122, 127, 188
Edwards, M. 3, 90, 92, 93
Ehrenzweig, Anton 71, 127, 164–5, 166, 170, 172, 175
Ekstein, R. 208
Evans, K. 7, 95, 98
Ezriel, H. 245

Fairbairn, W.R.D. 120, 170–1, 174
Fenichel, O. 80
Ferenczi, S. 80, 178
Fitzgerald, M. 7
Fonagy, P. 97, 98, 99, 102, 105
Fordham, F. 131
Foster, F. 139
Foulkes, S.H. 244, 246, 248, 249, 250, 264, 265
Fox, L. 7, 95
Fraiberg, S. 102

Frazer, J.G. 164
Freud, Anna 2, 114, 166
Freud, Sigmund 2, 4, 71, 76, 78, 102, 113–19, 120, 126, 129, 130, 133, 135, 160–1, 168, 169, 170, 171, 175, 176, 179–80, 213, 214, 230, 244
Fuller, Peter 117–18, 121, 124, 168, 171, 174–5

Galinsky, M.D. 245
Gersch, I. 90
Gill, D. 232–3
Gilroy, A. 2, 10, 90, 187
Glasner, D. 103
Gold 89
Gombrich, E.H. 113–14, 115, 116–17, 169, 170
Goncalves, S.J. 90
Gordon, R. 160
Gosso, S. 3, 82
Greenaway, M. 6
Greenson, R. 221
Greenwood, H. 94

Hall, P. 6
Hammans, Sue 22–7
Hardy, D. 8, 9, 89
Hastilow, S. 236
Hawkins, Peter 204, 207
Heimann, P. 80
Henley, D. 236
Henzell, J. 8, 92
Hermelin, B. 7
Hershkowitz, A. 4, 160
Hesse, E. 100–1
Hill, Adrian 3
Hillman, J. 93, 96
Hogan, S. 5, 92
Huet, V. 8, 251
Hyland Moon, C. 92, 232

Inhelder, B. 94
Isaacs, Susan 178, 179

Jacobvitz, D. 97
James, J. 7
Jensen 118–19
Jones, Ernest 176–8, 179–80, 182
Joseph, B. 80, 81
Jung, Carl Gustav 2, 3–4, 89, 92–3, 96, 118, 130–5, 137, 167, 177, 178, 251, 265

Kalmanowitz, D. 7
Kellogg, R. 95
Khan, M. 76
Killick, Kathy 4, 5, 8, 50, 90, 92, 94, 139, 181
Klauber, T. 7
Klein, Melanie 2, 78–9, 93–4, 119–22, 127, 128, 178, 179
Knight, S. 6, 106–7
Kris, E. 151, 161–2, 166, 167, 169–70
Kuczaj, E. 6
Kuhns, F. 84–5

Laing, J. 6, 9
Lane, R.D. 106
Langer, S.K. 137, 138, 182
Lanham, R. 93
Latimer, M. 8, 236
Levens, M. 8
Lewin, Kurt 245
Liebmann, M. 8, 9, 321, 251, 257, 259
Lillitos, Aleathea 6, 29–31, 189
Liotti, G. 97
Lloyd, B. 6, 7
Lowenfeld, V. 95
Luzzatto, P. 8, 92, 232
Lyddiatt, E.M. 92, 92–3, 233–4
Lyons-Ruth, K. 97

Maclagan, D. 4, 8, 95, 96, 187
McNeilly, Gerry 8, 248–9, 250, 251
McNiff, S. 93, 96
Mahoney, J. 8
Main, M. 100–1
Main, T.F. 244
Makin, S. 259
Malchiodo, C. 89
Males, B. 189, 192
Mann, David 3, 4, 82, 161, 213
Matthews, J. 6, 94
McGee, Pauline 32–4
McGregor, I. 7
Meyerowitz-Katz, J. 6, 7, 213
Milia, D. 8
Miller, B. 9, 192, 195
Milner, Marion 2, 4, 119, 122–7, 129, 138, 163, 164, 166, 170, 172, 173, 175, 178, 181, 182
Molloy, T. 9, 233, 249
Moreno, J.C. 74, 244
Morgan, Clare 35–42
Morter, S. 9

Muir, S. 6
Murphy, J. 6, 235–6, 236
Murray, L. 104

Naumberg, M. 93
Neisser, U. 95
Nelson, C.A. 104
Newell, T. 6
Newmarch, R. 70
Noble, J. 236
Nowell Hall, P. 4, 213, 256

O'Brien, F. 6, 75, 93, 106, 146
O'May, F. 5

Paisley, D. 7
Pally, R. 102
Papousek, H. 104
Papousek, M. 104
Parsons, M. 214
Patterson, Z. 7
Pedder, J. 245
Perry, B. 101, 102, 103, 106
Peters, R. 251
Piaget, Jean 94–5
Plowman, K. 7
Pounsett, H. 10
Pratt, M. 8, 9
Prinzhorn, H. 166
Prokofiev, F. 235, 236

Rabiger, S. 5, 7, 192
Radke-Yarrow, M. 100–1
Read, Herbert 3, 185
Reddick, D. 5, 94
Rees, M. 7, 8, 94
Rhode, M. 7
Rickman, J. 170, 171–2, 244
Riley, S. 236, 252
Robbins, A. 96
Robinson, M. 7
Rogers, C.R. 70
Ross, C. 259
Rothwell, K. 6, 190
Rozum, A.L. 236
Rubin, Judith 89, 97
Rutten-Saris, M. 95, 98
Rycroft, Charles 115, 119, 138, 175, 176,
 178, 182–3

Safran, D.S. 236
Sagar, C. 75, 193

Sandler, J. 213
Saotome, J. 251
Sarra, N. 251
Schaverien, J. 1, 4, 5, 8, 18, 21, 50, 70,
 72, 73, 80, 89, 90, 92, 93, 96, 141,
 149, 180–1, 187, 203, 213, 220, 221,
 228
Schilder, P. 245
Schore, A.N. 102, 103, 105–6
Schwartz, E.K. 245
Segal, Hanna 81, 120–1, 122, 172, 173,
 174, 179
Seigal, D.J. 102
Selfe, L. 7
Shaffer, J.B.P. 245
Sharpe, Ella 162–4
Shohet, R. 204
Simon, R. 96, 150, 213
Sinason, V. 192
Sinclair, D. 104
Skaife, S. 8, 90, 92, 251
Skailes, Claire 9, 65, 148, 251
Solomon, G. 7
Solomon, J. 100–1
Spitz, R.A. 103
Springham, N. 251
Stack, M. 7
Stern, Daniel 95, 97, 98
Stevens, A. 130, 132–3
Stokes, Adrian 113, 122, 126, 127, 164,
 165, 168, 170, 172, 173–4, 175, 181,
 182
Storr, A. 70, 166, 167
Stott, J. 189, 192
Sullivan, S. 251

Tamminen, K. 8
Target, M. 98, 105
Taylor, G.J. 101
Thomas, Helen 34–5
Thomas, L. 6, 94
Thornton, R. 249–50
Tipple, Robin 7, 22, 148, 214
Tracey, N. 102
Trevarthen, C. 95
Tronick, E. 104
Turnbull, J. 5
Tustin, F. 7

Vasarhelyi, Vera 6, 42–3
Viola, W. 185
Von Keyserling, E. 126

Waddell, M. 195
Wadeson, H. 8
Wallbridge, D. 130
Waller, D. 2, 3, 8, 9, 90, 185, 186, 187,
 188, 192, 211, 231, 251
Wallerstemn, R. 208
Warsi, B. 233
Weinberg, M.K. 104
Weir, F. 4, 80, 213
Welsby, C. 6, 7, 8
Weston, D. 100–1
Wexler, M. 221
Wilson, C. 5

Winnicott, Donald 2, 4, 76, 78, 85–6, 93,
 97, 100, 119, 120, 122, 127–30, 160,
 172–3, 175, 178, 179, 180, 181
Wise, S. 7
Wittig, B. 99
Wolf, A. 245
Wollheim, R. 115, 116, 117, 169
Wood, C. 5, 22, 90, 92, 94, 192, 232
Wood, M. 8, 9, 77, 90

Yalom, I. 231, 245

Zeanah, C.H. 104

Subject index

Note: page numbers in **bold** refer to diagrams and illustrations.

Abelour Child Care Trust, Stirling 32–4
abstract art 152, 174–5
accidents 146, 247
'acting out' 74, 174, 236
'action through non-action' 133
active imagination 3–4, 93, 132
Adamson Collection 234
adaptations, therapeutic 89–90
administrative tasks 20–1, 22
adolescents 8, 144–5, 152–3; and the art
 therapy room 17–18, 33–4, 40, 41;
 facilitating change with 158–9; group
 therapy for 235–7, 268; projection of
 badness onto 153; psychiatric units for
 17–18; sexual abuse of 235–6
adoption 101, 103
adult mental health services 5, 8; and the
 art therapy room 44–50, 59–64; see
 also secure psychiatric units
aesthetic experience 153, 160, 168–75,
 180, 247
aesthetic illusion 169
aesthetic-based art therapy 95–7
aggressive behaviour 33, 264; in the art
 therapy room 37, 39; of children 75,
 213–14, 240–1
aggressor, identification with the 102
alchemy 131–2, 137–8
alcohol abuse 144–5
ambiguity 167, 188
ambivalence 120, 206
Amicus 186
'analysis in the group' 245
'analysis of the group' 245–6
'analysis through the group' 246
analytic biography tradition 116–17

anger 38, 148, 154
animism 169
anorexia nervosa 147, 181
antisocial behaviour 147
antisocial personality disorder 57–9
anxiety 121, 145–6, 222; of the art
 therapist 217–18; defences against 264;
 warding off through creativity 167
archetypal images 93
archetypes 131, 134
Aristotle 169
art: abstract 152, 174–5; as bridge
 between inner and outer worlds 175,
 183; Freud on 113–19, 160–1; healing
 properties of 3, 230–1, 232; Jung on
 130–5; Klein on 119–22; Milner on
 122–7, 163; preservative nature of 162;
 and psychoanalysis 113–35; Winnicott
 on 127–30
art degrees 187, 208–9
art psychotherapy 1, 2, 92; in community
 mental health centres 60–1; group
 244–6
art therapists 1–2, 6, 185–211; and
 adolescent work 8; and ambiguity 188;
 anxiety of 217–18; and the art therapy
 room 18–66, 75; art work of 96–7; and
 assessments 190–1; and boundaries
 73–4, 75; and case conferences 192;
 comparison with the artist 166; as
 container 80–1, 139, 141, 146; and
 contracts 73–4; and the
 counter-transference 80–3, 220–1, 224,
 228; and feedback 192–4; freelance
 35–42; and group therapy 249, 253–8,
 262–5, 268; and interpretation 82–4,

85–6, 153; and materials 222; and multi-disciplinary teams 191; as part of the art-making process 153; personal therapy of 209; problems faced by 188; and projective identification 93–4, 265; and promotion of the understanding of art therapy 188; ratio to clients 195; receiving finished works 72; and recording sessions 194–203; and referrals 189–90; and supervision 203–8; tasks of 77; training for 185–9, 208–1; and the transference 77, 84; and the triangular relationship 90–2, **91**, 220; and 'triangulation around the potential space' 77; as tyrannical mother 86; understanding the client 160; visiting 59–64, 89–90; vital role of 98; and working with the image 138, 139, 141–3, 145–6

art therapy departments 44–5; setting up 20–7, **24–5**; temporary 22–7

art therapy rooms 17–68, **19**, **24–5**, **43**, **46**; and aggressive clients 37, 39; client associations regarding the 37; client's impact on 41; concreteness of 48–9, 76; consistency of 35–6, 42, 66, 74–5; as container 38, 47, 65, 94, 141; as creative arena/potential space 17–20, 26, 65; and the display of art work 66–7; entrances and exits 32, 45; as extension of psychotic self-structures 48–9; and the external environment 29, 30–1, 37; as 'good enough' spaces 34; for group therapy 267–8; and lack of resources 34–5, 36, 64; locked areas/doors 30, 32; messy spaces 20, 27–8; multi-purpose 27; peripatetic work 32–66; privacy issues 33–4, 44–5, 66; as safe space 47, 65, 66, 73, 76; security issues 36–7, 38; setting up departments 20–7, **24–5**; and sharing space 27–39, **30**, 42; and space shortages 32–4, 36, 37–8, 61–2, 64–5; as studio-type space 46–8, 49, 92; table placement in 45–6, 63; windows 30–1

Art Therapy Summer School, Leeds Metropolitan University 209

art works (products/objects) 1, 69, 106–7, 137–59; as bridge between inner and outer world 137; and bringing about change 80; changing meanings of 220,

225–6; as clinical record 195; coded statements of 149; communication with the 151–9; as container 139; and culture 69–70; destroying personal 75; display 23, 26–7, 66–7, 72, 231, 247, 256; disturbing 171, 228; and the ego 126; existence over time 71; as expression of inner experience 71–2; as expression of the unconscious 70–2; of group therapy 231, 247, 256; as having a life of their own 165; 'here and now' reactions to 247; interpretation of 82; keeping 226–7, 228; levels of 69–70, 82, 84; and 'life in/of the picture' 96, 141; meaning of 69–70, 82, 84, 89, 93, 139, 220, 225–6, 248; Milner on the role of 125–6; as part of the therapeutic frame 73, 76; pre-verbal communication through 105, 106; as representation of inner life 4, 18, 66; satisfaction gained from 171–2; as scapegoat for the patient 90–2; significance of 4; storage 190; in supervision 206; and terminating therapy 226–8; of the therapist 96–7; as transactional objects 181; and transference 80; and the triangular relationship 90–2, **91**, 220

artistic styles 150

artistic/image-making process 4–5, 222; defining the 70; in group analytic art therapy 230–1, 232, 249; healing nature of 230–1, 232; as regression to early infantile state 115; space of the 76; surrender to 125

artists 164–7; Freud on 114–18, 119; Jung on 134–5; as magicians 162; psychological characteristics of 161–2; Winnicott on 129–30

artists-idea-medium interaction 165

'as-if' thinking 180

Asperger's syndrome 7

assessment 189, 190–1, 214–21, 266

ASTMS 186

asylums 44–58

attachment 39, 60, 97, 98–102, 105–7

attachment figures 99

attachment patterns 100–2; anxious avoidant 100; anxious resistant 100, 101; disorganised/disoriented 97, 100–1; secure 100; self-perpetuating nature of 101

attention, 'free floating' 166

attention deficit hyperactivity disorder (ADHD) 6, 236
attunement 97, 98, 106
audiences 169–70, 172
autism 94; and developmental art therapy 95; and symbolic function deficits 178–9; working with clay in 139
autistic spectrum disorders 7, 98
autonomy of art therapy 62

baby talk 149–51
babyhood 167; wish to remain in/return to 223, 225
bad objects 120
Barlinnie special unit 9
beauty 168, 171, 175
'being', psychotic clients and 56
belonging 53
bereavement 39–40, 140, 144–5, **145**, 265
Birmingham and Goldsmiths College, London 187
Bloomfield Clinic, Guys Hospital, London 42–3
body, maternal 30, 122–3, 179
body-basis, of the creative process 163–4
body/mind relationship 125, 126
borderline personality disorder 44, 97
boundaries 4, 18, 72–7, 252; breaking of 74; dissolution of 34; psychotic patients and 49–50; and setting the therapeutic space 74–7; of time 73–4, 221, 252, 268; violent clients and 39
boxes 41–2
boys, and the affects of abuse 106
brain, development 97, 101, 102–5
breast 120, 122, 127, 173
British Association of Art Therapists (BAAT) 1, 5, 122, 186, 188, 189, 209, 210; *Code of Ethics of Professional Practice* 189; membership 5; training courses 2
broken homes 143, 152, **152**, 213–14, 216–17, 224–5, 237–8, 240
brokenness, expression of through art 140
budgets 20–1
burials, symbolic 140, 152

cancer patients 28–9
cannibalism 162, 163
care plan reviews 192

caricature 169–70
case conferences 192
catharsis 171
Cézanne, Paul 174, 175
change, facilitation of 150, 158–9
chaos 20, 151, 166, 228
Chapman, Jake 123
child and adolescent mental health service (CAMHS) 6, 213, 215, 236
child analysis 78–9, 119, 128, 178–9
child bearing, male envy of 30
child court proceedings 141, 216–17
child development 97–107, 120, 164
child protection procedures 192–4
childhood, loss of 265–6
childhood abuse 146, 193–4; and brain development 97, 101, 103–4; gender specific affects of 106; group therapy for sufferers of 235–6, 263; presentations of 106; transgenerational transmission of 102
childhood dissatisfaction 167
childhood physical abuse 194
childhood sexual abuse 235–6
childhood trauma 6–7, 78–9, 106; and brain development 97, 101, 103–4; *see also* childhood abuse
children 6–7, 124; aggressive behaviour of 75, 213–14, 240–1; art therapy rooms for 29–30, 34–43; and the art work 143, 145–8, 149–51, 152–3; and boundaries 75–6; bringing items to sessions 41–2; with communication difficulties 40–1; disturbed 93–4; with emotional and behavioural difficulties 34–5; fearful 41–2; group art therapy for 235–44, **242–3**, 262–5, **263**; individual therapy for 213–28; interpretation of the art works of 83–4; looked-after 6, 105–6, 143, 149–50, 152–3, 236; messy work of 145–6; and parental bereavement 39–40; and record taking 195–203
civilisation 162
clay work 83–4, 138–40, 223–5, 228, 262, **263**
client groups 4–5
client notes/records 22, 192–3, 194–203; group therapy interaction chronogram 199–203, **200–2**; observation method 195, 197–8, **197**; photograph/drawing

and checklist method 198–9; progress mapping 200, **201**
clinical placements 4, 210–11
cognitive behavioural therapy (CBT) 214
collages 23
collective unconscious 131, 134, 178, 250, 265
collusion 205–6
colour 141, 143, 154
'common group tensions' 245
community centres 32; *see also* day centres
community mental health centres (CMHCs) 59–64
community work/care 8–9, 22, 54–64, 90
compensation 114
computers 39–40
concrete models 63
Coney Hill Hospital, Gloucester 65
confidentiality 22, 190, 192, 193
conflict 147
Connell, Camilla 28–9
conscious mind 114–15, 126–7, 176; and the creative process 164–5; and symbols 130–5
containment 56, 75, 225, 228; and the art therapist 80–1, 139, 141, 146; and the art therapy room 38, 47, 65, 94, 141; and the art work 139; internal 146; *see also* non-containment
continual professional development (CPD) 210
control issues 146, 152
coordination difficulties 148
Council for Professions Supplementary to Medicine (CPSM) 2, 186
counter-transference 80–4, 105, 146, 220–1, 224, 228; in aesthetics-based art therapy 96–7; defining 80, 85; and supervision 204, 206, 207
court proceedings, child 141, 216–17
creative experience: body-basis of the 163–4; understanding of the 160–7; warding off unpleasant experiences through 167
creative writing 118–19
cubism 174
cultural evolution 178
cultural experience 129
culture 69–70, 168
Cumberland Lodge 209

Data Protection Act 192
day centres 190, 252–6, 257; *see also* community centres
death 39–40, 144–5, 151, 265
death instinct 119; *see also* Thanatos
defence mechanisms 122, 143, 174, 264
defining art therapy 1
degradation, expression through art **155–7**
dehumanisation 51
delinquency 143
dependency 246, 249
depression 97, 104, 154, **155–7**, 235
depressive personalities 167
depressive position 120–2, 172–4
desire 168
despair, expression through art 154, **155–7**
destructive impulses 171–2, 174
developmental art therapy 94–5
diagrammatic images 96, 141
Dinos 123
disabled people 21
disassociation 183
disasters 7
discussion, free-floating 253
displacement 114, 179
display of the art work/product 66–7, 231, 247, 256; choosing against 72; picture walls 23, 26, 27
dissociation 103, 106
dissociative personality disorder 97
divorce 237, 238
double identity 83–4
drama 20
'Draw Yourself as a Tree' exercise 258, **260–1**
dream work 133, 169, 206
dreams 70–1; making images of 93, 138–9; as primary process 114
drug users 32–3
dyad 76–7, 104

early infantile experience: failure to contain 94; re-experiencing of in therapy 77, 79
early intervention programmes 104–5
eclectic approaches 97
Education Act 1981 7
educational placements 5–6, 7, 10, 90; and the art therapy room 18–20, 34–5, 36–42; and group therapy 237–44, 259;

and referrals 189; supervision in 207
educational psychologists 214, 215
effigies 169–70
ego 114–15, 163, 169–70, 176, 178; and
 art works 126; collapse of control 161;
 Jungian theory of 131; Kleinian theory
 of 120; organising 55; regression in the
 service of the 161; strong 167
elderly clients 9, 234–5
embodied pictures 96, 141
emerging affective art therapy 95
Emin, Tracey 123
emotions: expression of unacceptable
 231; organisation of 102, 163, 173;
 spilling out of 75
encounter groups 250
envy 120
Eros 174
evidence-based practice 10, 193
experiential learning 209–10
external objects 119
external world 120–1, 124, 127–30, 140,
 172–3, 180–1, 183

families: broken 143, 152, **152**, 213–14,
 216–17, 224–5, 237–8, 240; conflict
 within 152, **152**; working with 32–3, 34
family meetings 215
family therapy 214, 249–50
fantasy 78–9, 128, 176, 179, 239; *see also*
 phantasy
fear: early infantile 94; of ugliness 171–2;
 see also terror
feedback 192–4
fees 73
felt tip pens 141, **142**
fight, flight, freeze responses 103
finger paints 144–5, **144**
first impressions 214, 215–21
food obsessions 158
fortress imagery 143
found objects 170, 171
Foundation Certificate in Art Therapies
 209
foundation matrix 265–6
fragmentation 165
frames 73, 76, 141, 172
free association 71–2
'free floating' attention 166
'free-floating' discussion 253
freelance art therapists 35–42
Freud Museum, London 113–14

fusion 173, 175

general practitioner (GP) practices 5
gestalt 165
Gilder, Caroline 59–64
girls, and the affects of abuse 106
Gogarburn Hospital 66
Goldsmith, Anna 44–59
good objects 120, 164
Goodall, Patrick 18
grief, complicated 140
group analytic art therapy 248–9
Group Analytic Society 246
group art therapy 230–68; adult clients
 246–8; approaches to 248–51; and the
 art therapy room 267–8; assessment
 for 266; benefits of 231–2; child clients
 235–44, **242–3**, 262–5, **263**; current
 level of relationships in 262; example
 of 252–9; and the group unconscious
 250–1, 265–6; intrapsychic processes of
 264; and materials 247, 255; practical
 issues for 266–8; primordial
 level/foundation matrix of 265–6;
 projective processes of 264–5; and the
 size of the group 267; studio-based
 open groups 232–5, 267, 268;
 theme-centred groups 256–9, 267;
 themes for 249, 250, 251, 256–9; and
 transference 250, 254, 262–4, 262–64,
 267; and verbal group therapy 232,
 244–9, 251
group leadership 245
group supervision 63, 208
group therapy: and the psychic content
 of the group 138–9; verbal 232, 244–9,
 251, 266–7
group therapy interaction chronogram
 199–203, **200–2**

Harperbury Hospital, Herts 22
hate 120
healing, art and 3, 230–1, 232
Health Professions Council (HPC) 1,
 186, 210
'here and now' 247, 257
Hertfordshire Partnership NHS Trust
 59–64
Hill End Hospital, St Albans 44–58, **46**
history of art therapy 1–2, 3–4
Hollymoor Adolescent Unit,
 Birmingham 18

Home Office 5
homosexuality 116
hopelessness 140
horrific images 228
hospital admissions 56
hospital closures 22, 32, 44, 50–9, 90; and the demonisation of hospitals 51; politico-economic agenda of 51, 54
hospital work 5; advantages of 51–8, 90; art therapy rooms of 17–18, 28–31, 42–3, 44–51; certainty/contextual stability of 51; and group therapy 233–5; and occupational therapy 52–3; and studio-based art therapy 92; and supervision 207; *see also* National Health Service; psychiatric hospitals
human potential movement 250
humanisation 53
hyper-arousal 103
hyper-vigilance 104

id 115, 161, 167, 176
identification 264; with the aggressor 102; projective 81–2, 93–4, 265
identity: double 83–4; problems with 258–9, **260–1**
illusion 76, 127, 180, 181
illusionary area 172–3
image-making process *see* artistic/image-making process
imagery: dealing with in psychosis 49; making concrete 49; phallic 143
images *see* art works (products/objects)
imagination 123, 161; *see also* active imagination
immortality 162
impulsivity 6, 236, 237
in-service education and training (INSET) days 188
individual art therapy 213–228
individuation 131, 133, 167
industrial therapy 52
Infant Observation Course 195
Information Act 192
information sharing 190
inner world 120–1, 123–4, 127–30, 172–3, 180–1, 183, 264; artist's access to 167; mingling with the external 174; primacy of the 187
insight 122–3
instincts 119; and archetypes 134; and phantasies 179–80; sexual 114–16

institutionalisation 8–9, 53
integration 165, 173, 178
'integrity of the object' 171
intelligence quotient (IQ) 103
interactive art therapy 95
internal objects 99, 119, 120, 264
internalisation 214
International Journal of Art Therapy: Inscape, The 1
interpretation 82–6, 153; premature 82, 85–6, 166
intersubjectivity 95, 97
intimacy 40
intrapsychic processes 264
isolation: of the art therapist 188; expression through art 154, **155–7**

Jungian frameworks 233–4

Khan, Masud 125
Kjar, Ruth 121
Kleinian theory 79, 162–4, 172

language 85–6, 98; absence of 5; facilitation of 95; and symbolism 182
leadership 245
learning difficulties 7, 22, 33, 94; group therapy for children with 239–44; moderate 148, 149; severe 148
Leonardo da Vinci 116–18, 119, 161
letter writing 39–40
Leytonstone House 22–7, **24–5**
libido 115, 116; *see also* life instinct
life, representations of 162
'life in/of the picture' 96, 141
life instinct 119; *see also* libido
logic 124, 125
looked-after children 6, 105–6, 143, 149–50, 152–3, 236
looks, between therapist and client 153
loss: of childhood 265–6; working through 141, 151
love 120

MA in art therapy 189, 209–11
madness, 'letting in' 123
magic 162–3, 169–70
mana 169
manic behaviour 150–1
manic defences 122, 174
manic reparation 122, 174
mark-making 69

materials 21, 28, 29, 43, 58, 106–7, 165, 222, 224–5; abundance of 222; changing 144; client's interactions with the 139–48; client's resistance to the 146; as clue to the mental state of the client 75; in group therapy 247, 255; lack of 222; and play 105; quality of 21; restrictions on 89–90
maturity, false 150–1
meaning: of the art work 69–70, 82, 84, 89, 93, 139, 220, 225–6, 248; generation of 82
medical-based art therapy 3
memory, visual 179–80
mental illness: protective effects of creativity against 167; subjective meaning of 131; see also psychiatric diagnoses
mental incapacity 177
mess/disorder 20, 27–8, 75, 106, 139–48, 151, 193, 228
metaphor 177
metapsychology 176
Michaelis, Karin 121
Michaux, Henri 69
Michelangelo 116, 117–18
mind/body relationship 125, 126
mindfulness 53
Miro 69
mirroring 264
Morelli, Giovanni 117
mother-infant relationship 60, 125–6; and brain development 104; and the containment of distress 81; and interpretation 85, 86; as model for the therapeutic relationship 81, 85, 86, 98; and non-verbal communication 93–4; play space of 93; and psychoanalysis 85; quality of and development 102–3; Winnicott on 127, 129
mothers: body 30, 122–3, 179; death 144–5; and depression 104; environment mother 175; 'good enough' 127; intrusive 86; object mother 175; object-relations theory of 120, 175
mourning 120–1
multi-disciplinary teams (MDTs) 59–60, 191, 213–14
multi-family groups 259
multiple personality disorder 97
mystic doctrines 177

mythology 162

narcissism 116
narrative 101–2, 105–6
National Health Service (NHS) 2, 5, 188–9, 209; community mental health centres 59, 60, 61; and hospital closure 50, 51, 90; supervision in 206–7; see also hospital work
National Union of Teachers (NUT) 186
Natkin, Robert 168, 175
needs of the client 266–7
neglect 146; and brain development 103; unintended 104
neoclassicism 3
Netherne Hospital 92, 186
neurobiology 97, 101, 102–4, 106
neurodevelopment 102–3
neurosis 46–8, 115–16, 130, 167, 176, 266
Newsbriefing (journal) 1
non-containment 20, 28
non-verbal communication 5, 147–8
not-knowing 82, 125
nursery environments 38–9
nurturance 76

object permanence 94
object-otherness 173, 175
object-relations theory 79, 93, 99, 119–20, 174–5, 178
object(s): bad 120; external 119; found 170, 171; good 120, 164; 'integrity of the' 171; internal 99, 119, 120, 264; part 120; primal 79, 179; restored 171; transactional 180–1; transitional 93, 128, 129, 180
observation method 195, 197–8, **197**
obsessional personalities 167
occupational therapy 52–3
Oedipal conflicts 121, 223
omnipotence 128, 163–4, 181
open groups, studio-based 232–5, 267, 268
openness 82
orbitofrontal cortex 103
organising self/ego, 'good enough' 55
orphanages 103
outpatient care 55–9

pain, psychic 102, 105
paint 147–8

painting 143–4, 219–21, 237–8, 240–4, 247–9, 253–5, 264
palliative care 9
parallel processes 60
paranoid-schizoid position 120, 122, 173, 174
parents: absent 31; childhood experiences of 102; depression of 97, 104; loss of 39–40, 144–5; primal identification with 163
part objects 120
part-time work 28–31, 59–64
past, re-engagement with the 77–9
peer interaction 236
pen and ink 151
personal growth 85
personality disorders: antisocial 57–9; borderline 44, 97; dissociative 97; multiple 97
pets, death of 151
phallic imagery 143
phantasy 114–17, 119–20, 171, 178–80; see also fantasy
photograph/drawing and checklist method 198–9
physical contact 75
physical disabilities 23, 26
picture walls 23, 26, 27
plasticine 223–4, 225, 228
play 38–9, 40, 41–2, 93, 123, 173; Kleinian analysis of 78–9; make-believe 180; psychoanalysis as form of 129; re-enactment of trauma through 78–9; through art therapy 105; Winnicott on 128–9
'play technique' 78–9, 119, 128
pleasure principle 114, 115, 178
pleasure-pain principle 177
postgraduate courses 189, 209–11
potential space 17–20, 26, 65, 175
pottery 27
powerlessness 140, 152
pre-operational stage 94–5
pre-symbolic stage 94
pre-verbal communication 85, 93–5, 105–6
primal objects 79, 179
primary maternal preoccupation 127
primary processes 114–15, 126–7, 138, 170; and creative experience 161–2; and the creative process 164–5, 167; and symbolism 180, 182–3

primitive art 69
primordial level 265–6
prisons 5, 6, 9
privacy issues 33–4, 44–5, 66
Private Practice 5
progress mapping 200, **201**
projection 165, 264–5
projective identification 81–2, 93–4, 265
pseudo-adulthood 150–1
psyche 135; quest for wholeness 131; reconciliation of the primitive parts of 133; symbol forming capacity of the 132
psychiatric diagnoses 214; see also mental illness
psychiatric hospitals: adolescent units 17–18; adult units 44–50; secure units 6, 9, 56–7, 190
psychiatrists 187
psychoaesthetics 96
psychoanalysis 160–83, 210, 264; and aesthetic experience 168–75; and aesthetics-based art therapy 95, 96; and art 113–35; and art therapy 2, 3–4, 71–2, 93–6; and creative experience 160–7; as form of play 129; and the mother-infant relationship 85; and narrative 105–6; and projective identification 81–2; and symbolism 175–83
psychodrama 244
psychogeriatric wards 234–5
Psychological Therapies Forum (PTF) 64
psychologists, educational 214, 215
psychotherapy 209, 210; and art therapy 236; as attachment relationship 105; as form of play 129; group 244–6; see also art psychotherapy
psychotic art 166
psychotic clients 90, 93–4, 176, 266; and the art therapy room 44, 48–50; and creative experience 161; facilitating change in 158–9; group therapy for 251; hospital work with 44, 48–50, 53–4, 55–6; and outpatient services 55–6; and relating 55–6; working with clay 139

racial tension 147
racism 262
rationalism 3
reality, turning away from 115

reality principle 114, 115, 177
record-keeping *see* client notes/records
'Red Book' (Jung) 133
referrals 62–3, 189–90, 213–14
reflection 5
reflective functioning 105–6
regression 38–9, 150–2, 181, 223, 225;
 controlled 161; in the service of the
 ego 151–2, 161
rehabilitation 9
reintegration 151
relating, problems with 55–6, 58, 59, 266
religion 131, 170, 177
reparation 125, 141, 172, 173, 174; manic
 122, 174; of the mother's body 122–3
repression 114, 115, 177
research 10, 210
resistance 245
restitution 171
restored objects 171
reverie 127, 151, 197, 248
rituals 6
romanticism 3
Royal Marsden Hospital, London 28–9

sadness, expression of through art 140
safety: feelings of 47, 65, 66, 73, 76, 225,
 268; issues regarding 36–7, 38
St Mary's School, Bexhill-on-Sea 18–20
St Thomas's Hospital, London 29–31,
 30
sand play 239
schizoid personalities 167
school exclusion 35
scientific method 117
Scotland 32–4
secondary processes 114–15, 126–7, 138;
 and the creative process 164–5, 166;
 and symbolism 180, 182–3
secure psychiatric units 6, 9, 56–7, 190
self: core 98; development of the 98, 126;
 divided 167; emergent 98; false 181;
 intersubjective 98; organising 55; and
 other 93; temporary loss of the 173;
 true 181; verbal sense of 98
self-blame 152–3
self-conceptualisation 258
self-cure 125, 132–3
self-directive therapy 63
self-discovery 153
self-preservation 162, 164
sensori-motor stage 94

sentimentality 174
sexual instincts 114, 115, 116
Shadow 131
shell shock 234–5
short-term art therapy 256–7
shyness 237
social services 5–6, 207, 257
space: for play 93; therapeutic 4
special educational needs 7, 237–9
special interest groups 5
speech, lack of 148
splitting 264
spontaneity 6, 71, 147, 233–4
staff offices 45–6, 55
stencils 141, **142**, 151
step-parents 31, 143
strange situation test 99
stuckness 143
'studio upstairs' approach 232–3
studio-based open groups 232–5, 267,
 268
studio-type space 46–8, 49, 92
sublimation 114–16, 119–20, 129, 161–4,
 168; and symbolism 177–8
sublime 168, 175
suicide 18, 158
suitability of clients for art therapy 214,
 215–26
superego 115, 163, 170–1, 222
supervision 4, 203–8; boundary between
 therapy and 204–6; definition of
 203–4; group 63, 208; image in 206;
 individual 208; in the main areas of
 practice 206–7; problems with 208;
 supervisor qualities and
 responsibilities 207–8; for trainees
 210–11
surrealists 170
symbolic communication, facilitation of
 236
symbolic space 268
symbolisation 95
symbolism 130–5, 175–83; alchemical
 131–2; anthropological 177; classical
 theory of 176, 177–8; discursive 138,
 182; functional 177; non-discursive
 138, 182; presentational 182; as
 primary process 175–6; as secondary
 process 175–6; true 177
symbols 130–5; as channels for the
 unconscious to become conscious
 130–5; collective 134; elements of

176–7; formation 127–8, 175, 182; individual 134; as innate 177–8
systems theory 249–50, 251

Tavistock Clinic 245
Tavistock Institute 195
Tchaikovsky, Pyotr Ilich 70
temporary art therapy departments 22–7
terminal illness 9
terminating therapy 74, 158, 226–8; final sessions 226–7
terror 94, 102, 166; see also fear
Thanatos 174; see also death instinct
theme-centred groups 256–9, 267
themes 249, 250, 251, 256–9
theory: developments in 89–107; training in 210
therapeutic communities 189–90, 257
therapeutic contracts 4, 72–3, 189, 190, 221, 222
therapeutic distance 18, 39, 40, 76
therapeutic frame 73, 76
therapeutic process 77–86; counter-transference 80–3, 84; interpretation 82–6; projective identification 81–2; transference 77–80, 84–5
therapeutic relationship 1, 4, 105–7, 158, 222, 225; ending of 226–8; in group art therapy 267; meaning within 149–51; mother-infant relationship as model for 81, 85, 86, 98; signs of growing 141; see also triangular relationship
therapeutic space: and boundaries 74–7; definitions of 74; as microcosm of society 76; setting the 74–7; see also art therapy room; time boundaries
therapy of art therapy 69–86; boundaries 72–7; therapeutic process 77–86
thought 114
time boundaries 73–4, 221, 252, 268
'total situation' 81
toys 40
training 97, 208–11; development of 185–9; pre-course experiences 208–9
transactional objects 180–1
transcendent function 130
transference 1, 76, 77–80, 84–5, 105–6, 220–1; in aesthetics-based art therapy 96–7; art-making as reflectance of 90–2; cultural 84–5; defining 77–8, 84; and diagrammatic images 141; in group art therapy 250, 254, 262–64,

267; held in images 151; in Jungian therapy 132–3; letting clients down during 140; scapegoat 90–2; in verbal group therapy 245, 246
transgenerational abuse 102
transitional objects 93, 128, 129, 180
trauma see childhood trauma
triad 77
triangular relationship 85, 90–2, **91**, 96, 220
'triangulation around the potential space' 77
trust 225
twins 83–4

ugliness, fear of 171–2
'uncanny, the' 168–9, 171
unconscious 114, 115, 126, 127, 176; bringing into consciousness of through imagery 82, 84, 85; collective 131, 134, 178, 250, 265; and the creative process 161–2, 164–5, 167; and creative writing 118–19; expression of the 70–2, 96, 113; 'group' 250–1, 265–6; Jungian theory of 134; penetration of by therapy 79; symbols as channels of the 130–5; see also phantasy
unconscious scanning 165
undervaluing of art therapy 34–5
University of Hertfordshire 209
unknown, terror of the 166

Venus de Milo 121
verbal contracts 47
verbal group therapy 232, 244–9, 251, 266–7
video 203
visiting art therapists 59–64, 89–90
visual impairment 21
visual memory 179–80
voluntary sector 5, 32

Wain, Louis 52
waiting lists 189
War Office Selection Boards 244
wheelchair-bound clients 21, 23, 26
whole person relationships 47, 48, 49
wish-fulfilment 128
Withymead Centre 135
work settings 4–6, 8–9
working models 100, 101, 102, 114
writing: creative 118–19; letters 39–40